The Other Side
of Color

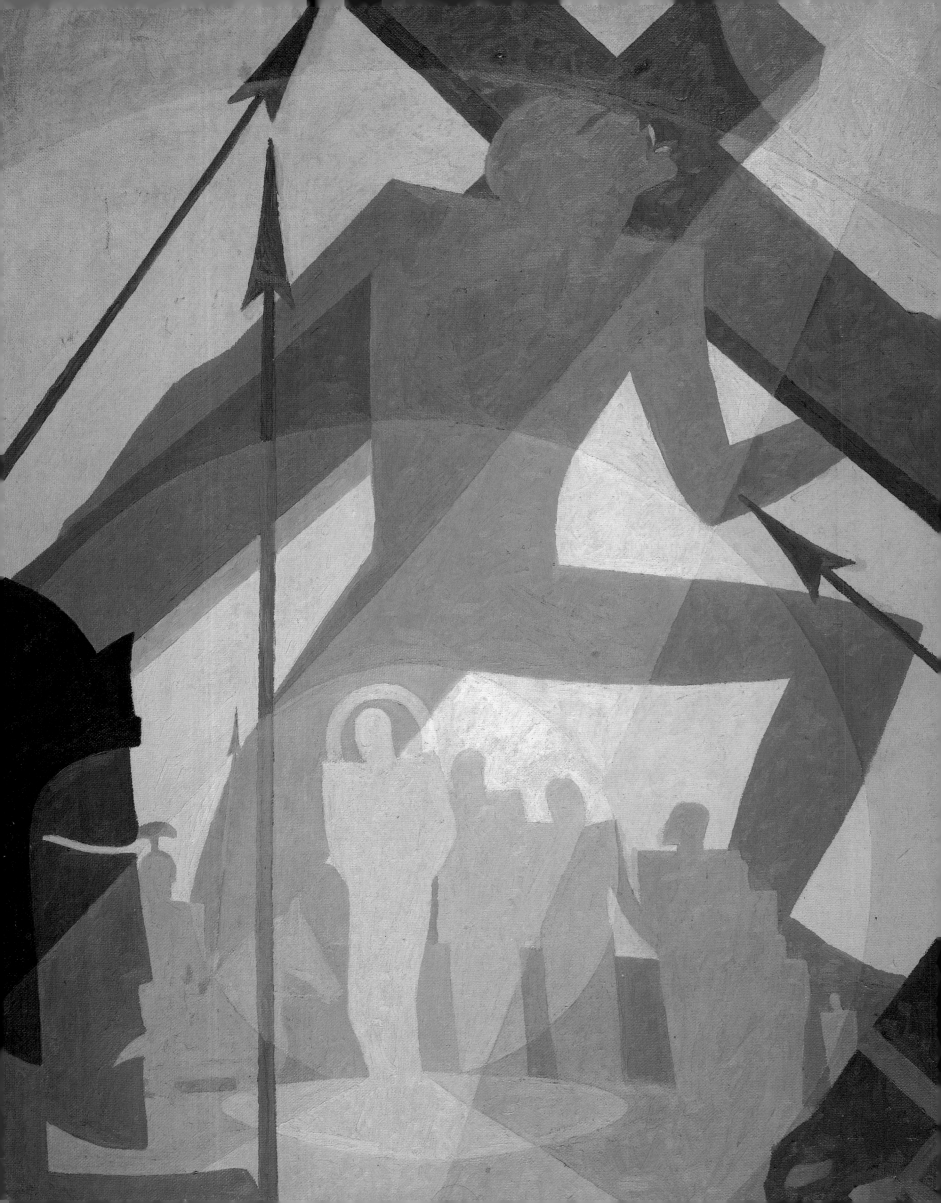

The Other Side
of Color

African American Art in the
Collection of Camille O.
and William H. Cosby Jr.

David C. Driskell

with Introductions by
Camille O. Cosby and William H. Cosby Jr.

Biographies by
René Hanks

Pomegranate

San Francisco

Published by Pomegranate Communications, Inc.
Box 6099, Rohnert Park, California 94927
1-800-277-1428; www.pomegranate.com

Pomegranate Europe Ltd.
Fullbridge House, Fullbridge
Maldon, Essex CM9 4LE, England

© 2001 David C. Driskell

All rights reserved.

No part of this publication may be reproduced or transmitted in any form or by any means, electronic or mechanical, including photocopying, recording, or by any information storage or retrieval system, without permission in writing from the copyright holders.

Library of Congress Cataloging-in-Publication Data
Driskell, David C.
 The other side of color : African American art in the collection of Camille O. and
William H. Cosby, Jr. / David C. Driskell ; with introductions by Camille O. Cosby and
William H. Cosby, Jr. ; biographies by René Hanks.
 p. cm.
 Includes bibliographical references and index.
 ISBN 0-7649-1455-3 (alk. paper)
 1. Afro-American art. 2. Cosby, Bill, 1937---Art collections. 3. Cosby, Camille O.
(Camille Olivia), 1944---Art collections. 4. Art--Private collections--United States. I.
Cosby, Camille O. (Camille Olivia), 1944- II. Cosby, Bill, 1937- III. Hanks, René. IV.
Title.

N6538.N5 D735 2001
708.13—dc21

 00-062364

Pomegranate Catalog No. A596
ISBN 0-7649-1455-3

Cover and interior design by Jamison Design, Nevada City, California

Frontispiece: Aaron Douglas, *Crucifixion*, 1934, oil on masonite, 48 x 36 in.

Photographs: Figures 3, 7, 15 and Plates 1 to 30, 32 to 93, Frank Stewart;
Figures 1, 2, 4 to 6, 8 to 10, 12 to 14, David Stansbury; Plate 31, Becket Logan

Printed in England
09 08 07 06 05 04 03 02 01 10 9 8 7 6 5 4 3 2 1

Dedicated to our special son and friend,

Ennis William Cosby

Contents

Foreword
Erika Ranee Cosby **ix**

Introductions
Camille O. Cosby **xiii**
William H. Cosby Jr. **xvii**

Overview
Daphne Driskell-Coles **xx**

Part**One**

Collecting African American Art: A Cultural Context 1

Part**Two**

Cultural Emancipation and the Quest for Freedom 11
Joshua Johnston c. 1765–c. 1830 **12**
Robert S. Duncanson 1821–1872 **13**
Edward Mitchell Bannister 1828–1901 **20**
Mary Edmonia Lewis c. 1845–c. 1911 **23**
Henry Ossawa Tanner 1859–1937 **25**

Part**Three**

Black Artists Come of Age: Twentieth-Century Torchbearers 35
Meta Vaux Warrick Fuller 1877–1968 **35**
Archibald J. Motley Jr. 1891–1981 **36**
Alma Woodsey Thomas 1891–1978 **41**
Augusta Savage 1892–1962 **44**
Palmer Hayden c. 1893–1973 **47**
Aaron Douglas 1899–1979 **47**
Hale Aspacio Woodruff 1900–1980 **52**
William Henry Johnson 1901–1970 **55**
Richmond Barthé 1901–1989 **56**
Beauford Delaney 1901–1979 **59**
James Lesesne Wells 1902–1993 **63**

Part**Four**

Black Artists of Popular Culture: The Visionary Spirit 69
Horace Pippin 1888–1946 **70**
Minnie Evans 1892–1987 **77**
Clementine Hunter 1887–1988 **79**
Ellis Ruley 1882–1959 **79**

Part **Five**

The New Black Image in American Art 85

James Amos Porter	1905–1970	**87**
Lois Mailou Jones	1905–1998	**88**
Charles Alston	1907–1977	**92**
Norman Lewis	1909–1979	**95**
Romare Bearden	1914–1988	**96**
William Ellisworth Artis	1914–1977	**102**
Hughie Lee-Smith	1915–1999	**102**
Elizabeth Catlett	1915–	**105**
Claude Clark	1915–	**112**
Eldzier Cortor	1916–	**113**
Jacob Lawrence	1917–2000	**119**
Charles White	1918–1979	**124**

Part **Six**

The Harlem Renaissance Inspires 133

Walter Williams	1920–1998	**137**
William Pajaud	1925–	**138**
Robert Colescott	1925–	**143**
Faith Ringgold	1930–	**143**
David C. Driskell	1931–	**144**
Emma Amos	1938–	**147**
Bob Thompson	1937–1966	**147**
Martin Puryear	1941–	**153**
William T. Williams	1942–	**157**
Margo Humphrey	1942–	**157**
Keith Morrison	1942–	**158**
Mary Lovelace O'Neal	1942–	**161**
Stephanie Elaine Pogue	1944–	**164**
Varnette Honeywood	1950–	**167**
Erika Ranee Cosby	1965–	**167**

Afterword **173**

Biographies **175**

Acknowledgments **203**

Selected Bibliography **205**

Index of Artworks **209**

Subject Index **211**

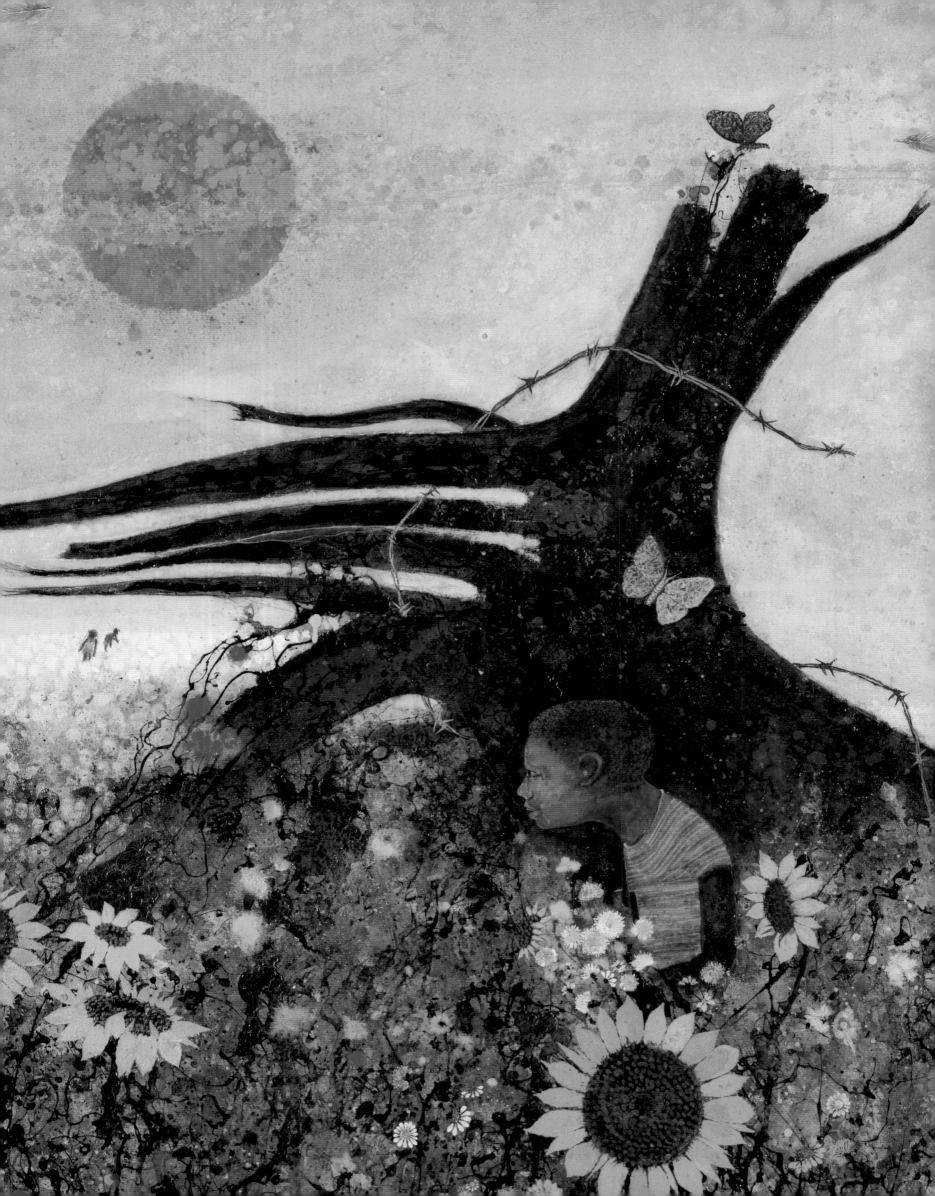

As far back as I can remember, my life has been surrounded by art. Paintings always filled the walls of our homes throughout the years of my early childhood and young adulthood. My memories of specific artworks are interconnected with some of the most poignant landmark events of my life.

One of my earliest favorites was *Roots, Southern Landscape* (see detail from Plate 72), a rose-colored pastoral scene with an enormous sunflower, painted by Walter Williams. This painting marked my first emotional response to color. I clearly remember the brilliant rich pink tones of the sky dotted with butterflies. The horizon was a layer of white flowers—or cotton—and vastly dispersed tiny black marks indicating people standing near a thimble-sized shack far, far away, by an uprooted stump of a tree. A boy closes in on a gorgeous golden sunflower.

When I was a child, the pinks and the brilliant color of the large looming sunflower dominated my memory of that painting. The images of children playing in the expansive bucolic field of butterflies and flowers echoed my own childhood wanderings through the fields and woods of my home after school every day. Over the years, as I grew up, I was surprised to see the giant sunflower was shrinking with my youthful dreamy innocence. But the beautiful intensity of its color never changed. Unwittingly, I had recognized and internalized the power art had on my life.

My childhood interpretation of that painting was purely visceral, devoid of the formal art historical teachings that would come later. I hadn't yet learned about formalism or technique; what type of materials the artist used or how certain colors complement one another; or about perspective and how to render objects spatially on the canvas. Yet it all came together for me as a successful image through its ability to catch my attention. Every time I passed that particular painting I would stare, and sometimes after the hundredth time of glancing at it, I'd discover something new.

Another artist whose works punctuate my early memories is Charles White. His numerous paintings, ink drawings, and lithographs in our home dominated my parents' early collection. I readily identified with the young people in White's works. One work in particular I recall is *The Wall* (Figure 1). It is a large india ink drawing of a black girl peering out at the viewer with a serious and somewhat sad expression on her face. The seductive quality of White's works is his ability to render images so meticulously realistic that they come to life. I was about ten years old when I noticed her. Her life-size, fully rendered body seemed to jump right off the paper. She was almost the same size and coloring as I, and she even had the same medium-length Afro I wore from early childhood through my late teenage years. She had a serious look, and as my world opened up to a less naive reality, so too did her expression. Daily, I'd run or walk by her face en route to my bedroom, never avoiding her gaze. She was like a sister to me, so physically akin to me and yet emotionally different. I was joyous and playful, and her heart seemed perpetually burdened by an unknown secret. During the years that followed, my long absences away at school enhanced my perception of the girl's serious gaze. It was as if she were my sobering alter ego, the reality check on my teenage frivolity. These small epiphanic moments consummated our unspoken sisterly bond.

As a child, I saw eye to eye with the life-size youths depicted in White's drawings. In *Dream Deferred,* the lower half of the young boy's face is concealed by the very thing with which the work is associated, a wall. Only the boy's eyes are visible, expressing a look of intense concentration that reveals a soul far beyond his age. He may be about six or eight years old, the same age I was when I first recall viewing this image. My young, shy mind empathized with what I took to be his apprehension about peering more daringly over the wall. As I physically outgrew the boy behind the wall, my interpretation became less of a measuring stick of my childhood timidity and more a symbol of the profundity of loss of innocence. What happened to that young boy to make him recoil with such serious sad eyes from the world?

The subjects in Charles White's works have souls that live and grow and change over time. I believe this to be one of a few key factors separating good art from great art. One last example of White's exceptional talent is the portrait he did of my father in 1968. Many people who viewed this work thought it was not an accurate likeness. Some didn't like it and said that it made my father look too serious. As a kid, I also thought that the head was rendered too small for Dad's exaggerated powerful shoulders. But my mother always loved that portrait. It remains her favorite, and she proudly displays it in her favorite room. Mom recently revealed to me that White perceived a part of Dad that she had always known, the private, more serious side of the man revered for his humor. I believe this is the only portrait ever done of my father that presents another side of him. Those of us who know him as a son, husband, father, and close friend know him not only as a person with an amazing talent to make the world laugh, but also as a man with a deep, compassionate, and contemplative soul. Charles White captured that soul.

That is the power of art. I am certain that the art I have grown up with has had a major influence on my decision to pursue art as a profession. When I became an art major in college, few courses were offered that explored the full history of African American art. If they touched on it at all, it was only in small fragments, with an emphasis on African styles. One course offered comparative analysis between African art and the more validated European modifications of African art. None offered a comprehensive look at African American art. My options didn't improve in graduate school, where one professor assigned our class to read one book for the entire seminar. This book stated that the contemporary artists featured were the most talented in the country and possibly the world. We were asked to select a few of our favorites and write a lengthy report. I was frustrated by the lack of awareness on the part of my professor. Not only did the book (written by a woman, no less) feature only a small number of women artists, but also no

African American artists at all were represented. Out of the eleven or so students in the class, most were women, and four were African American. After we brought this discrepancy to our professor's attention, he defensively challenged us to name any renowned contemporary African American artists worthy of inclusion.

That moment remained a point of contention for me throughout my graduate school experience. Two years later I was asked to deliver the commencement address to my graduating class. The absence of African American art history from the academic curriculum of many predominantly white institutions became the catalyst of my address. Most people seem unaware that African American art history is as much a part of white history as it is black history. In my opinion, nonblack children should know just as much about Elizabeth Catlett as they do about Henry Moore or Louise Bourgeois, or as much about Bob Thompson, Beauford Delaney, and Minnie Evans as they do about Vincent van Gogh or Jackson Pollock. Why is Henry Ossawa Tanner's name, like most African American artists' names and profiles, absent from several standard resources like *The Oxford Companion to Art*? When a major New York City museum decided to exhibit a retrospective of Jacob Lawrence's work, I was filled with pride, yet it was a bittersweet pride. Jacob Lawrence certainly wasn't the only African American artist to have a major retrospective exhibition. But Jacob Lawrence is one of only a few artists ever given widespread recognition, the kind more frequently bestowed upon his white counterparts.

As an artist and novice collector, I know how important it is to me that my parents collect African American art. I also realize it is a privilege for anyone to assemble a collection of this stature. I also know that art should be made accessible to everyone and that collecting art should not require major monetary expenditures. I began my collection with my younger siblings' drawings and paintings and some of my dad's works. At times, I trade works of art with my fellow artist friends. Anyone can collect. I cherish every item and

Figure 1. Charles White, *The Wall*, 1968, ink on artist's board with newspaper transfer lettering, 52 x 42¼ in.

consider each of equal value, whether it's an expensive painting or a napkin doodle. What matters is that you love it. I want my children to have the same education that my parents provided for my siblings and me as we were growing up. There exists an ever-expanding collection of African American art that can provide invaluable information to everyone.

In response to our professor's challenge to the four black graduate students in my class, we made sure to extend his very short—basically nonexistent—list of notable contemporary African American artists to include some of the ones I have mentioned here. That was in 1993.

Since then, a new generation of African American artists has been showcased in black-themed museum exhibitions and in some critically acclaimed solo gallery exhibitions. Lorna Simpson, Glen Ligon, Ellen Gallagher, Fred Wilson, Cathleen Lewis, and Kara Walker are becoming highly visible.

I hope this recent sudden interest reflects an increasing awareness, openness, respect, and recognition of black artists by the establishment and is not simply the latest expendable trend. After all, our ethnicity is not a trend; it is a vital and integral part of American heritage and American history.

ERIKA RANEE COSBY

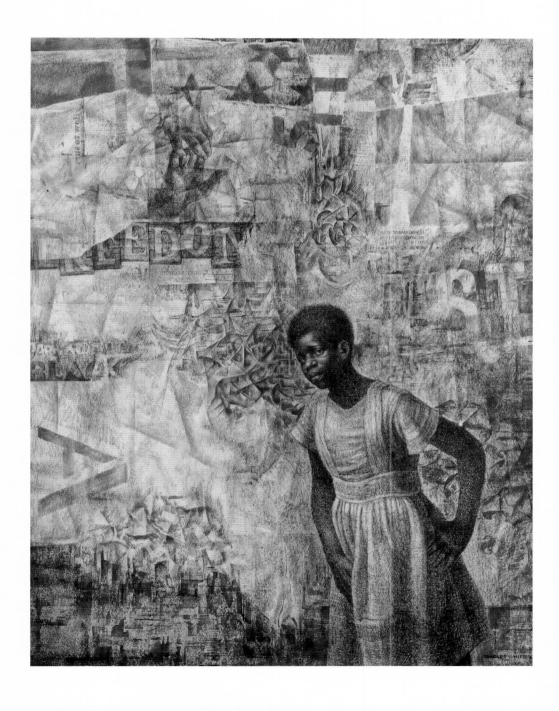

Art must answer a question, or wake up somebody, or give a shove in the right direction. — Elizabeth Catlett

Colors have always been affective in my life. Potent, bold, resplendent colors, the colors of the sun, oceans, trees, and rainbows. Colors that were integral in our African foremothers' and forefathers' civilizations but colors that they were forbidden to wear after their enslavement by uncivilized people in the "New World." Colors that African Americans were ashamed to wear until the latter part of the twentieth century because of the ubiquitous racist jokes about black skin contrasted with bright colors. Despite the humiliating jokes, I lived with and wore vivid colors, especially red, purple, blue, orange, yellow, and green. These are the same colors that were important to notable American artists such as Romare Bearden, Alma Thomas, Bob Thompson, Beauford Delaney, and many others.

I recognize also the profoundness of black, brown, and white colors. On September 8, 1967, Bill and I purchased our first African American artwork, a Chinese ink and charcoal drawing by Charles White titled *Nude.* Twelve days later we bought another Charles White Chinese ink and charcoal drawing titled *Cathedral of Life* (Figure 3), and in 1969 we acquired *Seed of Heritage* (Plate 69). Eventually we acquired eighteen of Charles White's works, all from the Heritage Gallery in Los Angeles, California. During the same year Bill commissioned Mr. White to create his portrait (Figure 2). Mr. White's depiction of Bill is unlike any other that I have seen; amazingly, Mr. White captured Bill's seriousness and complexities. Indeed, this portrait is my favorite Charles White drawing.

Sometimes Bill and I purchased art collaboratively; often we made our acquisitions singly. We respect each other's sense of beauty, and consequently we have exchanged gifts of art throughout the many years of our marriage. Without a doubt, Bill and I hold dear those mutual presentations of gifts. After all, those gifts are the historical, distinctive works of African American artists.

In 1981 a major auction house, Sotheby's, published a catalog listing important early American paintings to be sold at its auction in December. Subsequently, I received a joyful call from David C. Driskell, our curator, informing me that *The Thankful Poor* (Plate 12) by Henry Ossawa Tanner was appearing in the auction. This was significant since an African American artist's work was included with other American artists' works. Mr. Tanner's *The Thankful Poor* was completed in 1894 and had been in the collection of the Pennsylvania School for the Deaf for nearly a century; it was a gift from the artist to the school. For the latter half of the twentieth century, the painting had been stored in the basement of the school.

I shared Dr. Driskell's enthusiasm about the auction; I wanted to present a special gift to my husband for Christmas. On the day of the auction, December 10, 1981, I sent Dr. Driskell to New York City to bid on the Tanner painting. At the time I was in Los Angeles, California, awaiting Dr. Driskell's report about the progress of the auction. After the bidding started, the money advanced quickly before Dr. Driskell made an offer. One of two principal bidders dropped out of the competition, leaving one persistent bidder, a New England art dealer. Then Dr. Driskell raised the amount to what I had established as my ceiling. I achieved my goal of buying an exceptional painting for my husband. Unknowingly, I also established a new monetary value for African American painting. No one had ever paid as much for any African American art.

I ask the reader to deliberate the exclusionary practices of past and present "gatekeepers" of art. Historically, African American art has been defined by gatekeepers as "primitive" or "naive." This book's photographs and history of African American artists' paintings and sculptures authenticate the social, political, and historical value of African American art. How can people consider themselves to be art scholars or authors if they suppress information about Lois Mailou Jones, Robert S. Duncanson, Joshua Johnston, Elizabeth Catlett, Mary Edmonia Lewis, Norman Lewis, Charles White, and other eminent American artists? Why do these same

Figure 2. Charles White, *Bill,* 1968, charcoal on artist's board, 57 x 33¼ in.

Henry Ossawa Tanner, *The Thankful Poor* (Plate 12).

people omit discussion about cultural representations of artists? What are they gatekeeping?

Our eldest daughter completed undergraduate and graduate art programs in mostly white universities with pedagogical exposure to artists who were white and male and, occasionally, white and female. Scholarship about artists from America's varied cultures was unambiguously excluded. Because our daughter's educational experience is not uncommon in this country, I conclude that the miseducation of America's art students in predominantly white institutions is creating many atrociously uneducated artists.

Our fourth child was educated about African American, African, European, and other artists in the school of art of a predominantly African American university. If our eldest daughter had not been surrounded throughout her life by the

beauty and quality of the black American artists' works that have been in our home, she might have judged those works lesser in beauty and quality than the works of white artists. The unequivocal neglect of most of America's ethnic artists elicits an important question: How can one be educated about America's art if one hasn't been taught about America's artists?

Every day my family and I are surrounded by the skills, intelligence, perceptions, and colors manifest in our collection of African American art. I know that our collection of paintings and sculptures has ameliorated my life and the lives of my family.

Thank you, African American artists, for being tenacious. All the peoples of the world benefit from your inventiveness and productivity.

CAMILLE O. COSBY

Figure 3. Charles White, *Cathedral of Life*, 1967, ink on illustration board, 60 x 40 in.

Introduction: William H. Cosby Jr.

I am unable to document the exact time I first became interested in collecting art. I was exposed to art when I was a child attending the public schools in Philadelphia. But the art I saw between the ages of seven and twelve did not make me want to own it. Each visit to the museum left me longing for something I didn't quite know how to describe. Sometimes we were taken as kids to the Philadelphia Museum of Art, the Pennsylvania Academy of the Fine Arts, and the Philadelphia Convention Hall. We saw the art of old and modern masters in exhibitions at these institutions.

Not until after my tour of duty in the navy and my introduction to the entertainment world as a comedian did I realize why the museum world had not stimulated within me a desire to own art. When I visited these places of high culture, I saw little evidence that people of color could become visual artists or were worthy of being shown as positive subjects on canvas. I do not recall seeing any images of black people as subjects in sculpture, yet stereotypic images abounded. I began to ask myself whether the absence of black images, except stereotypic ones, was deliberate in our mainstream museums. When would I see the art of African Americans displayed beside English, German, Irish, French, and Italian artists? African American artists such as Robert S. Duncanson, Mary Edmonia Lewis, and Henry Ossawa Tanner were left out of these museums' collections, although they had received critical and international acclaim for their art in Europe in the nineteenth century.

African American artists were more widely accepted in Europe, particularly in France, Italy, and the Scandinavian countries, and their work was collected and exhibited without regard for the color of the artist's skin. This never happened in America. Duncanson's *Land of the Lotus Eaters* in the collection of King Gustav of Sweden and Tanner's *The Resurrection of Lazarus* in the collection of the Musée d'Orsay in Paris are two such works by African American artists acquired in the late nineteenth century.

When I realized the omission of African American art from art museums, a number of questions arose in my mind. I began by asking: Didn't people of color, particularly African and African Americans, make any form of art that showed or celebrated their cultural heritage? If they did, why was none of this art on view? I began to think about the life of each work of art I saw and wonder: Where had these works been shown, who were the owners, and where had they hung on the collector's wall?

In a strange and meaningful way, the art I viewed in museums caused me to think of my mother's and father's home at 919 Parrish Place, Apartment A, in the North Philadelphia Richard Allen Homes. My family collected photographs of relatives and friends and pictures of favorite U.S. presidents, particularly Abraham Lincoln and Franklin Delano Roosevelt. We cut out portraits of black children from magazines such as *Ebony* and *Sepia*, all of which showed our collecting interest. Prominent among all our possessions was a portrait of Jesus hanging over the mantel.

Most collectors in lower economic strata do not see themselves as collectors; they simply say they are keeping things. In this regard, few objects beyond those I describe were affordable for us. While the kind of collecting I note above crossed all racial lines in the United States in the 1940s and 1950s, poorer African Americans were less inclined to own original works of any kind. They collected only if a respected member of their family had been an artist, and that was seldom. White Americans who were poor shared the same practices in collecting.

As I thought about what I saw in the museums, I realized that most white people who migrated to this nation, particularly the English, Polish, French, Russian, Dutch, Portuguese, German, and Spanish, brought many of their cultural tools and artistic products with them. This included their musical instruments. Few had wealth, something often associated with collecting art, but they did have their

individual and collective cultures. They did not come to this country naked in body and soul and stripped of their names.

African Americans, in the period of enslavement, brought along only their bodies and a mind-set to be free. They had to leave behind every vestige of culture except what was in their memories. They were forced to give up most of their visual arts, dance, and music—even their drums—and adopt cultural modes of expression that fitted a European definition of culture. Ignorance of the richness of African culture by abusive slave masters led to these African Americans being labeled savages by white Americans. But who could imagine what would happen when the wealth of African artistry was allowed to inform a European model under more humane circumstances? Would cubism, as Picasso saw it, have come about in nineteenth-century America from the union of these two different continental influences if a more humane condition among slave masters prevailed and if Africans had been allowed to bring their art with them? And to create art here?

These are questions that came to my mind when Camille and I began collecting African American art in the 1960s. Certainly we have no way of knowing what dreams were deferred by the atrocities of American slavery and European colonization in those difficult years. But we can now visit some museums around the nation and see the work of a growing number of black artists whose creative talents are worthy to be admired by all. The art we see is the work of the descendants of African slaves. Yet African American art still is not allowed the range in price and aesthetic review that some art by European artists of lesser talent receives. For example, and importantly, Camille and I have collected Horace Pippin for the strength of his artistry and not for the notion that his art is "primitive." Such an uninformed notion does nothing but allow American art an easy entry into benevolent racism.

Our children are adults now, and things still have not changed to a great extent. I am not yet able to say, "Children, African American artists are now in the main-

stream of American art." The question remains: When will these artists receive their due and be honestly judged? I am not certain of the answer. But I have neither the time nor the patience to wait for it to happen. By the same token, we do not plan to be the lone African American family collecting art so that mainstream museums, many supported by taxpayers, can acquire token works of art by black artists for their special African American collections. While Camille and I have not collected art with the intention of displaying our wealth, we have also not bought for investment. We have not built a collection based on the color of the artist's skin alone, but we have diligently exercised our racial pride by collecting what we love. By the same token, we decided that we had to collect the best art by black artists and leave it as a rich cultural legacy for our children. It was the kind of legacy that museums did not offer to members of our race. By 1968 we had acquired fifteen or more drawings, prints, and paintings by Charles White. At the same time, we began looking at European and American artists, with a special interest in the landscapes of George Inness, urban scenes by Reginald Marsh, and the early works of Stuart Davis, among others.

Most important, we wanted our children to grow up with great art by black artists. This prompted us to seek professional advice about the direction we should take in acquiring art. We then sought the expert advice of artist and art historian David C. Driskell. Although we conversed with David by telephone many times, our first meeting did not take place until Wednesday, November 23, 1977, the day before Thanksgiving. At that time, we showed David our collection, most of which was housed at our home in New England. David and his wife, Thelma, came to visit us there. David was greatly impressed with what we had collected on our own, and he accepted our offer to become our curator. In addition to being our curator of art, David has been a most trusted friend and has served over the years as a cultural adviser to our family.

Camille and I often buy art as gifts for each other. At

Detail from Henry Ossawa Tanner, *Study for the Young Sabot Maker* (Plate 13)

times, neither of us knows that a painting will be given as a Christmas gift or to celebrate a birthday. But the joy of receiving a work of art as a gift is indeed a singular pleasure that I have come to treasure. Undoubtedly, the most memorable painting from Camille came on Christmas Day 1981. I was presented with one of the finest masterpieces of African American art, Henry Ossawa Tanner's *The Thankful Poor*. I am still waiting for Camille to give me a more important work. Upon receiving *The Thankful Poor*, I recall asking, "What about *The Banjo Lesson* as a companion work to this one?" Of course, I was joking, knowing that *The Banjo Lesson* is in the permanent collection at Hampton University. But on being told that it was not for sale, I asked David, "How much is Hampton?" No one has yet given me that answer.

Seriously, we think it is important for the public to know that we have not sought to build a collection the way museums do. We have acquired works of art—paintings, sculptures, drawings, photography, and prints—that we enjoy living with on a daily basis. We know that art appreciates when it is exhibited and documented in major exhibition catalogs, but we are not as concerned about the value of the work as we are about having it available to be enjoyed by our family day by day. This, in part, accounts for our unwillingness to lend some of our favorite paintings by artists such as Henry Ossawa Tanner, Romare Bearden, Robert S. Duncanson, Horace Pippin, and Jacob Lawrence for exhibitions. We do hope that you enjoy our sharing these works with you now in the form of this book, *The Other Side of Color*. We hope you enjoy the art in the book as much as we enjoy living with it.

Finally, I wish to encourage all of you who have not yet viewed similar works by black artists to visit those museums and galleries that have taken the bold step of displaying African American art in their permanent collections. If they have no such works in their collections, do not be discouraged. Ask the curators and directors to acquire them. African American art is an important part of our cultural heritage. No American should enter the twenty-first century unaware of the important cultural legacy that artists of all ethnic backgrounds have made to American culture. Therefore, I invite you to join us in this important endeavor, that of helping to collect the best that our artists have created for our visual understanding. Certainly, African American artists deserve your interest and patronage.

BILL COSBY

Overview

Bill Cosby's phenomenal success in the entertainment industry, his depth of humanity both on- and offstage, and America's love for him led to the reading public's fascination with his timely books. No strangers to best-seller lists, his published works include *Fatherhood, Time Flies*, and *Love and Marriage*, which have sold more than six million copies in both hardcover and paper. The admiration in African American circles for Bill and Camille Cosby and their philanthropic work, the growing trend of unprecedented numbers of African American book buyers, and a peaking interest in art by African Americans are compelling reasons for *The Other Side of Color: African American Art in the Collection of Camille O. Cosby and William H. Cosby Jr.*

"Never before have African American books been in such demand," reported the spring 1991 *ABA Quarterly Newsletter*. The newsletter noted, "The African American book industry is an awakening giant." In its American Demographics, the U.S. Census Department concluded, "The fastest growing targeted population is African Americans who have a collective buying power of more than $263 billion annually and represent 53 percent of all minority buying power in this country." These factors can be attributed to the large number of middle-class African Americans who now have disposable income.

Another growing phenomenon in the African American community is the unparalleled interest in purchasing African American art, a trend that began in the 1960s and has increased with each decade. Television shows like *The Cosby Show* and *Cosby* displayed African American art on their sets, further influencing this trend. Today many African Americans are actively viewing art as a pleasurable way of expressing the love of their culture.

Increasing numbers of African Americans are also purchasing art from community-based artists. Popular magazines like *Ebony* and *Essence* often feature African American artists and report that art is increasingly popular for their buyers. Vendors who sell African American art at such events

as the well-attended black expos, which are held in principal cities across the nation and frequented by hundreds of thousands of African Americans, enjoy plentiful sales.

This trend is also evident in the sales of African American art and related books. Although there is still a paucity of major art books on the market, the published ones have witnessed skyrocketing sales. An example of this phenomenon is *I Dream a World*, which chronicled the successes of noted African American women like Lena Horne, Barbara Jordan, Mother Clara Hale, Leontyne Price, and others through photography. A publishing surprise, the book sold over 350,000 copies in its first run and went on to sell an extensive number of calendars based on the book's photographs.

Two Centuries of Black American Art: 1750–1950 by David C. Driskell (Knopf, 1976) sold well over 100,000 copies, and *Harlem Renaissance: Art of Black America*, written by David C. Driskell, David Levering Lewis, and Debra Willis Ryan (Harry N. Abrams, 1987), continues to be a major seller in the art book market.

Like these three books, *The Other Side of Color* is technically in the art book genre, but it is more. It details a celebrity family's commitment to its culture and family reminiscences of collecting precious artworks. In publishing history, it will be the first time a book, unaccompanied by an exhibition, about the collection of a famous African American family has appeared. And the reading audience will be delighted with the unique insider's view of the beginnings and shaping of this famous collection by a friend and long-time curator for the Cosbys, David C. Driskell.

Driskell is one of the world's leading authorities on the subject of African American art. He holds the title of Distinguished Professor of Art, Emeritus, at the University of Maryland, College Park, where he was chair from 1978 to 1983. He began his teaching career at Talladega College in 1955 and then taught art and chaired art departments at Howard and Fisk Universities. He has been a visiting professor at Bowdoin College, the University of Michigan, Queens College, and Obadefemi Awolowo University (previously the University of Ife) in Ile-Ife, Nigeria, West Africa.

The recipient of ten honorary doctorates in art, he has

significantly contributed to the scholarship of art history and its role in shaping the African American artist's role in this society. His five exhibition books about African American art have received wide acclaim. In addition, he has written more than thirty catalogs on the subject.

Driskell has lectured extensively on African American art at the nation's leading cultural institutions, including the National Gallery of Art, the Metropolitan Museum of Art, the Brooklyn Museum, the Art Institute of Chicago, Harvard University, Howard University, Spelman College, and many other colleges and universities, and abroad he has lectured in museums in Europe, Asia, Africa, and South America.

No stranger to television, he has appeared on *The Today Show,* CBS's *In the News,* PBS, and on television shows in ten foreign countries. In 1977 CBS Television commissioned him to write the script for *Hidden Heritage,* an hour-long television program on African American art, which he also narrated. After its initial airing, the film became a CBS award winner, appeared on national television for three consecutive years, and has continued to be viewed around the nation.

Another of Driskell's noted television appearances was for the Washington, D.C., ABC affiliate WJLA-TV, on the program *Getting There* (December 15, 1984, and spring of 1985). Since then, he has appeared on many cultural news and information shows in Kansas City, Missouri; Nashville; New York City; Portland, Maine; Los Angeles, and many other cities.

In 1985 Driskell curated an exhibition titled *Hidden Heritage: Afro-American Art, 1800–1950,* which toured ten major museums from 1985 to 1988. In 1987 he cocurated, with Dr. Mary Schmidt-Campbell, *Harlem Renaissance: Art of Black America* and coauthored the accompanying text. In the same year he was curator for *Contemporary Visual Expressions: The Art of Sam Gilliam, Martha Jackson-Jarvis, Keith Morrison, and William T. Williams.* That exhibit was accompanied by a book published by the Smithsonian Institution Press. In September 1987 he curated *The Art of Black America* in Japan, which opened in Tokyo. In 1989 he cocurated an exhibition, *Introspective: Contemporary Art by Americans and Brazilians of African Descent,* with Henry Drewal at the California Afro-American Museum in Los Angeles.

In 1989 the Arts Council of Great Britain funded a one-hour documentary highlighting Driskell's contributions to the interpretation of African American art history. CUE Films of London produced the documentary *Hidden Heritage: The Roots of Black American Painting* for British Television's Channel 4. It premiered for the British Academy of Film and Television Arts at the Princess Ann Theater in London in the fall of 1990 and received acclaim from art enthusiasts on four continents.

Driskell received a bachelor's degree from Howard University and a Master of Fine Arts from the Catholic University of America. He pursued postgraduate study in art history at the Netherlands Institute for the History of Art in the Hague and studied art history independently in Africa and South America. He has received many fellowships, including three Rockefeller Foundation Fellowships, a Danforth Foundation Fellowship, and a Harmon Foundation Fellowship. In 1984 he was awarded a one-year Faculty Research Grant fellowship from the College of Arts and Humanities at the University of Maryland.

In *The Other Side of Color,* Driskell explores the significance of selected works in the Cosbys' collection. Although the Cosbys collected more than three hundred paintings, drawings, prints, and sculptures by African American artists over a twenty-five-year period, *The Other Side of Color* highlights approximately one hundred works by forty-seven African American artists, accompanied by Driskell's scholarly yet very readable text. Among the most outstanding and best-known African American artists of the nineteenth and twentieth centuries included are Joshua Johnston, Robert S. Duncanson, Edward Mitchell Bannister, Mary Edmonia Lewis, Henry Ossawa Tanner, Aaron Douglas, Palmer Hayden, William Henry Johnson, Archibald J. Motley Jr., Charles White, James Lesesne Wells, Lois Mailou Jones, Romare Bearden, Elizabeth Catlett, Horace Pippin, Augusta Savage, Jacob Lawrence, Walter Williams, Keith Morrison, and Faith Ringgold.

DAPHNE DRISKELL-COLES

The Other Side
of Color

Detail from Jacob Lawrence, *Harlem Street Scene* (Plate 68).

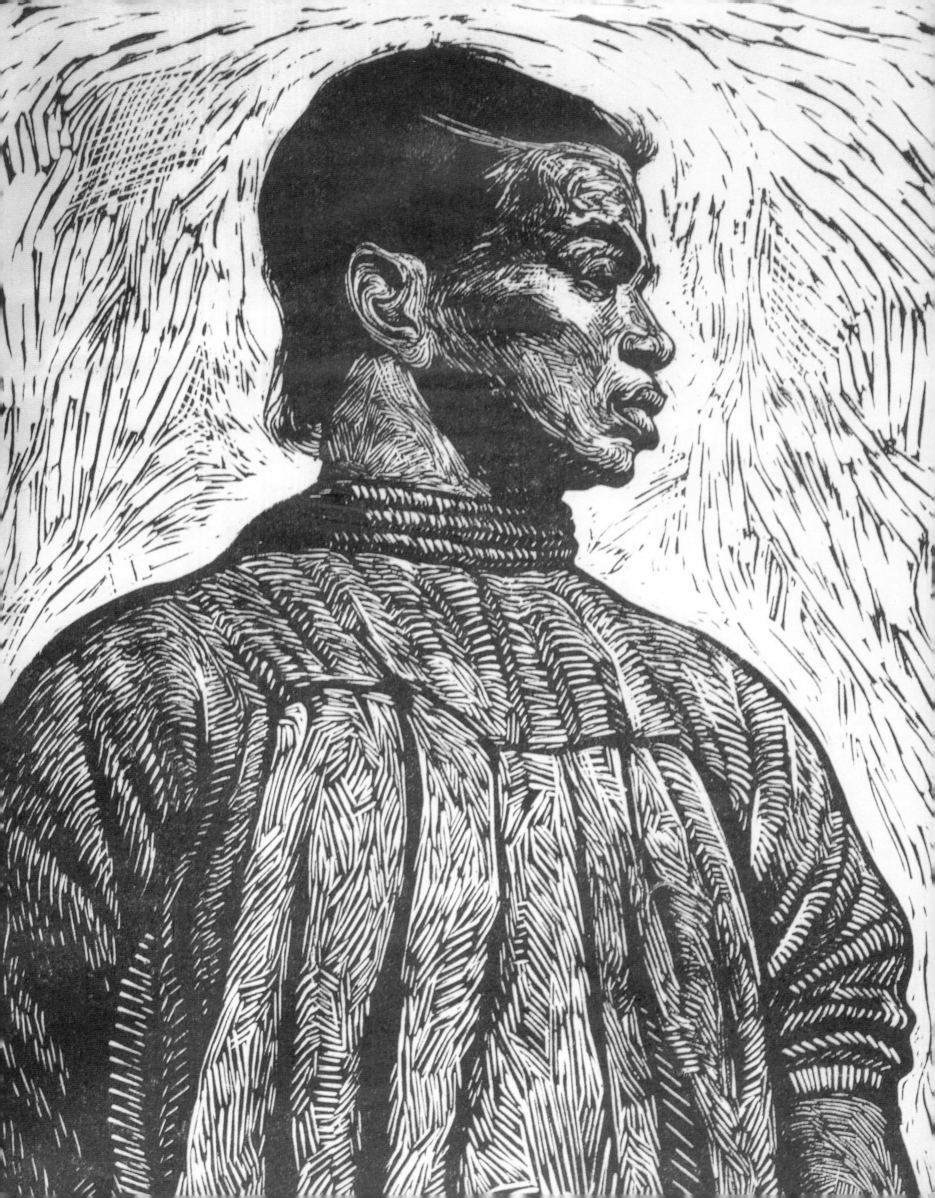

Collecting
African American Art

A CULTURAL CONTEXT

The fine tradition of collecting art in the African American community predates the Civil War. But much of the documented history that informs us of this important cultural endeavor has been lost, as few families have been able to keep artistic works in their heritable lineage over the years. The works of art by African American artists making up the collection of William H. Cosby Jr., affectionately known as Bill Cosby, and his wife, Camille Olivia Hanks Cosby, enable us to see this collection as exceptional in many ways. First, all the works were accrued over a period of less then thirty years. Second, none of them was handed down to the Cosbys by relatives; all the works were chosen by the Cosbys or reviewed by them before they were purchased. This hands-on method of collecting enables the Cosbys to bring a diversity in taste and talent to art connoisseurship. It is also a means of communicating to the viewer one particular family's cultural agenda.[1]

Bill and Camille Cosby have collected works of art that appeal first and foremost to their own taste and visual sensibilities. They did not enter into collecting for investment purposes; neither did they try to emulate other collectors by modeling their collection after existing ones. This fact alone attests to the highly personal nature of the Cosbys' collecting, and it signifies the statement they wish to make about the need for African American families to take the lead in preserving their own cultural history.

Throughout his long and colorful public career, Bill Cosby has been not only one of America's most popular actors and entertainers but also one of our strongest advocates for positive images of African Americans. Beginning with his successful career as one of the nation's most original comedians and an important recording artist, and continuing through unparalleled television and film achievements, Bill Cosby has continually affirmed the best of American culture and the African American's role in it. But his public image and the strength of his artistry have been greatly enhanced by the role that his astute and enlightened partner and wife, Camille, has played in creating the cultural climate of their home. Among other things, she has assumed the important roles of buyer of art at major auction houses, visitor to artists' studios, and patron par excellence to upcoming and established artists alike.[2]

Yet, while the public knows of Bill Cosby's success as actor, comedian, entertainer, educator, and activist, few are aware of or have ever seen the vast collection that he and Camille began in 1967. It is by far the most significant collection in the hands of an African American family. The collection is comprised of major works of museum quality by some of the most renowned African American artists of the past two hundred years as well as significant paintings by well-known artists of European ancestry. Starting with their initial purchase of drawings and prints by their friend, the late Charles White, an African American artist well known for his sensitive portrayal of the black experience, the Cosbys' interest in African American art has grown measurably over the years in their quest to build a collection that honors and celebrates the seldom-acknowledged genius and creative spirit of African American artists. Particular attention is paid here to African American collectors so as to enlighten the general public about the growing number of young and established black families—the Cosbys among them—who undertake this important endeavor of seeing

Plate 1. Charles White, *Solid as a Rock (detail)*, 1958, linoleum cut, 39 x 17 in.

that their own cultural contributions are rightly recorded in the historical record.[3]

When we closely examine our cultural past, we learn that collecting art is not a new phenomenon in the African American community. As early as the mid-nineteenth century, a number of African American people in cities like New Orleans, Philadelphia, and Baltimore sat for portraits by recognized African American artists in an effort to pass on their likenesses to future generations and to patronize the important artists of the day.[4] A case in point is a pair of well-preserved paintings, *Portrait of Burwell Banks* and *Portrait of Charity Banks*, which are portraits of two nineteenth-century African American entrepreneurs from Baltimore that were exhibited at the University of Maryland Art Gallery in 1984.[5] These two handsomely painted works are from the hand of Boston painter William Simpson (1823–1903) and were completed sometime prior to 1872. The two portraits, on loan to the Maryland Commission on Afro-American History and Culture in Annapolis from the History Department of the University of Maryland at College Park, are among a growing number of works from the descendants of nineteenth-century black families whose lifestyles and cultural aspirations help single them out as members of a growing black middle class in nineteenth-century America.

While owning an art collection does not by itself ensure social arrival or class acceptance, it does affirm that collecting art is an important cultural endeavor, denoting one's commitment to gathering and preserving significant elements of material and cultural history. Material culture is an important indicator of societal progress in the African American community. The same can be said of majority-culture participants who have relied on the records of painters and sculptors in a given era to add measurably to their understanding of history. But people collect different forms of art and for significantly different reasons. The problem of economics and the need to provide one's family with the basic necessities of life have prevented many black families from investing in art as a cultural statement. But this too is

changing as young professionals now count buying a work of art as important as making an addition to their wardrobe. More important, since the black cultural revolution of the 1960s, African Americans have sought to affirm their own cultural identity by turning to artists of the race to reinforce a positive image of themselves as a people.[6]

More and more African Americans have amassed the kind of wealth that now permits them the luxury of competing in the marketplace, buying art in the normal course of events, and showcasing it as an important quality in life. The rich and the famous—titles appropriately fitting for Bill and Camille Cosby—are expected to be leaders in collecting the finest art. But some collectors are neither rich nor famous, and some rich people have been known to collect bad art. I have known stagehands at local theaters, police officers, and public school teachers—all poorly salaried by middle-class standards—who are avid collectors of the best art within the African American community. Some of these dedicated art enthusiasts have adorned the walls of their humble urban homes with works by late-eighteenth- and early-nineteenth-century artists such as Joshua Johnston, Edward Mitchell Bannister, and Patrick Reason as well as paintings, sculpture, prints, and drawings by modern and contemporary twentieth-century African American artists like Hale Aspacio Woodruff, Aaron Douglas, Elizabeth Catlett, Lois Mailou Jones, Alma Thomas, and Sam Gilliam.

There are other means by which we gain knowledge of how collections that are comprised principally of art by African Americans have been formed. Among the most important documents known are exhibition catalogs from earlier decades. They reveal the role that individuals and cultural institutions played in making known the extent to which African Americans have collected art over the past two centuries. This method of recording was especially important at black universities such as Fisk, Howard, and Hampton, where for more than one hundred years art exhibitions were (and are still being) arranged to supplement curriculum offerings in the humanities.[7] On rare occasions,

names of lenders to these exhibitions were cited in the historic documents, thereby pinpointing early collectors of artists' work. This was the case with educator John Hope, president of Atlanta University in the 1930s. According to Jim Hope, grandson of President Hope, Edward Mitchell Bannister's work was greatly admired by Hope, and he collected three of the artist's paintings, which are now in the younger Hope's collection.[8]

Similar accounts of art patronage by African American collectors have surfaced in the black press in articles giving an account of events in urban clubs in which art was the focus of a social circle. The newspapers *Chicago Defender*, the *Atlanta World*, the *Amsterdam News*, the *Norfolk Journal and Guide*, *The Afro-American*, and the *Pittsburgh Courier* and the periodicals *Opportunity* and *The Crisis* were among the leading African American journals in the first half of the twentieth century. These newspapers and periodicals often highlighted the cultural contributions of black visual artists, noting who purchased various works of art at the art openings that were frequently covered in the press.

As an independent curator and a spokesperson for many black visual artists, I have been privileged to witness the growth of one of the most comprehensive collections of works by African American artists for more than two decades. But more importantly, I have participated as adviser for a major collection of quality art collected by an African American family. This situation has no parallel in our history.

Quality art has seldom been bound by the social restrictions so often placed on it by those who would divide it along racial lines. Yet it has been difficult to substitute goodwill and common sense for some of the unpleasant incidents that have occurred under the guise of culture and art collecting in our nation, a nation that often seems obsessed with keeping alive the myth that quality art is a product of artists of the Western world, particularly artists of European ancestry. The art collection that has been assembled by Bill and Camille Cosby clearly defies such long-held myths.

Although African American artists, in the main, have been trained in methodology and processes similar to accepted European models, it has remained nearly impossible to get their works properly indexed and included in the major art historical compendia. Some call the problem of the omission of women and minorities from the art registers of our museums a cultural oversight. But the problem touches upon economics and racial and gender prejudice, among other things. Largely, there remains intact in our culture an unwritten law that such omissions be overlooked as though they do not happen. African American artists have suffered greatly at the expense of those who promote such a cultural agenda. At the start of the new millennium, our knowledge of all the peoples within the larger culture remains fragmented and is at best piecemeal.

But an art collection serves its owner beyond the function of its visual impact. It provides a cultural context that describes the creative impulse held by collectors.[9] This then becomes the principal aim of sharing with the public what Bill and Camille Cosby have collected.

Bill and Camille began collecting art by African Americans three years after their marriage in 1964. As noted, they collected works across racial lines at an early stage. They would be among the first to tell you that the collection was very uneven at the beginning. But their aesthetic taste in collecting widened over the years, as did their insightful view of the world. Among the most celebrated names appearing in their early collecting were Auguste Renoir, Rembrandt van Rijn, Pablo Picasso, Henri Matisse, and George Inness. Later they would turn to the auction houses of New York and Los Angeles for help in assembling their collection. A sizable number of works was purchased at Sotheby's, while others were bought at auction at Christie's. They then added works by George Carlson, Reginald Marsh, Henry Ossawa Tanner, Georgia O'Keeffe, Milton Avery, Ben Shahn, Bob Thompson, Jacob Lawrence, Alma Woodsey Thomas, Romare Bearden, and Maurice Prendergast, among others.

When I assumed the position of curator of the Cosby

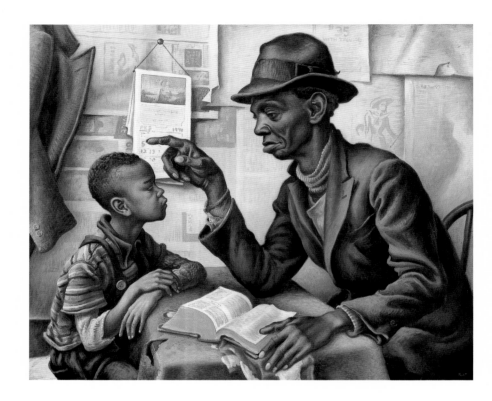

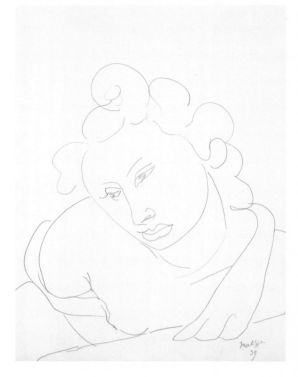

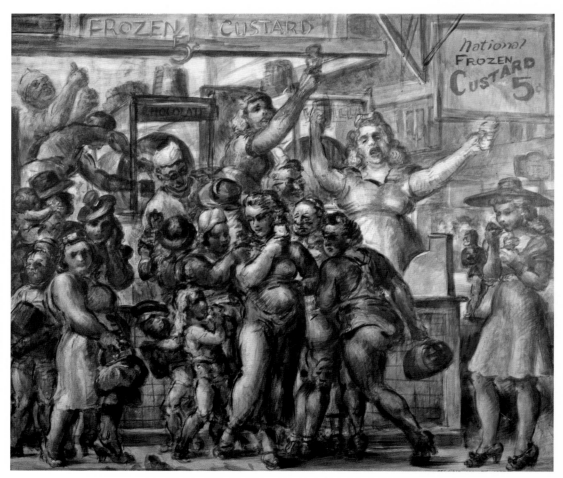

Figure 5 (top left). Thomas Hart Benton, *The Bible Lesson*, c. 1940, tempera on canvas mounted on panel, 33 x 40 in. © T. H. Benton and R. P. Benton Testamentary Trust/VAGA, New York, NY

Figure 6 (top right). Henri Matisse, *Tête au Volutes*, 1939, pencil, 20 x 16 in.

Figure 7 (bottom). Reginald Marsh, *Frozen Custard*, 1939, watercolor with gouache on wood, 28 x 32 in.

Collection of Fine Arts in October 1977, Bill and Camille had already amassed a rather large collection of works by American artists of European ancestry, many of whom chose to paint black subjects. *The Bible Lesson* (Figure 5) by Thomas Hart Benton was one fine example. But they bought works other than those having black subjects. The Cosbys increased the importance of their collecting interest in the late 1970s and early 1980s by purchasing such notable works as *Tête au Volutes* (Figure 6) by Henri Matisse, *Frozen Custard* (Figure 7) and *High Yeller* (Figure 9) by Reginald Marsh, and *In the Hackensack Valley (Landscape with Stream)* (Figure 8) by George Inness. And in many ways, their taste remained catholic as they sought to collect only the best available art by American artists regardless of their race or ethnic origin. Subject matter of the paintings by European Americans was not always limited to the black theme. Other celebrated works in the Cosbys' collection are Maurice Prendergast's *Summer Day* (Figure 10); Milton Avery's *Connecticut Landscape* (Figure 11); *Anger* (Figure 12) by Ben Shahn; *Red Pear with Fig* (Figure 13) by Georgia O'Keeffe; and *Going West* (Figure 14) by Thomas Hart Benton.

In *Going West,* a steam-driven locomotive aggressively puffs its way over a curved track as it heads westward. It is a composition of major significance and in many ways reminds me of the positive aggression the Cosbys showed in acquiring good available works of art when they appeared at auctions or in the hands of a willing seller. Often I was summoned from the studio to go and inspect a particular work. Usually, it was a work of art both Bill and Camille admired.

Their collecting also has a more romantic and demanding side. Severin Roesen (Figure 15, *Still Life with Fruit*) is represented by three handsomely painted still lifes in which the handiwork of human and nature are both clearly observed in the manner common in the works of seventeenth- and eighteenth-century Dutch masters. Steuart Davis is represented by three early gouaches that comment on the hard life of those who lived on the Lower East Side of New York City at the turn of the twentieth century.

I have cited these artists, all of whom are of European-American ancestry, to show the depth of this important collection and to note the care with which it has been assembled. However, the focus of this book is the work of African

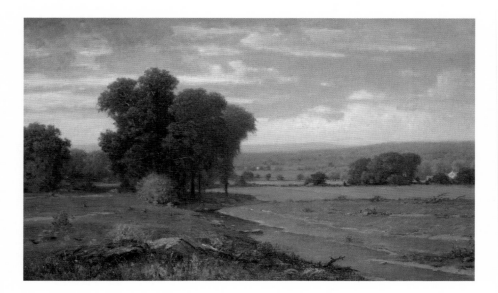

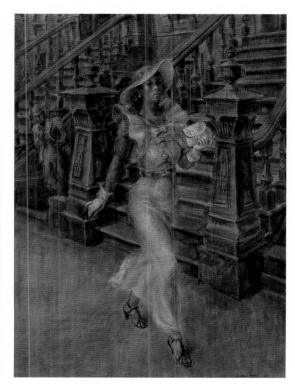

Figure 8 (above). George Inness, *In the Hackensack Valley (Landscape with Stream)*, 1865, oil on wood, 22 x 36 in.
Figure 9 (right). Reginald Marsh, *High Yeller*, 1934, tempera on canvas mounted on masonite, 24 x 18 in.

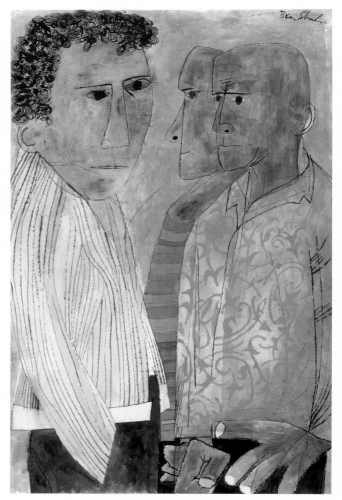

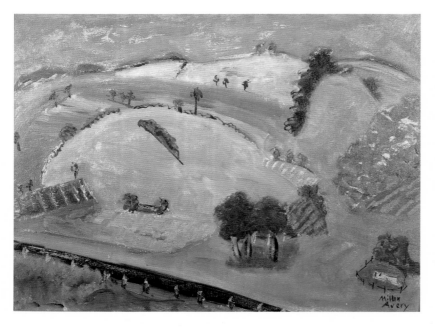

Figure 10 (top). Maurice Prendergast, *Summer Day*, 1918, oil on canvas, 40 x 48 in.

Figure 11 (bottom). Milton Avery, *Connecticut Landscape*, c. 1939–1945, oil on canvas, 18 x 24 in.

Figure 12 (right). Ben Shahn, *Anger*, c. 1960, gouache on paper, 38¾ x 25½ in. © Estate of Ben Shahn/ VAGA, New York, NY

Figure 13 (facing page). Georgia O'Keeffe, *Red Pear with Fig*, 1923, oil on panel, 6¾ x 5½ in.

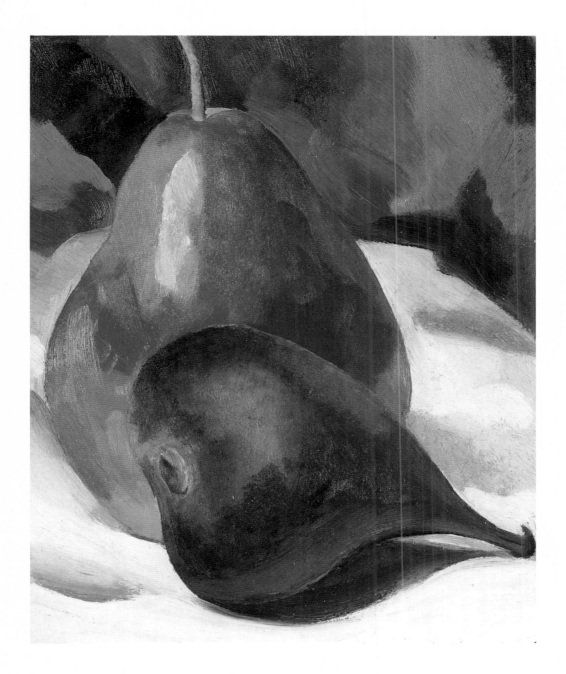

American artists the Cosbys collected. I would be remiss if I did not emphasize that Bill and Camille made a conscious effort to celebrate the importance of collecting art by artists of their own race. They have proven that the quality canon so often cited by writers on the subject of American art is often incomplete; indeed, it is seldom fully explored and at times is prejudiced against the creations of African American artists. The Cosbys remind us, through their collecting, that there is another world in art yet to be explored and reported upon as part of the larger American scene. For in the prevailing art world, that which is already known gets cited over and over, and that which is unknown, particularly to historians and critics of the majority culture, remains unknown and unexplained. The works of countless black artists remained unknown until the latter half of the twentieth century. That such an omission of creative work remained hidden in our history should come as no surprise to those who know that for many years there was a widely held belief in our nation that quality art could not be created by persons of color.

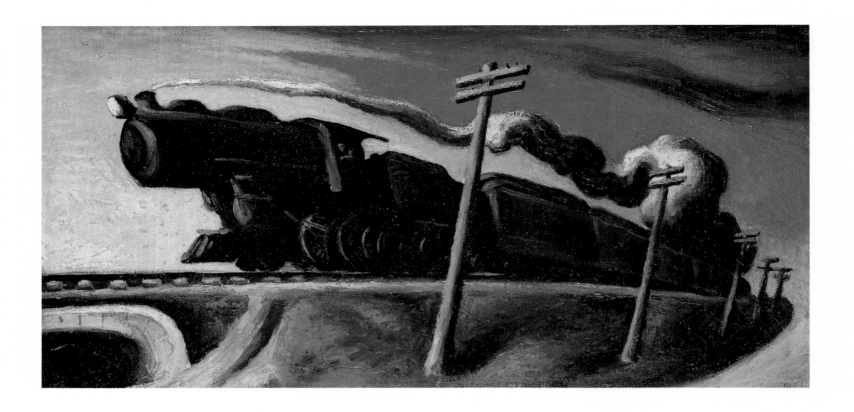

Few writers on the subject of art have looked far enough into the pages of history to make note of the record of accomplishment that artists like Joshua Johnston (c. 1765–c. 1830) brought to portrait painting in the late eighteenth and early nineteenth centuries or Robert S. Duncanson (1821–1872) brought to landscape painting in the tradition of the artists of the Hudson River school in the mid-nineteenth century.[10] These two painters were among the most sought after artists in their day, working in their highly competitive cultural communities of Baltimore, in the case of Johnston, and Cincinnati, in the case of Duncanson. The works of both have been rediscovered by African American scholars in their pursuit to more fully document the salient contributions that artists of color have made to the history of American visual culture.

The works of art selected for this book are representative of the overall quality of the three hundred or more works by artists of color that the Cosbys have collected. Here we elaborate on one hundred or so such works. They show an important progression in the development of American art, much of which in its years of infancy showed no signs of a racial boundary. While some would cheer this notion, viewing it as an appeal to our rather early taste at promoting universal ideals, others would see it as a confining element, evidencing a European sensibility in art devoid of other ethnic and racial contributions. Creativity in the nascent years of artistic flowering in America moved in one undisputed direction—toward a Eurocentric model in painting and sculpture, one unyielding in its attention to Western aesthetics. That early African American artists showed no signs of moving their art away from the prescribed European formula should come as no surprise, since they felt obligated to make certain that their art addressed the prevailing styles in order to guarantee artistic acceptance and a chance to be numbered among the early pioneers who produced a body of acceptable work.

8 Figure 14 (top). Thomas Hart Benton, *Going West*, 1926, oil on canvas, 20¼ x 41¼ in.
 © T. H. Benton and R. P. Benton Testamentary Trusts/VAGA, New York, NY
 Figure 15 (bottom). Severin Roesen, *Still Life with Fruit*, c. 1860, oil on canvas, 30¼ x 25 in.

This gift of artistry in the African American experience is the other side of color—that which is by any standard genuinely American yet so often omitted from American art history. With these facts in mind, we are able to contribute to a larger and more equitable definition of American art by presenting the reader with a private collection—a personal view of how one African American family has collected art over a period of nearly three decades.

Part 1 Notes

1. Bill and Camille Cosby, conversations with author, 1990. I have emphasized the Cosby family's cultural agenda over one that celebrates racial acuity since the acknowledgment of a racial agenda is often done in response to being defined as different, e.g., the white race versus the black race. While it is virtually impossible to disregard the harsh penalty whites inflicted on Americans of African ancestry, first through slavery and then through racism, it is, in the main, an ideology of resistance to an equal humanity in a cultural context. See Barbara J. Fields, "Slavery, Race, and Ideology in the United States of America," *New Left Review* (May–June 1990):118–181, and W. E. B. Du Bois, *The Souls of Black Folk* (1930; reprint, New York: New American Library, 1969), p. 2. See also Juanita Holland, "Co-Workers in the Kingdom of Culture: Edward Mitchell Bannister and the Boston Community of African American Artists, 1848–1901" (doctoral dissertation, Columbia University, Department of Art History and Archeology, 1996), p. 95.

2. Juanita Holland, "A History of Collecting African American Art," in *Narratives of African American Art and Identity: The David C. Driskell Collection* (San Francisco: Pomegranate, 1998), p. 45.

3. Many African American families have amassed significant collections of art in which works by black artists predominate. Notable among these collections are those of Harriet and Harmon Kelly,

Kenneth I. and Kathryn C. Chenault, the Reverend and Mrs. Douglas Moore, Linda and Walter Evans, Barbara and Leon Banks, Norma and William Harvey, Earl Hooks, James Parker, and the late Thurlow Tibbs Jr. Prized among early collections was the Barnett Aden Collection assembled by James V. Herring and Alonzo Aden in the 1930s and 1940s. The collection that my wife, Thelma Driskell, and I assembled was greatly influenced by knowledge gained from associations over the years with notable teachers and friends such as James V. Herring, Dorothy and James A. Porter, Mary B. Brady of the Harmon Foundation, and Aaron Douglas, among others.

4. Cedric Dover, *American Negro Art* (Greenwich, CT: New York Graphic Society, 1960), p. 21.

5. See catalog notes by Elizabeth Johns in *300 Years of Art in Maryland* (College Park: University of Maryland Art Gallery, 1984), p. 55.

6. Halima Taha, *Collecting African American Art* (New York: Crown, 1998), pp. ix, 2, 6.

7. Richard J. Powell and Jock Reynolds, *To Conserve a Legacy* (Andover, MA and New York: Addison Gallery of American Art and The Studio Museum in Harlem, 1999), pp. 103–105. While teaching at Fisk University, I was surprised to learn that the Fisk University Museum existed as early as 1871. It was located in the basement of old Bennett Hall. Portraits of the Fisk founders and the early faculty and displays of African art and geological and biological specimens were among the items exhibited. Bennett Hall was razed in the late 1960s.

8. Jim Hope, grandson of John Hope, president of Atlanta University, conversation with author, February 12, 1985. On the invitation of Jim Hope, I was invited to view the three paintings by Edward Mitchell Bannister that had been given to him from the estate of his grandfather.

9. Ana M. Allen, *The Beginner's Guide to Collecting Fine Art, African American Style* (Washington, D.C.: Positiv! Productions, 1998), p. 15.

10. Guy McElroy, *Facing History* (San Francisco: Bedford Arts, 1990), p. 46.

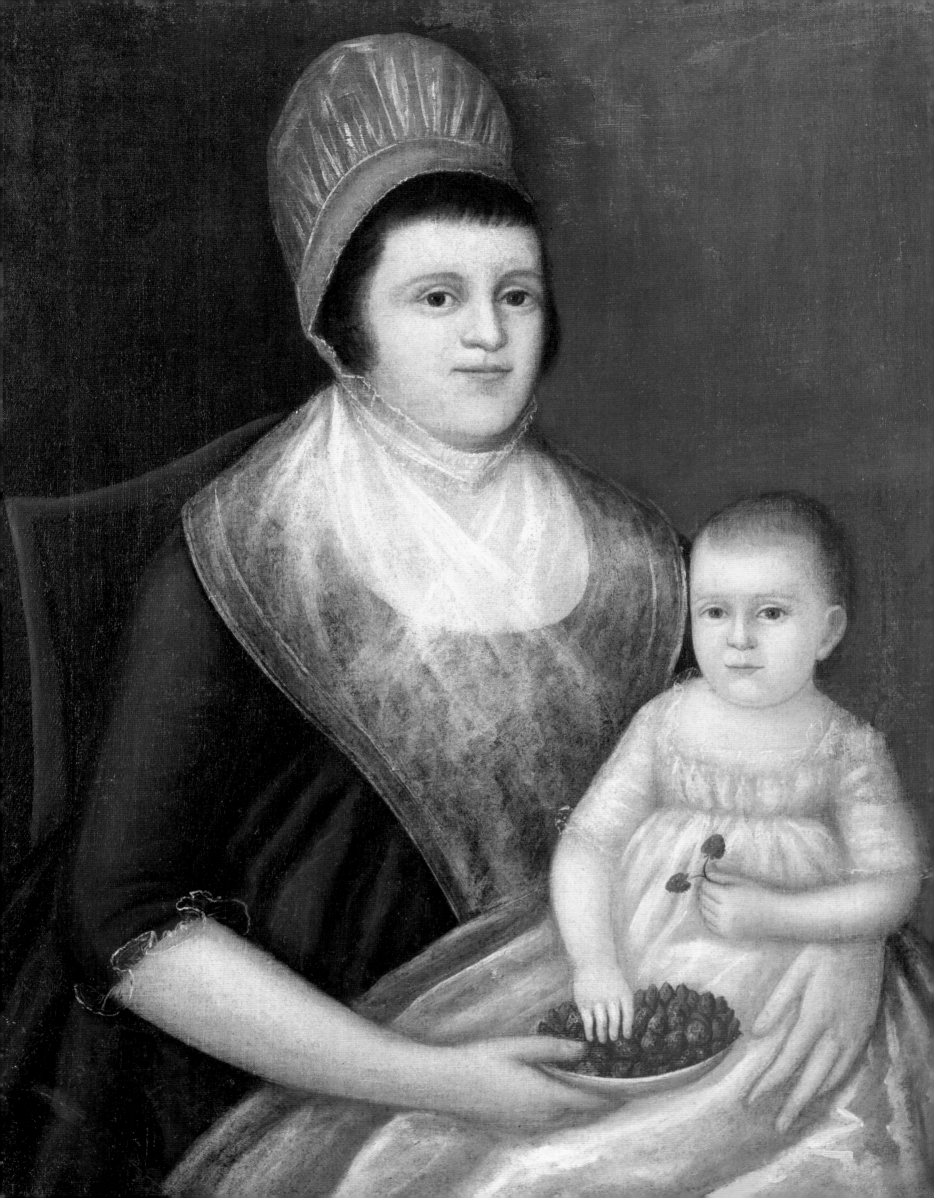

Cultural Emancipation
and the
Quest for Freedom

The interest that has developed over the past three decades in collecting American art created by people of African ancestry provides the context for this book. The eighty-two works from the Cosby Collection of Fine Arts that I review here raise the subject of race, since all the plates and Figures 1 to 4 in this book are by American artists of African ancestry. Yet more important than the fractious notion of race, always dividing Americans along color lines especially in the subject of art, is the continuity of African American art with that created by artists of the majority culture. This continuity receives little attention in art history texts.

Seldom is the art African Americans create so different in style and context from that of white artists that it can be said to have a racially based premise. Yet as long as race remains the overriding factor in cultural and interpersonal relations in American society there will continue to be a compelling reason to write about the subject of art and race. African American artists deserve to have their work written about and shown in exhibition halls because the public is often ignorant of black achievements in the visual arts. And while the works of many artists in the Cosby Collection of Fine Arts, particularly those by black artists in the nineteenth century, are at times indistinguishable in style and theme from those by white artists, few black and women artists are listed in the American art historical compendium.

The discipline of art, particularly visual art such as painting and sculpting, does not lend itself to adopting a style that lies outside the traditions of a given cultural era. Thus most artists, regardless of gender or the color of their skin, create works of art within the prevailing genre, a genre most often matching their training. For example, Pablo Picasso and Jackson Pollock, both innovators in Western twentieth-century art, arrived at distinct definitions of modernism only after pursuing relevant studies within the French and American academic traditions. In the same way, African American artists of the nineteenth century sought first to master their craft, and they seldom depicted racial themes that would set them apart in an isolated cultural context. Their goal, beyond the mastery of their craft, was to show to a skeptical world that black skin was not an impediment to delivering quality art. Their goals and objectives in art helped promote cultural emancipation and an atmosphere of acceptance in the American mainstream.[1]

The social circumstances under which black artists lived and produced art in the nineteenth century included an often-hostile and unaccommodating working environment. Life for most artists in postcolonial America, regardless of race, was not easy. Artists of color were likely the target of much racial bigotry, discrimination, and uncompromising race prejudice. A case in point is Joshua Johnston (active 1796–1824), the nation's first black professional painter to receive widespread white patronage.[2] In an advertisement that appeared in the *Baltimore Intelligencer* on December 19, 1789, Johnston noted that he "experienced many unsuperable obstacles in the pursuit of his studies. . . ."[3] Without doubt he was referring to the racial climate in which he, a former slave in Baltimore, worked as a portrait artist. But Johnston, like Robert Douglas Jr. (1809–1887), David Bustill Bowser (1820–1900), and Charles Ethan Porter (1847–1923)— none of whom appear in the Cosby collection—Robert S. Duncanson (1821–1872), Edward Mitchell Bannister (1828–1901), and Henry Ossawa Tanner (1859–1937), the

leading African American painters in the nineteenth century, worked diligently to emancipate themselves culturally from the belief that they had neither the intellectual capacity nor the discipline to create art befitting the high standards of white society.

A cursory glimpse into our history seldom shows that artists of African ancestry enriched America's visual arts tradition at a level beyond that of yeoman. A few literary journals note the anonymous contributions slave artists made by working as artisans in European-influenced trades. Yet deeper research reveals that many immigrants from the African continent, forced into slavery, brought to the Americas an accomplished tradition of artistry.

Many of the artistic traditions brought from West Africa rivaled and surpassed in aesthetic expression and technical process the forms of visual art known to Europeans in the seventeenth and eighteenth centuries.[4] Early Portuguese explorers who established trade with the people of Benin City in present-day Nigeria in the fifteenth century marveled at the accomplishments of the ivory carvers that they saw in the royal court in Benin City. Carvings now labeled Afro-Portuguese are among the finest examples of carved ivory in the Middle Ages, contributing to a lineage that extended into the nineteenth century. Some West African slaves excelled as portrait artists, working in bronze, brass, and copper casting with full knowledge of the cire-perdue process, as had their Yoruba and Ashanti forebears.[5] The tradition of the smith shaping iron—the mystery of transforming earthen matter into a permanent object—was well known among sculptors in the ancient kingdoms of West Africa, territories from which many slaves were taken as cargo for the Americas.

But sculpture, the most widely known art form in West Africa because of the fine craftsmanship of the carver of masks and statues, was not the only art in which African slaves excelled in the New World. Woodworking and building, jewelry making and silversmithing, household decorating, and tailoring were among those arts that some slaves found readily adaptable to their skills.[6]

Our knowledge of this rich tradition of African-inspired artistry in the Americas is often encumbered by the paucity of information in art history journals. Black achievements in crafts and the fine arts were not the priority of white writers in their accounts of American slavery. That some African Americans could become distinguished as skilled painters or sculptors after the ordeals of slave rule in postcolonial America speaks of both the dedication and discipline they showed in pursuing their craft.

Reading and writing, both forbidden in strict slave societies, as well as the making of art in a leisurely fashion, offended the beliefs of white slaveholders in the North and the South. Black skin was equated with inferiority. And while the harshness of chattel slavery did not block some African Americans from entering the professions of painting and sculpture, these professions were normally reserved for people of European ancestry.

Competent artists of color who became painters and sculptors entered into direct competition with their white counterparts in a market in which few commissions for landscapes and portraits were available. Most notable among those African Americans who excelled, in spite of the harsh rules of a racially biased system of selection during the period of slavery, were a number of artists who forsook the trade of the sign painter and made their living working as limners, or draftsmen.[7]

Joshua Johnston (c. 1765–c. 1830)

Joshua Johnston was a portrait artist whose services were in demand in Baltimore and the eastern shores of Maryland and Virginia during the early years of the nation's independence. Johnston is represented by five portraits in the Cosby collection, none of which is of black subjects. Johnston painted no more than three black subjects in his short career, one of which, located in Flint, Michigan, is thought to be a self-portrait.

Among the five paintings by Johnston in the Cosby collection is the portrait of a woman sitting in three-quarters view holding a child wearing a gauzy white lace and a dark red dress. The work is titled *Mrs. Thomas Donovan and Elinor Donovan* (Plate 2). The mother-and-child portrait reveals the typical formula of stiffness, object placement, and accompanying furniture by which the artist's work, normally unsigned, is identified. This popular mother-and-child portrait is considered one of Johnston's earliest extant works, as it dates from about 1799.

Two other single portraits in the Cosby collection, *Lady on a Red Sofa* (Plate 3), believed to have been painted c. 1825, and a portrait of young *Basil Brown* (Plate 4) of Baltimore, painted on or about October 26, 1813, the date that appears scripted in the work, are among Johnston's finest pieces. These two portraits readily affirm, in stylistic appearance and painterly appeal, the usual assumption that Johnston indeed was tutored by either Charles Wilson Peale or Charles Peale Polk, both prominent Baltimore painters who were established artists when Johnston began his career in the 1790s.[8]

Johnston's identity as a black artist was not widely known before the second quarter of the twentieth century. Thus his work was seldom singled out as proof of the acculturation possible between downtrodden members of the slave society and European Americans. Yet, unknown to Johnston, his art would provide the historical link future generations of artists of color would need to demonstrate the distinction won by some African Americans in a slave society.

Perhaps more important than citing the ills of a slave society and the irreparable damage it heaped upon Americans of African ancestry during Johnston's lifetime is celebrating the fact that some skilled artisans of color transcended the anonymity assigned them by slavery and imprinted a mark of lasting significance on the culture around them by becoming portrait and landscape painters of some distinction.

Robert S. Duncanson (1821–1872)

Robert S. Duncanson was an artist of color whose attempt at portrait painting led him early in his career to painting landscapes. His name became a household word in art circles in Cincinnati, Ohio, in the late 1840s. He searched for the ideal place in nature to show the presence of God, both physically and spiritually, and he viewed the American wilderness as a divine gift to humankind. In this regard, Duncanson showed little difference from the white artists he emulated. He pursued the same formula for painting the wilderness, idealizing "America the beautiful," as did those artists before him who followed the traditions of the Hudson River school of painting.[9] A trip to Italy in the early 1850s allowed Duncanson to meet William Sonntag, another Cincinnati artist who worked in Rome. Duncanson also admired the work of Thomas Cole, an Englishman who took to the American wilderness and was considered the leader among first-generation artists of the Hudson River school of painting.[10] But in spite of his adherence to the rules of painting Cole advocated, Duncanson worked to perfect his personal signature in landscape painting, offering an accomplished understanding of nature handsomely rendered with sensitive skill.

While Duncanson enjoyed a measure of support for his art in America, it was in Europe that he gained the highest respect of critics of the day. Upon his return to Cincinnati, one critic called him "the greatest landscape painter in the West."[11] He found the American wilderness to be a place of infinite beauty, revealing a primordial reserve and providing a sanctuary away from the growing cities he had visited in Europe. *Landscape with Brook* (Plate 5) shows a mature style in Duncanson's oeuvre. He introduces us to a bubbling stream and a view of distant hills, pockets of nature that show its unity even through scenes that differ in place and time. *Falls of Minnehaha* (Plate 6) reminds us how grand is nature's plan. The cascade of water roars powerfully before the lone figure of Minnehaha, who sits contemplating

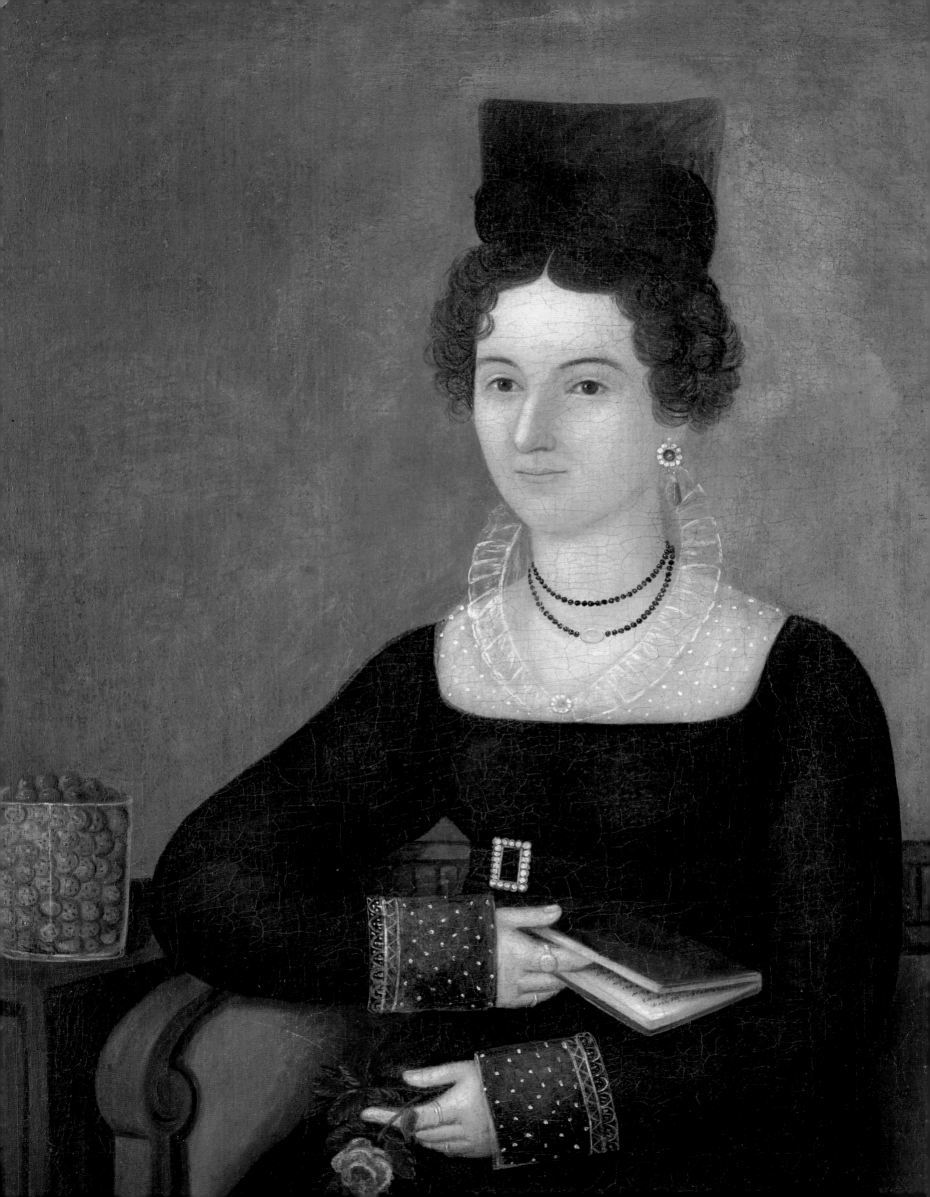

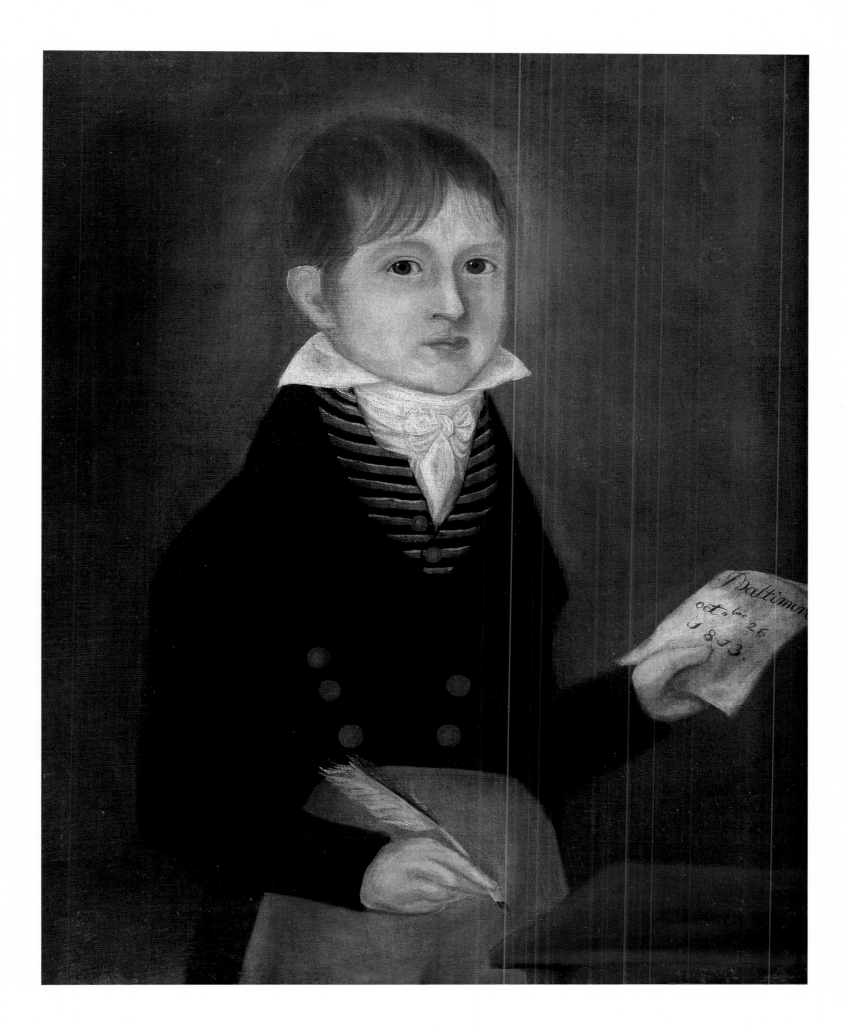

Plate 3 (facing page). Joshua Johnston, *Lady on a Red Sofa,* c. 1825, oil on canvas, 30¼ x 25½ in. 15

Plate 4 (this page). Joshua Johnston, *Basil Brown,* 1813, oil on canvas, 25 x 20 in.

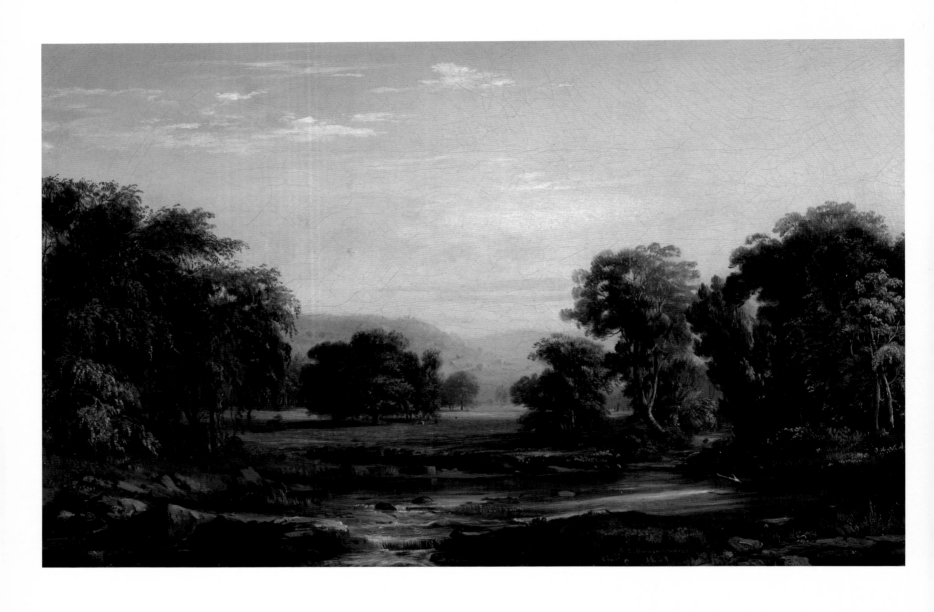

Plate 5 (this page). Robert S. Duncanson, *Landscape with Brook,* **1859, oil on canvas, 10 x 16 in.**

Plate 6 (facing page). Robert S. Duncanson, *Falls of Minnehaha,* **1862, oil on canvas, 36¼ x 28¼ in.**

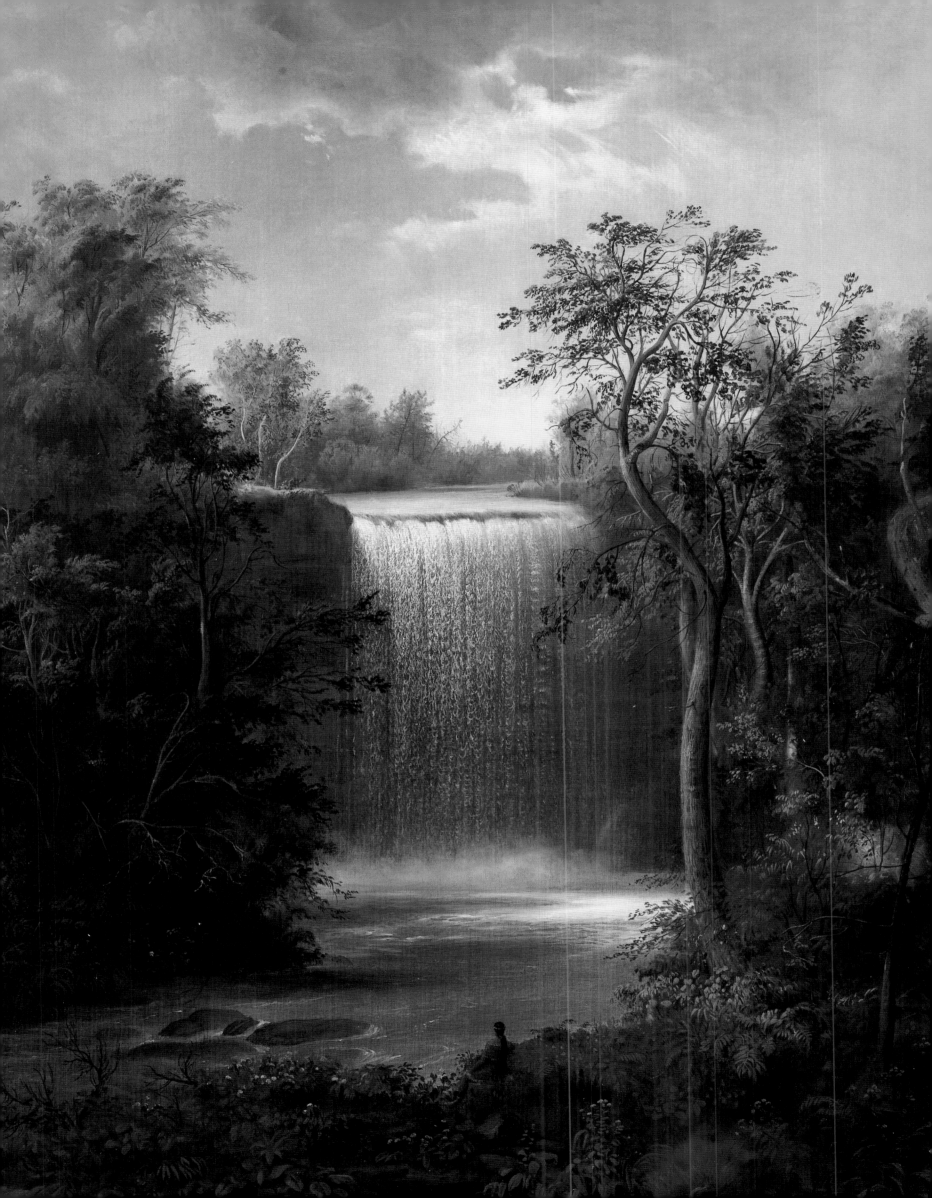

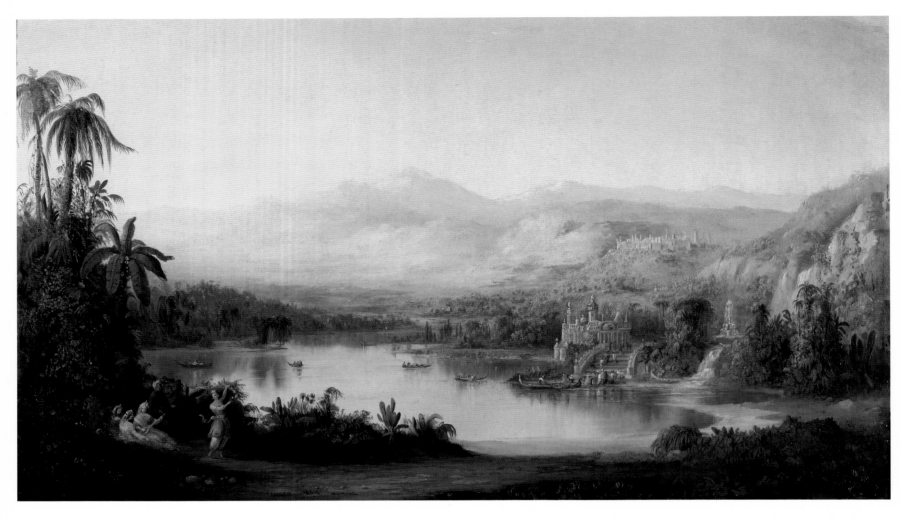

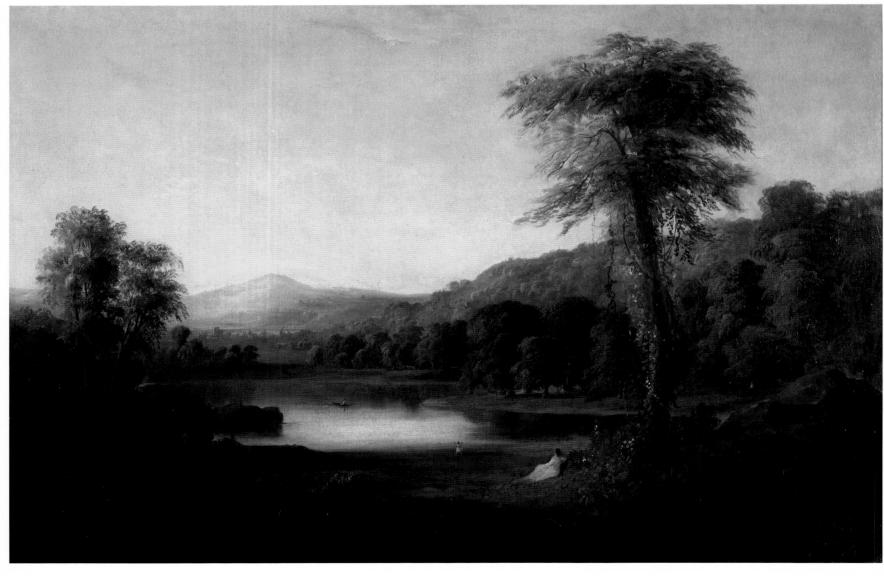

nature's transcendent ways. A third composition, *Vale of Kashmir* (Plate 7) combines Duncanson's view of the real world with his construction of nature in fantasy. The painting shows an ideal tropical setting full of the mystical feeling that nature can evoke. *Vale of Kashmir*, one of several variations by Duncanson on the same theme, combines familiar landscape themes with subjects from previous compositions such as *Ellen's Isle* and *The Land of the Lotus Eaters*, the latter a major landscape inspired by the poetry of Alfred Lord Tennyson. In *Romantic Landscape* (Plate 8), a central lake, similar in plan of the *Lochs of Scotland*, which Duncanson painted in 1853, is framed by distant hills and a lone tree in the foreground. It is a bucolic view of the ideal place for people to relax and enjoy the beauty of nature.

Confidently viewing the world as a peaceful place where beauty abounds, Duncanson chose nature scenes over those emphasizing race. His dedication to landscape painting showed an American sensibility, one that placed interest in the beauty of the land—the vast American wilderness—over the moral question of slavery and race. Although Duncanson showed little or no signs of race in his work, race is said to have been an important factor in his life, particularly as he grew older. Although light skinned, he, like all people of color at the time, was regarded as incapable of intellectual pursuits. His mulatto appearance did not guarantee that whites showed him racial tolerance, and he therefore struggled with the issue of double consciousness that is part of being black in white society.[12]

Duncanson was well aware that the vast majority of African Americans during his lifetime remained without the barest rites of citizenship. But recognizing injustice did not cause him to move his art beyond the safe haven he had chosen: of considering himself culturally emancipated in the larger context of art society. With the one exception of a landscape titled *Uncle Tom and Little Eva,* in the collection of the Detroit Institute of Art, Duncanson seems to have made no real attempt to invoke the subject of race in his work. In the *Uncle Tom and Little Eva* painting, a docile-appearing black male is in the company of a young white girl, suggesting that the white child offers advanced communication to the person of color and that white children's minds were superior to those of African American adults. While landscape painting can inform the viewer of both literary and historical matters, it is hard to see in Duncanson's paintings any attempt to explore racial issues. Contrary to one writer, who finds echoes of the spirituals in the pools and lochs Duncanson painted, traditional landscape painting simply does not lend itself to providing us with symbolic messages on race.[13] Although Duncanson's skills reveal him as an accomplished artist for the times, he created no works of art that can be called exceptional. His works at best reveal an ongoing search for thematic unity between past and present visions of the world, not racial formulas.

While Duncanson enjoyed a measure of support for his art, which included many commissions during his lifetime, his work was all but forgotten in the years immediately following his death in 1872. It would not be brought to the attention of the American public again until Alain L. Locke, the nation's first African American Rhodes Scholar, and art historian James A. Porter began writing about the subject of African American art in the decades following the New Negro movement of the 1920s.

Art historians since that time viewed Duncanson's work in many ways. To some, he was a neoclassical painter referring to the ancient ruins of Italy as a primary landscape source. To others, he represented the spiritual embodiment of a romantic realist observing keenly the heartfelt flow of nature—that which was divinely given with light and form for the inspiration of the artist. Duncanson was later joined by other nineteenth-century African American artists who also idealized the land and rendered a painterly version of America the beautiful.

Plate 7 (facing page, top). Robert S. Duncanson, *Vale of Kashmir,* 1864, oil on canvas, 18 x 30⅛ in. 19

Plate 8 (facing page, bottom). Robert S. Duncanson, *Romantic Landscape,* 1853, oil on canvas, 16⅛ x 24 in.

Edward Mitchell Bannister (1828–1901)

A photographer and painter by profession, Edward Mitchell Bannister, who in the later years of his life resided in Providence, Rhode Island, was the connecting link between the American romantic ideal in nature painting and a style that relied heavily on new European models prior to the impressionists. Unlike Duncanson, whose search for the ideal in nature inspired travels to Italy, England, Scotland, and Canada, Bannister saw no foreign shores other than the land in the vicinity of St. Andrews, Nova Scotia, where he was born.

Inspired by the bucolic pastoral scenes in the environs of Providence and the Narragansett Bay, Bannister sought not to change our view of the natural world but to add to its established beauty a touch of the personal. He both defined and outlined the emotions the changing spectacle of nature evoked. A solitary house surrounded by tall graceful elm trees with cows grazing in the adjacent pasture signaled to Bannister the call to see a different kind of beauty from that Duncanson and other second-generation painters of the Hudson River school of painting observed. Closely associated with a style of painting in America that had its grounding in the Barbizon tradition,[14] Bannister repeated over and over a formula that expressed the joy of nature with all its impending uncertainties and surprises—clearly romantic painting, painting from the heart.

Although Bannister seldom turned to people as subjects in his paintings, one work, *Fishing* (Plate 9), stands out as a major study in his depiction of young men. In *Fishing*, two rowboats stretch across a horizontal plane; they seem motionless in the water. In the foreground, two boys occupy the nearer boat, and they fish in opposite directions from each other. A brown jacket is flung over the side of the boat nearer the viewer. Three boys can be seen in the second boat: One boy sits on each end, contemplating the undertaking at hand. The third boy stands with a pole and line in hand, baiting his hook. The boy standing, aided by the angle of the poles, cre-

ates a triangular emphasis in the composition that gives the viewer relief from the strong vertical plane formed by the descending line of oak trees on the inclining slope in the background. The scene is believed to have been painted in Roger Williams Park in the city of Providence, a place Bannister is said to have frequented for his sketching expeditions.

The poetic vision that Bannister brought to landscape painting in compositions such as *Homestead* (Plate 10) and *Fishing* was no different from what artists of European ancestry drew on when they sought to portray the romance of the American landscape in a light and fanciful way. Moreover, Bannister relied heavily on the artistic revelations of his colleagues for guidance with his transposed vision, a vision closely associated with American artists of the French Barbizon tradition.[15]

In 1876 Edward Mitchell Bannister was awarded the Bronze Medal, the highest award for painting, at the United States Centennial Exposition in Philadelphia. It was presented for his painting *Under the Oaks*. However, when he inquired about the award, he was told that a mistake had been made. He was turned away from the exhibition hall without apology and was not permitted to receive his award in ceremony, an honor that would have been accorded to any white artist.[16] He was allowed to claim his award only later, after considerable review.

While Bannister excelled in conventional landscape painting, as had Robert Duncanson before him, African American artists in the first half of the nineteenth century did not in any great measure exercise their talent as sculptors. Sculpture materials were not as readily available as those for painting, and there were few people with whom artists of color could apprentice. It might seem odd that a people whose cultural heritage relied so heavily on three-dimensional sculpture, particularly the human figure and various depictions of the mask, did not bring the same strength of character and volume of execution to the medium as had their forebears in West Africa. But, given the cruel practices of slavery, which attempted to rob black people of all vestiges of the African experience, it is a

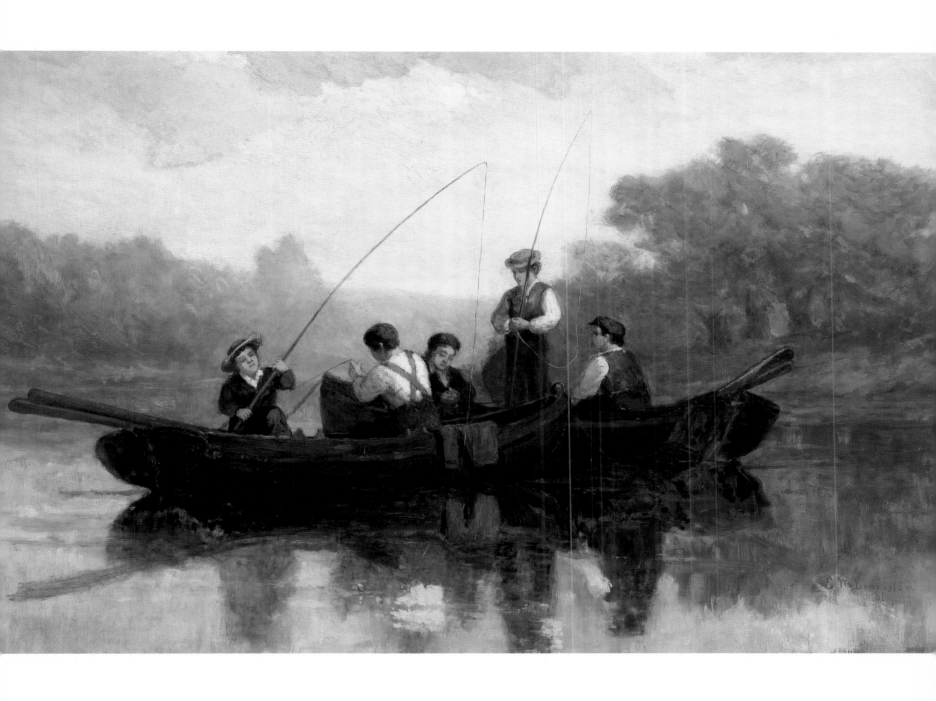

Plate 9. Edward Mitchell Bannister, *Fishing,* **1881, oil on canvas, 30 x 50 in.**

Plate 10. Edward Mitchell Bannister, *Homestead,* **1883, oil on canvas, 34 x 44 in.**

great wonder that so many Africanized visual forms were expressed in the Americas. Some notable examples of these trans-Atlantic survivals can still be found in the architecture of slave builders in Virginia, Louisiana, and South Carolina.[17] The few examples of sculpture that survived the trans-Atlantic voyage are more evident in the crafts tradition than in the fine art of the sculptor.[18] Yet the latter half of the nineteenth century saw an emerging tradition of African American sculpture, and most of the artists who worked in this mode created works of art in the European style.

Mary Edmonia Lewis (c. 1845–c. 1911)

Mary Edmonia Lewis, who worked as a sculptor in the last quarter of the nineteenth century, is the only African American artist of the period who left a body of work worthy of review. She began her training at Oberlin College in Ohio; after leaving Oberlin, she had the personal sponsorship and private tutelage of Edmund Brackett, a Boston sculptor. After two years in Boston, she moved to Italy, where she resided most of her life.

In West Africa, sculpture had been the domain of the male artist, yet among Americans it was black women who developed the tradition of carving from wood and modeling in plaster and clay.[19] Women artists have continued to explore sculpture as a medium of expression since Lewis's time, and later in this book we will discuss the late-twentieth-century work of Augusta Savage, Elizabeth Catlett, and Meta Vaux Fuller.

Lewis excelled as a carver of figures and portraits in the neoclassical mood. In Rome she was greatly admired for her creative lifestyle and her art, establishing herself as a model for future generations.[20] As romantic as she was neoclassical, Lewis referred to the writings of Henry Wadsworth Longfellow, whose poems often romanticized the life of First Americans, from whom she was descended on her mother's side. Themes such as *Marriage of Hiawatha* (Plate 11) and *The Old Arrowmaker and His Daughter*—the latter

work not included in the Cosby collection—were executed skillfully and with a passion for ethnological accuracy. Lewis was an endearing companion to fellow artists of the "white marbalan" group in Rome in the 1870s. On a few occasions she turned to portrait sculpture for commissions. These special assignments were often dictated more by her association with Harriet Hosmer and other Americans living in Rome than by what seemed to be her real sense of dedication to the neoclassical style in sculpture.

In *Marriage of Hiawatha*, c. 1866, Lewis universalizes the family union as Hiawatha takes Minnehaha as his bride. The work is a romanticized version of holy matrimony using Lewis's mother's people, the Mississauga. In classical style, Lewis rendered the drapery meticulously and dressed her subjects in Roman togas, showing that Lewis was fond of transcending racial and ethnic labels in popular-culture themes. One of her most celebrated works, *Forever Free*, in the collection at Howard University, shows an African American man and woman with facial features that reveal close kinship with the Roman ideal in sculpture. The most salient aspect of *Forever Free* remains the symbolic formula through which the emancipation of the slave is celebrated. No such symbolic gesture denoting the First Americans as outcasts in American society are present in *Marriage of Hiawatha*.[21] Hiawatha's hairstyle, the necklace he wears, and the moccasins the newlyweds wear show this composition to be in the genre of "Indian" lore rather than representing a serious confrontation with Lewis's ethnicity.

Lewis was confident and secure in the expression of a style that seemed well patronized in her day. It has been said that Lewis received commissions in Rome of as much as $50,000 at a time. But a rather sad turn of events occurred after her return to the United States in the last quarter of the nineteenth century. Lewis's work was well received in California in the 1870s but was not in great favor among patrons of the arts in the East. She died, all but unnoticed, financially broke, and without fame, in northern California at the age of sixty-six.

Recent scholars have engaged in lively review of Lewis's sculpture, particularly Marilyn Richardson, who offers a more sympathetic understanding of the artist's work. Richardson has reintroduced Lewis's *The Death of Cleopatra* to the American public, noting its whereabouts along with the circumstances of its disappearance for more than one hundred years, and it is expected that a thoroughly insightful analysis of Lewis's sculpture will ensue in the near future, which will add measurably to our understanding of one of the first African American sculptors of international note.[22]

Henry Ossawa Tanner (1859–1937)

While the career of Mary Edmonia Lewis was on the decline in the United States, Henry Ossawa Tanner was gaining the attention of the art critics and museum officials in Europe as a painter of considerable genius. His studies at the Pennsylvania Academy of the Fine Arts under the tutelage of teachers such as Thomas Eakins, one of the nation's preeminent painters, had prepared him for the rigors of an artist's career and to some extent an expatriate life in Paris. Tanner set sail for Europe in 1891. Resolute and genuinely committed to pursuing an active career in art at an early age, he found the social climate for his development as a painter in the United States lacking the support he desperately needed. Having received discouragement from peers during his study at the academy, Tanner knew that ever-present racism could consume an inordinate amount of his time. To avoid racial humiliation and promote his career, he chose to live in Paris and only occasionally visited America from 1891 until his death in 1937.[23]

Tanner was reared in a nurturing and highly religious environment. Early in his career he therefore turned to interpreting religious themes. But before distinguishing himself as a painter of religious subjects, he embraced a wide range of themes, some of which would single him out as an artist of consummate skill in the area of black genre painting. His painterly view of black family life was especially refreshing to African Americans at a time when artists of the majority culture, with the exception of a few, including Tanner's friend and former teacher, Thomas Eakins, and Winslow Homer, portrayed African Americans after slavery with humor and derision. Some artists found favor among white patrons who wanted to see a stereotypic image of black subjects and often depicted blacks as being childlike and without the benefits of civilized society.[24] In 1893 Tanner painted *The Banjo Lesson,* which is now in the collection of Hampton University. It became Tanner's first major work to re-create the image of dignity black people expected to see.

In 1894, Tanner created another black genre composition titled *The Thankful Poor* (Plate 12). In it, the same subjects as in *The Banjo Lesson*—an elderly black man, seeming more the grandfather than the father of the young black boy across the table from him—says grace at a table on which meager victuals are about to be eaten. The boy, not yet in his teens, has not been issued his plate, a sign that parity at the table is the domain of grown-ups—a tradition in black extended family circles that remains visible today in the Deep South.

The style in which Tanner painted the clothing and tablecloth in *The Thankful Poor* indicates his acceptance of an impressionistic formula, yet he introduced this recently acquired style via a subdued method. He avoided the use of broken strokes with bright colors by which several impressionist artists were known. Instead, he settled for a subtle and more restrained palette in which muted gray-greens, umbers, and ocher punctuate in silhouettes the density of the off-white wall against which the familial drama unfolds. The lower regions of the composition, below the front line of the table, are nearly concealed in the tenebrous shadow in which the man and the boy sit, an attribute Tanner probably learned more from seventeenth-century Dutch paintings in the Louvre than from impressionist technique. The brushwork techniques of Rembrandt, Gerome, and Constant provided inspiration, as evidenced by the keen observation apparent in Tanner's application of paint.[25]

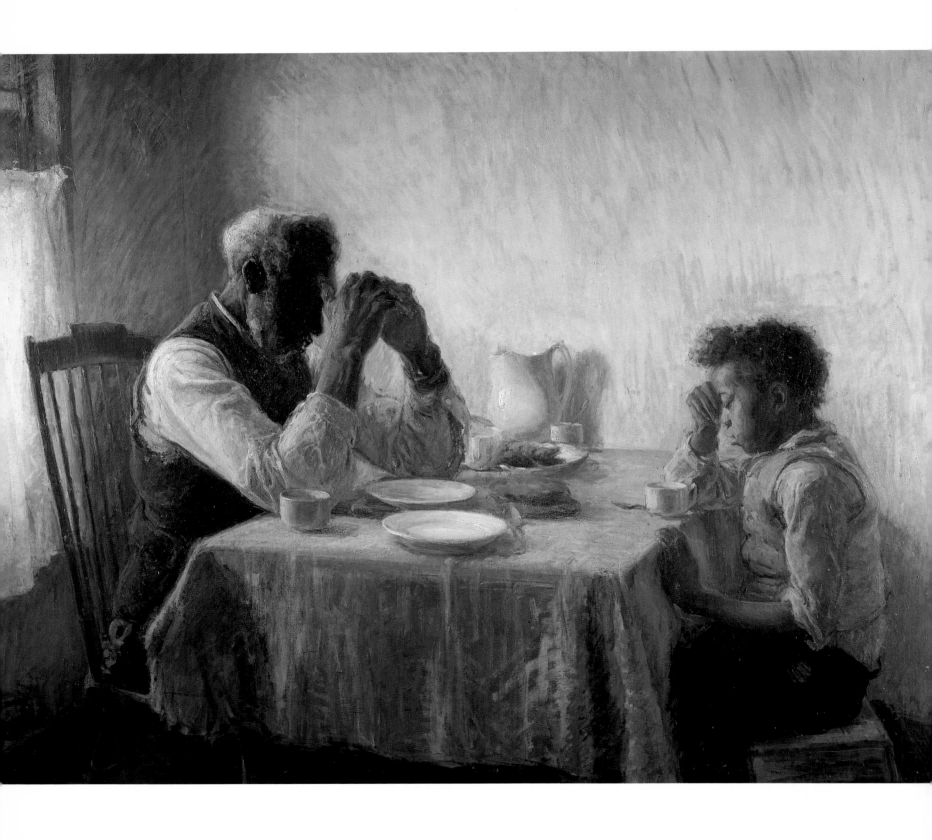

Plate 12. Henry Ossawa Tanner, *The Thankful Poor*, 1894, oil on canvas, 35½ x 44¼ in.

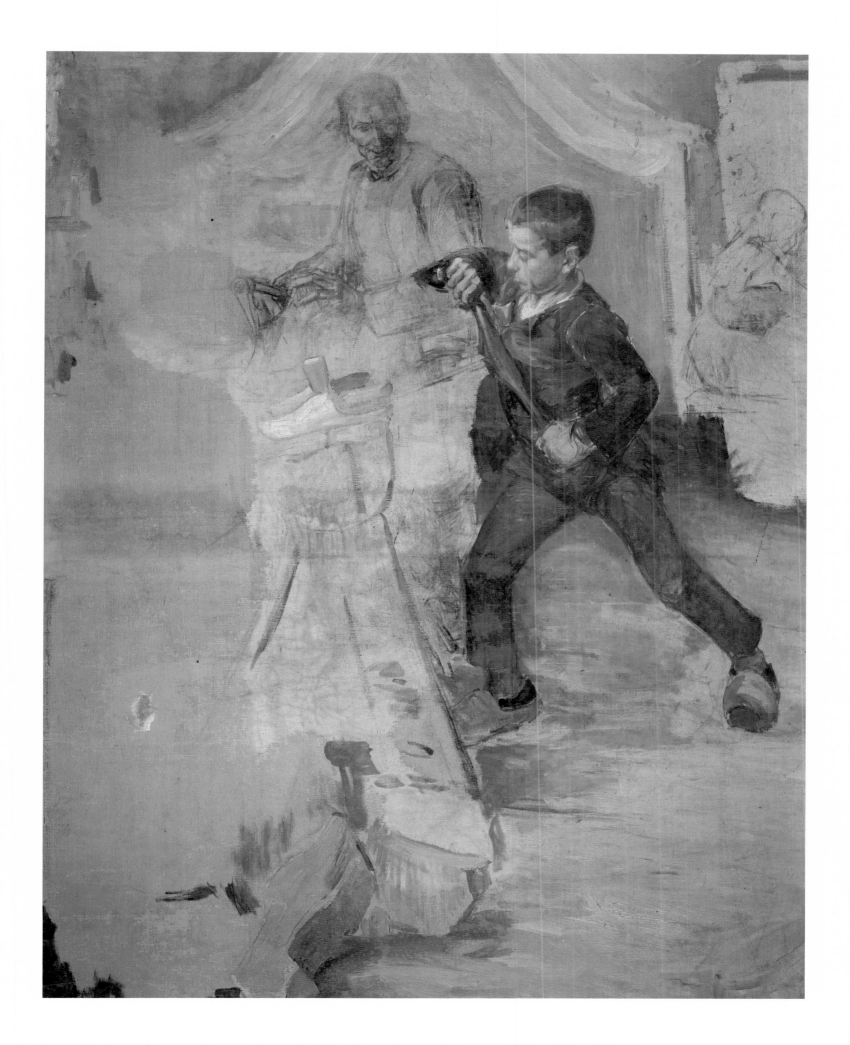

Plate 13. Henry Ossawa Tanner, *Study for The Young Sabot Maker,* ca. 1894, 44½ x 35½ in.

Tanner used umbers and siennas to sketch and outline studies that have survived as independent works or on the backs of a number of canvases. On the back of *The Thankful Poor* is a large unfinished sketch of *Study for The Young Sabot Maker* (Plate 13), another genre theme undertaken by the artist in which two white subjects, possibly another grandfather with his grandson, appear. They seem to be about the same age as the sitters in *The Thankful Poor*.

Tanner's unrelenting pursuit of themes defining Christianity kept him busy after he moved beyond genre subjects. During a visit to the United States after World War I, Tanner painted portraits of his mother and father, yet by then black genre scenes seemed not to interest him as they had in the 1890s. He moved on to biblical subjects by making visits to the Holy Land and to North Africa and depicted there rather precise and literal scenes of village landscapes and local characters he associated with the Bible. Having used familial themes in *The Banjo Lesson* and *The Thankful Poor*, Tanner then turned to using his immediate family, in particular, his beloved wife, Jessie, and later possibly his son, Jesse, as subjects in his religious paintings. Perhaps it is Jesse who appears as the young Christ in *Learning to Read the Scriptures*, a work in the collection of the Dallas Museum of Art. His wife, a European American of Swedish descent, became his constant model, posing as Mary in other such celebrated compositions as *The Annunciation*, *The Three Marys*, and *Mary*, among others (none of which appears in the Cosby collection).

In *And He Vanished Out of Their Sight* (Plate 14), Tanner renders figures stylistically more in the Dutch tradition of painting than in the impressionist. In a lowly lit room with bare necessities, a visitor has come to share a meal. The three figures are seen as though caught in action by the camera, an invention Tanner used from time to time to anchor his artistry and a device that calls to mind his photographic skills.[26] Christ is placed off center as if to give special credit to the host in whose house he will dine. Some of the same meager tableware, a pitcher, and a loaf of bread

appear in this painting as in *The Thankful Poor*. Prayer, in the form of the blessing, the overriding theme in both works, is introduced by the symbolic gesture of Christ having his left hand raised. The female figure in the background is the model seen over and over in Tanner's religious works. The elderly male sitting at the end of the table also appears in Tanner's other religious compositions, such as *Two Disciples at the Tomb*, which is in the collection of the Art Institute of Chicago.

By 1897 Tanner had received major reviews in the French press. They attest to his ability to communicate the drama and mystery of the religious subject in a way that would arouse museums' interest in collecting his work. This sense of drama is apparent in a composition over which Tanner's second version of *Daniel in the Lion's Den*—in the collection of the Los Angeles County Museum of Art—was painted. Dark Rembrandt-like colors dominate this composition, called *Scene from the Life of Job* (Plate 15). Here the lingering ideas of both Benjamin Constant and Gerome, reintroduced by Tanner, can be observed in the heavily impastoed paint surface and a simple compositional space. Tanner's notes and letters leave us no clues as to why he pasted his last version of *Daniel in the Lion's Den* over this composition. And contrary to the belief of some authorities, research is not sufficient to identify this work as *Job and His Three Friends*, a painting that was signed and dated by Tanner and exhibited in 1904 at the Pennsylvania Academy of the Fine Arts in Philadelphia.[27]

In Tanner's devotion to painting scenes from the Bible, he held steadfast to the notion that the historical and biblical Christ he painted was best represented as white, as was traditional in European art. The years 1900 to 1920 were perhaps much too early for one so steeped in traditional European Christianity to see the Christ figure as any race other than white.

Tanner did not readily convert his palette or his state of mind to accept the move under way in America by people of African ancestry as early as the late 1920s to see the Christian

Plate 14. Henry Ossawa Tanner, *And He Vanished Out of Their Sight*, 1898, oil on canvas, 25¾ x 32 in. 29

experience as one deeply rooted in African society.[28] Even after Tanner visited the Holy Land and saw Arabs, Jews, and other Semitic peoples whose strains of Africa's blood showed visibly on their faces, and even though he had been reared an African Methodist Episcopal, a religious faith born of protest against white religious racism, Tanner saw no conflict in painting biblical subjects in the European mode. The thought of African Americans seeing themselves reflected by using the color of their skin to represent the godhead was indeed uncommon before 1920.

The Good Shepherd (Plate 16), painted late in Tanner's life, is one example of a subject he painted repeatedly in later years. In many ways, Tanner's life exemplified that of the Good Shepherd, as he helped many artists of color coming to Paris, among them Albert A. Smith, Meta Vaux Warrick Fuller, and William Harper, find the best for themselves in the turn-of-the-century Paris art scene. Without committing himself to the notion that race should be a major theme in art or religion, Tanner always found room in his schedule to counsel and advise African American artists who visited his Paris atelier in the 1920s and the 1930s.[29]

Tanner provides us with a rather clear understanding of the mind-set of late-nineteenth-century African American artists. It was an age of European colonization and conquest, American segregation, and cultural apartheid, a time when black skin was still equated with inferiority. In Tanner's day, art was not thought of as having the power to change social injustice or alter the course of human history in any great moral and ethical way. And while whites had used art as a tool for propaganda to vilify black people in the United States since the beginning of slavery, protest art, the kind that became known as propagandistic in the 1930s, was thought by some critics to be less than art. The question of how African American artists would address the subject of race as a tool for self-empowerment in their quest for freedom remained strong in the mind of early-twentieth-century black artists. In his mild yet uncompromising way, Tanner helped pave the way for African Americans to begin realiz-

ing that their art could rise above the false distinction of race and thus could be seen in its proper context alongside art produced by other immigrants.

The nineteenth-century African American artist lived fully within the shadow of racism and all its harm to the human spirit. But artists of the period were equally aware of the need to discipline themselves in order to compete formally with artists of the majority culture and emancipate themselves from the notion that black skin was a badge of inferiority. Joshua Johnston was the first American artist of African ancestry to attract a large following for his services as a limner beyond the race. Duncanson, Lewis, and Bannister matured as artists of note at a time when the nation was at war with itself and the issue of slavery was of major concern to its social and cultural growth. Tanner proved, without doubt, that the African American artist had come of age at a critical time in our history, for he garnered many accolades not often given even to Americans of European ancestry. He lived to see the flowering of his own artistry in racially segregated America, the country he chose not to return to permanently because of the premium the nation placed on dividing people along racial lines.

The pioneering black artists of the nineteenth century, often without knowing, lit the torch of self-esteem and self-affirmation that would blaze the way for twentieth-century African American artists who would see black America in a positive light. They illuminated, in the words of Langston Hughes, "our dark skinned selves" with a visual language that expressed pride in the race, pride in the ancestral image, and pride in the American way of life. Cultural competency in the discipline would become the goal in the 1920s as artists of all media looked forward to the day when they could set aside racial conflict and prejudice and pursue their art in an atmosphere of racial harmony. Unfortunately, it was still too soon for the nation to reflect this cultural emancipation even in the first two decades of the twentieth century, the flowering years of important creative discovery for the molding of a black ethos in American art.

Plate 15 (top). Henry Ossawa Tanner, *Scene from the Life of Job,* c. 1914, oil on canvas, 41 x 49⅝ in.

Plate 16 (bottom). Henry Ossawa Tanner, *The Good Shepherd,* c. 1920s, oil on canvas, 25½ x 32 in.

1. David C. Driskell, *Two Centuries of Black American Art* (New York: Alfred A. Knopf, 1976), pp. 41–42; Lynda Roscoe Hartigan, *Sharing Traditions: Five Black Artists in Nineteenth-Century America* (Washington, D.C.: Smithsonian Institution Press, 1985), pp. 65–66, 82.

2. I retain the spelling *Johnston* instead of Johnson—the spelling adopted by writers since 1985—following the tradition of Dr. J. Hall Pleasants, who rediscovered Johnston's work in 1939, and following the respected scholarly tradition of art historian James A. Porter and philosopher and art critic Alain Leroy Locke, both of whom were among the first modern black scholars to write definitive accounts of the life of Johnston. The spelling Johnson apparently began when that name appeared on the page of a book held by Sarah Ogden Gustin, whose portrait was painted by the artist about 1805. On other documents signed by the artist, including the baptismal papers for Johnston's children in the Roman Catholic church in Baltimore, the spelling Johnston appears.

3. Carolyn Weekley and Stiles Tuttle Colewill, *Joshua Johnson, Freeman and Early American Portrait Painter* (Williamsburg, VA: Abby Aldrich Rockefeller Art Center, Colonial Williamsburg Foundation, and Maryland Historical Society, 1987), p. 55.

4. Sharon F. Patton, *African American Art* (New York: Oxford University Press, 1998), pp. 32, 41, 67, 83.

5. David C. Driskell, *Amistad II: Afro-American Art* (New York: United Church Board for Homeland Ministries, 1975), p. 41.

6. James A. Porter, *Modern Negro Art*, 3d ed. (Washington, D.C.: Howard University Press, 1992), pp. 6, 14.

7. The term *limner* refers to a mechanic or draftsman trained in the art of drawing or rendering. The term is used most often with early American artists, particularly those who did not have the benefit of academy training.

8. Hartigan, *Sharing Traditions*, p. 46.

9. Guy McElroy, *Robert S. Duncanson: A Centennial Exhibition* (Cincinnati: Cincinnati Art Museum, 1972), p. 11. See also *St. James Guide to Black Artists* (New York: Schomburg Center for Research in Black Culture, 1997), p. 161.

10. Landscape painting was the hallmark of the Hudson River school artists, who depicted the beauty of the often unexplored American wilderness. Nature in all its magnificent ways was studied and drawn with fidelity to what the eye saw and what the heart romanticized it to be. This love of the land, often painted without the presence of human beings, was greatly imprinted in all the works of these artists.

11. *Cincinnati Gazette*, May 30, 1861.

12. W. E. B. Du Bois, in his celebrated book *The Souls of Black Folk* (New York: New American Library, 1969), asserted that people of color in America had to be mindful of the values of black culture while physically living in a white world; thus the double consciousness within the racial equation.

13. Joseph Ketner, in *The Emergence of the African-American Artist: Robert S. Duncanson, 1821–1872* (Columbia: University of Missouri Press, 1993), theorized that Duncanson was in contact with his own racial sensibilities when he painted landscapes such as *Blue Hole, Flood Waters, Little Miami River,* and *Vale of Kashmir.* Ketner associates the symbolic River of Jordan in the Negro spiritual with these bodies of water in Duncanson's work. Few African American cultural scholars believe this to be the case with Duncanson.

14. Bannister's knowledge of the Barbizon painters was at best secondhand. Some late-nineteenth-century French painters—among whom Bannister most admired was Jean François Millet—turned to the depiction of people and their ties to the land as the ideal subject for painters. They considered farmers toiling to raise and harvest their crops as a worthy social theme in art. Bannister did not go so far as to imitate this theme in his paintings, but he did admire the works of those Barbizon artists whose work he saw in America.

15. Juanita Holland, ed., *Narratives of African American Art and Identity: The David C. Driskell Collection* (San Francisco: Pomegranate, 1998), pp. 26, 28.

16. David C. Driskell, *Two Centuries of Black American Art* (New York: Alfred A. Knopf, 1976), p. 46. See also Juanita Holland's essay "Reaching Through the Veil: African American Artist Edward Mitchell Bannister," p. 29, in the exhibition catalog *Edward Mitchell Bannister (1828–1901): Research Chronology and Exhibition Record* (New York: Kenkeleba House, 1992).

17. Patton, *African American Art*, p. 31. See also Driskell, *Amistad II*, pp. 39, 41–42.

18. Driskell, *Two Centuries of Black American Art*, pp. 14, 23–24. See also Steven L. Jones, "A Keen Sense of the Artistic: African American Material Culture in 19th Century Philadelphia," *International Review of African American Art*, vol. 12, no. 2 (1976):4–29.

19. James A. Porter, *Ten Afro-American Artists of the Nineteenth Century* (Washington, D.C.: Howard University, 1967), p. 17.

20. Marilyn Richardson, "Edmonia Lewis, *The Death of Cleopatra*: Myth and Identity," *International Review of African American Art*, vol. 12, no. 2 (1995):36–52. See also Jacqueline F. Bontemps and Arna Alexander Bontemps, eds., *Forever Free: Art by African-American Women 1862–1980* (Alexandria, VA: Stephenson, 1980), pp. 13–18; Rinna Evelyn Wolfe, *Edmonia Lewis* (Parisippany, NJ: Dillon Press, 1998), pp. 115–116.

21. As with many subjects Lewis executed, more than one version of *Marriage of Hiawatha* may have been carved. Certainly this is the case with *The Old Arrowmaker and His Daughter*, of which several versions are to be found.

22. Richardson, "Edmonia Lewis, *The Death of Cleopatra*," pp. 36–52.

23. Marcia Matthews, *Henry Ossawa Tanner: American Artist* (University of Chicago Press, 1969), pp. 65–76. See also Dewey F. Mosby, Darrel Sewell, and Rae Alexander-Minter, *Henry Ossawa Tanner* (Philadelphia Museum of Art, 1991), p. 122.

24. For an enlightened view of the subject, see Michael Harris's discussion of black caricatures and stereotypic images white artists created to deride African Americans in the nineteenth century:

"Memories and Memorabilia, Art and Identity: Is Aunt Jemima Really a Black Woman?" (paper presented at Howard University, April 22, 1995), p. 108.

25. Tanner studied painting under the tutelage of Jean Joseph Benjamin Constant after his arrival in Paris in 1891, yet he studied Gerome and Rembrandt on his own to learn how to represent light and shadow.

26. Tanner studied photography and later set up a studio on the campus of Clark College, now Clark Atlanta University, where he taught art before sailing for Paris. He often used photographs to paint from after making a photographic image of a particular scene. In 1985, Tanner's grandniece, Dr. Rae Alexander-Minter, discovered a photograph among the artist's belongings in the possession of Tanner's son, Jesse, that showed how Tanner used the photograph to compose the painting we know as *The Banjo Lesson*. See Hartigan, *Sharing Traditions*, p. 108.

27. Although no scholarly evidence exists to prove that the painting now called *Scene from the Life of Job* in the Cosby collection was exhibited in 1904 at the Pennsylvania Academy of the Fine Arts, the work was listed with the title of *Job and His Three Friends* by writers of the catalog accompanying the Tanner exhibition at the Philadelphia Museum of Art in 1992. The change of title was made without the knowledge and approval of the owners of the work, who loaned it to the Tanner exhibition as *Scene from the Life of Job*; thus the reversion to this title. In my research at the Los Angeles County Museum of Art in 1975 in preparation for the exhibition *Two Centuries of Black American Art*, it was noted that *Daniel in the Lion's Den* had been placed over another canvas. I requested that the painting be X-rayed. X rays reveled another image beneath, and further conservation work was done to uncover and separate *Scene from the Life of Job* from the well-known *Daniel in the Lion's Den*. *Scene from the Life of Job* was deaccessioned by the Los Angeles County Museum of Art in 1987.

28. Aaron Douglas and James A. Porter, conversation with author, Fisk University, January 5, 1967.

29. As early as 1927, Aaron Douglas created compositions that centered on a black version of Negro spirituals and folk poetry to accompany James Weldon Johnson's book of poems titled *God's Trombones*. Compositions such as *Crucifixion* and *Noah's Ark* show black religious subjects in a biblical context and are among Douglas's most influential works.

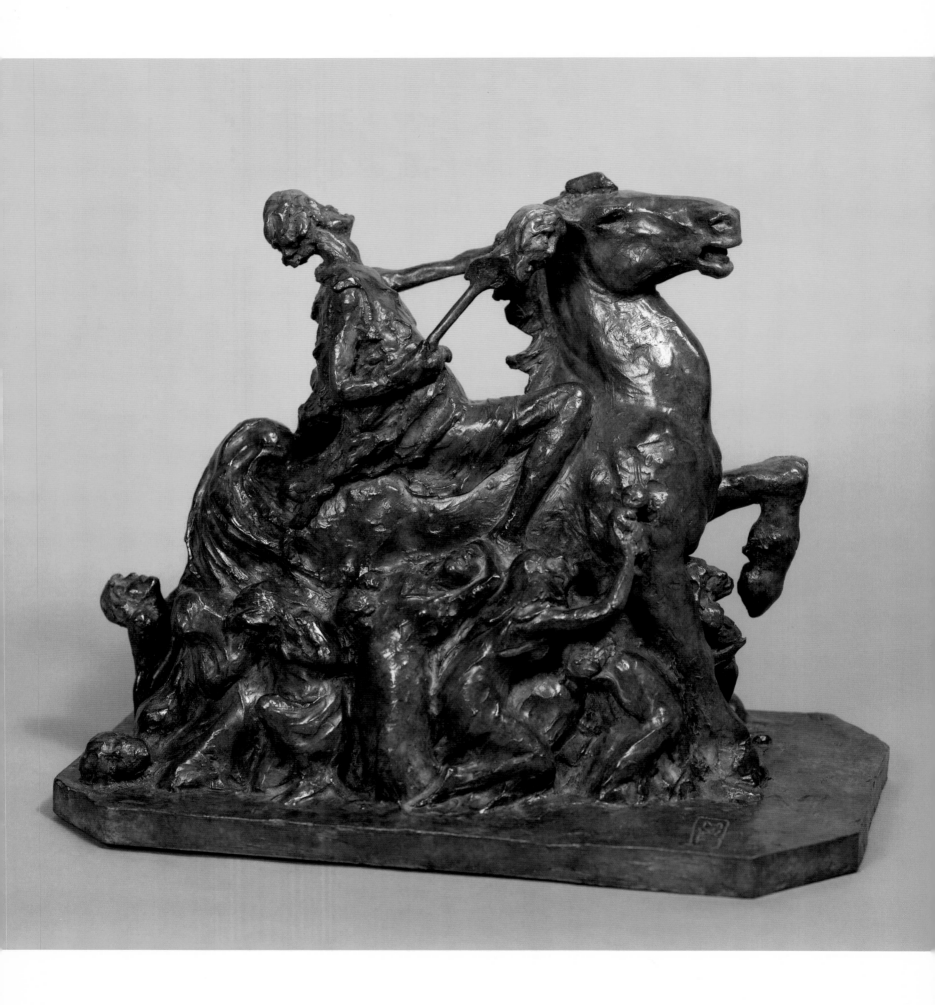

Plate 17. Meta Vaux Warrick Fuller, *Peace Halting the Ruthlessness of War*, 1917, bronze, height 14 in.

Black Artists Come of Age

TWENTIETH-CENTURY TORCHBEARERS

As the twentieth century began, African American artists still had not achieved recognition as a viable part of the American mainstream. They were still shut off from exhibiting in the nation's major private galleries and museums, and some cultural institutions limited black access even for regular visits. It was not uncommon for museums in the South to set aside one day for "colored visitors," a practice that continued well into the 1950s.[1] Under these circumstances, African Americans had few incentives to pursue art as a career. At the turn of the century, none of the black institutions of higher learning offered accredited courses of study in art.[2] It was a time when racial prejudice against African Americans remained a daily practice among whites.

There were, however, other avenues to the exhibition halls, particularly in Europe, where black artists could create and exhibit their art in an atmosphere of greater acceptance. The record of achievement by American artists of color in Europe the first two decades of this century served as both a badge of pride and a beacon of hope for those resisting the harsh artistic realities of segregated America. A case in point was Henry Ossawa Tanner (1859–1937).

Tanner's record of accomplishment in the Salon in Paris in the 1890s, versus the limited acceptance that his art received in Philadelphia in 1900, in Buffalo in 1901, in New Orleans in 1904, in St. Louis and Pittsburgh in 1905, and in Chicago in 1906, signaled a changing social order for young, aspiring artists of color in the United States. Some noted these achievements and headed abroad for England and France in hopes of their art meeting with the same success as Tanner's. Among those artists who traveled to Europe to receive Tanner's critiques in the late 1800s and who benefited in the next two decades from a more benevolent atmosphere of teaching were William A. Harper, Albert H. Smith, and William Edouard Scott. Although none of these artists is represented in the Cosby Collection of Fine Art, they nevertheless were an important link between the young, aspiring black artists at home and artists such as Tanner and Meta Vaux Warrick Fuller, who had earned a measure of success abroad, particularly in France. Harper took to landscape painting in the tradition of the Barbizon school. Smith, as did Scott in later years, turned to genre painting, in which the black image was seen as an imprint of the dignity that came with racial pride.

Meta Vaux Warrick Fuller (1877–1968)

Meta Vaux Warrick Fuller, a Philadelphia sculptor of critical note, went to Paris in 1899 and was greatly inspired by black African sculpture. Fuller's exhibition at Paris in Samuel Bing's Art Nouveau Gallery in 1902 was prophetic. It showed how African art would inform the art of twentieth-century European artists such as Pablo Picasso, Amedeo Modigliani, and Karl Schmidt-Rotluff, among others, long before the same influences were seen in the work of African American artists of the Harlem Renaissance.

Belonging more in spirit than in tradition to that group of artists who in the nineteenth century felt a special calling or passion for art, Fuller created an extraordinary type of sculpture for her time and gender. Her training as an artist at the time did not demand of a woman—in particular, a woman of color—the insightful artistic vision that registered poverty or the agony of racial discord or a social

commentary on the horrors of war. What was desired of women of Fuller's day was domesticity. But Fuller proved herself an artist of selective vision, one who seized upon every possible opportunity during her three years in Paris to study the art of various cultures, including those of both East and West Africa. Later, in 1909, she married Solomon C. Fuller, an African doctor from Liberia.[3] From the time she arrived in Paris in 1899 until she departed in 1902, her work was viewed with exceptional interest by Americans who visited her studio as well as by a select number of influential French artists and critics.

A devout Catholic who felt that she had to give special reverence to the gift God had bestowed upon her, Fuller still found time in her busy schedule of being both an artist and devoted mother to take on civic duties. Fuller paid special attention to race relations in the South, and she was active in the women's peace movement. One of the most complicated and dramatic works she undertook was a model for a work called *Peace Halting the Ruthlessness of Wars* (Plate 17). The work, done in 1917, is a powerful visual metaphor of the agony of war and the sting of death. This genuinely terrifying composition took her back in time to the work she so dearly admired by her mentor, Auguste Rodin. Writhing and screaming amid the chaos of death's triumphant stroll, men, women, and children are trampled beneath the hooves of the striding horse with arrogant gait. Although the model was never translated into a permanent monument, it stands today as an important testimony to the strength of Fuller's broad sculptural will and her determination to be a sculptor whose social conscience influenced her artistry.

If the European art scene provided the cultural ingredients that freed the African American painters from the academic yoke that had long dominated their art, it also liberated those few black sculptors who ventured abroad. Fuller's work took on a modernist format, closely following in the tradition of Auguste Rodin, to whom she had taken her work for criticism. A sizable number of emerging artists born just before and after 1900 benefited immeasurably from Tanner's, Fuller's, and Albert H. Smith's experiences in Europe. Torchbearers for the cause of freedom, they moved far from the stereotypic images of white artists of the past to more positive ones of their race and inspired a new brand of black artist born between 1890 and 1902. Some of these artists would mature in the afterglow of the Harlem Renaissance. All were receptive to the making of images in art that centered on black culture and more particularly on what Alain Locke called "the Negro's African past."

Work by ten other artists born between 1889 and 1902 whose art matured in the period now known as the Harlem Renaissance are included in the Cosby Collection of Fine Art. Eight became painters, while two chose to work as sculptors. Some became teachers of art at black colleges and universities in the South, and others moved to the urban North, where a better-organized community of artists existed. A small number took up residence in France and Denmark, living the life of expatriates as had Tanner before them. While some went abroad to study and briefly experience the life of the artist in the European capitals, others chose to remain in America. There they nourished the hope that they too would be able to move their art beyond the marginal position that African American art then held in American society. They hoped for a position of power and wider acceptance.

Archibald J. Motley Jr. (1891–1981)

Archibald J. Motley was born in New Orleans in 1891 and lived in Chicago. As he was growing up, the city provided both the substance and sources out of which Motley's work would emerge. In contrast to Palmer Hayden, whose roots in the rural South harshly and adversely affected his painting, Motley chose to depict the rich flavor that African Americans brought with them to the urban scene. His art seemed racially informed but colorfully embellished by having lived as a child in a mixed Chicago neighborhood.

In painting urban scenes, Motley painted city people he knew, including the members of his family, such as his grandmother, his wife, and other family members, as well

as friends. In the 1920s he achieved a measure of success as a portrait artist. *Mending Socks*, in the collection of the North Carolina Museum of Art in Raleigh, which he painted in 1924 and which became one of his best-known works, is a portrait of his maternal grandmother. She was a reserved Catholic whom Motley greatly admired. The composition moves beyond general portraiture by depicting a woman of gentle benevolence surrounded by still-life objects that define the narrow racial boundaries of his grandmother's life while at the same time emphasizing the highly sophisticated elements of her culture. Books, indicating the sitter's literacy, also appear in the painting.[4]

Next came the portrayal of a particular black genre centering on nightlife in predominantly black Southside Chicago. Oddly enough, Motley did not live in the Southside. He lived in a mainly white neighborhood but traveled to the Southside to observe the characters of the black inner city that he portrayed in his work.

He often painted party scenes of cabaret life showing the joy of dance and race celebration. Such a scene appears in *Stomp* (Plate 18), a composition Motley painted in 1927. The painting illustrates fully and stereotypically the theme of race, which was just what some black people wanted to avoid. Many hoped to imitate white society's middle-class values, and they did not cherish the notion that, as Motley said, "one sees them doing the Stomp, . . . in the best of their Marshall Field dresses and suits, getting down."[5] "Getting down" when dancing, for African Americans, was not associated with the higher classes. Some African Americans who dreamed of becoming part of the American mainstream thought paintings like *Stomp* showed them in a marginal fashion and thus lessened their chances of being welcomed into white society.

In 1929 Motley received a Guggenheim Fellowship, which he used for a year of study in Paris, where he met people of many ethnic and racial backgrounds. *Senegalese Boy* (Plate 19) was painted that year. In that work, Motley describes the boy's features precisely; thus we can label the boy as an African subject of Wolof ancestry. The Wolof and Mandingo peoples of Senegal are noted for their striking physical beauty, jet black skin, and keen features, racial characteristics that Motley associated with members of his own family. The boy leans casually against a light wall and wears a white shirt with a collegiate-style red necktie. Perhaps he is one of the new African acquaintances Motley made while living in Paris, acquaintances he deliberately pursued in an attempt not to associate himself too closely with the growing numbers of Parisian African Americans.

So strong was the black nightlife theme for Motley that when he arrived in Paris in 1929, the cabaret scenes he had begun painting in Paris immediately connected in style and content with those of Chicago, the only difference being that participants in the Paris works were usually white. They strolled fashionably along the streets in café scenes much as black people would in the urban life compositions Motley painted after returning to Chicago in the 1930s.[6]

Motley returned to a slightly changed Chicago. It was a city revitalized with the will of the people to survive the oncoming Depression. He was thoroughly committed to painting works that portrayed the colorful and buoyant character of what he called true "Negro expressions." Nearly twenty years later, Motley was still fascinated with the urban street life of African Americans. In *Bronzeville at Night* (Plate 20), painted in 1949, he paid strict attention to the fancy dresses worn by the women as well as the stylistic zoot suits of the men. Motley seemed obsessed with what may be called the base side of black life, that which emphasized ethnic food, black dance, and some of the stereotypes white Americans associated with black culture. An example of this genre not included in the Cosbys' collection is *Chicken Shack*, which was painted in the mystical glow of the evening light, showing beer joints, massage parlors, and social establishments where barbecued and fried chicken were sold.

Throughout the years, Motley worked in isolation. Seldom did he compromise his intent in painting the black

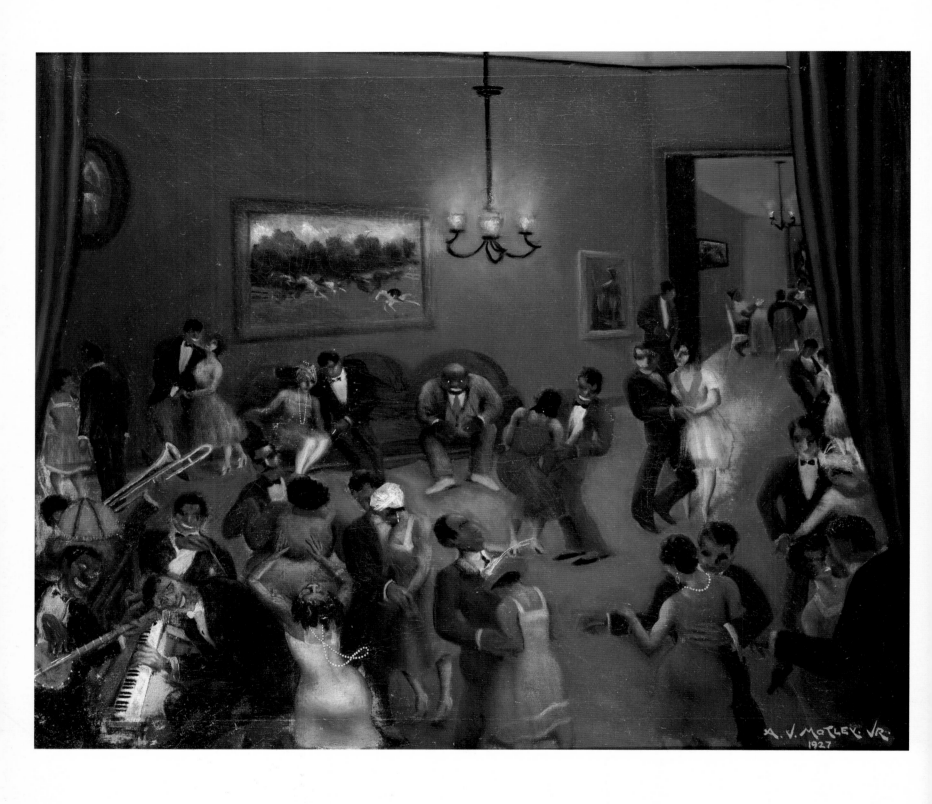

Plate 18 (this page). Archibald J. Motley Jr., *Stomp,* **1927, oil on canvas, 30 x 36 in.**

Plate 19 (facing page). Archibald J. Motley Jr., *Senegalese Boy,* **1929, oil on canvas, 32 x 25¾ in.**

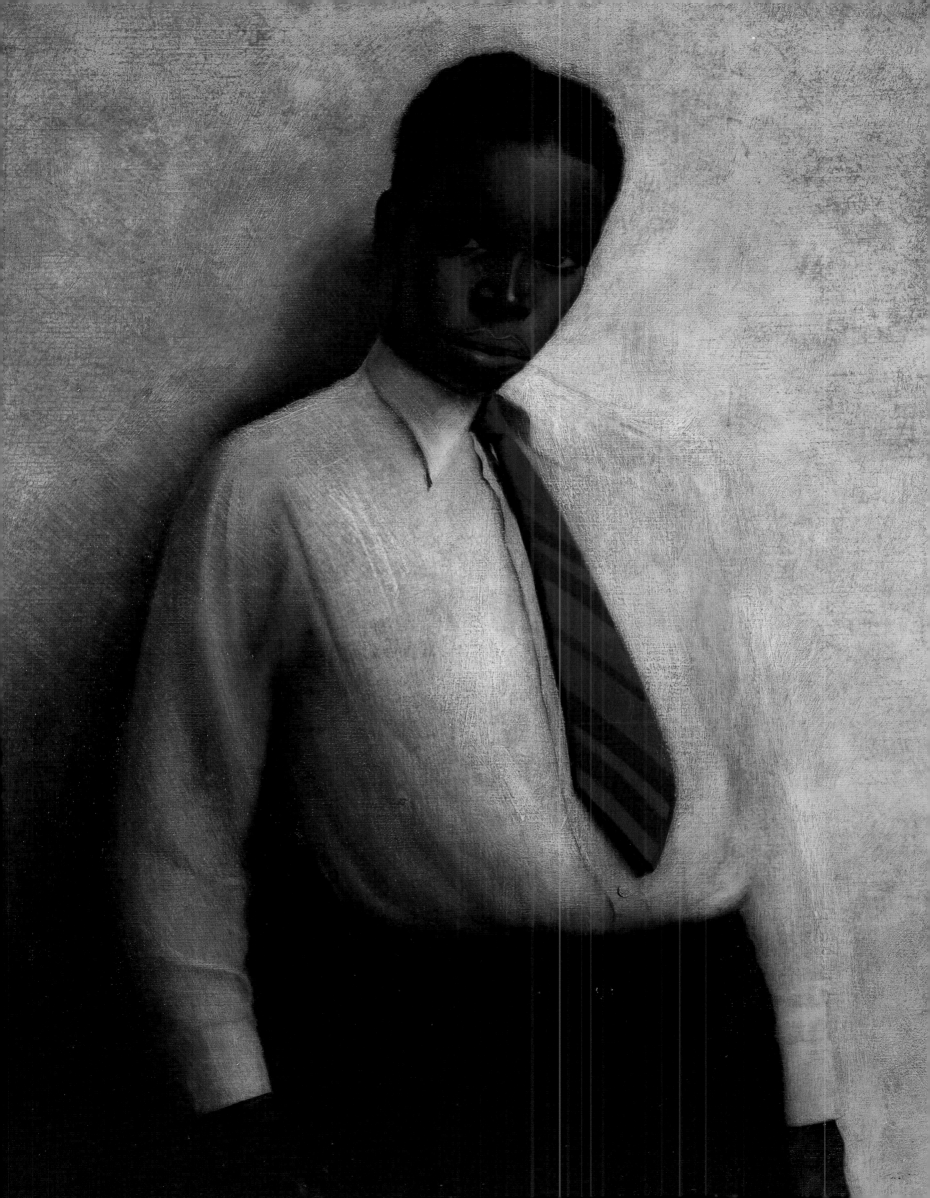

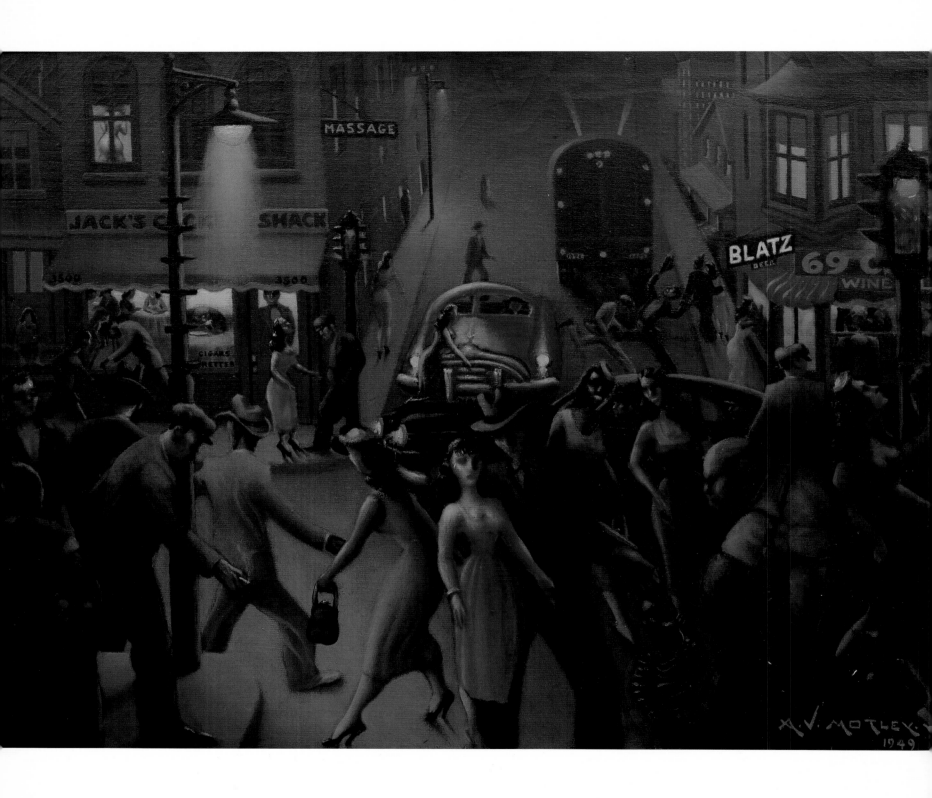

Plate 20. Archibald J. Motley Jr., *Bronzeville at Night,* **1949, oil on canvas, 31 x 41 in.**

experience in a personal way, and seldom did he march to the beat of the drum of his black artist colleagues. His world was a creation of his own imagination, fueled by African American rituals, the celebration of syncopated jazz, and the racial differences that remained throughout his long life. At the time of his death in 1981, Motley had before him several canvases in which he was still trying to solve the mysteries of his own magical formula: that of intertwining humor and sadness in painting the black experience.

Alma Woodsey Thomas (1891–1978)

Born September 22, 1891, in Columbus, Georgia, Alma Woodsey Thomas aspired to become an architect. Switching from design to art in college, she graduated from Howard University in 1924, the first graduate of the school's art department. Thomas pursued a career as an art teacher in the District of Columbia's public schools until she retired in 1960.

Thomas took advantage of every available opportunity to study and improve the quality of her work. She studied independently in the northeast Washington studio of Lois Mailou Jones after receiving a Master of Arts degree from Columbia University's Teachers College in 1934. As a member of the board of directors of the Barnett Aden Gallery in Washington, D.C., from its inception in 1943, she had access to the art exhibited there. She also benefited from the critical advice of many artists from around the nation who came by to seek the wise counsel of James V. Herring, one of the gallery's two founders. (Alonzo J. Aden was the other founder.)[7] Thomas frequently greeted visiting gallery artists such as Theodore Stamos, Romare Bearden, Jacob Lawrence, I. Rice Perieria, and Lois Mailou Jones, and her art grew through these professional associations.

She studied painting at American University in the 1950s with Jacob Kainen, Ben Summerford, and Robert Gates. This training led to her experimentation with abstraction, and she became acquainted with the Washington color field school of painting.[8] Some authorities refer to her as a second-gen-

eration artist of this genre. Undaunted by the ills of racial segregation, and unlike the artists who preceded her, Alma Thomas did not exhibit her paintings widely until the 1960s. At that time, her style was still evolving from the realist academic tradition to a more modern form of abstraction.

All the formal training Thomas received in her earlier years was channeled into one direction in the late 1960s, when an astonishingly individual style of painting emerged. From the hand of an octogenarian of seasoned creativity came a series of paintings that burst with bright and exhilarating colors. Articulating a new style in which the static lines of color field painting were shattered as though broken up by the sculptor's mallet—a craft she had learned in the years when she studied sculpture—Thomas created vertical and horizontal circles, wheels, and linear patterns based on nature's fantastic color, form, and fluctuating patterns. An interplay of enlarged, impressionistic brush strokes dominated large and small canvases alike, in which lively colors echoed the rhythm of time and place. For Thomas in the late 1960s, events became color coded in large, vibrant statements.[9] *A Fantastic Sunset* (Plate 21), done in 1970, shows the artist at her best, revising and designing the prismatic flow of colors that cross the fragile boundaries of hot jazz, poetry, and dance.

She worked with acrylic paints in a small kitchen that served as her studio. Thomas revolutionized her palette, adding to what she had learned from interactive study with Lois Mailou Jones and Jacob Kainen. Synthesizing both color and space in abstract rhythms, she developed a way of painting nature without violating the academic formulas with which her work had first been empowered. The carefully arranged rows of flowers at the National Arboretum in Washington, D.C., inspired the linear-based painting called *Azaleas Extravaganza* (Plate 22), rendered in 1968. Although *Azaleas Extravaganza* is similar in physical mood to another series of paintings paying homage to science and space flight, it nonetheless is a continuing exploration of the active color field in painting, in which tone and emotion

Plate 21. Alma Woodsey Thomas, *A Fantastic Sunset,* **1970, acrylic on canvas, 47¹/₂ x 47¹/₄ in.**

Plate 22. Alma Woodsey Thomas, *Azaleas Extravaganza,* **1968, acrylic on canvas, 72 x 52 in.**

define a universally appealing theme. The painting is similar in tone and mood to the linear strips of color found in the work of Kenneth Noland and Morris Louis, two artists Thomas knew well, who were the founding artists of the Washington color field school of painting.

While Thomas admired the work of those pioneering modernists, she was never a yes woman to the cause of any "ism," racial theory, or gender theme. She was at all times herself, a lively spirit of her own calling, a person far removed from the Victorian past into which she was born. Living to the ripe and productive age of eighty-six, Thomas moved her art progressively from the category of the concerned student to that of an accomplished artist, one whose work is still highly sought after by museums and private collectors alike. At the time of her death in 1978, Thomas had triumphed over race, gender, and locale by becoming an artist of international reputation, one whose work had been featured in exhibitions in major American museums and in museums around the world. [10]

Augusta Savage (1892–1962)

Augusta Savage was born Augusta Christine Fell on February 29, 1892, in the village of Green Cove Springs, Florida. Throughout her life she struggled against the forms of racial prejudice so prevalent in American society then. Early on in life she noted that much prejudice was directed at persons of African ancestry and that women encountered many biases in art and in life as a whole. These facts did not hamper the genius of her art, but they did resoundingly prevent her from winning the accolades an artist of her talent and calling should have received. Thus when she turned to teaching in the 1930s, Savage was a seasoned commentator on the rejection of the black artist in American society.

She was introduced to racial intolerance early in her career as she, like Edward Mitchell Bannister, was prohibited from claiming a prestigious award. Unlike Bannister, however, Savage was not eventually reinstated as the right-ful winner. In the summer of 1923 she was not allowed to enroll at the prestigious art school for women at Fontainebleau, France, after winning one of its scholarships. The scholarship was an honor of great merit, and Savage was denied entry because of her race. Some members of the admissions committee noted that Savage's presence as a Negro at Fontainebleau would have been unacceptable to some of her American colleagues, particularly the white women enrolled from the South. [11]

Savage endured another severe disappointment at the tragic destruction of a major commission she created for the 1939 World's Fair in New York City. *Lift Every Voice and Sing*—also called *The Harp*—her most ambitious work, was a sixteen-foot-tall sculpture in which black children were aligned side by side like the strings of a harp. They diminished in height as they reached a large hand at the top, which suggested that Savage was also trying to illustrate the Negro spiritual, "He's got the whole world in his hand." At the front, a young man offered musical notes to the gods. The work, executed in plaster, was destroyed at the close of the world's fair, as Savage was unable to attract sponsorship to remove it from the fairgrounds in Queens and have it cast in a permanent medium.

Savage taught art at the Harlem Community Art Center, which she also cofounded during the Depression. With a $1500 grant from the Carnegie Foundation, she opened the Savage School of Arts and Crafts in 1932. She inspired a number of young artists, including painters Jacob Lawrence and Norman Lewis. It was in one of Savage's classes at the center that a young urchin posed for the work called *Gamin* (Plate 23), a small plaster bust that she created in 1929. Done in several sizes, it has remained one of her most popular works.

Gamin, a portrait of a Harlem boy, perhaps a relative of the artist, is also a character study of the young African American male whose destiny beyond the streets of Harlem could not be predicted. Several versions of the work have been cast in bronze since the artist's death in 1962, and they

Plate 23. Augusta Savage, *Gamin*, 1929, plaster, height 9⅛ in.

are now in a number of collections throughout the nation.

Confident in her own talent yet hindered by the prejudiced society in which she lived and worked, Savage lived a creatively unfulfilled life, unable to pay the fees necessary to have her work cast in permanent materials. Many of her plaster portraits have survived, thanks to the care the sitters for the work devoted to preserving the studies she executed. Savage knew the strength of her own work. However, it has been said that she felt despondent and let down spiritually after the advent of the Harlem Renaissance because of the unpredictable direction that African American art took after the Great Depression. She did not create sculpture in any great measure after the 1939 New York World's Fair.

Yet one work, *Seated Boy* (also called *Boy on a Stump*) (Plate 24), sculpted in 1940–1942, remains a poetic statement to the lyrical quality that Savage was able to invest in a number of sculptural works. Originally executed in plaster, it was cast in bronze more than thirty years after Savage's death. In the work, a slender, young black male sits nude in a mannered pose on the stump of a large tree. He glances cautiously to the left side as if expecting to be called to another task. As lean and gaunt as the boy appears, he nonetheless displays the face of a strong-willed individual. The subject of the work is thought to have been the model for a fountain, not a portrait.

The sad events of Savage's life helped prevent the full realization of an important talent in sculpture. Savage did, however, inspire other artists such as Ernest Chrichlow, Elton Fax, Gwendolyn Knight, and Jacob Lawrence to fulfill their creative dreams. Harlem became an important art community in spite of the walls of racial prejudice that surrounded it in the 1930s. Savage helped bring forth its eminence by planting the seeds of artistry that inspired creative inquiry and productivity in promising young artists.

Plate 24. Augusta Savage, *Seated Boy* (*Boy on a Stump*), 1940–1942, bronze, height 31¼ in.

Palmer Hayden (c. 1893–1973)

Palmer Hayden, whose name was Peyton C. Hedgeman before he became a soldier in World War I, began painting and drawing as a child. He gained no real recognition for his art until 1926, when he entered the first Harmon Foundation *Exhibition of the Work of Negro Artists* in New York. He later received some critical acclaim as an artist of popular culture themes, centering many of his compositions on black genre scenes that highlighted family and community activities. Most notable among Hayden's paintings depicting black lore is the *John Henry Series*. This series consists of twelve paintings based on the story of a black folk hero who worked faster than the newly developed steam engine drill in carving out Big Ben Tunnel through the West Virginia mountains. Other later genre scenes, such as *Woman in Garden* (Plate 25), c. 1966, identify Hayden as a close observer of the lifestyle of African Americans in the South, who lived close to the land.

A brief sojourn in Paris between 1927 and 1932 did not alter the course of Hayden's work. It also did not change his folkish style of painting, which vacillated between a rather naive approach to representing the human figure and a more sophisticated portrayal of landscape and still-life subjects in the academic tradition.

Hayden often referred to himself as a self-taught artist. But he studied independently in New York, Maine, and Paris, invalidating his claim to being untutored.[12] Still, there remained in his work a rather plain, almost abstract, way of representing animals and people. The people who ride Hayden's merry-go-round, as seen in *Carousel* (Plate 26), are not convincingly real. They exist stiff and stale, frozen in place, not full of the motion expected of the merry-go-round. More likely painted from memory than observation—Hayden no doubt recalled his early years as an employee of the circus—*Carousel* depicts a popular theme among artists of the 1920s and 1930s, especially those living in New York City. Hayden closely followed the prescription artists of the majority culture adhered to in depicting popular themes familiar to people across racial lines.

In contrast to the frozen faces of *Carousel*, the faces in *When Tricky Sam Shot Father Lamb* (Plate 27) communicate every form of emotion imaginable. A crowd of people of all classes is assembled on a hot summer evening, and the drama of the event is highlighted by the glow of dim streetlights. The people anxiously observe the events in the story of the respected cleric who was shot by Tricky Sam, a local scion. Themes of community solidarity, deep concern, and sympathy for an accused person shine from this painting. Hayden forces the viewer to become one with the onlookers and to wonder, What did the august cleric do to bring such violence upon himself?

This scene of the crowded street follows closely the genre of one of Hayden's most celebrated works, *Midsummer Night in Harlem*, in the collection of the Whitney Museum of American Art. Considered one of Hayden's best-known compositions, *Midsummer Night in Harlem* takes us into the busy streets of Harlem, where people sit on steps, pose in their automobiles, and stroll at a leisurely pace down a sultry street. The plan of the work is somewhat reminiscent of the urban scenes of Archibald Motley Jr., the Chicago painter whose stay in Paris coincided with Hayden's visit there. Yet the two artists remained worlds apart in their depiction of racial types. A lively interest in Hayden's paintings has emerged in recent years, making him a highly sought-after artist.

Aaron Douglas (1899–1979)

Aaron Douglas was the artist most in demand during the New Negro movement, the period in the mid-1920s and early 1930s when Harlem came alive with an outburst of artistic genius. Literary figures such as W. E. B. Du Bois and philosopher Alain Leroy Locke inspired this efflorescence. Artists of all media were encouraged to create works that expressed the flowering of the visual arts known as the Harlem Renaissance.[13]

48 **Plate 25. Palmer Hayden,** *Woman in Garden,* **c. 1966, oil on canvas, 24 x 31 in.**

Plate 26. Palmer Hayden, *Carousel,* **c. 1934, oil on canvas, 20¼ x 26 in.**

50 **Plate 27. Palmer Hayden,** *When Tricky Sam Shot Father Lamb,* **1940, oil on canvas, 30 x 39¾ in.**

Born in Topeka, Kansas, on May 26, 1899, Douglas received a Bachelor of Arts degree in art from the University of Nebraska at Lincoln, taught art for the next three years in a high school in Kansas City, Kansas, and then migrated to New York City. By 1927 he had become "the fairheaded boy" of black artists in Harlem, contributing illustrations for books and for the covers of *The Crisis and Opportunity* magazines, among others.

Douglas had not expected to be the model for black artists seeking to divest themselves of the Negro stereotyping and caricaturing common in white literature of the time. Therefore he felt unprepared to accept the responsibility of pursuing racial change in his art or fostering the creation of a positive iconography celebrating the black image. He was an academic by training and insisted that he was unqualified to be a visual spokesman for the race, until he was invited into the studio of painter and illustrator Winold Reiss (1887–1953). Reiss, a white Bavarian artist, challenged his student to set aside his pursuit of the realist models of the Eurocentric model and to concentrate instead on a style of cubism in which geometric forms informed by African art could be seen.

Although Reiss's philosophy was based on a misguided notion of African Americans and First Americans as natural extensions of primitive races, his request had good effect. Douglas turned to the icons of Africa as inspiration for his work.

Douglas's first successful attempts to synthesize the academic with the abstract were in a series of compositions for a book edited by Alain Locke titled *The New Negro*.[14] *The New Negro* became the bible of black culture in that period. It announced the coming of age of artists of the Negro Renaissance in New York and Chicago. Locke proved to be the key figure to whom visual artists turned during the flowering of the arts in Harlem, because he had such excellent connections with publishers, patrons of the arts, and respected members of the academic community.[15] Locke was also well connected to the Harmon Foundation, the organization that provided widespread support to artists in

the period by offering prizes and honorable mentions to African Americans at a time when few other badges of recognition were given to black artists.[16]

Locke singled out Douglas as a fine example of the New Negro in art. Locke saw in Douglas's work the visual elements of a transition that Locke hoped for in all African American art: a return to the ancestral arts of Africa for inspiration. Locke, like Reiss, encouraged Douglas to look beyond the formula of academic painting; he urged him to express a clearly defined racial style.[17] Douglas was one of the few African American artists of the period who took Locke seriously. Locke rewarded Douglas by offering him connections to publishers, who hired him to create book jackets and illustrations for books by authors of both races.

Douglas's mature style in painting drew on the sculpture of black Africa by adding geometric abstraction to a modernist formula with a limited tonal palette.[18] He executed forms with precise accuracy, adding elements of synthetic cubism. People, animals, and fauna moved in and out of concentric circles as though they were interwoven like the strips of an Afro-Carolinian sweetgrass and pine needle basket. In Douglas's art, European modernism took a backseat to a simplified formula of forms and figures inspired by the iconography of African art. However, Douglas later recalled, he was hesitant about "going off on a tangent, picking up the paintbrush, and seeing the African spirit in everything in sight."[19]

Douglas had seen African art in the Blondeau Collection, some of which was later purchased by Alain Locke. He had also seen African art at the Countee Cullen Library in New York City. He would later spend a year studying at the Barnes Foundation in Merion, Pennsylvania, where Albert C. Barnes had amassed a large collection of West African art. Douglas considered Egypt an important part of black Africa, following theories he learned from the writings of J. A. Rodgers about the importance of ancient Africa in world history. He took elements of Egyptian art from the time of the pharaohs, freely mingling them with masks and statues from West Africa in the same compositional frieze.

A composition titled *Crucifixion* (Plate 28), originally created by Douglas in 1927 for James Weldon Johnson's *God's Trombones* and re-created in large oil panels in 1934, shows the strength of Douglas's highly personal style, inspired in part by his knowledge of African art. In *Crucifixion*, Roman soldiers mix freely with the figures of contemporary black people standing beside Christ. Douglas painted Christ small in comparison with the massive figure of Simon of Cyrene, the black man who carries Christ's cross before him to Golgotha. Seldom before had an artist so blatantly violated the rules of white Christianity by emphasizing a black subject over a white one. For this and other such forms of creative disobedience, Douglas, during the period of the Works Progress Administration, was labeled by some a Communist, although he was never a member of the party.[20]

In the 1930s Douglas was asked to paint a number of murals in New York, Chicago, and Greensboro, North Carolina. None was more widely viewed and commented upon than *Aspects of Negro Life*, four panels on African and African American culture and history at the 135th Street branch of the New York Public Library, named for the African American poet Countee Cullen. These historic works have been restored and are a valuable visual treasure in the archives of the Schomburg Center for Research in Black Culture.

Following the completion of the murals, Douglas was invited by his good friend and Harlem Renaissance founder, Charles Spurgeon Johnson, to teach at Fisk University in Nashville, Tennessee. At Fisk he painted a series of murals in the Erasto Millo Craveth Library in 1931 with the aid of Charleston artist Edwin Harleston. Douglas also founded the art department at Fisk in 1937.

Douglas's death in 1979 marked the end of an era in African American cultural history. He was the only remaining figure among artists of all media who had been a major participant in what came to be known as the Harlem Renaissance, that period marked by the search for identity and self-determination by artists of color in America.

Douglas was a pioneering, twentieth-century African American artist who carried the torch for self-esteem and racial pride at a time when there were few noticeable awards for those brave enough to do so. He became an important example for other artists to emulate, artists who saw Harlem as the new Mecca for creativity in the arts.

Hale Aspacio Woodruff (1900–1980)

Hale Aspacio Woodruff was born in Cairo, Illinois, on August 26, 1900, but he spent his childhood and adolescence in Nashville, Tennessee. He returned to the Midwest to pursue art studies at the John Herron Art Institute in Indianapolis when he was eighteen. Like Douglas, Woodruff came to appreciate African sculpture at an early age. The bold, angular designs he saw in African sculpture were a major influence in his work in later years.

Woodruff first produced compositions closely akin to the paintings done by Max Weber and those European artists who had seen African art as a driving force in modernism in the 1920s. But the style for which Woodruff is best known uses expressionistic brush strokes like those of the Mexican muralists, particularly Diego Rivera, whose art became popular in the United States in the 1920s and the 1930s and who painted murals at the Detroit Institute of Art and the Rockefeller Center in New York City. Woodruff went to Mexico in the early 1930s to study and understand more clearly Rivera's style.[21]

Like Aaron Douglas, Woodruff painted a number of murals at African American colleges. He was helped by painter Charles Alston, who worked with him on murals painted for the Trevor Arnett Library at Atlanta University and the home office of Golden State Mutual Life Insurance Company in Los Angeles. In 1938 Woodruff completed *The Amistad Murals*, which show the influences he absorbed from studying Diego Rivera's work.[22] The murals are in Savery Library at Talladega College.

Indian Summer (Plate 29), a small landscape displaying

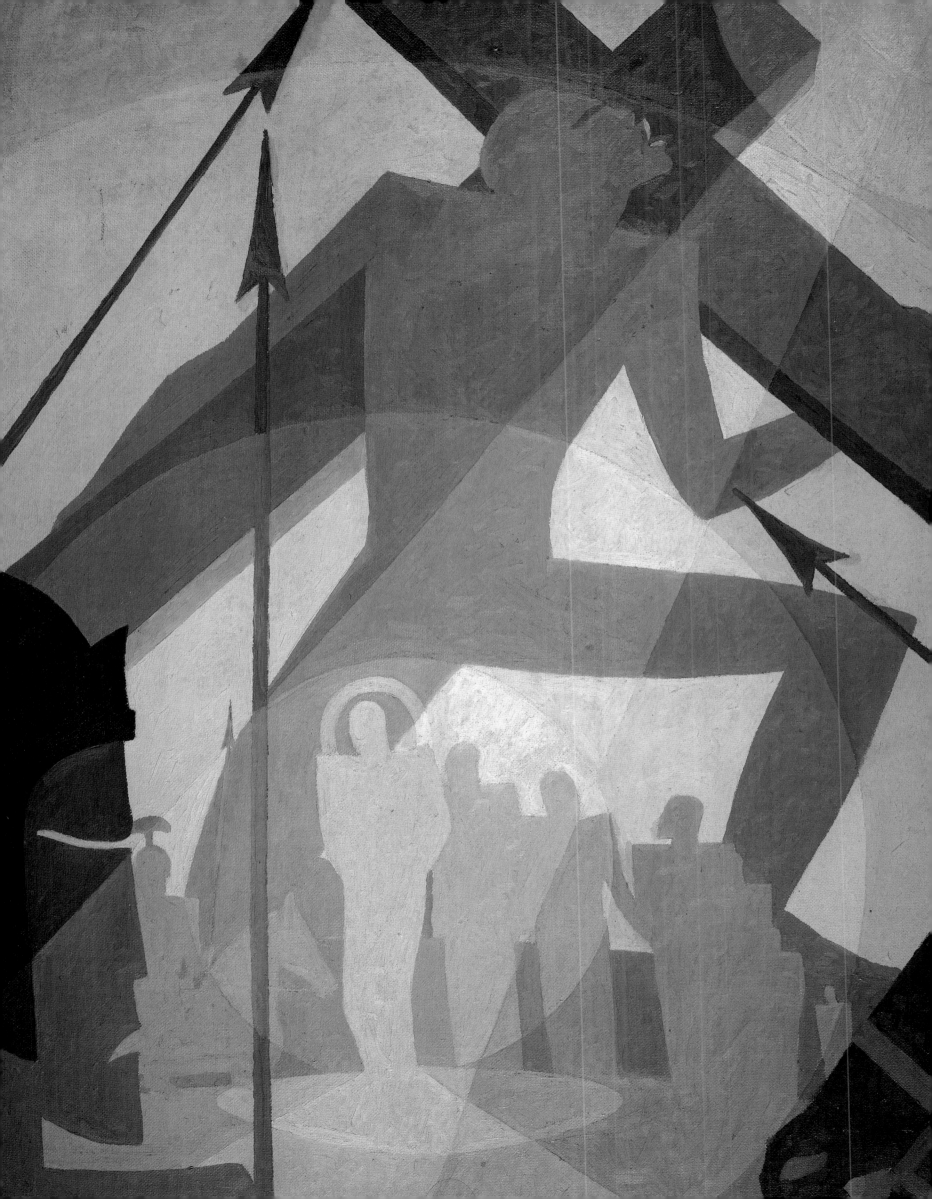

Plate 29. Hale Aspacio Woodruff, *Indian Summer,* **c. 1939, oil on canvas, 7¹⁄₂ x 10¹⁄₂ in.**

the bright colors of an autumn day, shows the spontaneous action of Woodruff's brush within a modified postimpressionist format. *Indian Summer*, typical of the rhythmic flow of color present in much of Woodruff's work in the 1930s, displays the passionate hand of an artist who sees nature in a poetic way and at the same time distinguishes all its elements one from another.

Woodruff's move to New York City in the 1940s brought him into closer contact with modern art at its best. Admiring the work of the abstract expressionists, he quickly modified his painting to incorporate their style. But he also sought to resolve the conflicts in his painting that centered on the strong figural influences from the Mexican muralists. He did so by simplifying the formal aspects of his compositions, introducing the linear framework of African sculpture as the dominant figural element in his paintings.

Because he was recognized for his many contributions to painting and art education over many years, Woodruff felt compelled to remain in the classroom, where he served his students as a dedicated teacher even when his art more and more was being sought after by collectors and art institutions alike. Having taught for many years at Atlanta University, he moved to teaching art at New York University in 1947 and later became a full professor, a position he held for nearly two decades. His aim in art was always to validate his own culture with a sense of pride and knowledge and to help his fellow artists realize their worth in the broader context of American culture. Woodruff was eighty years old when he died September 26, 1980. He left behind a legacy of a concerned and dedicated artist who helped nurture a number of important American artists of different races during a long and distinguished career as an artist and a teacher.

William Henry Johnson (1901–1970)

William Henry Johnson was born in Florence, South Carolina, on March 18, 1901. He was the unacknowledged son of a local white man, and his mother was a caring and endearing black woman. From his early years, when he copied cartoons from the local newspaper, Johnson knew that his calling was to be an artist.[23] But he had to leave the South to realize his dream. He settled in New York City, where he enrolled in 1921 at the school of the National Academy of Design. His teachers there were encouraging, especially Charles W. Hawthorne, whom Johnson greatly admired.

However, Europe was still the place in which to prove one's allegiance to the discipline of art, and racial prejudice was not as common there as in the United States. For most artists, Paris was the ideal place for working and living the bohemian life; Johnson arrived there in 1926. He was greatly impressed by the work of the fauvists, the postimpressionists, and a number of European nationalists who had congregated in Paris. The artists who captured his interest most were Chaim Soutine, Paul Cezanne, and Vincent van Gogh. Johnson roamed the French countryside searching for the ideal place in which to vent his creative emotions on the landscape and village scenes churning in his mind. Although he did not find in France or North Africa the ideal places to generate expressionistic landscapes, portraits, and simple sittings from local folk types, he did later find them in Denmark and Norway.

Johnson married a Danish artist by the name of Holcha Krake, a weaver and potter he met four years into his European sojourn. Krake was from Kerteminde, a fishing village that became an important subject in Johnson's work when he and Krake settled there.[24] But Johnson became restless in Europe and could not help comparing the types of folk who fished the waters of Kerteminde with the types he knew in Florence, South Carolina. From this vision of a primitive type was born the idea of getting to the essential roots of one's native culture, which Johnson wanted to do by painting the compositional elements that showed the essence of a given form, especially that of people.

A succinct form of geometric abstraction, enhanced by linear enclosures of bright colors and figuration based on black characters from cartoons, was the result of Johnson's new experiment, which began in 1938. With this

evolving style, which emphasized playful form and symbolic content, Johnson moved his art into a modernist posture, one informed by abstraction, expressionism, and what would later come to be known as hard edge painting. *Ezekiel Saw the Wheel* (Plate 30) abbreviates in form and fashion the rhythmic play one associates with the Negro spiritual of the same title. Here, "wheel in a wheel" in *Ezekiel Saw the Wheel* becomes a play on words that helps to announce the prophecy of freedom within reach, even in hostile surroundings.

Ezekiel Saw the Wheel shows Johnson trying to put aside some of his academic training and allow his untapped dream world and childhood memory to dominate his compositions. However, as hard as he tried, Johnson never completely laid aside the color and design teachings he learned from the National Academy of Design.

Yet Johnson, perhaps more than any other artist in the aftermath of the Harlem Renaissance, interpreted the black image in a way that allowed him to claim it in the provenance of his own creative gardening. He briefly defined the human figure with geometric abstraction as a source, counting heavily on brown and black colors to inform the viewer that he was painting a black image. He forged ahead in a culture in which the artistic climate was not welcoming to people of color, hostile to black imagery, and suspicious especially of black religion. Johnson painted a black Christ, in an unfriendly sea of doubt and denial within the race. He reasoned, as many African Americans have since come to believe, that black Christians had a right to show themselves as important subjects within the Christian tradition, in the same manner that European painters did in the art of the Renaissance.

Although Johnson painted during only twenty-eight of his sixty-nine years, more than two thousand of his works were in European and U.S. collections when he died April 13, 1970. He created the works from 1925 to 1946, during the short period he worked in Africa, Europe, and North America. In 1946 he fell ill and was confined to a mental hospital in Islip, New York, until his death.

The largest single body of work by Johnson is at the National Museum of American Art, a branch of the Smithsonian Institution, in Washington, D.C. Deposited there are more than one thousand paintings, drawings, and prints by Johnson that were a gift of the Harmon Foundation[25] in 1967.

Johnson's search for the new "primitive" spirit in art led him halfway around the world. He returned home in both spirit and flesh for his greatest inspiration in art, that of portraying what he called the "lowly ways of the Negro people." It was the Negroes of Harlem and the Deep South with whom he had an avowed and enduring empathy. Although he might have considered the subject of his handsome 1939 composition *Untitled (Seated Woman)* (Plate 31) "lowly," the woman portrayed is anything but lowly. She sits comfortably relaxed and beautiful, as though she is being painted for coming generations to adore her. The portrayal is why this painting is singled out as one of Johnson's fine moments as an accomplished modernist. *Seated Woman* is painted with an ease of style that by 1939 had become second nature for Johnson, as he was able to paint effectively without struggle.

While the adept and lively expressions of Soutine, Cezanne, and van Gogh had been stamped indelibly on Johnson's art when he first traveled to Europe in the mid-1920s, Johnson emerged as an innovative painter whose voice became singularly his own, deeply steeped in the knowledge of African American folk culture. He became a twentieth-century torchbearer.[26]

Richmond Barthé (1901–1989)

Richmond Barthé was among the first African American twentieth-century sculptors to concentrate on subjects thoroughly grounded in the black experience. Prior to Barthé, no African American men had produced sculpture

Plate 30. William Henry Johnson, *Ezekiel Saw the Wheel*, c. 1939, gouache and silkscreen on paper, 17½ x 11½ in.

that could compete with that of black women sculptors, including Meta Vaux Warrick Fuller, May Howard Jackson, Elizabeth Prophet, Selma Burke, and Augusta Savage.

Born in Bay St. Louis, Mississippi, on January 28, 1901, Barthé took to art early in his childhood, beginning first as a painter. He formally studied at the school of the Art Institute of Chicago in the early 1920s. He later moved to New York City and continued informal studies at the Art Students League. Themes that pointed directly to Barthé's interest in social commentary art emerged early in the artist's career: He paid strict attention to crimes committed by whites against blacks in the South, such as torture and lynchings.

Like most of the established black artists living in New York between 1926 and 1934, Barthé entered his work in several Harmon Foundation exhibitions. It was there that his sculpture caught the eye of Alain Locke, whose eminence as the spokesman for the new Harlem Renaissance movement was widely recognized. Although his art was well grounded in a tradition that respected and paid homage to the black image, Barthé did not wish to separate himself from artists of the majority culture (some white patrons recognized his talent and encouraged his artistry through a number of purchases and commissions).

Barthé expressed, particularly in portraiture, the physical characteristics of his subjects, and his move to lyricize his work was perhaps his most innovative element. The onrush of expressionism never moved him. As competent as he was in the academic tradition, Barthé made no new discoveries in any of the sculptural media in which he worked. Neither did he move stylistically beyond the comfort of a heightened form of realism, which gave him a place of favor in the safe havens of conventional art.

A handsome and debonair man of exquisite taste, Barthé, from his youthful years in Chicago and New York until his death in Pasadena, California, on March 5, 1989, surrounded himself with important men and women of all races, many of them artists in theater, film, or dance. Theater people often posed for him. He had a great love for music. Well known among his celebrated works is a composition titled *The Singing Slave*, in the collection of the Schomburg Center for Research in Black Culture. Modeled according to the acknowledged and most accomplished genre of his work, *The Singing Slave* is actually a portrait, a subject in which the artist excelled. Yet his most lyrically executed work is that of dancers, some representing sparsely clothed men and women swaying to the rhythm of jazz or African-inspired music. Other works, such as *Musical Interlude* and *Inner Music* (Plate 32) are of nude male dancers posed in a fast-moving twirl that emphasizes the dancers' graceful, athletic torsos.

The agility with which Barthé worked was not common among his sculpting colleagues, and few of them attracted the attention that he earned for himself. The classical mood into which Barthé's work was born and nurtured served him well throughout a long life, and he enjoyed many years of creativity as a sculptor of unquestioned significance.

Beauford Delaney (1901–1979)

Unlike Barthé, who traveled to Europe rather late in life and decided not to become an expatriate, Beauford Delaney spent his most productive years in Paris. There his art moved through a series of themes that included portraits of notable African American artists and scholars and a few French celebrities as well. Working in Paris from the early 1950s on, Delaney was no stranger to American writers such as Henry Miller and James Baldwin and the visual artists who came to Paris in search of new forms of expression.

However, Delaney brought with him to Paris his own brand of abstraction. His life in Greenwich Village in the 1940s was that of a bohemian. He frequented nightspots, enjoyed the music, and captured this life in his paintings.[27] A composition called *Beauford Delaney's Loft* (Plate 33) proves Delaney an excellent colorist and a keen observer of

the bohemian lifestyle in New York City. His canvases pulsate with activity, ripe with the colorful mood of music and party companionship.

Delaney's love for a saturated, heavily impastoed, painterly surface is the one feature by which his work can be readily identified. He seldom tired of layering one coat of paint over another until the canvas was heavily encrusted like the surface of an antique bronze dug from the earth.

During the early years of his career, when abstraction dominated the scene in New York, Delaney's brand of abstraction retained some figural references. A highly plastic and fluid approach continued to dominate Delaney's canvases long after he had settled in Paris. In *Untitled (Abstraction)* (Plate 34) a work created in 1954, soon after his arrival in Paris, Delaney displayed the same patterned forms peculiar to the works he experimented with prior to leaving New York. Here an active palette of reds, greens, and yellows is held together by a network of large, white threads of color; red and black lines define nonobjective figures. But as Delaney moved toward abstraction and a new form of color field painting, he drew on the good life of the streets of Paris.[28]

In the 1950s, new friendships with Americans such as writer James Baldwin and musician Howard Swanson, painter Herbert Gentry, and the fine cadre of jazz buffs in the great city kept Delaney in touch with the American scene back home. Even in Paris, the artist continued to create scenes that had their origin in New York City. In years to come, he attracted an endless number of admirers. Writer Henry Miller called him "The Amazing and Invariable Beauford Delaney." According to James Baldwin, Delaney became a revealer of the kind of color we were taught not to see, referring to bright colors that blend together in a harmony not expected of the color wheel. These are the "loud" colors associated with the clothes of some African Americans.

Delaney's passion for art was fed by sources beyond jazz and the bohemian lifestyle he embraced in Paris. The art

Plate 32. Richmond Barthé, *Inner Music,* 1985, bronze, height 22¾ in.

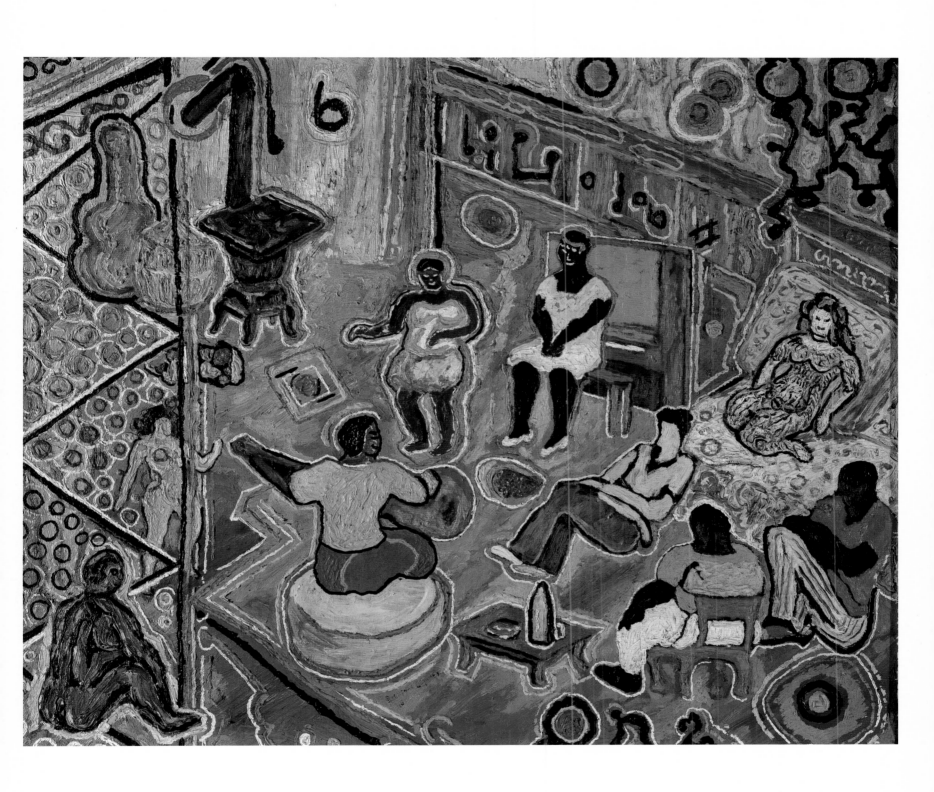

Plate 33. Beauford Delaney, *Beauford Delaney's Loft,* **1948, oil on canvas, 31 x 38 in.**

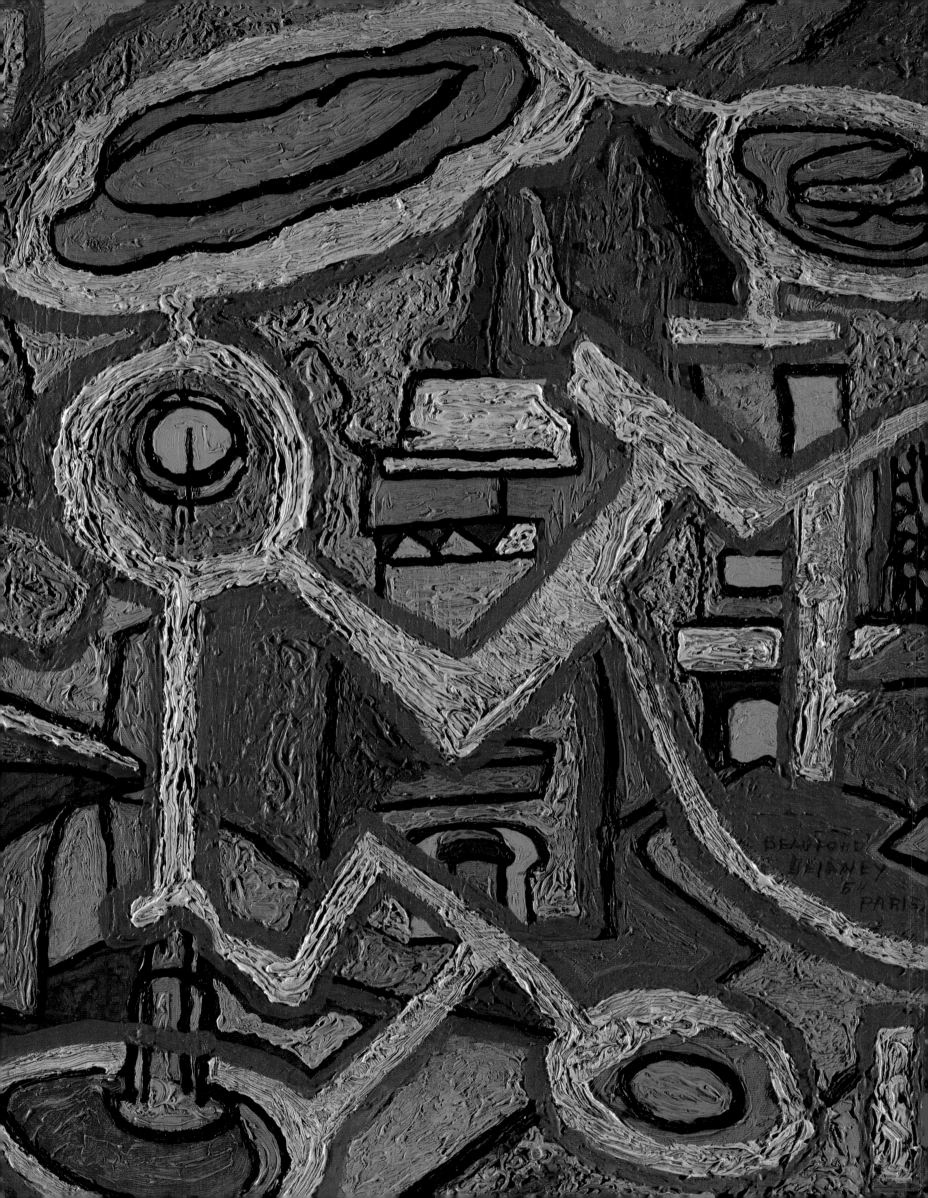

historian Richard Powell cites his "heartfelt" dedication to forms of "blackness," a descriptive passion writer Henry Miller equated with "solar radiance." These were all valid inspirations for the rich intellect of the artist. He took inspiration also from the quiet home life in what was then the segregated South in Knoxville, Tennessee, where he was born in 1901. With all its failure to promote relationships across lines of race, the mountainous region of Tennessee where Delaney spent his childhood still contributed a vision of flowers growing and blossoming as in the Garden of Eden. The colors of this visual garden haunted him throughout his adult life. It was in Paris that the long-delayed dream of colorful sunlight, the kind of light Baldwin delighted in seeing in Delaney's work, strongly appeared.[29]

Delaney brought that light into his studio. His poetic and artistic vision of a joyful world muffled the agony and pain of his own life. He chose to incorporate that light into many of the compositions he created in the 1960s. Some paintings combined elements of impressionism with a mild form of expressionism in the figural shadow of action painting. Yet nothing seems lost in Delaney's unusual juxtaposition of rival techniques. One builds on the other, while both help define what is bold and unique about the Delaney style.

Delaney's portraits captured the likeness of the sitter, but the appeal he imbued them with always remind us that the sitter is little more than the colorful dream the artist had as a child. The plan of his art was to subvert color and form and make them allies of an introspective look at his own colorful soul.[30]

Since Delaney's death in 1979, a number of his paintings have made their way back to the United States. Their light seems ethereal here and all but alien. As Baldwin noted, "They speak the stricking [sic] metamorphoses into freedom." Baldwin is referring metaphorically to the quickening, or hastening, process of becoming a free soul or a free person. This was the experience of black people in Europe, especially in Paris, unlike the slow road to freedom African Americans trod in the United States.

James Lesesne Wells (1902–1993)

Harlem became the meeting place for artists of all media. For some, it was the breeding ground for ideas as well as the place to seek one's fortunes in the higher culture for black people. Artists' workshops were established in the city within the city, and young people were encouraged to study painting, sculpture, and other forms of the visual arts. This would later be called a new renaissance. It was in this environment that James Lesesne Wells worked as a young painter and graphic artist.

Wells, the son of a Methodist minister, was born in Atlanta, Georgia. He moved to New York City in 1919 and enrolled at the National Academy of Design for one term. He later attended Lincoln University in Oxford, Pennsylvania, and Teachers College at Columbia University. The experience of growing up in a religious environment remained with him, and biblical themes dominated his art in the 1930s and 1940s, especially when he chose the mediums of woodcut, wood engraving, and linocut. Secular themes such as industrial views within cities, urban workers, and still lifes were among the subjects he portrayed in 1929 when he left Harlem to join the faculty of the art department at Howard University. Most of the works done before the Howard University period were executed in lithography and linocut. Some African themes were executed in these two mediums as early as 1929.

Prior to coming to Howard to teach drawing and printmaking in the fledgling art department, Wells had an active career as a teacher at the Harlem Workshop in the Arts for Children. Although he was hired by James V. Herring to teach printmaking, Wells taught ceramics and oil painting as well.[31]

The graphic arts studio in which Wells worked and taught at Howard University was poorly equipped. But it also served as a drawing studio, where traditional plaster casts were mounted on the walls. A view of a classical face appears from time to time in Wells's work, particularly in his prints and paintings, recalling the plaster casts in the Howard studio. In this studio Wells taught in the company

of colleagues Lois Mailou Jones and James A. Porter. Jones, Porter, and Wells provided the core studio arts curriculum at the nation's premiere university for African Americans from 1930 until the late 1960s.

In the early years of his development as a painter, Wells used heavy layers of paint, texturally applied with a palette knife. He invested his lavishly impastoed canvases with the strength and richness of a Georges Rouault or a Henry Ossawa Tanner.

Having spent considerable time creating compositions anchored in biblical themes, Wells moved as early as 1929 to an African-based iconography, one of the first African American artists to do so. He was among the handful of black artists in the later stages of the New Negro movement who found comfort, indeed solace, in depicting black African masks in still-life and black genre scenes during the years of the Harlem Renaissance. Wells was in tune with the New Negro movement, honoring Locke's mandate to see Africa as an inspiring source for his work. Throughout his long life he invested his work with ancestral images from Africa's powerful, traditional forms.

Unlike Archibald Motley, Palmer Hayden, and William Henry Johnson, all of whom were his art colleagues in distant places, Wells did not need the racially benevolent atmosphere of the Paris art scene to affirm his artistry. The streets of Washington, D.C., and the biblical context he revered as a child visited and informed his artistry in important ways. Salome danced on the edge of criminal obsession in a composition in which the decapitated head of John the Baptist was served up. Wells recast *The Flight into Egypt* in his own pictorial language, a biblical theme that Henry Ossawa Tanner, one of his idols, had painted several times.

Secular themes danced in and out of Wells's oeuvre as he sought to depict Washington, D.C., the city where a majority black population—similar to New York City's Harlem—was eminent in the late 1950s and the 1960s. He often portrayed popular street scenes that distantly resembled the beautiful café scenes Lois Mailou Jones created during her many visits to Paris. When he painted *Georgetown Garden* (Plate

35) in 1958, few paintings of outdoor café scenes existed in the nation's capital. However, Georgetown was in many ways a city distinct from Washington in taste, nightlife, and urban scenery. The old buildings that made up the narrow streets of Georgetown reminded the artists who worked there of the narrow streets of Montmartre and other Parisian locales. Wells used simple areas of color to define, delineate, and detail the bohemian lifestyle of Georgetown.

Wells traveled to Europe rather late in life and returned reinvigorated to the nation's capital. He brought with him a lighter feel for the cityscape, for still life, and even for the heavily impastoed biblical subjects he once labored over with such great passion. A late composition titled *Spanish Steps* (Plate 36) is lightly rendered and labor free. It, like many woodcuts Wells created in the last decade of his life, brought a sense of direction to his art at a time when most artists his age were no longer making art. In 1986 James Wells's art was the subject of a major exhibition at the Washington Project for the Arts, then an alternative museum space in Washington, D.C. Here the enduring spiritual force of his art proved him a voice stronger than the lion's roar.

The legacy of Wells's art is connected to history, as is that of Aaron Douglas, William Henry Johnson, Richmond Barthé, and Palmer Hayden. All were participants in the great cultural experiment in Harlem that enveloped and nourished the Harlem Renaissance. Their art remains strongly rooted in the ideals of the New Negro movement and is the wellspring from which so much of their art has come down to us today. This art had its grounding in Harlem and the city of Chicago at a time when black creativity in the visual arts was not a high priority with mainstream art directors.

Chicago and New York were the nation's two largest cities, and black artists congregated there in pre-World War II days seeking comrades and trying to win their place in the lineage of those nineteenth-century African American pioneers who chose art as their calling. That these black artists succeeded in spite of great odds is a daring testament to

Plate 35. James Lesesne Wells, *Georgetown Garden,* 1958, oil on canvas, 19 x 22 in.

Plate 36. James Lesesne Wells, *Spanish Steps,* **1972, oil on canvas, 39¾ x 30 in.**

their strength and fortitude as bearers of the new cultural torch. Such was the Harlem Renaissance, the movement in art that paved the way for an enlightened cadre of young artists to migrate to urban America and work in the shadow of those giants, our cultural torchbearers.

Part 3 Notes

1. Visiting days for "Colored Only" remained in practice at the Birmingham Museum of Art, Birmingham, Alabama, as late as 1955. I organized visits for students from nearby Talladega College to the Birmingham Museum, under the directorship of Richard Howard, in 1955 while the "Colored Only" day was still enforced. Many museums in the South observed this practice, while others barred African Americans entirely until the *Brown v. Board of Education* Supreme Court decision was handed down in 1954.

2. Howard and Fisk Universities, along with Hampton Institute, now Hampton University, offered a course of study that later would be characterized as humanities, with an occasional lesson in the practice of art. Howard University became the first African American institution of higher learning to offer a major in art in 1920.

3. Samella Lewis, *Art: African American,* 2d ed. (Los Angeles: Hancraft Studios, 1990), p. 52.

4. Archibald Motley Jr., conversation with author, Chicago, December 1979.

5. Ibid.

6. Lewis, *Art: African American,* p. 72.

7. Exhibition catalog *The Barnett Aden Collection,* from the Anacostia Museum (Washington, D.C.: Smithsonian Institution Press, 1974), pp. 10–11, 154–158.

8. Led by Kenneth Noland and Morris Louis, two Washington, D.C., nonobjective painters of the 1950s, the Washington color field school of painting emphasized geometric linearly based, content, with emphasis on bright colors. All the artists who worked as color field painters after Noland and Louis used line interchangeably with formal content in their work.

9. Exhibition catalog *Alma Thomas,* foreword by David C. Driskell (Nashville: Carl Van Vechten Gallery, Fisk University, 1971).

10. For a comprehensive overview of how Alma Thomas abandoned academic painting for a modernist formula, see Ann Gibson, "Putting Alma Thomas in Place: Modernist Painting, Color Theory, and Civil Rights," in *Alma Thomas: A Retrospective of the Paintings* (San Francisco: Pomegranate, 1998), pp. 38–53.

11. Romare Bearden and Harry Henderson, *A History of African-American Artists from 1792 to the Present* (New York: Pantheon Books, 1993), pp. 169–170.

12. Eric Hanks, "Journey from the Crossroads—Palmer Hayden's Right Turn," *International Review of American Art,* vol. 16, no. 1 (1999):31–35.

13. David C. Driskell, David Levering Lewis, and Debra Willis Ryan, *Harlem Renaissance: Art of Black America* (New York: The Studio Museum in Harlem and Harry N. Abrams, 1987), pp. 106–107. See also Richard J. Powell, *Rhapsodies in Black: Art of the Harlem Renaissance* (Berkeley: Hayward Gallery, Institute of Visual Arts, University of California Press, 1997), pp. 20–29.

14. Sharon F. Patton, *African American Art* (New York: Oxford University Press, 1998), pp. 118–119.

15. Elton C. Fax, *Seventeen Black Artists* (New York: Dodd, Mead & Company, 1971), p. 155.

16. Gary A. Reynolds and Beryl J. Wright, eds., *Against the Odds: African-American Artists and the Harmon Foundation* (Newark, NJ: Newark Museum, 1989), pp. 20–24. See also David C. Driskell, "Mary Beattie Brady and the Administration of the Harmon Foundation," pp. 65–67, in *Against the Odds.*

17. David C. Driskell, "The Flowering of the Harlem Renaissance: The Art of Aaron Douglas, Meta Warrick Fuller, Palmer Hayden, and William H. Johnson," pp. 110–111, in Driskell, Lewis, and Willis Ryan, *Harlem Renaissance.*

18. Ibid., p. 110.

19. Aaron Douglas, conversation with author, September 1971.

20. Amy Helene Kirschke, writing in *Aaron Douglas: Art, Race, and the Harlem Renaissance* (Jackson: University Press of Mississippi, 1995), refers to Douglas as having held membership in the American Communist Party. However, there is no record of Douglas ever having been a member, even though accusations of membership in such organizations were rampant in the 1930s. Douglas never compromised his liberal views on civil rights and equality of the races, and thus he was a target of many hard-core conservative white writers, who equated such views with Communism. In an interview with me in 1971, Douglas suggested that the rampant fear of Communism in the 1930s and the revival of unfounded suspicions about memberships in the Communist Party in the 1950s during the McCarthy era were dormant and not dead.

21. Bearden and Henderson, *A History of African-American Artists,* p. 200.

22. For a detailed account of the Amistad story that inspired Woodruff's murals, see Clifton H. Johnson, "The Amistad Incident," in David C. Driskell, *Amistad II: Afro-American Art* (New York: United Church Board for Homeland Ministries, 1975), p. 15–35.

23. Adelyn D. Breeskin, *William H. Johnson: 1901–1970* (Washington, D.C.: Smithsonian Institution Press for the National Collection of Fine Arts, 1971), p. 11.

24. Richard J. Powell, *Homecoming: The Art and Life of William H. Johnson* (Washington, D.C.: The National Museum of American Art, Smithsonian Institution Press, 1991), pp. 55–64.

25. Ibid., pp. 108, 223–224. See also Bearden and Henderson, *A History of African-American Artists,* pp. 189, 198; Patton, *African American Art,* pp. 148, 161.

26. Powell, *Homecoming,* pp. 228–229.

27. *Beauford Delaney: A Retrospective,* foreword by Mary Schmidt Campbell (New York: The Studio Museum in Harlem, 1978).

28. David Leeming, *Amazing Grace: A Life of Beauford Delaney* (New York: Oxford University Press, 1998), pp. 112–127.

29. Ibid., p. 135.

30. Ibid., p. 199.

31. Keith Morrison, *Art in Washington and Its Afro-American Presence: 1940–1970* (Washington, D.C.: Washington Project for the Arts, 1985), pp. 12–13, 18.

Black Artists of Popular Culture

THE VISIONARY SPIRIT

Trying to divide American artists along lines of race, gender, and culture, writers about the subject of art have often created categories that reflect an incessant effort to name and therefore exercise cultural control over the visual expressions of others. One of the most controversial categories in the art scene in recent decades is the term *outsider art*. Although it is difficult to understand exactly what the cultural kingpins who insist on using the word *outsider* mean, the term prevails.

The category *outsider* is applied to anything from forms made by untrained or unschooled "folk" artists and craftspeople, whose work is reminiscent of the impulsive imagery created by children, to art that is grounded in the naive and unsophisticated. But these definitions bring nothing new to the theme. Works of "outsiders" are never considered art of the first order. So, then, of what are these works outside? Only that nebulous "American mainstream," the same flowing tide that often excludes black artists, women, and other so-called minority artists, people who really are of the majority in the larger world.

In this order of the "outsider" are Horace Pippin (1888–1946), Minnie Evans (1892–1987), Clementine Hunter (1887–1988), and Ellis Ruley (1882–1959). Did these four artists, and others of their calling, see themselves outside anything besides the privileged race? I think not. And the race factor in their art connects them to the artists discussed in the previous pages.

These four artists registered the hopes and aspirations all artists offer the world. They expressed their own inner visions, ones unencumbered by the rules of the elitist canon. For them, as for other so-called untrained artists, form emanated from within. Their models and visions of the world came in the form of dreams, and they saw images in the clouds and rocks and found objects. Some "waited on the Lord," and some found for themselves a voice speaking directly to their souls, endowing them with a vision of self and otherworldly ideas.

The inner voice that informed the vision of unschooled African American artists came first through itinerant slave artisans. While few two-dimensional images created by slaves remain with us today, we retain many examples of slave artistry in three dimensions, in the form of sculpture and folk forms whose roots lie in Africa. Among the surviving craft forms often called "outsider art," found mainly in public collections, are walking canes, fireplace end irons, votive dolls, and handmade baskets. But the tradition of creating sculpture or paintings for a particular event, or of painting images that portrayed character and celebrated the good deeds of persons of African ancestry, was an act that crossed racial lines in eighteenth- and nineteenth-century America. This was long before the work of such artists was labeled naive or "primitive."

These artists were not trained in the academic tradition, but they did not consider themselves uninformed or naive about those experiences in life that informed their sculptural or painterly vision. In their attempt to encapsulate their own well-grounded vision of a beautiful world, these artists succeed magnificently. If we judge the genius of their artistry by a narrowly conceived academic canon, then they do not fare well. But if we approach them on their own terms, then their visions of hope, of places of peace and beauty, often speak to our deepest longings. Our eyes yearn

Detail from Minnie Evans, *Design Made at Airlie Garden* (Plate 42).

for their vision, which takes us closer to the world of our childhood memories. They transport us to the beautiful abode where the lion lies down with the sheep, where men beat their swords into plowshares, and the peaceable kingdom is ours to inherit.[1] Such is the artistic dream of the visionary, the enlightened call to unity, to our glimpsing the One, the True, and the Beautiful. This call echoes in the myriad images expressing spiritual longing for that mystical place on the other side of the human mind.

The dialogue that we now enter into with the art of Horace Pippin, Ellis Ruley, Minnie Evans, and Clementine Hunter is a rapturous one. Their vision is sumptuous; it imparts to us a new way of seeing the world, one untouched by the usual hierarchies of class or culture. Theirs is the dream world of belief that our journey here on earth is only the beginning of a limitless dream beyond the unconscious. Their art, grounded in the basic elements of our folk tradition, points beyond our feeble attempts to categorize it by race or form. It reveals to us what is primary in the universe: an art that transcends all narrow canonic notions of quality.

We still have much to learn from the visual messages of these uninhibited practitioners, who command form without the sense of guilt so often imposed by the traditions of the academy. Their artistry convincingly drives us out into the cities and countryside in search of a fresh view. Like the fantastic images from a chapter in the book of Revelation, the beliefs they mold into our consciousness border on the absurd. But their hallucinatory vision is a joyous one that does not rely on synthetic substances. Our minds dance with joy at the promise of the dream that was never meant to be real. Such is the passion of the visionary artist.

Horace Pippin (1888–1946)

The most celebrated African American artist who worked independent of the academy is Horace Pippin. Born just beyond the lingering shadow of slavery, Pippin came to art, in part, as a way of providing physical therapy for his hand

and arm, which were disabled in service during World War I. Art also allowed him to put into two-dimensional form the joyous expression of his painterly dream.

The stories that Pippin's mother told him, about the hero John Brown going to his hanging or episodes from slavery or themes centered on the quiet life in West Chester, Pennsylvania, where he was born, lay at the core of Pippin's artistry. His paintings, often heavily impastoed with visible brush strokes that signify both signature and style, were vivid reminders of the vastness of ideas from which these rich themes were drawn.

The first painting by Pippen that Bill and Camille Cosby purchased is titled *Woman Taken in Adultery* (Plate 37). In the composition, eight people witness the humiliating scene, portrayed in the Gospel of John, of a woman charged with committing adultery. The woman's body is racked with pain from stones people are casting at her. Christ stands off center against the wall of a building in which a single arched doorway serves as an entry to the world beyond, the narrowly perceived world of good and evil. Christ surprises the onlookers by not condemning the accused women to the horrible death demanded by Old Testament law. He unconditionally commands with authority, "Let him who is without sin cast the first stone."[2] Showing surprise, disgust, and anger at Christ's sense of morality and fair play, the onlookers begin to turn their backs on the scene, not wishing to become accused of the same sin as that of the woman.

Pippin, said by some to have rejected themes that emphasized race, deliberately painted a Christ of color presiding over a white world. In so doing, he upended the American social order, where a white Christ presides over the African American church and community. This cultural subversion, an example of Pippin's religiosity, shows the artist as cunning and clever in telling a different story about the sacred world of the African American.[3]

He is equally passionate in treating secular themes that appeal to our common humanity. *Cabin in the Cotton II,*

Plate 37. Horace Pippin, *Woman Taken in Adultery,* 1941, oil on canvas, 19⅝ x 24 in.

71

72 **Plate 38. Horace Pippin,** *Victory Vase,* **1944, oil on canvas, 19 x 19 in.**

painted by Pippin during the height of World War II, does not re-create a scene from the artist's own experience but instead depicts one based on stories of black life on southern cotton plantations. Log cabins occupied by slaves were associated with the harsh institution of slavery. Pippin's images are unlike the popular scenes of slave life painted by William Aiken Walker, in which black men, women, and children are reduced to stereotypic images strewn across endless fields of cotton. Slave cabins, cotton gins, and white overseers are in constant view in Walker's paintings; not so in Pippin's work.

By contrast, *Cabin in the Cotton II* shows a black mother sitting in front of a cotton field and log cabin. Around her are a few meager accoutrements of home life, including a wooden washtub and metal wash pan. Pippin emphasized the tranquil family setting in which the black mother lovingly nurses her own baby while her older child plays at her side. A contented family dog lies at the mother's feet, and a family of chickens appears in the foreground. Painted August 21, 1944, probably from a photograph of the type seen on calendars at an earlier time, *Cabin in the Cotton II* is one in a series of works by the same title Pippin painted in his fifty-sixth year.

Victory Vase, *The Love Note*, and *Roses with Red Chair* are among Pippin's best-known still lifes. The one common visual element in these three paintings is a flower arrangement placed at the center of the compositions; the negative space balances the intricately arranged flowers. Red, pink, white, and yellow roses complement asters, gladioli, and zinnias within the V-for-victory-shaped vase in *Victory Vase* (Plate 38). This could have been a strong reminder that the beautiful flowers came from the artist's own victory garden, the kind highly prized for providing flowers and vegetables during the difficult years of World War II.

The Love Note (Plate 39) was painted in 1944, two years before Pippin's death. Efforts by some writers to tie it to his desire for someone other than Jennie Ora Pippin, his wife, have met with naught. Highlighting a floral arrangement poised with the grace and elegance of that in *Roses with Red Chair* (Plate 40), *The Love Note* is one of the smaller works Pippin created that celebrates the beauty in flowers, a quality some men shun in an effort to be macho. Floral still lifes and rural southern scenes in which king cotton reigned in the vast fields with log cabins in the foreground were among Pippin's most celebrated subjects.

But none of Pippin's paintings is more revealing of his spiritual temperament than three variations on the theme *The Holy Mountain*. Begun in 1944, during World War II, they show the artist at his best. Images of World War I in Europe no doubt recurred in his mind. Memories of the war had appeared in other compositions, and even in *The Holy Mountain I* (Plate 41), in which Pippin is inspired by the biblical vision of peace, he includes, in a manner similar to a cinematic film clip, soldiers lurking in the thickets adjacent to a military burial ground. The composition introduces the biblical prophecy from Isaiah announcing the day of joyous peace. On this day the Good Shepherd, an Old Testament image understood by Christians to refer to Christ, "shall feed his flock,"[4] and the lamb and the wolf shall both live together in the peaceable kingdom. The spiritual manifestation of a peaceful world is epitomized in the way little children play among the beasts of the fields. The central figure around which the drama takes place in *The Holy Mountain I* is a black man, the shepherd of Pippin's world—no doubt a portrait of himself—a figure also seen in *Woman Taken in Adultery*. At no time in any of the three versions of *The Holy Mountain* does the shepherd take on the appearance of the traditional white shepherd of popular biblical literature. The shepherd had appeared as a major theme in the work of Henry Ossawa Tanner, an artist whose work Pippin certainly had viewed.

While Pippin's compositions centered on religious subjects, black life in West Chester, Pennsylvania, still life, and themes based in the memory of his childhood and World War I, Pippin occasionally turned to portraiture. He painted portraits of his wife, Jennie Ora, himself, other persons in

Plate 39 (facing page). Horace Pippin, *The Love Note,* 1944, oil on canvas, 10¼ x 8¼ in. 75

Plate 40 (this page). Horace Pippin, *Roses with Red Chair,* 1940, oil on canvas, 13¾ x 10½ in.

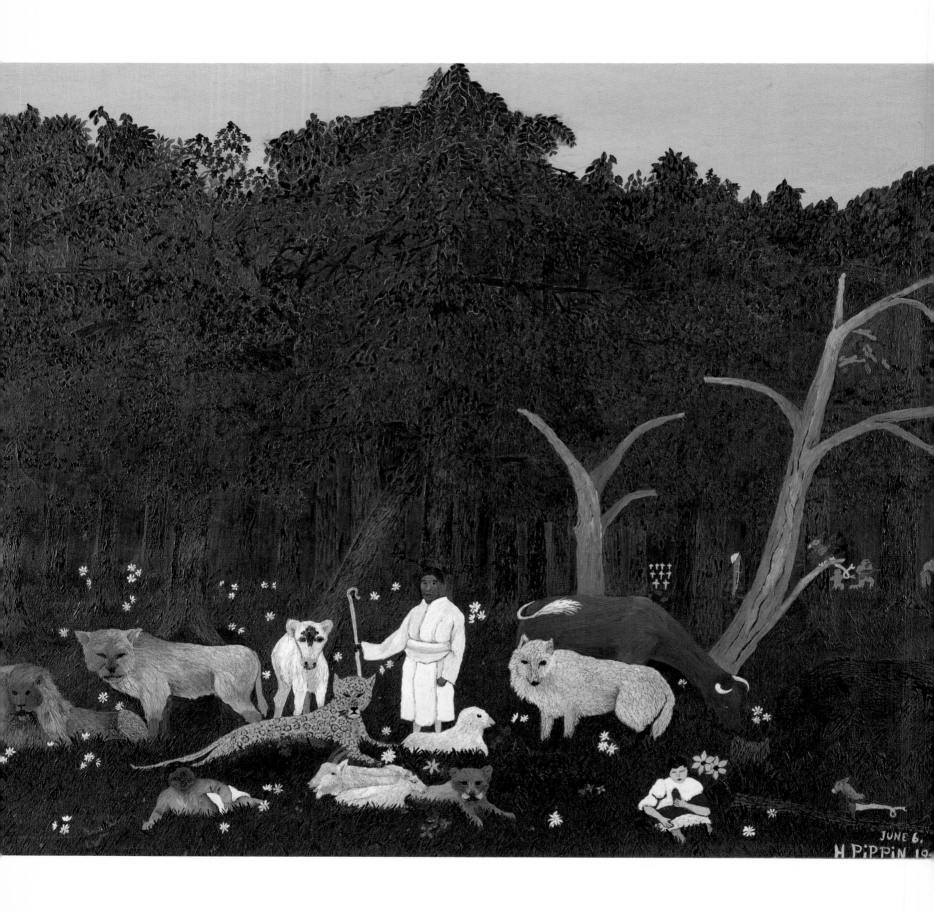

76 Plate 41. Horace Pippin, *The Holy Mountain I,* 1944, oil on canvas, 30 x 36 in.

his immediate family, his art dealer, and Marian Anderson.[5] But his real passion in painting remained with those subjects that allowed him the freedom to improvise and reconstruct salient images from a distant past.

Subject and thematic content took precedent over stylistic principles in Pippin's work, but seldom did an academically perceived formula operate on a conscious level in his oeuvre. For Pippin, art was a meaningful spiritual exercise, and it was a way of reconciling himself with the larger world beyond West Chester. His sense of what was both physical and spiritual in the world caused for some viewers a dislocation of reality similar to that induced by Henri Rousseau.

Artists like Pippin, who linger more fully in the fertile boundaries of the folk tradition, are able to see with a clear and simple sight the things that academicians so often miss. They do not overburden themselves with form copied directly from nature or tradition. Theirs is the chance to make known, without mockery, the near invisible, sometimes perceived as the exotic.

It is to the order of the valued visionary that Horace Pippin was born, and he never relinquished the gift he possessed. His way of seeing the world was unique, but his singular vision was a part of a great continuum of those who dare see the world uncluttered by tradition.

Minnie Evans (1892–1987)

Minnie Evans seldom used the title of artist in association with her work. Little is known of her early interest in art beyond the likely influence that gardening may have had on her work. She was born in Lorn Creek, North Carolina, and spent many of her early years as a gatekeeper at Arlie Gardens near the city of Wilmington. Like Pippin, Evans came to painting late in life and pursued it with a passion until her death in 1987.

Her visionary review of the world was untouched by current art sources, and she drew heavily on a wellspring of the imagination that seemed unending in its supply of images of flowers and masklike heads. These she interwove with balance and skill into a highly colorful, symmetrical arrangement of arabesque compositions. No one, not even the artist, knew who the half-smiling faces are that peer out at the viewer in so many of Evans's crayon, chalk, and oil compositions. They appear sometimes side by side with leaflike forms, which help define wings and other birdlike objects in Evans's highly stylized works. The Bible, particularly the book of Revelation, was often her inspiration. She revealed her devout religious beliefs in many of her somewhat surreal color drawings, saying they were anchored in God.[6]

Seldom is one able to see in a single glance all that is going on in Evans's paintings. Her images are serialized as though they represent two sides of the picture folded one over the other. While the two sides of the composition can be matched with each other, they are never the same. Brilliant primary colors make Evans's palette a lively one, sometimes as clearly defined as the colors in stained glass. Evans uses the white line sparingly in compositions such as *Design Made at Airlie Garden* (Plate 42), a mixed media painting executed in 1969. At this time in Evans's work her skillful use of color was at its peak, and her proficiency dazzles the eye. Her works suggest that there exists, above and beyond this world, a colorful celestial plane made real and descending from the heavens. This plane exists particularly in the mind of the artist, as a Platonic realm of good and perfect order. In matters of color, Evans is in many ways closer to Bob Thompson in a spiritual definition of painting than she is to Pippin. Her art could be readily translated into stained glass without losing the power of the image.

In her declining years, Evans's hand was less steady at showing the accuracy of line and the handsome blending of colors she so capably displayed in the middle years of her career. But as late as 1979 she exhibited the characteristics of an active mind unaltered in many ways by the limits of age and loss of muscular coordination. She continued to work passionately to reveal from the spiritual realm that which only a true visionary could see.

Plate 42. Minnie Evans, *Design Made at Airlie Garden,* **1969, oil and mixed media on canvas board, 16¼ x 22¾ in.**

Clementine Hunter (1887–1988)

Like many "outsider" artists whose work is represented by commercial dealers, Clementine Hunter received much acclaim in her lifetime for art that was regionly based. To some, particularly her liberal white patrons in the Bayou State of Louisiana, Hunter was their "Black Grandma Moses." To others, she was a crafty embodiment of the old plantation style. Local seers, such as novelist Francois Minion, the art dealers in New Orleans, and friends in her hometown of Natchitoches, Louisiana, thought Hunter represented a vanishing breed of untutored, would-be artists lingering in the shadows of a highly valued bygone era. It was the era of the Old South that inspired Hunter, and tales of mulatto life on Melrose Plantation remained vividly etched into the minds of both black and white residents in the fertile regions of the Cane River.

Hunter, who lived to the ripe old age of one hundred and one, began painting as late as 1948. Her early pieces showed a narrative unity, and this ability to tell a story cinematically in one compositional statement drew viewers into Hunter's world. In her little clapboard cottage only a short distance from historic Melrose Plantation, Hunter painted over and over, with a heavy, loaded brush, the marriage scenes, burials, and good times of congenial life on the Cane River.[7] Her favorite subject was one of a historic series of African-inspired houses built by the former slave Marie Therese Quan Quan in the eighteenth century. The manor house, historic Melrose Plantation, was built by Quan Quan's grandson Louis Metoyer in the nineteenth century.[8] Hunter found many of her themes in the local Catholic church, which is often the central building in her compositions.

The Burial (Plate 43) is one such variation on this theme. It shows the church and a long procession of mourners. Pallbearers carry the deceased to the newly dug grave, and flower girls handsomely dressed in brightly colored dresses and matching hats follow along. The illiterate Hunter saw her paintings as friendly reviews of a highly prized pattern of living that had begun in the antebellum South. By con-

trast, her contemporary, Sister Gertrude Morgan, whose religious base lay in New Orleans, more often portrayed her direct communion with Jesus. Although Hunter and Morgan shared an interest in local landscapes and Louisiana's architectural landmarks, Morgan's paintings were more personal than Hunter's.

Perhaps the least sophisticated of the four artists singled out here as experiencing the patronage of serious collectors, Hunter seldom veered away from depicting the scenic life of Melrose Plantation. Harvesttime, picking cotton, gathering pecans, and quilting were the themes that defined her special interests. Clementine Hunter considered herself a serious interpreter of the local lifestyle, although she spoke humorously when asked about her work. One cannot help but chuckle at Hunter's seriousness about her own art. She knew her sales strategy and based the cost of each work on the size of the canvas, gradually reaping a handsome profit from the sales she encouraged from every visitor. Hunter's entrepreneurial finesse won full respect from me when, visiting her at her studio cottage in November 1972, I saw by the door a small sign that read, "25 cents to look."[9]

Ellis Ruley (1882–1959)

One of the four "outsider" artists most recently collected by Bill and Camille Cosby is Ellis Ruley. Mystery and secrecy are both important ingredients in Ruley's art, and this enigmatic combination seems destined to follow him even beyond death.

The idyllic flavor of Ruley's peaceful and pastoral scenes are inviting to people, particularly to those who enjoy nature in a leisurely manner. Nature and people are most often the subjects in Ruley's paintings. Most of the extant works were painted on what appears to be discarded cardboard and other cast-off materials, some of which had been used as cartons and storage containers. Brilliant hues of red, yellow, blue, and green often dominate Ruley's palette, with an occasional use of brown, black, and purple.

Plate 43. Clementine Hunter, *The Burial,* **c. 1964, oil on panel, 16 x 20 in.**

Plate 44. Ellis Ruley, *Cherry Blossom Time,* c. 1960s, oil-based house paint on board, 21 x 27 in.

Ruley attracted to himself and the small-town society in which he lived in Norwich, Connecticut, a mean-spirited cadre of people. Most were disturbed that a black man in the 1930s had acquired land in a white neighborhood. He also committed the unpardonable sin, in the eyes of the local whites, of marrying a white woman. To his white neighbors, he was a stranger, a free spirit, one unwilling to fit their definition of the docile black man. To the few blacks outside his family who knew him, he was "a brother gone bad," a phrase often used by African Americans who disapprove of interracial marriages. For poor Ruley, it was a catch-22. However, what Ruley lost in social matters he won in matters pertaining to art. Not that he made money from the sale of his work; on the contrary, he sold very little, and his work did not gain the recognition among his peers until nearly thirty-five years after his death.

In *Cherry Blossom Time* (Plate 44), four women appear in the foreground. Their racial origin is not easily determined but most likely is Caucasian. Two of the women are dressed in bright yellow costumes and are sitting at the base of a large flowering cherry tree, which covers the entire upper sections of the painting. The other two women, in the foreground, stand apart from each other. The woman in red stands within conversational range of the two seated women. The other standing woman, who is farther away from the other three, is dressed in a long, blue, flowing costume. The style indicates they have dressed up for a special occasion.

In the background of the painting, curiously, are two separate gatherings of people, each painted as a different audience. This was a device Horace Pippin used when he painted two distinct audiences in *The Holy Mountain I:* those who engage the viewer directly in the foreground, and those who are an audience to themselves in the background. In *Cherry Blossom Time*, the near audience is with the viewer on one level, but the background audience is turned away toward another scene. Two men stand silently behind the woman in blue. One is nearly out of sight.

Otherwise, the background crowd is divided along gender lines, males on the viewer's right and females on the left.

The strict division in time and place continues. The flowering cherry tree in the foreground represents spring, the time of regeneration, resurrection, and birth. The red trees in the background seem to signal fall. Thus the unanswered questions: Who are these people? Are they members of his own family, of his wife's family, or close relatives? Because of the peculiar nature of Ruley's death, people seem reluctant to speak about the overt symbols of conflict in Ruley's work. It is reported that Ruley met his untimely and brutal end on a country road at the hands of those who had threatened him over the years. The law seldom intervened on his behalf while he lived, and to this date his death one night on a road near Norwich remains an unsolved mystery.

Perhaps we will never know the full meaning of Ruley's art. But for a moment he created a contemplative and visionary memory in which people in a romantic place seem to celebrate something unusual and mysterious.

Most of the unschooled African American artists who carried the torch of the painter did so with serious dedication and with the belief that they were making divinely inspired images. Often they said that they heard creative voices that came from a spiritual place. They listened to voices that our tutored and trained ears were too sophisticated to hear.

For Horace Pippin, Minnie Evans, Clementine Hunter, and Ellis Ruley, art marks the place where the primordial is found. It is an idea even children who make art understand. It is the place where the mind lives a vision untouched by what is fashionable or what we feel deeply inside. The horses of the naive painter, like those of children, are often purple or blue, not because the artist saw one like that but because the artist dreamed it into being. Thus the unmanicured mind remains forever fresh with visions of the new order.

The visionary order to which these four artists belong will always allude to oneness, truth, and beauty. It is never

"without" the walls of understanding. The art of the vision-aries is the order of the insider, for those who believe their remarkable view, not that of "outsiders," those who set some things apart from the rest of the world.

Part 4 Notes

1. Peace and happiness among the nations of the world is a subject commonly found in the work of artists who rely on the visionary image, particulary when interpreting the Bible; see Isaiah 2:4 AV. The lyrics in the Negro spiritual, "Going to lay down my sword and shield, down by the riverside—and study war no more," refers to this scriptural text.

2. Judging another's character is frowned upon when those judging may be guilty of the same as the accused; see John 8:7 AV.

3. Although Horace Pippin does not fit the description of "outsider artist," he nevertheless has been looked upon as an artist who did not benefit measurably from academic training. His keen understanding of the subject of race in American society is often reflected in some of the subjects he chose to paint, particularly those in which black subjects appear.

4. "He shall feed his flock like a shepherd: he shall gather the lambs wih his arm, and carry them in his bosom, and shall gently lead those that are with young," Isaiah 40:11 AV.

5. Linda Roscoe Hartigan, "Landscapes, Portraits, and Still Lifes," in *I Tell My Heart: The Art of Horace Pippin*, Judith Stein, ed. (Philadelphia: Pennsylvania Academy of the Fine Arts, in association with Universe Publishing, 1993), pp. 105–111.

6. See Richard J. Powell, *Black Art and Culture in the 20th Century* (New York: Thames and Hudson, 1997), for an insightful interpretation of the "spiritual and divine" accent Minnie Evans brought to her work. See also her obituary in *The New York Times*, "Minnie Evans, 95, Folk Painter Noted for Visionary Work," December 19, 1987.

7. See commentary on Clementine Hunter in David C. Driskell, *Two Centuries of Black American Art* (New York: Alfred A. Knopf, 1976), p. 137, in which the Cane River is identified as a source for many of Hunter's subjects.

8. Driskell, *Two Centuries of Black American Art*, p. 28.

9. Notes from a conversation with Clementine Hunter, Oral History Tapes, Fisk University Special Collection, November 1972; also photographs in David C. Driskell Archive.

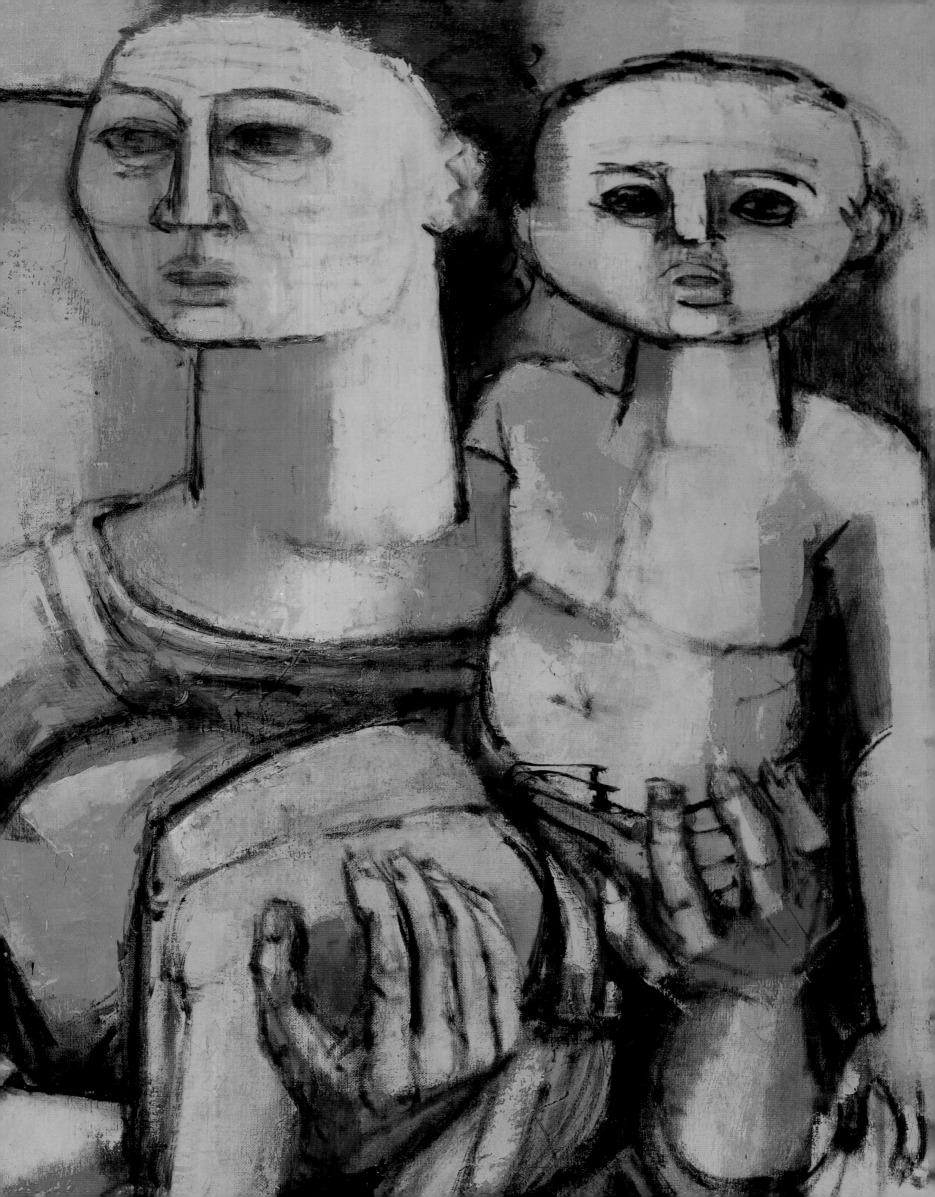

The New Black Image in American Art

Those nineteenth-century African American artists whom I labeled pioneers exerted courageous efforts to prove to a skeptical world that art was a calling all humanity needed. Some African Americans who sought to validate this notion were looked upon with suspicion and derision, since it was a widely held belief that slaves and free people of color needed fewer instruments of culture for survival than did whites. Besides, there was little time in the slave society for leisure activity. Art in any form in nineteenth-century America was thought to be a luxury. Although some free people of color practiced artistry in the crafts, they were not in the majority among artisans.

Five of the nineteenth-century artists I have cited—Joshua Johnston, Robert S. Duncanson, Edward Mitchell Bannister, Mary Edmonia Lewis, and Henry Ossawa Tanner—were born before American slavery was abolished. Johnston was the only one the record lists as having been a slave. It is thought that he may have acquired his own freedom by being apprenticed as a limner. Few of these artists knew the true meaning of first-class citizenship in the land of their birth.

Even fewer artists received the kind of patronage that would have allowed them to set up their studios around the nation and rely on their art as a sole means of livelihood. For an artist of color in the nineteenth and early twentieth centuries to be validated, he or she had to win acceptance in the art worlds of Paris, London, or Rome. Duncanson, Lewis, and Tanner traveled to Europe and experienced freedom and patronage along with white artists, thereby enabling them to compete favorably with artists in the international scene. But for artists who were black, being favorably received in Europe in the nineteenth century carried little weight back home. Always black artists returned to a rigidly segregated America; it was a nation determined to retain segregation in the North even if it meant keeping African Americans in servitude.

Gradually, over a period of many decades, artistic expectations in the nation changed. Eventually the United States claimed its own in certain areas of expression, such as landscape painting. This was true in the mid-nineteenth century for the Hudson River school led by Thomas Cole. The Ashcan painters[1] also claimed a place for themselves in New York City in the early twentieth century. At about the same time, cubism and expressionism entered the American mainstream through pioneering modernists such as Max Weber, Constantin Brancusi, and Leonard Maurer. Thereafter, modern art claimed an unyielding hold on the nation. Weber's and Brancusi's art, in part, had been informed by their study of African Negro sculpture they had seen in European collections. Synthesizing formal elements taken from the art of the German expressionists, particularly those making up the group called Die Brücke, Weber, Brancusi, and Maurer incorporated the elongated elements found in certain forms of African sculpture.

As we have seen, philosopher and art historian Alain Locke and other black writers were among the first to point out this practice among European artists. Locke also noted the important contributions some European artists made to modern art after incorporating the iconography of African art into their work. He invited African American artists to do

Detail from Charles Alston, *Woman and Child* (Plate 48).

the same in an essay he wrote in 1931 titled "The African Legacy and the Negro Artist."[2]

In part, Locke's plea for African American artists of the Harlem Renaissance to "return to the ancestral arts of Africa for inspiration in their work" fell on deaf ears. The exceptions, we noted, were two pioneering Africanists, Aaron Douglas and Hale Aspacio Woodruff. Douglas included African masks and statuary in his paintings as early as 1925, and Woodruff followed suit in 1929. Douglas, Woodruff, and Sargent Johnson were the most ardent exponents of subjects relying on the formal aspects of African art. But they did not move far beyond a limited definition of synthetic cubism in their attempt to change the format of their art. In the main, it was the task of a new generation of black artists, whose work matured in the decade following the Harlem Renaissance, to create the new black image in American art.

The New Negro movement of the 1920s challenged African American artists to look within the black community for their inspiration. It celebrated "black is beautiful," in the words of the Harlem Renaissance poet Langston Hughes. Hughes admonished artists to write about and create images of themselves without shame and with pride.[3] He called upon musicians of the period to play the songs and blues that emphasized racial pride and love of Africa as the home of the most ancient civilizations known to humankind. In the eyes of African American artists, Egypt and Nubia were reconnected to the black American experience, and Egyptian art was lauded as the preeminent milestone of human accomplishments in the African diaspora.

Painter Aaron Douglas and sculptor Meta Vaux Warrick Fuller were among the first African American artists in the twentieth century to incorporate Egyptian themes into their art. They did so by using African iconography as important visual elements in their work. Fuller's *Ethiopia Awakening*, created c. 1921, helped establish a new sense of racial pride for Africa, heretofore described as the "dark continent." Popular black cultural historians such as Pan-Africanist J. A. Rodgers, social activist W. E. B. Du Bois, and black nationalist leader Marcus Garvey helped invalidate common myths about Africa as a land of cannibals and primitives. They redirected the thinking of vast numbers of African Americans toward social emancipation for people of the African diaspora.

Black artists then began to teach art in institutions of higher learning. They established art departments at Howard and Fisk Universities, at Hampton and Tuskegee Institutes, and at a small number of predominantly black state colleges throughout the South. Howard University introduced an art major in 1920 as well as art history courses throughout the 1920s, some of them highlighting the contributions of African and African American artists. These were the first curricular changes in the nation's institutions of higher learning that took note of black achievements in the arts.

The art department at Howard University played a significant role in training artists who became teachers in many of the newly founded art departments in southern black colleges. Principal among those institutions was Fisk University in Nashville, Tennessee. In 1931, as we saw, Fisk invited Aaron Douglas to paint a series of murals in the Erasto Millo Cravath Library, and Douglas responded by painting the progress of the Negro in Africa and America, slavery, and black achievements in the twentieth century.

Other black colleges also commissioned murals. We noted Hale Aspacio Woodruff's 1938 *Amistad Murals* at Talladega College's Savery Library. The series of three large panels depicted the 1839 mutiny by slaves aboard the Spanish slave ship, *The Amistad*. Woodruff and Charles Alston worked together to create the panoramic murals inspired by African themes in the Trevor Arnett Library at Atlanta University in 1950–1951. Charles White painted *Contribution of the Negro to American Democracy* at Hampton Institute (now Hampton University) in 1943.[4] Both White and Lois Mailou Jones were invited to create individual mural compositions

about black culture at Howard University in the 1940s.[5]

By 1935, black artists were being welcomed into academia and appointed to the faculties of black colleges throughout the South. However, few were invited to exhibit their work in museums around the nation. Also, they were not welcomed as teachers of art at predominantly white institutions. It was Hale Aspacio Woodruff who finally broke the barriers of segregation when he was invited to become professor of art at prestigious New York University in 1946.[6] He joined the art faculty there the following year.

Mary Beattie Brady, director of the Harmon Foundation, saw the need for African American artists to have a forum and a place to exhibit their work in a national competition. In 1926 she conceived the idea of an annual *Exhibition of the Work of Negro Artists.* Substantial prizes in the form of gold, silver, and bronze medals were awarded to black artists from 1926 through 1931, and 1933 through 1934. Brady encouraged those artists submitting works to be proud of their "Negro heritage" while at the same time reminding them that their art should also reflect their American legacy. Brady took great pride in promoting black images that dealt with the American experience. She expressed to me that Alain Locke "had missed the boat" in what she called "a great window of opportunity" by encouraging Negro artists to try to create African images in their art. Brady felt African art was separate from the black experience in America and should only be seen as "grist for the mill."[7] Clearly Brady's criticism of Locke was more a difference of opinion about who controlled what black artists painted than about aesthetics.[8] Romare Bearden was one of a few artists who dared to speak out about the controlling grip Brady and the Harmon Foundation tried to exercise over African American artists.[9]

In the midst of disagreements on the relevance of African iconography for black artists, the creation of the new black image became the aim of African American

artists born between 1905 and 1920, and to these artists we now turn. In the afterglow of the Harlem Renaissance, black artists began to turn away from the safe nineteenth-century goal of cultural emancipation toward the more uncertain aim of freeing themselves from Eurocentric themes. Instead of imitating mainstream art, they embraced forms of expression that were inspired by black life in America and by African art.[10] Paintings of African American genre scenes depicting black life in the rural South, along with those of the urban scenes in the North, were the subjects black artists of the new generation undertook after the Harlem Renaissance.

Unlike those African American artists who introduced black themes prior to 1930, several of the artists born between 1905 and 1920 trained at the nation's most prestigious art academies. Some attended leading universities with outstanding art departments. They also established themselves as exhibiting artists and teachers of art at black institutions of higher learning around the nation. The black artists who came of age in the 1930s became the purveyors of new images that bolstered racial pride. They portrayed historical events and deciphered cultural mythology in a way totally different from that white artists used.

The newly emerging artists of the 1930s pursued more vigorously such distinctly different paths as historical narration, African mythology, and compositions reclaiming an African past. Other artists undertook landscape painting and nonfigural abstraction. With the making of new black images that pointed to racial pride came a renewed interest in art education and scholarship. Art historians noted the salient achievements African Americans had made in the visual arts from the period of slavery into the third decade of the twentieth century.[11]

James Amos Porter (1905–1970)

First among those who showed this duality of talent as painter and scholar of African American art history was James Amos Porter. An avid student of art history and a painter of consummate skill, Porter became the first black

art historian whose writings centered on the art of African peoples in the diaspora. Mentored by James V. Herring, Porter had been greatly influenced by the scholarship of Alain Locke, who had come to art history by way of philosophy. But it was Porter who defined the field. He put it on a level with the scholarship of other parts of African American culture, such as the literary and performing arts. Porter visited Africa, Cuba, Haiti, Mexico, and Brazil in search of African art retentions in the New World. Outstanding within Porter's scholarly oeuvre were his pioneering efforts on the subject of black art and crafts in the American South. Wherever Porter traveled, he took along artist materials and worked as a practicing artist as well as writer. The result was the creation of a wide range of paintings that depicted native life in Haiti, Cuba, and the continent of Africa from 1946 until his untimely death in 1970.[12]

Porter's painting caught the discerning eyes of critics in Washington, D.C., where he had been a member of the Howard University art department faculty since 1927. His art was singled out in Baltimore, Maryland, the place of his birth, as being both academically sound and highly original. Within a short time, following his appointment to the faculty at Howard in 1927, Porter began to exhibit his art widely on the East Coast. He regularly showed in New York, at the Harmon Foundation's annual *Exhibition of the Work of Negro Artists*. There he was the recipient of an Harmon Foundation Portrait Award in Painting in 1933. He later exhibited in traveling exhibitions sponsored by the College Art Association of America. Major art magazines and journals such as *Art in America* invited Porter to contribute essays about black artists and craftspeople in colonial America. Some of the essays became the basis for his 1943 definitive book on African American art, *Modern Negro Art.*[13]

While the scholarly writings on African American artists and craftspeople commanded a great deal of Porter's time, he remained equally active in the discipline of painting. He created still lifes, portraits, landscapes, and genre scenes reflecting black life in the city. In his genre composition *Washerwoman* (Plate 45), Porter painted a black woman swaying backward under the weight of the heavy bundle of clothes she has washed. She prepares to place the garments on a clothesline to dry. She is accompanied by a young child, no doubt her daughter. The child is learning about the mother's job. The black girl clings lovingly to a white doll while helping her mother by carrying a smaller bundle in her left hand. At the time, white dolls were commonly seen among black children. They made evident the contradiction in the African American community, that of choosing a white doll as a daily idol instead of a toy that would boost the child's racial pride.

Dark and somber colors dominated the palette of much of Porter's early work. However, by 1936 the artist had turned to painting portraits and social scenes in which events such as a riot in Chicago were depicted vividly. A series of Caribbean trips to Haiti and Cuba in the 1940s allowed Porter the chance to return to painting genre scenes. *On a Cuban Bus* was one of the most celebrated works. Retaining his position as the major scholar in the field while continuing to be a productive artist, Porter set the pace for artists of color in matters of African American art scholarship. At the same time, he maintained an active career as a painter-teacher and museum administrator. It was a calling not so easily achieved among those to whom he sought to pass the artistic mantle.

Lois Mailou Jones (1905–1998)

Lois Mailou Jones, born in Boston, came to Howard University in the fall of 1930 to teach design and watercolor painting. Joining a faculty of some distinction, including James A. Porter, James Lesesne Wells, and James V. Herring, the venerable chair of Howard's art department, Jones soon established herself in the Washington art community as a painter of fine reputation. Her formal training at the School of the Museum of Fine Arts, Boston, and the Boston Normal

Art School, now the Massachusetts College of Art, had prepared her well for the academic profession. Her schooling also prepared her for the mentoring role she would later assume for artists such as Elizabeth Catlett, Alma Woodsey Thomas, and myself, among others.

Prior to coming to Howard, Jones had served on the faculty of a private high school for African American girls, the highly respected Palmer Institute in Sadelia, North Carolina. She sought employment in Boston but was told that in spite of her excellence in textile design, painting, and drafting (some of this work was based on African art) she would not be hired because of her race. This incident convinced Jones that her talents would be better appreciated at the Negro colleges, as they were called in those days, such as Fisk, Hampton, and Tuskegee,[14] so she moved to the South. Howard University proved to be the place where Jones's artistry began to soar, and it was there that she had the chance to teach, paint, and travel to Paris, then the art capital of the world.

Jones heeded the advice of Alain Locke and other Africanists at Howard University in the late 1930s to pursue using African art in her work (they were unaware of the African-based art she had created while in Boston). In 1937 she created *Les Fetisches*, a juxtaposition of five West African masks positioned to show movement and a harmonious relationship among the diverging forms.[15] Many of Jones's drawings, illustrations, and textile designs from as early as the late 1920s included abstract motifs based on influences from African sculpture.[16] She created cretonne designs and travel posters in which African motifs were dominant. Thereafter, Jones used patterns and forms from African art in her paintings for more than thirty years. Revitalizing them in the 1960s and 1970s during the Black Power movement, she reembraced the African theme almost entirely in her work.[17] Jones consciously created works of art that showed a strong affinity with the protest art of the period.

In the intervening years, between 1940 and 1965, Jones pursued a steady course of painting inspired by the colorful art of both the French impressionists and their immediate successors, the postimpressionists. Her trademark image in the 1940s and 1950s became the streets of Paris. She also concentrated on handsomely painted interior scenes, with still lifes and views of the French countryside.

Nature Morte aux Geraniums (Plate 46), completed in 1952, is typical of the many works Jones painted during her annual summer visits to France. Her mastery of color was uncontested in still lifes and landscapes, and she painted both the French countryside and the streets of Paris, showing the special beauty of places where Paul Cezanne, Maurice Utrillo, and Vincent van Gogh, among others, had once labored. Lois Jones loved the good life Paris offered artists of color. Here she was not discriminated against, and her work was not denied entry into the major exhibitions.

Ville d'Houdain, Pas-de Calais (PLate 47), a composition painted in 1951, reveals Jones's romantic ties to Cabris, France, the town where she married Haitian artist Vergniaud Pierre-Noël in the summer of 1953. After her marriage, Jones began traveling frequently to Port-au-Prince, Haiti, Pierre-Noël's home. There her palette changed to reflect the close observations she made of native life in the Republic of Haiti, the first black nation in the Western world to obtain its independence from European colonial rule. In Haiti, Jones found an array of subjects to paint, from the beautiful hillside view of Port-au-Prince at night to the African-inspired ceremonies of Voudoun rituals. Upon her return to Washington, D. C., she opened there her busy studio in Brookland as well as one on Cape Cod's Martha's Vineyard, where artists enjoyed congregating. They were greatly inspired over the years by Jones's presence and the artistry she continued to create.

Jones, like her colleagues James Lesesne Wells and James Porter, had a long and productive career as an artist and teacher at Howard University, where she helped establish a tradition of excellence that she remained proud of until her

death June 9, 1998. At a symposium at the Hirshhorn Museum and Sculpture Garden in Washington, D.C., in the spring of 1992, Jones remarked that she was "the only surviving painter of the Harlem Renaissance."[18] While some dismissed Jones's assertion of a Harlem Renaissance connection, others noted that she did exhibit at the invitation of the Harmon Foundation during the period thought to be the most productive years of the Negro Renaissance. Thus Jones's claim that she was a Harlem Renaissance artist, an attribution reserved for few artists of her generation, prompts us to inquire who the surviving Renaissance artists are.

Charles Alston (1907–1977)

Clearly allied with the Harlem Renaissance movement, Charles Alston benefited immeasurably from his association with the Harlem artists who kept alive memories of the flowering of the arts in that period, like William Henry Johnson and Hale Aspacio Woodruff. He was also a relative by marriage of Romare Bearden.

Alston was born in Charlotte, North Carolina, and began painting as a teenager. Seeking first to establish himself as an academician who mastered the various styles of realism in painting and sculpture, Alston showed great skill in rendering the human figure. He paid particular attention to family scenes with mothers and children. Later he turned to a more simplified formula, painting abstractly inspired figures. At the time of Alston's death in 1977, his art had been widely seen in major exhibitions around the nation and throughout the Western world.

A major contribution of Alston's occurred through the execution of several murals, some of which were done when he worked as a WPA artist in Harlem in the 1930s. Having studied African art and its influences on Western artists at Columbia University's Teachers College, Alston chose to expand the realistic format in his work. He went on to synthesize the abstract elements of African art with cubism, combining the two in the murals he created. His murals at Harlem Hospital portrayed a historical overview of medicine, showing Western medicine as evolving from magic and ritualistic practices in ancient Africa.

By 1950 Alston turned his back on realism and thereafter devoted more time to developing a formal approach to abstraction. He later abandoned pure abstraction to return to the figure as a means of creating an imposing structure in painting, similar to that seen in traditional African sculpture.

Alston devoted much of his professional time to teaching painting at New York's well-known Art Students League. Later in life he became a professor of art at the City College of New York. Even before he received a measure of recognition as a fine artist, Alston had mentored a number of African American artists over the years, among them Jacob Lawrence.

Alston was a skilled technician. He carefully crafted his paintings using techniques of both old and modern masters. Many of his late paintings, such as *Woman and Child* (Plate 48), are subtly rendered in a limited chromatic palette of ultramarine blue, yellow ocher, and flesh tones, created by mixing tints such as mars red, white, and burnt umber. A modified version of synthetic cubism is used in modeling planes that allow the figures to project and recede. Alston's figures appear monumental so as to emphasize the strength of the hands and the limbs of the body.

In *Woman and Child,* Alston uses a well-articulated burnt umber and black line to enclose the figure, as if he is following the classical European style of painting of the 1890s. He underpaints in grays, reds, and chrome green and then scumbles the paint, applying another layer of paint over it so that small amounts of the underpainting show through.

Alston often concentrated on the theme of the loving care of the family as a social unit. He often depicted a strong and willful mother holding her child in her arms. In *Woman and Child,* the pose of the mother strikes us a classical one but also shows universal elements that cross all lines of race and ethnicity. It is the ideal picture of a strong, working mother standing guard over the life of the entire family.

Such was the accomplished style of Charles Alston, a painter who charged his figures with dynamic presence

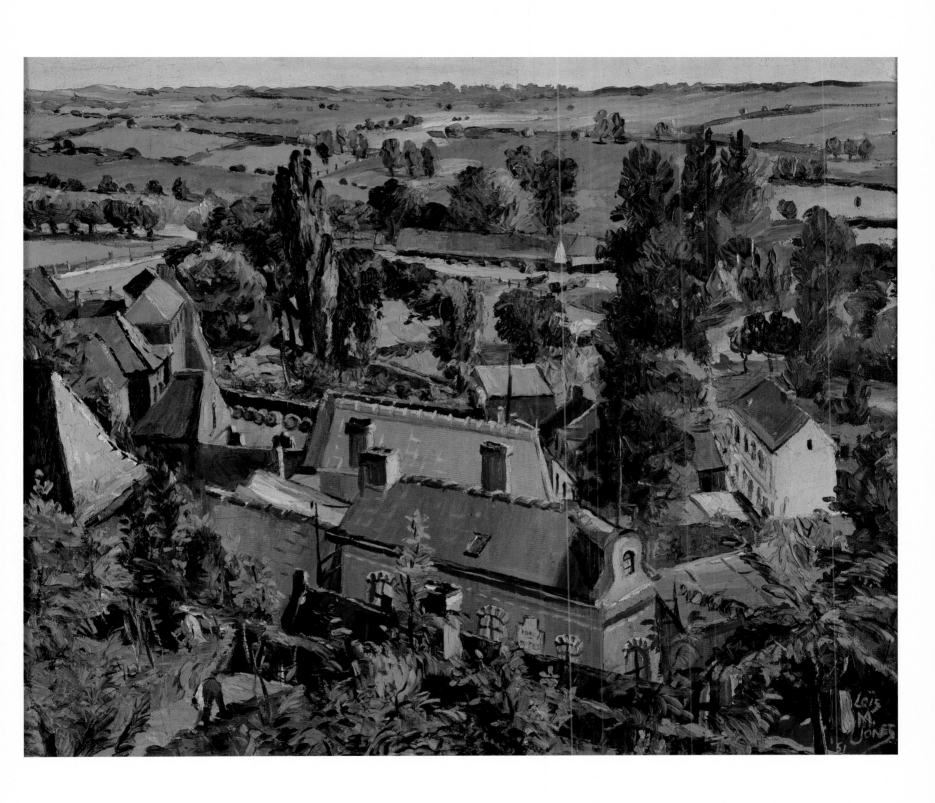

Plate 47. Lois Mailou Jones, *Ville d'Houdain, Pas-de-Calais,* **1951, oil on canvas, 21¼ x 25⅝ in.** 93

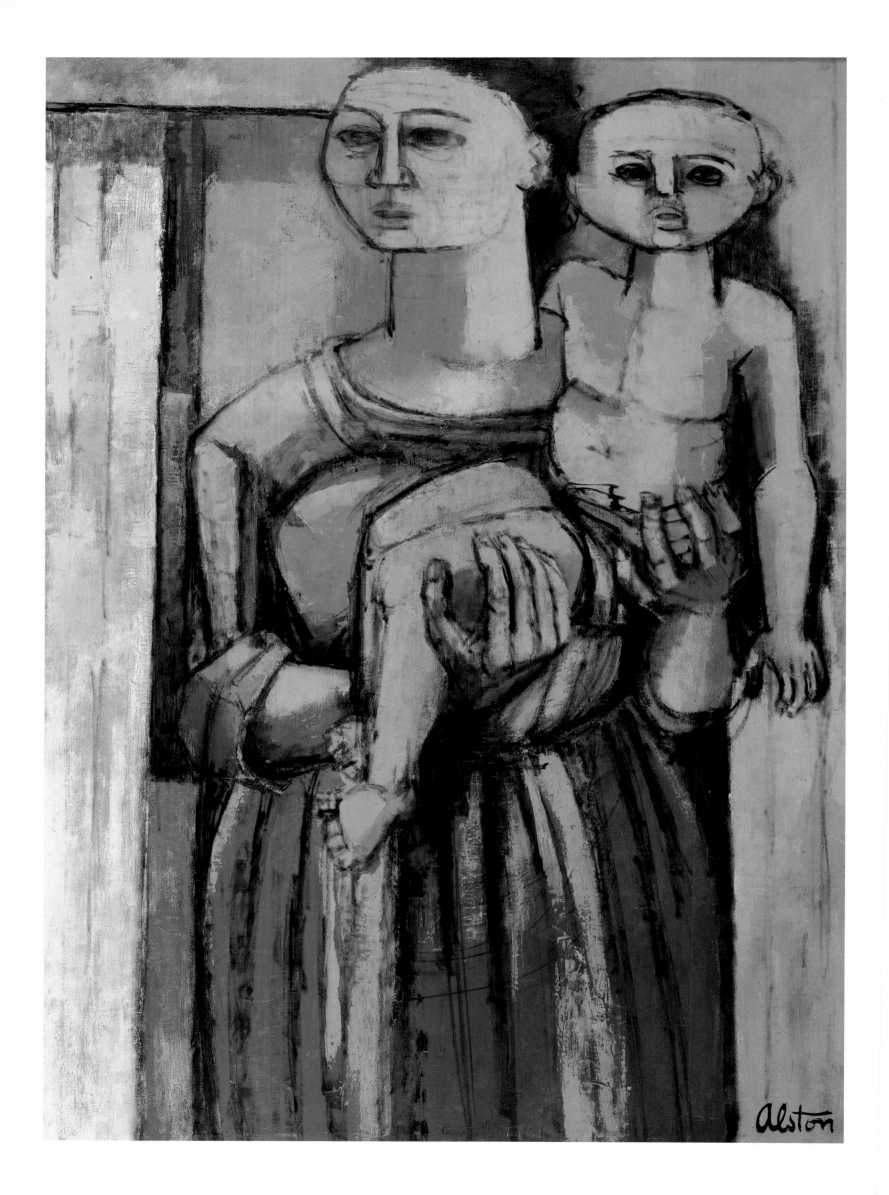

reflecting both realism and cubism. Alston's art connects spiritually with that of Wilfredo Lam, Hale Aspacio Woodruff, and a number of other African American artists influenced by West African sculpture. Paramount in Alston's oeuvre is the role played by the drawn figure. Alston drew with an informed sense of the abstract, yet always mindful that form is most clearly defined when the artist holds an attitude of less is more, an idea many African American artists of the 1960s came to observe. This rule in Alston's work allowed him the freedom of expression that shows him to be a modernist among black artists, especially among those influenced by African art.[19]

In 1963 Alston cofounded Spiral, a group of some twenty African American painters who came together in New York City to share common professional experiences. All male artists, with the exception of Emma Amos, these painters discussed and critiqued one another's work. The participants were seriously dedicated to creating art, and many were teachers. They crossed several generations, some of them laboring in the shadow of the renaissance spirit that kept Harlem alive in the 1920s.

Although the members of Spiral had no manifesto or written document, they nevertheless saw themselves as a cohesive unit that could influence aesthetic taste in New York and the larger African American art community. Romare Bearden, Ernest Chrichlow, and Norman Lewis, with others, founded Cinque Gallery to help implement Spiral's creative agenda.[20] The gallery exhibited and promoted the work of artists from around the nation, and it continues to play a vital role in the African American art community in New York City today.

Norman Lewis (1909–1979)

One of Spiral's most ardent supporters was Norman Lewis. A native New Yorker, Lewis was the leading abstractionist in the Spiral group. He had already been well known in the white art community for more than a decade when Spiral was founded. Lewis was a colleague of the painters who defined the abstract expressionist movement in the early 1950s. His style of painting is readily associated with the form of experimental abstraction characterizing the period.[21] He became the first African American artist since Henry Ossawa Tanner to be widely exhibited in mainstream galleries in New York, and other artists often turned to him for advice on how to coexist with whites in a world where racial prejudice and blatant segregation were daily experiences.

The style of painting that Lewis adopted in the 1930s adhered more closely to the principles of realism than to the emerging forms of abstraction. Working as a WPA artist in the mid-1930s, Lewis often painted representational figures. Typical of the works produced during this period is a familial composition, *Untitled (Family Portrait)* (Plate 49) of a black family consisting of a mother, a father, and two boys. Simply rendered in rather large but subtle painterly patterns, each person commands the viewer's attention but in very different ways. The father, the dominant figure, reads the newspaper while one of the boys dozes at his feet. The boy behind the father calls attention to his hunger by making noise with his knife and fork. The mother is working hard, washing the soiled clothing. She is using an old-fashioned washboard, the kind often used as a musical instrument among black blues musicians. Nearby are a wash pail and a tub, in which the clothes will be rinsed and hung out to dry.

No doubt influenced by his childhood memories of such a scene, Lewis captured the spirit of the work ethic in the traditional black urban family of the 1930s. During the Great Depression the mother often served as the principal breadwinner, taking in washing as a part of her domestic work. Alluding to the social circumstances of the time without committing himself to a narrative review of black family life, Lewis captured the essence, the time, and place of a black genre scene.

After the end of World War II, Lewis began searching for a personal vocabulary in which to center his work. Broad,

three-dimensional planes gave way to lyrical patterns of color and form related to the fields of abstraction found in analytical cubism. In Lewis of the 1940s, we can see a prelude to the abstract expressionist painting to come. He built upon the simple format of reintroducing the flatly painted forms that Aaron Douglas had explored in *Aspects of Negro Life*. Lewis's style was a highly personal one in which he consciously chose abstraction over realism. With the soundness of an accomplished painter's position, Lewis helped create black images African American artists were looking for. By 1950, he had moved almost completely to abstract expressionist painting, experimenting with forms in black and white.

In the 1950s, with abstract expressionism and various forms of action painting, the world art scene shifted to the United States, and Lewis figured prominently in New York art. He was the only African American artist who participated in the abstract expressionist discussions at the Studio 35 Club organized by Willem de Kooning and Franz Kline. The Willard Gallery exhibited his work frequently. He also exhibited at the Metropolitan Museum of Art, the Whitney Museum of American Art, the Museum of Modern Art, the Baltimore Museum, and other important East Coast cultural institutions.

Lewis's close association with Jackson Pollock, Robert Motherwell, and other emerging artists of the abstract expressionist movement made him aware of the need to share with his fellow African Americans the innovations of the changing art climate. In the 1950s Lewis and Romare Bearden were the two most prominent black artists working as abstractionists. They shared a common interest in defining the new African American aesthetic, which was being shaped by postmodernism. Especially after Spiral was established in the early 1960s, a large number of African American artists followed their lead in committing themselves fully to abstraction. Norman Lewis's art led the way in exploring the new forms of the changing aesthetic order.

Romare Bearden (1914–1988)

Romare Bearden put his stamp on Spiral in the 1960s by asking the members of the group to work with collage in their painting instead of relying solely on the brush.[22] Bearden thought using collage could become a common thread uniting the founding members of Spiral in the atmosphere of an atelier. Collage combined with enlarged photo blowups became synonymous with Bearden's name in the 1960s, and he called his creations photomontages.

Early in his career, from the mid-1930s until the late 1940s, Bearden created works in oil, watercolor, and gouache. He turned to forms of abstraction in the 1950s as a way of working toward a modernist formula. Bearden explored forms of painting in which city scenes, groups of people, and domestic and genre scenes were prominent. As a collage artist from the 1960s on, he returned to themes of the inner city, people in interiors, in which African Americans observed rituals and rites of passage.

Drawing heavily upon photography and discarded paper products, Bearden juxtaposed paint and collage. He constructed, washed, and glued together images of people, places, and things to create a montage of events similar to synthetic cubism. Neo-African symbols were meshed with masks from ancient Ife, Benin (Nigeria), and from the Baulé people of Côte d'Ivoire. These works showed photographic enlargements of hands, feet, and other body parts from contemporary African Americans.[23]

Influenced by the same musical aesthetics as his longtime friend Norman Lewis and a host of African American artists, Bearden saw jazz as both an experience and a source in which to anchor his art. Closely related to jazz musicians from his early childhood in Harlem, Bearden used the musical side of his life to inspire much of the art he created after the 1960s. From memories of the "good old days" of night life in Harlem and the cabaret culture of the 1920s and 1930s, Bearden created colorful compositions that were both lyrical and disjointed, reassembled and dismantled.

Plate 49. Norman Lewis, *Untitled (Family Portrait)*, c. 1936, oil on burlap, 26¼ x 36 in.

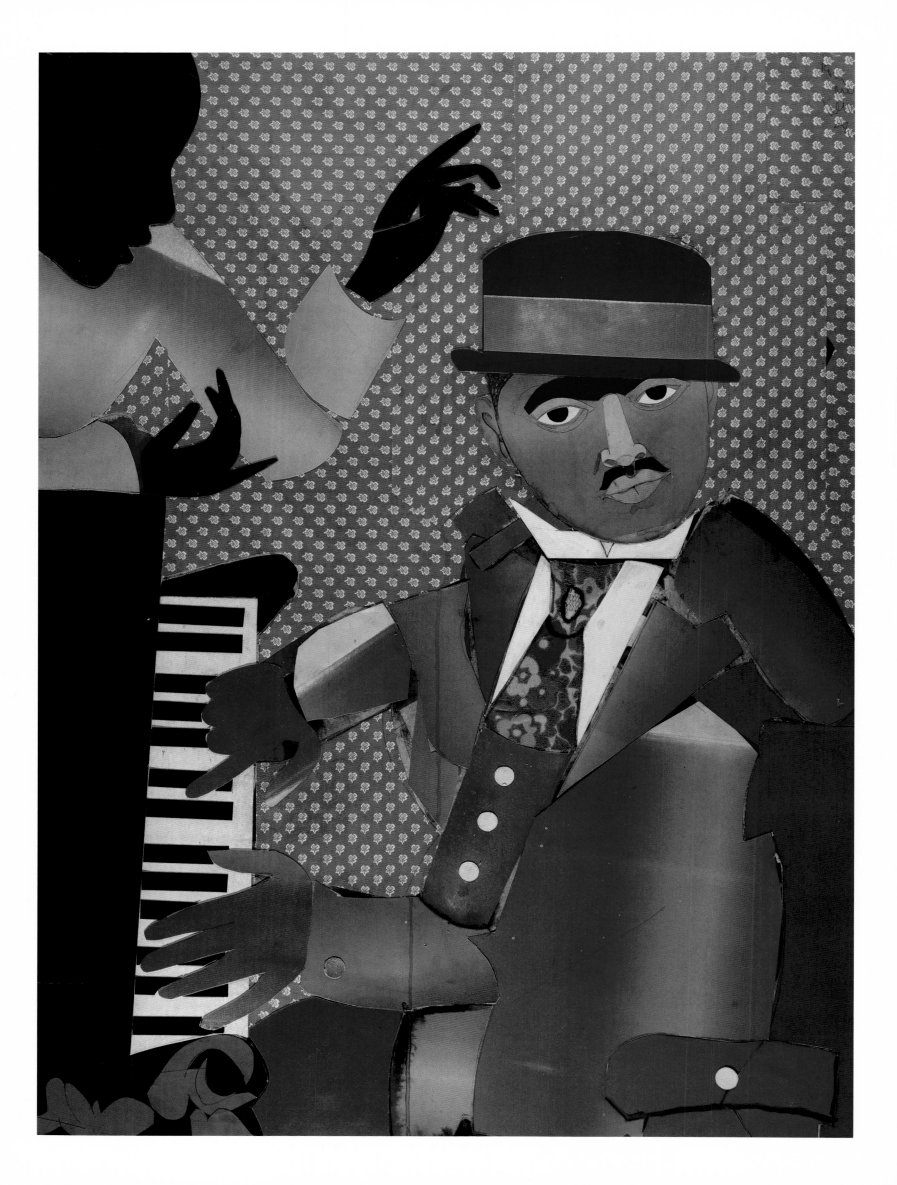

Sitting In at Baron's (Plate 50), painted in 1980, brings us face-to-face with the style, chemistry, and racial pride that accompanied being black in the heyday of the Harlem Renaissance. Bearden invented ways of recounting the past without being overly narrative. He showcased the elegant tradition of clothing as art, emphasizing the loud colors, zoot suits, and derby hats with which African Americans ushered in the Jazz Age. He introduced us to a way of telling a story in which the lyrical flow of form was clearly bonded with color.

Bearden's style does not fit easily into a single category. While his work is two dimensional, Bearden's collages stretch the definitions of painting. He orders materials into arrangements that make them obedient to his will. We are startled, and visually held, by the force of color and the inventive directions form takes in his work. To this end, Bearden stands without company as an artist who sees beyond the usual, creating the mythic vision.

The style begins with paint, paper, and a story. Torn and cut bits of paper are applied to another paper surface. Line and color follow. Occasionally textiles provide a touch of reality. Pieces of cloth or cut paper set into motion the artist's ideas. Geometric forms are juxtaposed with soft, curving edges. Bearden's magically inspired compositions thus show an orderly, dynamic structure.

Bearden's style demands some important things of the viewer. We must be willing to make the journey to the bowels of the city where the blues song is heard and seen. We hear the lament of the black preacher chanting a sermon in a storefront church and smell the sweetness of flowers growing amid morning glory vines in the quiet southern countryside. In *Magic Garden* (Plate 51), from 1980, a woman walks through a garden of beautiful flowers making selections for her kitchen table. No doubt inspired by childhood memories of Maude Sleet's[24] garden in Charlotte, North Carolina, the painting re-creates stylistically a blend of collage with a stainlike form of watercolor painting. We witness the warm, lyrical sights that tease the mind and give

personal joy. The opulently rich colors show Bearden as much the poet as the painter.

Throughout his long career, Bearden acknowledged the contributions of the seventeenth-century Dutch masters, the fauvists, and cubists to his work. The art of Rembrandt van Rijn, Henri Matisse, and Georges Braque served as compositional models. In his use of materials, he was related to Matisse, Kurt Schwitters, Pablo Picasso, and Braque. He also relied heavily on nature for inspiration. However, Bearden's style should not be mistaken as eclectic simply because he combines sources both old and modern. Instead, it shows him shaping form in a poetic and personal way. He pays homage to his heroes through the quietness of his unique mode of expression.

Harlem Brownstone (Plate 52) also from 1980, presents a familiar family scene. A mother grooms her daughter's hair in the company of a woman whose face looks like a Baulé mask while she remains otherwise African American. This visual transformation of facial features in Bearden's work draws our attention to a renaissance of ideas, the birth of new visual metaphors in African American art. It calls to mind the writer Toni Morrison, whose *Song of Solomon* re-creates the African in the Americas.

The style of Bearden's collages in the 1980s is drawn from the same wellspring that brought the photomontages into existence a generation earlier. Brilliant colors explode over the edges of shapes that are simplified to read hand, skirt, or bather. But these sensitively perceived compositions are never without interest. They show the logical growth of an artist whose style is flexible enough to permit joy and pain to be registered at the same time.

The montage of the city scene—page upon folded page of tenement houses lavishly filled with urban smells and sounds—appeared over and over in Bearden's energy-charged compositions. Bearden took useless piles of paper waiting to be discarded, and out of these heaps, with the help of stain and dye, he formed strong images. He seemed

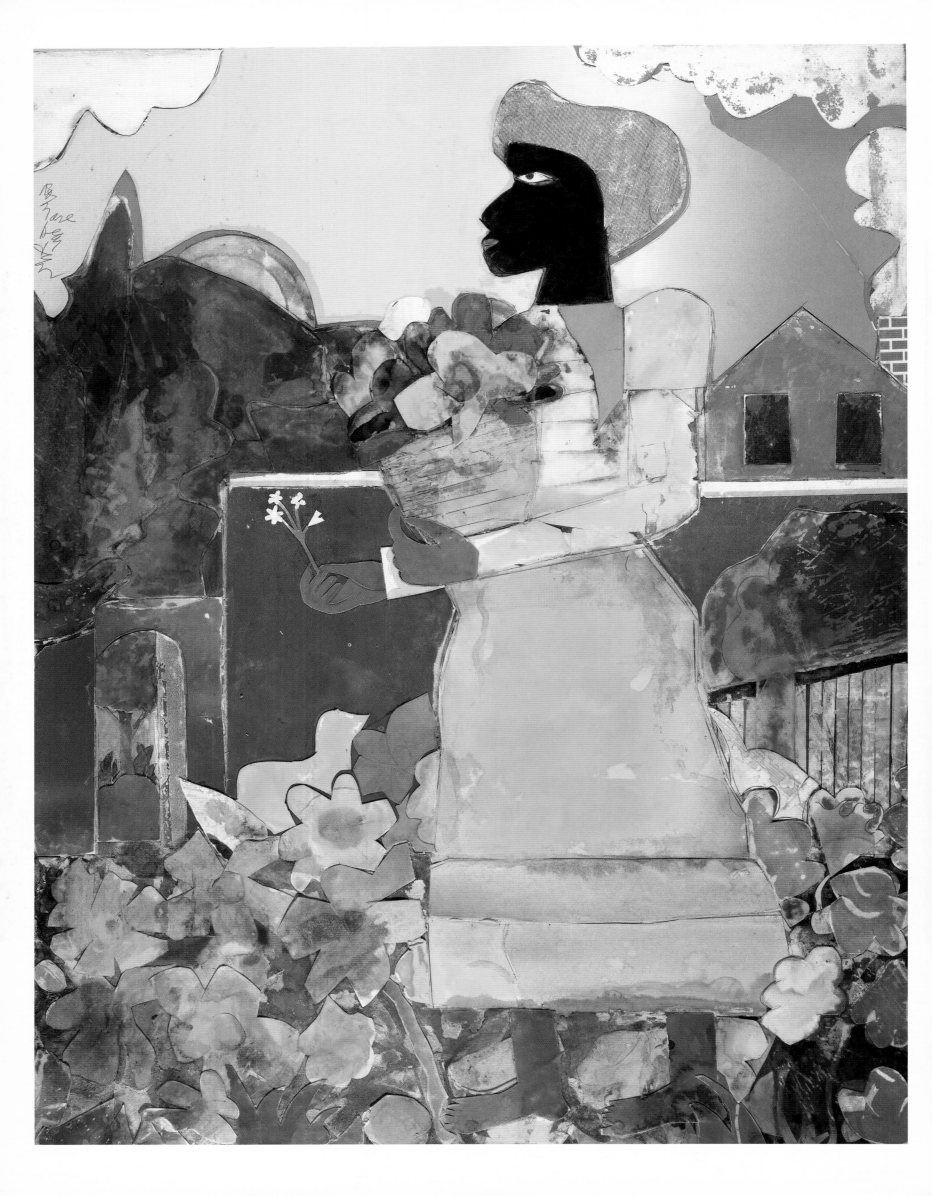

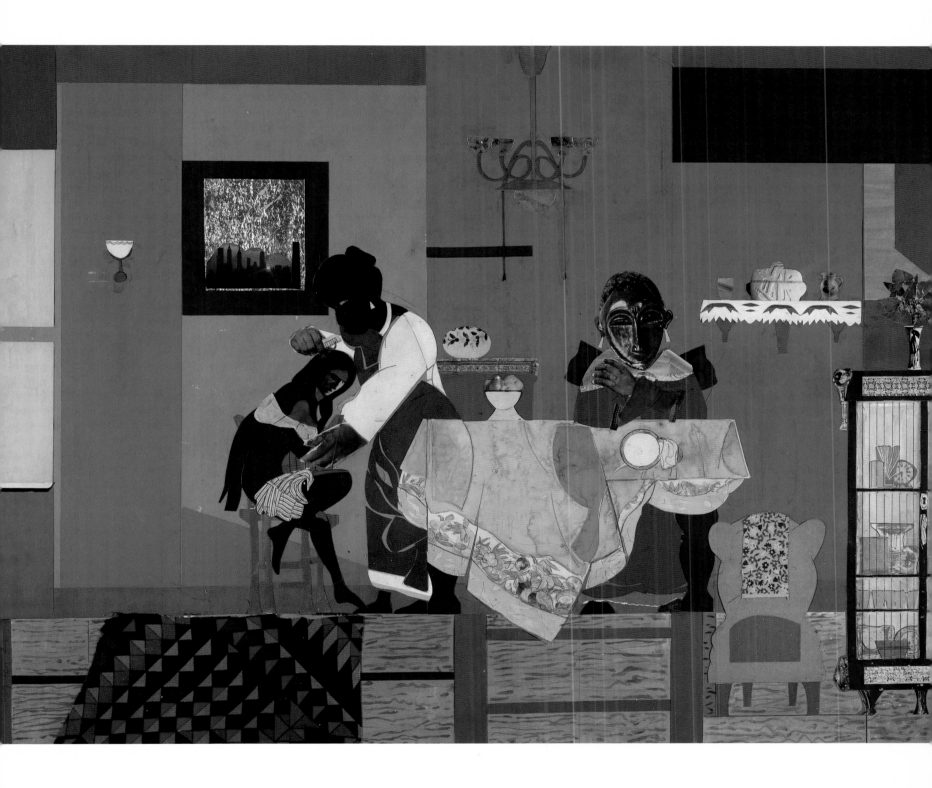

Plate 51 (facing page). Romare Bearden, *Magic Garden,* **1980, collage on masonite, 39¾ x 31 in.**

© **Romare Bearden Foundation/VAGA, New York, NY**

Plate 52 (this page). Romare Bearden, *Harlem Brownstone,* **1980, collage on masonite, 29⅞ x 40 in.**

© **Romare Bearden Foundation/VAGA, New York, NY**

always receptive to the right shape, the necessary color, and the spontaneous response the materials created.

The style of Bearden's art dictated that he should mix what is real with the world of dreams. The mythic dream appears in Bearden's work, laden with familiar themes from Neo-African and African American cultures. Bearden retrieves for us a glimpse of the dream gloriously described in the poetry of the blues and the lyrical jazz that fill his art.

Bearden's visionary dream has inspired many young artists to work with discarded materials such as paper, scraps of textiles, and paint. The autobiographical element—Bearden's physical presence—in his art is overwhelmingly moving, and it expresses his own unselfishly shared and rich humanity.

William Ellisworth Artis (1914–1977)

Part of the fourth generation of African American sculptors who worked in the realist mode, William Ellisworth Artis came of age in the 1930s, creating handsomely modeled terra-cotta heads of black children and adults that captured the essence, indeed the beauty, of ordinary black people. His goal as a sculptor was to reveal as best he could the physical and spiritual elements of his people, characteristics so often missing when artists of other races depicted them. Equally well known as a ceramist, Artis was an outstanding artist and teacher at a number of colleges around the nation. His work is closely aligned with that of other African American sculptors working in the realist tradition during the 1930s and 1940s, such as Augusta Savage, Sargent Claude Johnson, and Richmond Barthé.

African Youth (Plate 53) reveals the kind demeanor of the young male sitter whose stylized head appears throughout Artis's oeuvre. Originally modeled in clay, the work was later cast in bronze and belongs to a series of portrait heads that became the signature style of an artist whose work moved evenly among the fields of sculpture, ceramics, and printmaking. Art historian Theresa Leininger-Miller noted the close cultural affinity that Artis's sensitively modeled heads of black people have with the "smooth skin and stoic expressions . . . of ancient Nok terra cotta heads and Benin bronzes."[25] Artis's competent style, while similar to that of sculptors from ancient Nigeria was inspired by African American experience. It is the New Negro movement with its cry of "black is beautiful" that animates *African Youth*.

During Artis's successful career as a sculptor, he won more than one hundred distinguished awards, commissions, and honors. He became one of the most widely collected African American artists of the twentieth century.

Hughie Lee-Smith (1915–1999)

Over a period of more than fifty years, Hughie Lee-Smith created a body of work that has the tenets of realism at its core. Described by some writers as romantic-realist, Lee-Smith's work shows elements both of realism and—especially beginning in the mid-1940s—an ethereal quality similar to that of the surrealists and symbolists.

Lee-Smith's interest in the magic of form takes us to the outer edges of what we know to be real. His presentation leans more toward a psychological investigation of visual phenomena than a mere representing of things and events in the natural world. His art tends to move the viewer away from the physical presence of things, toward an abstract world where feelings and emotions and all things that are manifest in concrete form are not easily expressed.

In *Soliloquist* (Plate 54), a male figure, dressed partly as a harlequin, reads aloud in a desolate landscape. The barren foreground establishes a situation more than a single moment. It is an illusion of permanence within a landscape void of human activity other than that of the reader. Neat piles of broken brick, like crumbled buildings from an ancient past, lie strewn beneath the decaying walls on which the reader stands, symbolizing the feeble human attempt to create a permanent place in the modern world. Neither the reader's voice nor the presence of two balloons

Plate 53 (facing page). William Ellisworth Artis, *African Youth*, 1940, bronze, height 9½ in.

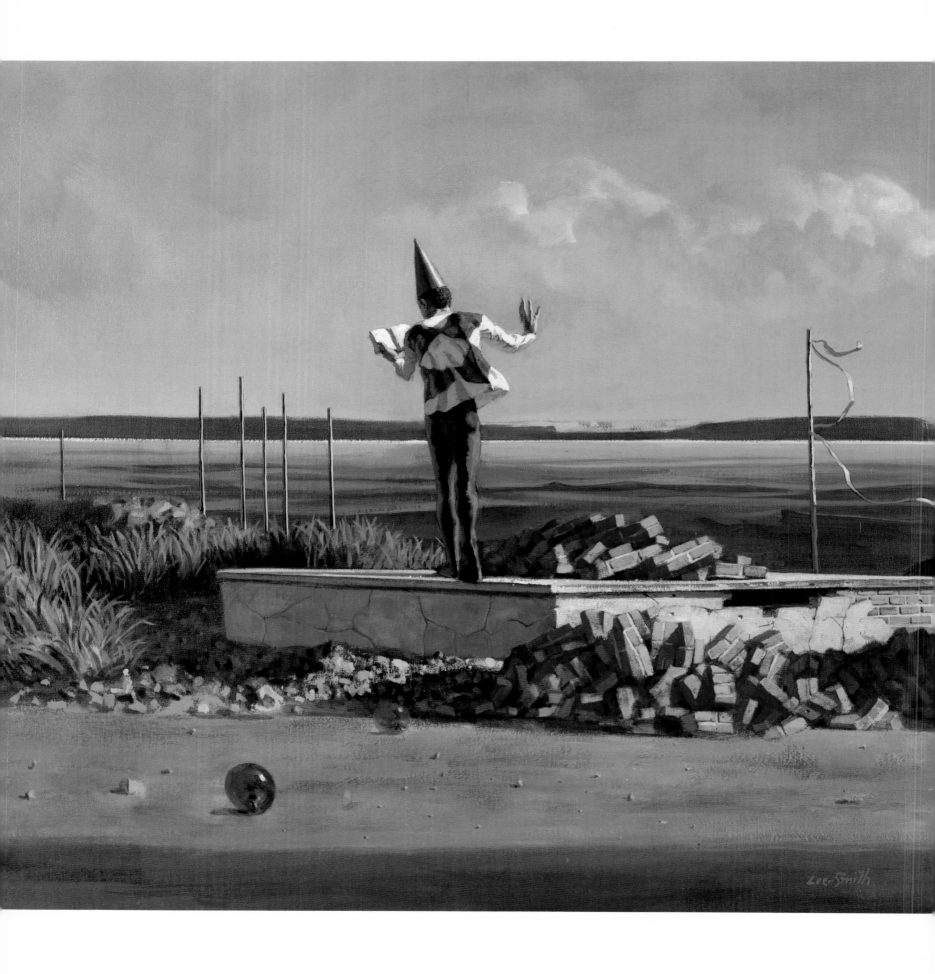

104 **Plate 54. Hughie Lee-Smith,** *Soliloquist,* **1973, oil on canvas, 33¾ x 36½ in.**

© **Estate of Hughie Lee-Smith/VAGA, New York, NY**

in the foreground convinces us that this is a real-life situation. Instead, the real and unreal mingle together in this vision, set in a surreal twilight that is neither morning nor eventide. Such is the painterly will of this well-schooled academician. His scumbling technique of pulling a dry brush over the canvas is as poetic as it is visually seductive.

The iconography of Lee-Smith's art speaks of alienation from the self. A oneness not measured by the presence of recognized form permeates the air, the sea, and the lonely atmosphere. Time seems unmeasured, as does the medieval costumes worn by the reader. All point to an otherworldly feeling that the figure emits. We sense the mysterious presence of those who watch from afar yet are hidden from our natural vision. The feeling in Lee-Smith's art is that of an all-pervasive dream. That he is able to communicate such a feeling without resorting entirely to surrealism speaks eloquently of his creative confidence, grounded firmly in knowledge of classical art. The landscape in many of Lee-Smith's paintings becomes a metaphor for that which is serene and mysterious beyond our vision. However, it is never a dreamscape but a peaceful place we long to see.

Poetic and lyrical, Lee-Smith's paintings are romantic in style, communicating a remarkably melancholy atmosphere in which the heart seems lonely beyond measure. Lonely people talk to the wind, with their backs facing the viewer. Vertical poles recur in his works, pointing upward to a sky empty of all but clouds, as in *Festival's End #2* (Plate 55). Most often, one pole in the picture is decked with a pink ribbon that blows gently in the wind, like clouds in a windy sky. The stillness of time seems unaltered by the flow of the ribbon. It is a faint reminder of the artist's feelings about the desolation in life.

The scenery takes center stage in Lee-Smith's work, with illusionary props often added. The figure of a woman or a man at times seems incidental to the mysterious presence of nature and an ordered world that borders on the surreal. Therein lies the clue to Lee-Smith's magical approach to form, form that we see daily but view differently according

to our individual lives. Perhaps more than any other African American artist of his generation, Lee-Smith drew upon the psychological vision from within and remained an optimist about the power of the image to influence the soul.

Elizabeth Catlett (1915–)

Elizabeth Catlett is one of many African American artists whose creative skills are not limited to a single medium. Born in 1915 in Washington, D.C., Catlett is widely recognized as a talented artist whose work in sculpture, painting, and printmaking has been viewed and collected around the world. At Howard University, where she received the Bachelor of Science degree in art in 1937, Catlett proved herself a competent artist in several media, although her principal one was painting. In 1940, after two years of concentrated study in sculpture at the State University of Iowa, Catlett was awarded the university's first Master of Fine Arts degree. Thereafter, Catlett's career as an artist would be both courageous and colorful as she chose a path in art that was partly uncharted, especially with regard to the role of black artists in the social and political scene in modern America.[26]

Taking her cue from artists who, often without patronage, created works that spoke to the inhumane conditions of underclass people, Catlett chose a similar pursuit. She shaped her art to address social issues among women and ethnic minorities. Catlett visually narrated such themes as war, hunger, poverty, motherhood, and the plight of women of all races who live in a white, male-dominated society.

Art, in the eyes of Elizabeth Catlett, does not always have to be narrative. However, she prefers that it always carry a message, speaking to social issues such as race and gender. For Catlett, art is not a profession isolated from society. It is part and parcel of a larger whole, and for her, a humane understanding of people transcends the issue of race. Catlett's own background is multiracial; the blood of Africa, Europe, and the Americas flows in her veins. Samella Lewis, noted artist, historian of art, and former Catlett student, describes the artist: "In her person she is tall; in her carriage, regal; in her

106 **Plate 55. Hughie Lee-Smith,** *Festival's End #2,* **1987, oil on canvas, 38½ x 38¾ in.**

© Estate of Hughie Lee-Smith/VAGA, New York, NY

demeanor she is usually modest and gentle, but injustice hits her like flint and sends off sparks of assertiveness."[27]

Catlett's art, in the form of printmaking and sculpture, embodies the strength and character of her own multiracial heritage. Her subjects are more often black, and the blackness she portrays is sometimes, but not always, a universal symbol for suffering. She reminds us that the homeless, the deprived, and the forgotten souls among us often are people of color. In a style that moves between realism and an abbreviated form of cubism, Catlett's sculpture is individually and personally marked by her knowledge of the real world. Her art follows the tradition of competency set forth by so many African American women, beginning with Edmonia Lewis, over a century and a half of working in the medium.

In 1946 Catlett traveled to Mexico and was immensely impressed with the social content of work by Diego Rivera, Jose Clemente Orozco, and David Siqueiros. After she returned to the United States, Catlett's art showed influences from the modern Mexican art movement, influences in which the social and spiritual needs of people were magnified in the subjects she undertook. In 1947 she moved to Mexico City, where she married Francisco Mora, a Mexican painter of multiracial heritage. From 1959 until 1975 Catlett taught sculpture at the University of Mexico in Mexico City. Here she served as head of the sculpture department for more than a decade, overseeing an all-male department during her tenure. She won, in Mexico, the status of a creative prophet whose talents were highly applauded. At the same time, however—during the McCarthy era—the U.S. Department of State denied her a visa to visit relatives and friends in the United States. Even the loss of U.S. citizenship did not deter the artist from her resolve to pursue truth about American racism and prejudice through art.

A trademark of Catlett's art became the subject of the African American mother tenderly and lovingly holding in her arms her infant child, a theme she devoted attention to as early as 1939. While people of all races appear in her work, the African American woman, sometimes alone in a

troubling world, at other times enthroned in quiet and intimate moments as mother to a downtrodden race, dominates in her production.

Drawing heavily on African and Mexican art as a source of inspiration, Catlett has served for sixty years as a relentless voice of the people of the world crying out for justice, truth, and reason. This is a time when war, poverty, racism, anti-Semitism, and sexism have dominated contemporary life. Catlett has persevered in spite of losing her political voice in America. She continues to speak through her art about the issue of inhumanity to others in a violent and often chaotic world.

Among the first pieces of sculpture that the Cosbys purchased from Catlett was a work commissioned in 1980 titled *Maternity* (Plate 56). A triangular piece carved from black marble, *Maternity* moves away from the traditional poised mother and child based on the iconography of early Christian art. It instead shows the mother from her upper torso only, folding her arms lovingly around her child. A distant glance by the mother reveals the profile of a woman whose head is as ancient as the Mayans yet as modern as contemporary African Americans. The child, while joyously clinging to the mother, sits freely, implying the separation of the two that will follow in the name of the child's personal freedom. Polished with the perfection of an ancient stone from the tomb of an Aztec king, *Maternity* fluctuates between two worlds: that of an ancestral past where art was part and parcel of daily living, and one in which a modern view of enlightened motherhood is seen.

Woman Resting (Plate 57), a polychromed mahogany sculpture, was carved in 1981. Quiet and serene, the woman sits gracefully over a triangular space in which four spatial openings provide relief from the density of the wood while accentuating its grain. An abbreviated masklike face emerges from the woman's circular head, which rests gently in the woman's right hand. One of two Catlett sculptures of wood in the Cosby collection, *Woman Resting* relies heavily on a modern formula for sculpture that is informed by the academic

Plate 56 (this page). Elizabeth Catlett, *Maternity,* **1980, marble, height 26 in.** © Elizabeth Catlett/VAGA, New York, NY

108 **Plate 57 (facing page). Elizabeth Catlett,** *Woman Resting,* **1981, polychromed mahogany, height 19 ⅝ in.**

© Elizabeth Catlett/VAGA, New York, NY

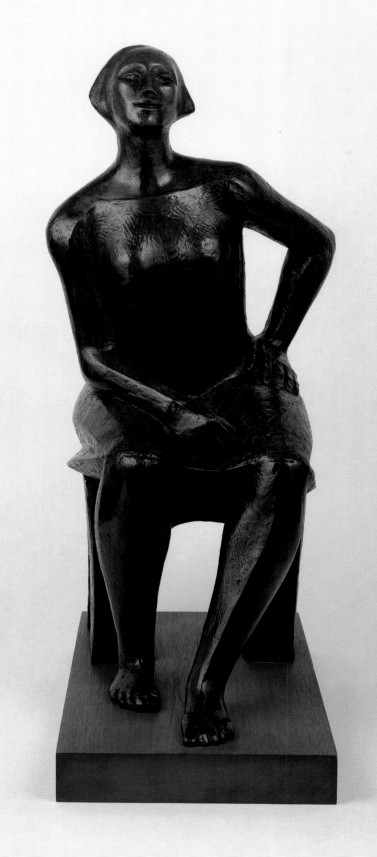

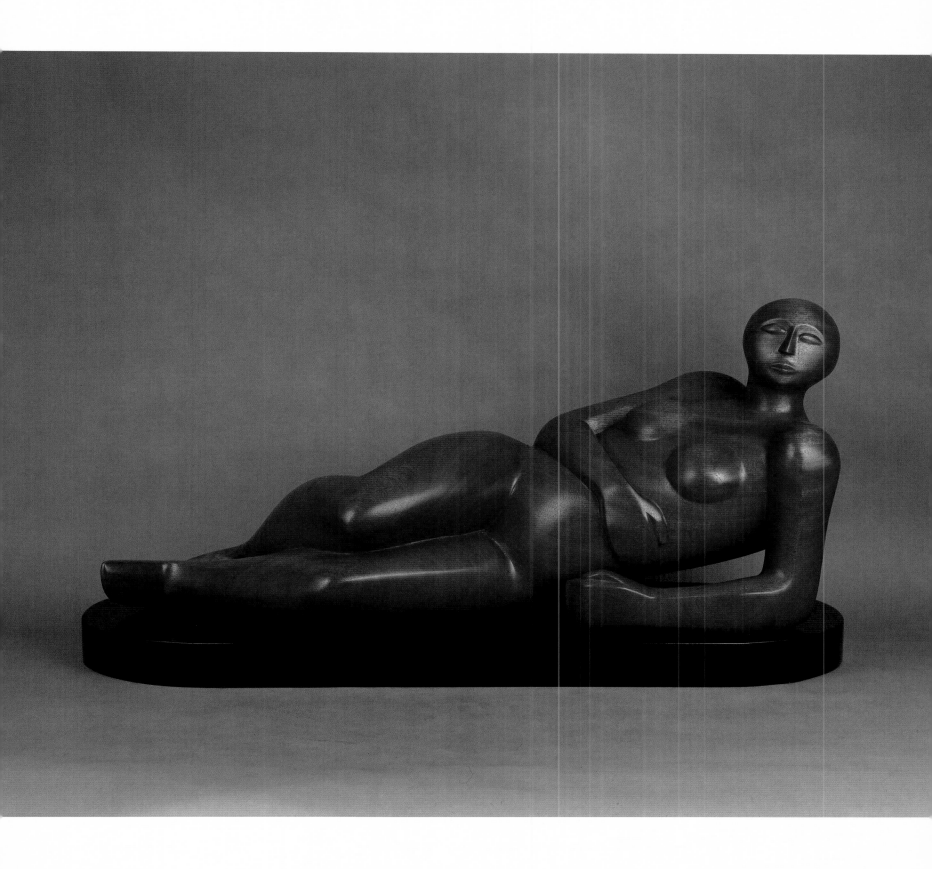

Plate 58 (facing page, left). Elizabeth Catlett, *The Family,* 1983–1984, marble, height 58 in.

 © Elizabeth Catlett/VAGA, New York, NY

Plate 59 (facing page, right). Elizabeth Catlett, *Woman Sitting,* 1985, bronze, height 26½ in.

 © Elizabeth Catlett/VAGA, New York, NY

Plate 60 (this page). Elizabeth Catlett, *Reclining Woman,* 1986, mahogany, height 14 in.

 © Elizabeth Catlett/VAGA, New York, NY

tradition, a tradition in which Catlett's art has been seasoned.

Most ambitious among the Catlett sculptures commissioned by Bill and Camille Cosby is a work titled *The Family* (Plate 58). Executed in the artist's studio in Cuernavaca, Mexico, in 1983 and 1984, the work was carved from a solid block of black marble. Its heaviness dictated that new engineering supports be installed in the floor on which the work stands in the Cosbys' residence. The sculpture weighs in excess of one ton.

Standing more than four feet high, *The Family* shows the embrace of a couple whose oneness is sealed by the interwoven mass each figure gives to the other. It is monumental in its totemic presence. Bound by their love, husband and wife are engaged in an erotic, timeless embrace. On the right shoulder of the mother can be seen the faces of the five Cosby children, all of whom have their own individual facial identity. The two open spaces between the bodies of the parents are more circular than geometric, thereby helping to relieve the density of the monumental stone.

In the fall of 1983 I visited Catlett's studio in Cuernavaca to see *The Family* in progress. At that time Catlett showed me a series of notes from a telephone conversation she had had with Bill Cosby. He explained to her that he wanted a surprise gift for Camille on the occasion of their twentieth wedding anniversary, and he had given a detailed description of what he envisioned in the sculpture. He had, in fact, sculpted in words a poetic statement for his beloved Camille and their five children.

The second commissioned work that Bill requested of Catlett was a sculpture he wanted executed in bronze. I received a call from Bill at half past one in the morning on a cold winter's night. He gave minute details about what he wanted in the work, which he thought should be titled "Sophisticated Woman". He spoke joyously for about an hour about the woman's poised look and her posture and dignity. Catlett responded with a strong sculptural statement, a portrait that reveals the soul of a woman. A quiet and gentle spirit emanates from the sitting figure, who, in

the words of Bill Cosby, is "confident of herself and knowledgeable about her spiritual worth and the solid institution of motherhood." *Woman Sitting* (Plate 59) exudes confidence, self-esteem, and an undisputed charm. But it is equally grounded in the classical mode of seeing beauty as the splendor of natural form. This and many other works of the female figure by the artist—including *Reclining Woman* (Plate 60)—reveal the archetype in Catlett's oeuvre.

Claude Clark (1915–)

Claude Clark began his career in art in the late 1930s. His parents moved in 1915 from rural Rockingham, Georgia, where Clark was born, to Philadelphia in order to escape the harshness of southern racism. In the Philadelphia suburb of Manayunk, Clark was exposed early to the visual arts. He was judged a professional artist just in time to be included in the last group of young black painters hired by the Works Progress Administration in Philadelphia in 1938. However, from the outset, Clark saw that his mission was not so much to see things realistically like most young artists of his generation but, like Elizabeth Catlett, to be a voice for change in the African American community.

Clark matured as a painter in a generation when some African American artists were looking at abstraction as a means of delivering their art into the American mainstream. By 1940 Clark focused his work on subject matter closely aligned with black genre. Folkways of the rural and urban scenes interested him greatly, and he set out to depict black America in a variety of ways. This was a time when the "Negro theme" was struggling to gain respectability and black artists were battling the stereotypes so often assigned black images. For Clark, the traditional arts of Africa influenced his work over the next three or four generations.

Clark's interest in African art went back to the formative years of his career when he studied art under renowned collector and art enthusiast Dr. Albert C. Barnes of the Barnes Foundation at Merion, Pennsylvania. Exposure to the modern European art at the foundation made him conversant

with the art of Picasso, Matisse, Cezanne, Renoir, and van Gogh, and he learned measurably from the techniques of those who had provided the visual blueprint for change in twentieth-century art. But at the Barnes Foundation he also learned about the role that African art played in the development of modern European art. There Clark first saw African art as an important place from which to begin his own aesthetic explorations. In later years he would draw directly upon African art to inspire his own paintings.

Clark bridged the gap between the Harlem Renaissance and the black cultural revolution of the 1960s. He embraced the tenets of Pan-Africanism and black nationalism at a time when many African American artists of his generation, notably Hale Aspacio Woodruff and Norman Lewis, were expressing their vision in abstract expressionism rather than social realism.

When Clark traveled to the Caribbean islands in the 1940s, he looked for subject matter that fitted his formula of showing black people throughout the African diaspora. *Sponge Fisherman* (Plate 61) is an engaging composition in which a black boatman retrieves sponges from the dangerous waters while guiding his boat safely back to shore. The composition is simply arranged to give prominence to the intense labor involved in both the work of the oarsman as well as the arduous task of keeping afloat "on the sea of life."

Whether painting at home in Philadelphia in the 1940s or at Talladega College in Talladega, Alabama, where he served as professor of art from 1948 to 1955, or Oakland, California, where he has lived since 1958, Clark always shows great respect for local subject matter. He often combines the immediate landscape with subjects that fit his painterly oeuvre. Among the most celebrated works in which people and place are made into a memorable visual statement is *On Sunday Morning* (Plate 62), an expressionistically rendered study of the African American Episcopal Church in the Philadelphia suburb where Clark grew up.

Over the years Clark has painted the social, political, and cultural journey of his people in the African diaspora. His visual odyssey seems unending in its approach to ideas that show great reverence for life. His work explores and at the same time creatively reveals to the viewer the depth of his artistry and humanity.

Eldzier Cortor (1916–)

Eldzier Cortor traces his ancestry to the South, a place where his art still lingers in spirit and form. Although his academic credentials are from midwestern and northern art institutions, Cortor's art reads invincibly southern. Born in Richmond, Virginia, during the waning years of the World War I, Cortor began art studies at the School of the Art Institute of Chicago. In the late 1920s, after working independently as a painter in Chicago, Cortor qualified as a working artist for the Illinois Federal Art Project. His art had received the attention of a number of art dealers in the East as early as 1940. He is among the few living American artists who have received both Rosenwald and Guggenheim Foundation fellowships.

Cortor was much sought after in the 1940s for his highly personal treatment of the black figure. His work was commended by novelist Sinclair Lewis, writers of *Life* magazine, and art historian James A. Porter, among others. All praised Cortor as the leading black artist of his day.

While Cortor's work was readily exhibited in the 1940s at the nation's leading museums, among them the Carnegie Institute in Pittsburgh, the Metropolitan Museum of Art, and the Art Institute of Chicago, few of these mainstream institutions purchased his work for their permanent collections. Was he not collected because of the age-old problem of racism in the American museum world? Certainly the fact that Cortor was a black man took its toll on the assessment of his talent by writers and critics of the majority culture. He was also married to a white American woman, which may have affected his marketability in some cases. But other factors pertained to the changing cultural order in art. American artists were gradually moving away from art that was figurally based to following forms of abstraction,

114 **Plate 61. Claude Clark,** *Sponge Fisherman,* **1944, oil on board, 18¹⁄₄ x 24¹⁄₂ in.**

Plate 62. Claude Clark, *On Sunday Morning,* **1940, oil on canvas, 40 x 60 in.**

particularly to that of abstract expressionism. While Cortor had excelled as an academician and also proved himself capable of creating skilled surrealist compositions, his talent and commitment remained with figural representation.

By 1950, Cortor's work was no longer in great demand. Less than five years after *Life* magazine had listed Cortor as the most talented black artist, Cortor no longer fit into the categories white critics used to assess black artists. For example, they called attention to black artists who were categorized as "primitive," "unsophisticated," and "naive," as was Horace Pippin. Then they wrote about artists who were well trained as academicians but who were not considered worthy of ranking with white artists. They also wrote about the handful of black artists who were shown in high-profile, mainstream galleries such as Edith Halpert's Downtown Gallery, Antoinette Kraushaur's Gallery, or those sanctioned by Mary Beattie Brady of the Harmon Foundation. Cortor did not fit any of these types.

After a brief hiatus in his production, Cortor began working without dealer representation, creating a series of lithographs and drawings that echoed the stylistic principles of his earlier work. Placing special emphasis on black nudes in crowded interiors, Cortor continued to paint in the superrealistic style of his earlier years. He was not greatly hindered by loss of patronage. Now in his eighties, the artist continues to produce a body of work that in many ways recounts and reestablishes him as a master of mysterious and ethereal settings. Figures in these settings, some of celebrity status, others unknown, mesh in an intriguing painterly format. They take the viewer back to another highly prized era in American art, the decade of the 1940s.

In recent years Cortor's early work has attracted the attention of new patrons of African American artists. As early as 1936, when he was only twenty, Cortor, like Jacob Lawrence at about the same age and time, painted black genre scenes. These paintings have attracted a new generation of black collectors, who are now searching the galleries and attics around the nation, particularly in Chicago, for Cortor's early work.

Women are the subjects of many of Cortor's early works. Most memorable are the compositions showing black women sitting in desolate interiors. Decaying walls, furniture, and architectural remnants seem synonymous with the lifestyle of the women who inhabit these rooms. Some of the nudes, their skin glistening as though oiled to an unusual darkness, live in a world close to that of the prostitute. They appear to be the neglected in society or those who live in deprivation.

These works reveal Cortor's keen ability to translate social analysis into visual understanding. In the decaying social order of the 1940s, black women were still looked upon as targets of abuse and as easy prey for marauding men of both races. The southern aristocracy had failed, and its outmoded mores belonged in a bygone era. Cortor often comments upon these changes in his works of the late 1940s. Even when he drifts quietly into that painterly moment where past and present blend harmoniously like dawn turning into daylight, he causes us to question the logic of his surreal journey. Time is often highlighted by the light that silhouettes and shadows the landscape beyond the main subject, adding to the sense of mystery.

In *Southern Theme/Magnolia II* (Plate 63), less than one-half of the torso of a solemnly poised black woman is visible in front of an ancient wall. The things viewed beyond the wall become a metaphor for those experienced in the real world. With this gesture of depicting both decay and growth, life and death, in the same iconographic sweep, Cortor proves himself a lyrical poet painting a dynamic picture with words. But he is always a painter of an inner vision. The swaying tree and Spanish moss in the background denote a southern setting. The equestrian mount, southern in style, and the meticulously painted magnolia that come to rest at the top of the right breast of the woman suggest those nights of spring when people's seri-

117

118 **Plate 64. Eldzier Cortor, *Homage to 466 Cherry Street*, 1987, oil on masonite, 36¾ x 46½ in.**

ous thoughts turn to fancy. Who is the partially eclipsed female who peers solemnly beyond the viewer into the future of the South? She calls to mind the rambling woman who, to paraphrase the blues singer, is never content to stay at home. Her manner of dress and her pose evoke vivid images of William Faulkner's novels about the South.

The social content of Cortor's paintings continues to hold the viewer spellbound even in works created as late as 1987. In a harmonious but complex composition titled *Homage to 466 Cherry Street* (Plate 64), Cortor depicts three rows of mailboxes at the entrance to an apartment building. Harking back to late-nineteenth-century trompe-l'oeil painting, the canvas dazzles the viewer with its accurately depicted twentieth-century images.

Several visual clues in the painting point to the race of the artist. The *Pittsburgh Courier,* a black weekly newspaper African Americans relied on for information before and during World War II, is protruding from a mailbox in the top row. Few whites have ever heard of, or read, the *Courier.* A postcard from Haiti rests on the top of the row of tiles in which the mailboxes have been built. African Americans knew of the societal ills associated with the Republic of Haiti regarding matters of class and race. Most also knew Haiti in the 1940s as a symbol of self-determination and freedom.

The juxtaposition of time, place, and event in *Homage to 466 Cherry Street* shows the formula by which Cortor distinguishes himself from the ordinary academic painter: He represents form in a personal manner, thereby rendering it timeless. Cortor's style is unencumbered by the knowledge of what is in vogue, even when fashion renders art of a figural nature less appealing to contemporary viewers.

The names Tiger Flowers, Jack Dempsey, and the Brown Bomber, as well as Joe Louis's portrait—all situated at strategic places throughout Cortor's *Still Life: Souvenir No. IV* (Plate 65)—tell the viewer of a particular era in American history. Another black journal appears, the *Chicago Defender*, one of the nation's oldest African American newspapers. Nostalgia allowed Cortor to present the race as

strong, healthy, and proud. It was an important cultural device black artists, journalists, and clerics used during a period of governmentally sanctioned segregation, FBI spying, and racism.

Although *Still Life: Souvenir No. IV* was painted in 1982, it is characteristically Cortor. It is classically composed to show the artist's competency at rendering complex drapery folds and his scientific accuracy in depicting the flow of light on the objects throughout the composition.

Cortor has never abandoned the human figure as a central element in his work. It is, without doubt, the trademark by which his work will be known in years to come. The reading of history, meshed with the unique character of the people who make the history come alive, are vibrantly celebrated in the artistry of Cortor, who remains an academician of the first order.

Jacob Lawrence (1917–2000)

Jacob Lawrence, like Romare Bearden, was a venerable visionary of African American art. His art often reflected painstaking research into the social history of African Americans. Lawrence redefined, with historical accuracy, the social and political paths African Americans traveled over the past three centuries. He focused in particular on our inhumanity to one another, painting with a discerning eye the social problems of oppressed peoples. Although his themes are often racial pride and human justice and his subjects often black, his art addresses the larger issues of human despair, illness, violence, and racial strife, all of which appear in the vernacular of black experience.

By the young age of twenty-five, Lawrence had done a number of paintings that visually defined black history. First in the line of such works was the series of forty-one tempera paintings titled *The Toussaint L'Ouverture Series.* Painted in 1938, these works showcased François Dominique Toussaint L'Ouverture's bravery and racial pride as he brought independence to the Haitian people in 1804. Lawrence's success as an easel painter was virtually assured

with the painting of *Toussaint L'Ouverture*. Following the completion of this work, Lawrence painted a series of narrative paintings based on the lives of John Brown, Harriet Tubman, and Frederick Douglass and on the great migrations of southern black families.

Lawrence's art often exhibited a narrative format, when few other artists of African ancestry followed this path. He introduced straight planes that overlapped one another to create a formal dimension. But Lawrence was not intentionally following a modernist formula. Instead, he was simplifying form based on his chosen elements of design. From the beginning, his palette was limited to basic colors that could readily be obtained from mixing ordinary tempera and poster paints. He often used the three primary colors with infusions of black, brown, white, and gray. Understanding the magic of line used as content, not just to enclose form, Lawrence created meaningful spatial relations within each composition. A self-styled image emerged, one that was uniquely flavored by the artist's knowledge of history, by his formal training, and by his own personal view of the world.

Prior to entering the United States Coast Guard in 1943, Lawrence began a series of paintings that drew its subject matter from the streets of Harlem. Encouraged by the patronage of the Harmon Foundation, the Phillips Collection, and the Museum of Modern Art, Lawrence saw his fortunes rise on the American art scene, an ascent then unequaled by any other black artist except Horace Pippin. His patronage in the white art world was strengthened when Edith Halpert, director of New York City's Downtown Gallery, exhibited his work in 1941. Thereafter, the Harlem community and black people in general became the main subjects of Lawrence's work.

The three Jacob Lawrence works illustrated here, chosen from more than fifteen in the Cosby collection, all center on life in the busy streets of Harlem. In a composition from 1942 titled *Street Scene, Harlem* (Plate 66), Lawrence chronicled, with the eye of a photographer and the heart of a storyteller, the myriad activities of Harlem. The local hotel, the bar and grill, and the quiet sanctuary of the black church with its prominent display of the cross appear. Automobiles, delivery trucks, and fruit wagons appear, and people stroll leisurely on a crowded street, as if programmed for action in a movie. Like Romare Bearden, whose work the artist saw in Harlem early in his career, Lawrence found in the black urban metropolis the inspiration for his work.

In a composition titled *Blind Musician* (Plate 67), also from 1942, the subject holds a crowd spellbound with his music at the entrance to the local store, which doubles as a bar and grill. With a cigar box spread before him to collect coins, the street musician invites patronage from the listeners as he celebrates the joy of music before the stylishly dressed crowd. As in *Street Scene, Harlem*, Lawrence does not assign individual features to the people in the crowd. All seem silently engrossed in the entertainment. But the color in *Blind Musician* is highly charged and fits clearly in a modernist formula of painting.

In many ways Lawrence was following the lead of artists in Harlem whom he greatly admired, among them Augusta Savage, Charles Alston, and James Lesesne Wells. The result was a series of paintings, executed between 1942 and 1943, that gave personal definition to the community the artist had known since the age of ten. While other artists looked for subjects beyond Harlem, Lawrence continued to see the streets of the city as an important laboratory in which to remake his own creative world.

By 1950 noticeable changes appeared in the way Lawrence composed a painting. He remained capable of simplifying form and reducing it to its most essential elements, but he became more conscious of the quiet nuances of color and the tonal relations he could achieve. Style for Lawrence, unlike for Bearden, meant pressing every inch of life out of each color before employing another. Lawrence carefully selected the elements of cubism and formal abstraction to be included in his compositions. He thus

Plate 66. Jacob Lawrence, *Street Scene, Harlem*, 1942, gouache on board, 21 3/4 x 29 3/4 in.

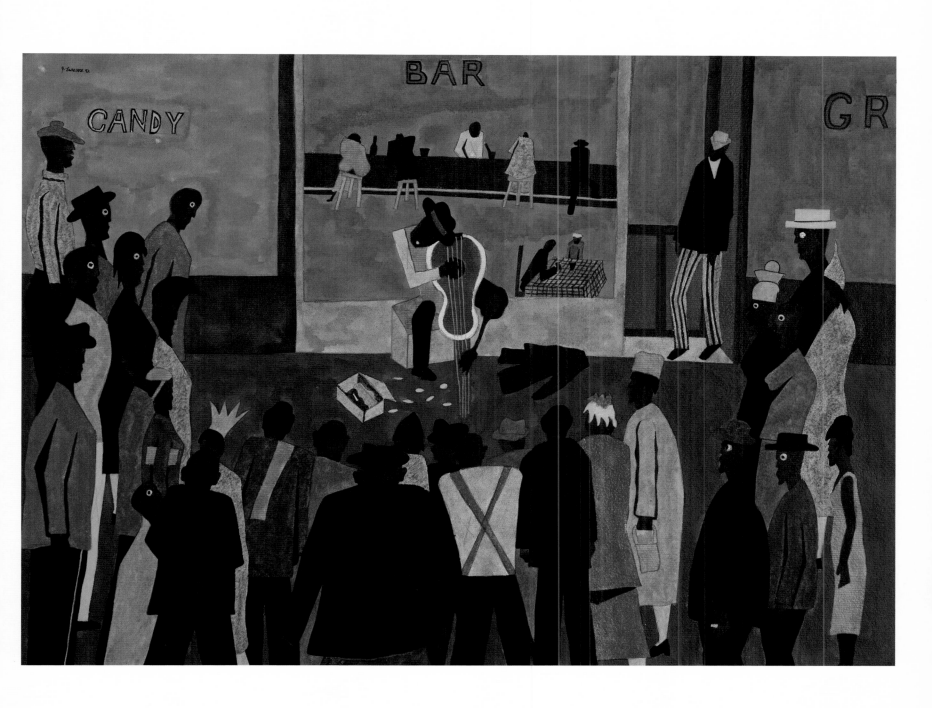

Plate 67. Jacob Lawrence, *Blind Musician*, 1942, gouache, 21 x 29 in. 123

achieved a more sophisticated view of the same Harlem street scenes he had depicted in the 1940s.[28]

In a composition titled *Harlem Street Scene* (Plate 68) from 1959, Lawrence no longer relies solely on a flatly painted surface, where the figures seem to have little or no individual space. Each figure stands firmly on its own, contributing to the overall success of the composition. Divisions within the shapes that translate as children jumping rope, a mother holding an adoring child, and young acrobats balancing on a wrought iron fence reveal a more active and mature plan of composing and painting. Yet, in his sophisticated way of altering the composition, Lawrence did not allow the cubist formula to dominate his style. He chose instead a style of painting in which the literal narration of a theme was paramount.

Throughout the 1950s and beyond, Lawrence continued to paint life in its many forms in black America. For the 1955 to 1956 series titled *Struggle: From the History of the American People,* Lawrence researched the subjects of democracy, peace, and the struggle to be free and presented them in the same self-empowered style that characterized *Harlem Street Scene*. The freedom of all Americans regardless of color was his overriding theme.

Lawrence moved to Seattle to become a professor of art at the University of Washington in the early 1970s, leaving behind the busy streets of Harlem. However, in Seattle Lawrence engaged in another series of paintings in which carpenters dominated the scenes. The handsome tool collection he displays in his studio is the visible source of this series. *Builders,* as the series was called, was a prophetic name for paintings that built upon the strength of Lawrence's past artistry. The series also provided direction for the work that followed his productive tenure away from his beloved Harlem, the source of so much of his art in the years of his flowering.

Lawrence delivered a positive formula that contributed succinctly to the making of the new black image in American art. It redefined the meaningful boundaries of forms of social emancipation, moving away from popular artistic forms toward a special racialization in art that paid strict attention to self-definition, self-identity, and self-affirmation. Lawrence led the way throughout his lifetime in affirming the permanency of the new black image in American art.

Charles White (1918–1979)

Charles White completes our overview of artists born between 1905 and 1920 who labored untiringly for more than forty years to create images of dignity portraying the black experience. White's intention was to depict the lifestyles of African Americans with recognizable symbols that were both culturally and historically relevant and pleasing to look at. That he was able to fulfill such an important mission and at the same time invite an unselfish, introspective look at black culture is as inventive as it is commendable.

Although other artists of White's generation moved their art further into abstraction, White, without apology, pursued a steady diet of academic realism. He portrayed black subjects as race hero or heroine, or he depicted the racially deprived black victim as society's throwaway, noting that there will always be a viable underclass, separate and unequal, in American society. Considered by some to be one of the nation's most able interpreters of the multifaceted black experience, White used his art as a tool through which to inform his people of their sufferings, their culture, and their history.

Setting out to portray positive images of the black race at a time when the American press, educational journals, popular novels, and textbooks were still locked into the myth of the inferiority of African Americans, White worked in the tradition of the Mexican muralists, who greatly inspired him. White created images of dignity that refuted the usual stereotypes of black subjects.

Many of White's works—more than twenty in the Cosby Collection of Fine Arts—were created during the height of the Civil Rights movement in the 1960s. It was a critical time for African Americans, fighting to validate their own culture in a society that had legally mandated segregation. They observed some liberal white Americans in the 1960s

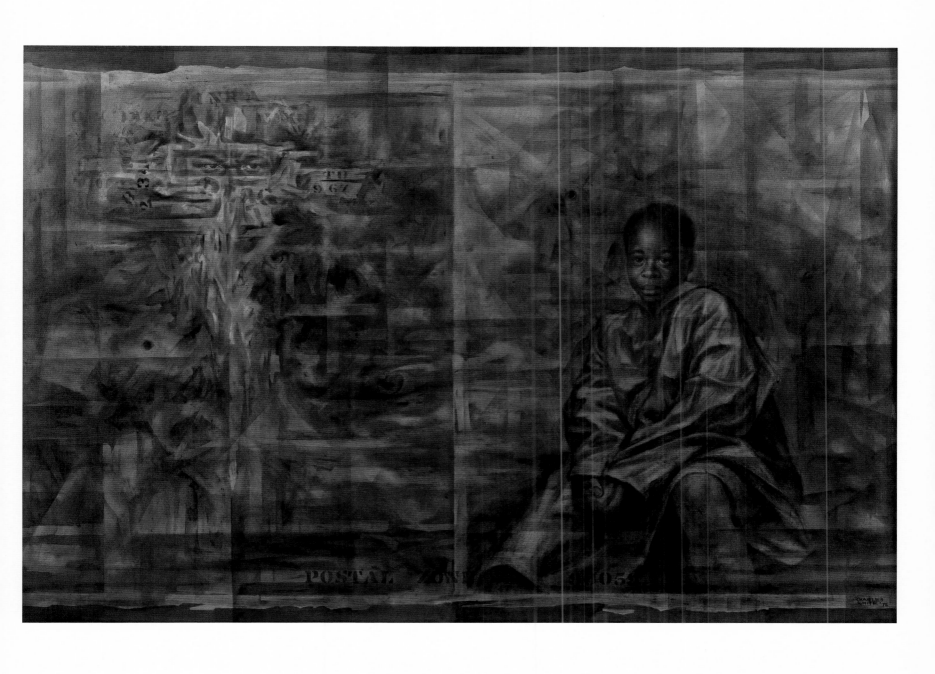

Plate 69 (facing page). Charles White, *Seed of Heritage,* **1968, ink on illustration board, 60 x 45 in.**

Plate 70 (this page). Charles White, *Wanted Poster #18,* **1972, oil on illustration board, 37³/₄ x 54⁷/₈ in.**

pursuing the goal of integrating schools while still holding onto the tenets of a well-segregated social order.

White became keenly aware of these contradictions in American society and lent his skills as a draftsman to the effort of showcasing the ills of the nation, particularly those pertaining to racial prejudice. He did this through the academic expressions of realism and at times through elements of naturalism. Yet he did not succumb to the idea that art based in figural content is by its nature social protest art. White's art indeed protests injustice, but the visual impact of his message is larger than a particular school of thought. His art addresses all forms of prejudice within the rubric of his own personal experience. The black experience was what he knew best, and from it came an outpouring of soulful drawings, paintings, and prints that mirrored images from everyday life.

In a quiet moment in his Altadena, California, home, White told me in 1972 that he had tried "to paint but one picture all of his life." He described his task as being an "unending toil—one aiming to show the black race in all of its majesty, its triumph, its weakness, and even its downfall." Images of the black race, he noted, must be images of dignity devoid of the stereotypes some white artists imposed on African Americans. To this end, White felt that political ideas were an important wellspring from which he as an artist of color should draw freely. White felt that freedom, courage, and self-assertiveness went hand in hand with visual literacy.

Seed of Heritage (Plate 69), dynamic in its graphic structure and symbolism of motherhood, is a powerful visual depiction of the African American woman contemplating the birth of her child. She speaks, through her gaze, an eloquent voice of concern for past, present, and future lives in the same way that her forebears in Africa professed concern for the children to come. Executed in a monochromatic scale of deep sepia browns, *Seed of Heritage* is the archetypal fecund woman. Yet in contrast to her European model, *Felicitas Publica*, the ideal black mother

lacks the more erotic felicitous description; for her no epithalamium is heard. Instead, this mother of the race, a Harriet Tubman, the Moses of her people, registers depth of thought on her solemn face. She is the goddess enthroned without royal accouterments. She communicates the strength of artistry of which White so eloquently spoke when he said that all his life he had worked to create one inspiring image.

White offered a special vision when he created images of injustice among African Americans. Beginning in the late 1960s, White painted a series called *Wanted Poster* that combined subjects from popular culture such as posters, want ads, and urban graffiti in a format that appeals as much to our emotions as to our visual sensibilities.

Wanted Poster #18 (Plate 70), created in 1972, was among the last works of this series. The drawing is divided into two equal rectangles. On the left side a series of crosses forms a calligraphic setting, sometimes collaged with small strips of paper from which the partial face of a man appears. Words and numbers are painted into the background of the wash and stained drawing, alluding to the coded and symbolic messages found on scraps of paper carried by escapees on the underground railroad. Multiple linear devices are used in the same way as a painter employs layer upon layer of glazes over an agitated sepia background.

On the right side of the picture, the full figure of a boy is sitting in front of the heavily washed surface on the left. The image evokes memories of White's own childhood, a relatively deprived one in the Chicago of the 1920s. Stenciled into the bottom of the work is "Postal Zone 90059," the artist's zip code in Altadena, California. The numbers allude to White's notion that even in the twentieth century he was still actively connected by numbers to the slave trade and its atrocities. Typical of the artist's humility, the citation of the zip code places us at a particular location and condition in life. Indeed, the autobiographical references identify the artist as one of the myriad of people

Plate 71. Charles White, *Homage to Langston Hughes,* **1971, oil on canvas, 48 x 48 in.**

throughout the world who has endured suffering, oppression, religious persecution, or some form of social injustice. For this reason White's art is said to belong not just to African Americans but to all the oppressed peoples of the world. *Wanted Series* and *Seed of Heritage* need no verbal amplification to make real their universal message.

Although one trademark of White's artistry is his reliance on black-and-white images that are closer in technique and execution to drawing, he was equally adept at using color as a major element in his work. This technique was particularly evident when he painted in oil. Showing White's skill with color is an oil composition from 1971 titled *Homage to Langston Hughes* (Plate 71). Contrary to expectation, the poet laureate of the Harlem Renaissance is not shown in this painting. Instead, a young black male dominates the composition. He is standing at its center with arms folded, staring frontally at the viewer. Slightly below the center of the composition is a gray band rendered in a monochromatic scale. Here have been painted five portraits of a derby-wearing entertainer from the Harlem Renaissance. Immediately behind the standing male figure and near the apex of the work is the image of a white bird. It looks more like a wounded or captured eagle, although smaller in size than a dove. The geometrically patterned background of crosses and collaged markings seen in *Wanted Poster #18* is used in *Homage* but with a limited dispersion of color.

Emerging from the core of this square composition is a circle that ties together all the narrative elements of the painting. Stars, alphabets, and question marks augment the complex design, imbuing the painting with a sense of mystery. The composition singles out as the poetic subject the street dude who is hip and hard and schooled in the ways of life. He is the ideal subject for artists who use words and emotions to communicate individual spirituality.

White labored assiduously to create a weblike composition whose threads stretch restlessly over the surface of the entire painting. No technical stone is left unturned in his pursuit of compositional maturity in this homage to a black

literary giant in the person of Langston Hughes.

Painting in oil challenged the artist to seek his own path within the limiting formula of realism. White combined the technique of the old masters, which entailed painting in a dominant background of earth colors, with the technique he learned from using charcoal and Chinese ink in drawing. In most of White's late paintings, particularly those he created in the 1970s, a limited palette of earth-related colors such as burnt umber (a color close to the ink stains he used in his drawings), mars red, burnt sienna, and yellow ocher becomes a code by which these works are readily identified. The white bands of paper painted to look like strips of collage, scattered throughout as a unifying force, contribute to the success of *Homage to Langston Hughes* and similar works.

White sought not to pursue any style simply because it was in vogue. Instead, he embraced the universal by incorporating black images of dignity into the human family. Seeing the world through the eyes of the black experience, Charles White worked in the long shadow of the Harlem Renaissance, and he willingly followed its mandate to create the new black image in American art.

Part 5 Notes

1. The Ashcan painters, named for their interest in urban scenes in American cities, worked principally in New York City. They defined urban life differently than had previous artists: They painted people, street scenes, alleys, and everyday life in a way uncharacteristic of traditional academic painters, incorporating into their work a flair for modern stylistic principles of painting. No African American artists were among the school's ranks.

2. Alain Locke, "The African Legacy and the Negro Artist," *Exhibition of the Work of Negro Artists* (New York: Harmon Foundation, 1931), p. 10.

3. David Levering Lewis, *When Harlem Was in Vogue* (New York: Oxford University Press, 1979), pp. 190–191, 237.

4. White's celebrated mural at Hampton Institute was completed in 1943 with assistance from young aspiring student artists, among them John Biggers, who was invited back to Hampton University to complete his most ambitious mural project in the early 1990s at the Norma and William Harvey Library.

5. The mural painting tradition of the 1930s, the 1940s, and the 1950s—including the work by Lois Mailou Jones and Charles

White at Howard University in the 1940s—served as a model for young African American muralists of the 1960s, who took to the streets, vacant lots, and sides of buildings and urban viaducts to keep alive an important cultural tradition. Most notable among the urban murals of the 1960s during the Civil Rights movement, a theme that young black muralists of the period often celebrated, was the famous *Wall of Respect* in Chicago.

6. Hale Aspacio Woodruff, conversation with author, April 1975 in New York City.

7. Mary B. Brady, correspondence with author, April 1959, Talladega College.

8. Elton C. Fax, *Seventeen Black Artists* (New York: Dodd, Mead & Company, 1971), p. 155. See also Tuliza Fleming, *Breaking Racial Barriers: African Americans in the Harmon Foundation Collection* (Washington, D.C.: Smithsonian Institution Press in association with Pomegranate, San Francisco, 1997), pp. 6–7, 10–11, 20–26.

9. Romare Bearden, "The Negro Artist and Modern Art," *Journal of Negro Life* (December 1934), pp. 371–372.

10. Allan M. Gordon, *Palmer C. Hayden* (Los Angeles: Museum of African American Art, 1988), pp. 16–26.

11. Alain Locke, *Negro Art: Past and Present* (Washington, D.C.: Association in Negro Folk Education, 1936), p. 47.

12. Starmanda Bullock et al., *James A. Porter: The Memory of the Legacy* (Washington. D.C.: Howard University Gallery, 1992), p. 23.

13. James A. Porter, *Modern Negro Art,* 3d ed. (Washington, D.C.: Howard University Press, 1992), pp. 3–34.

14. Tritobia Hayes Benjamin, *The Life and Art of Lois Mailou Jones* (San Francisco: Pomegranate, 1994), pp. xv, 13–15.

15. Ibid., pp. 26, 41.

16. Drawings by Lois Jones first appeared on the cover of *Opal* magazine as early as the 1920s.

17. Benjamin, *Lois Mailou Jones,* pp. 97–99.

18. In a discussion with Lois Jones following the symposium, I asked her if she meant "the only surviving painter who had connections to Harlem Renaissance artists," since she did not figure into the initial aspects of the New Negro movement. She responded by asking, "Who are the others?"

19. Romare Bearden and Harry Henderson, *A History of African-American Artists from 1792 to the Present* (New York: Pantheon Books, 1993), pp. 260–271.

20. Richard Mayhew, conversation with author, National Conference of Artists, Detroit, Michigan, March 30, 1999.

21. Bearden and Henderson, p. 321.

22. Emma Amos, conversation with author, Skowhegan School of Painting and Sculpture, Skowhegan, Maine, 1998.

23. Gail Gelburd and Thelma Golden, *Romare Bearden in Black and White* (New York: Whitney Museum of American Art; Harry N. Abrams, 1997), p. 28. See also Myron Schwartzman, *Romare Bearden: His Life and Art* (New York: Harry N. Abrams, 1990), pp. 211–228.

24. "Maude Sleet" is a name Bearden used over and over in many of his collage paintings. It is unknown if she really existed; more than likely she did. If so, Bearden remembered her from his childhood while growing up in Charlotte, North Carolina.

25. Theresa Leininger-Miller, conversation with author, Cincinnati Museum, Cincinnati, Ohio, March 2000.

26. Samella Lewis, *The Art of Elizabeth Catlett* (Claremont, CA: Hancraft Studios, 1984), pp. 97–101.

27. Ibid., pp. 165–166.

28. Ellen Harkins Wheat, *Jacob Lawrence: American Painter* (Seattle: University of Washington Press, 1986), pp. 107, 143, 190–192.

The Harlem Renaissance Inspires

Art history texts written by white authors seldom mention the Harlem Renaissance. Few writers of the majority culture have ever heard of this movement, which most African Americans regard as the turning point of their culture in twentieth-century America. Robert Bone is one of the few white writers who move beyond the narrow confines of race to write inclusively about American culture. He defines the Harlem Renaissance as pivotal to a full understanding of twentieth-century American art and asks why the movement is so central to black scholars and artists and so ignored by others. One answer seems clear: History continues to be chronicled in the Eurocentric formula, which honors the work of white male artists over that of women and people of color.[1]

Significantly, race was the subject that helped single out the importance of the arts in Harlem in the 1920s. By the same token, it was race that caused black artists of the nineteenth century not to look at themselves and their families as subjects worthy of depicting in art. Instead, these artists followed the prevailing trends, seeking to emancipate themselves culturally from the widely held assumption that people of African ancestry could not produce art comparable to their European counterparts.[2]

Robert S. Duncanson, Mary Edmonia Lewis, and Edward Mitchell Bannister were among those nineteenth-century African American artists who proved to a skeptical white world that they were capable of competing in the visual arts. They were among the first to challenge the myth that racism in art had a scientific basis and that slavery had imprinted an indelible mark on the culture of the African in the United States. They refuted the notion that black cul-tural aspirations were hampered by the African's so-called pagan past. The cultural emancipation these nineteenth-century artists sought helped enable artists of the Harlem Renaissance to move toward social emancipation, a move that took the form of black artists defining their own cultural agenda and forging a direction in art that did not embrace aesthetic opinions from outside the black race.[3]

The Harlem Renaissance became a movement by black writers, musicians, dancers, painters, and sculptors living in New York City in the 1920s to promote the best talent within their ranks. The artists of Harlem, while somewhat distant from the art scene in Greenwich Village in downtown New York City in the 1920s, knew they were part of a lively social circle. It was nurtured alike by academics, a few patrons of the arts, and artists. In this conglomerate of black southern folk traditions and northern sophistication, the newly inspired look back to African culture became paramount.[4] The Harlem Renaissance encouraged scholarship and creative entrepreneurial involvement in the arts among African Americans throughout the nation. It encouraged black artists to think of Africa as their ancestral home. The rekindling of interest in African ancestral arts in the first quarter of the twentieth century in Harlem was, indeed, a rebirth of black artistry.

Adding to the creative inquiry that the Renaissance fostered, collectors of African and African American art played an important role in preserving the art of people of color, thereby establishing patronage within the race. Alain Locke and James V. Herring, both Howard University professors in the 1920s, led the collecting of works by black artists. Herring and Locke singled out the art of nineteenth-century

pioneering artists such as Joshua Johnston, Robert S. Duncanson, Edward Mitchell Bannister, Mary Edmonia Lewis, and Henry Ossawa Tanner. Without this insightful leadership, these artists' viable contributions to American art in the period of slavery and immediately thereafter most likely would have remained undocumented.[5] Because of the efforts of Herring and Locke, many African American colleges and universities began collecting the works of black artists, and thus many of these collections date from the period of the Harlem Renaissance.[6]

Knowledge of the Harlem Renaissance, as well as the history of the pioneering black artists who preceded the New Negro movement, is crucial to our understanding of why African American families, particularly Camille and Bill Cosby, have collected African American art. The legacy of collecting black art became one of the main tenets of the Harlem Renaissance, and for this reason a review of the role of the Renaissance on contemporary African American artists is important.

An important question regarding the Harlem Renaissance must be asked: Was a rebirth of African culture really under way in the 1920s, or was the "Renaissance" the beginning of a new era of creativity that showed the genius of black artists only in hindsight? Aaron Douglas, considered by Alain Locke to be "the father of black art in America,"[7] was among the first to choose African iconography as a means of connecting his art to Africa and the ancestral legacy. Many years after retiring from Fisk University, Douglas said, when asked about the Harlem Renaissance, "The world was shocked and amazed at the spectacle of an economically depressed and culturally retarded group of people giving artistic forms to their deepest spiritual yearnings, as well as to their social, economic, and political concerns. This movement is called the Renaissance because of its sudden appearance, its vigor, its wide scope and its nearly exclusive concern with the creative arts. . . ."[8] Yet recent authors, including the late Nathan Huggins, writing in *Harlem Renaissance,* concluded that the

Harlem Renaissance may have been more a manifestation of white folks' desires for primitivism and exotica than a legitimate rebirth and revival of African culture in Harlem.[9]

Most observers conclude that a different approach to making and understanding art in the African American community in Harlem did indeed take place. As Aaron Douglas said, "The Renaissance was a cultural experience, in a sense, a sort of spiritual experience." He added, "It was difficult to put your hands on it, because it wasn't something the people actually understood as really a thing of great importance."[10] Douglas acknowledged that the Renaissance did not filter down to the average household in Harlem. Instead, it remained mainly among those of the black intellectual community who lived on Sugar Hill.[11]

I believe a rich and powerful movement was in fact reborn from the latent talent so long dormant and unrecognized among African people in the United States. I ask, Did we not manifest the spirit of artistry in the making of serviceable art forms during the period of slavery?[12] The outpouring of creative energy black artists showed in the 1920s was indeed a rebirth and revival of our creative spirits.

Historians of the Harlem Renaissance often are unable to pinpoint an exact date for its beginning. However, certain milestones in the making of the New Negro movement are indicators of the readiness of the African American community in Harlem to forge ahead in a new cultural direction.[13]

As early as 1919, when black soldiers returned from the Great War in Europe, signs of a changing cultural order were visible in the streets of Harlem. Literary clubs were open, and art exhibitions and musical and dance evenings were being held, intended solely to uplift the race through art.[14] Black soldiers returned home to the welcoming cheers of a New Negro mind-set, one intent on changing Jim Crow laws in American society. But the United States was not yet ready to yield the rights of citizenship to the black soldiers who had fought in World War I. The years 1919 and following also mark the unusual sagacity of black intellectuals who congregated in Harlem and demanded civil rights. Movements

committed to what later would be called black nationalism, such as Marcus Garvey's United Negro Improvement Association, were founded during those years.[15] Racial issues became important to common folks. People took to the streets and marched for peace, racial justice, and women's suffrage.[16]

An equally important date in establishing Harlem as the cultural capital of black America is 1925, the date of the publication of *The New Negro,* an anthology of the literary arts of African Americans.[17] Edited by Alain Leroy Locke, the progenitor of the Harlem Renaissance movement, the book soon became the bible for those who led in the creative arts. Locke, an art critic, aesthetician, and professor of philosophy who became the nation's first black Rhodes Scholar, reasoned that if Picasso, Modigliani, Bruncusi, and other modern artists had used African art as a source for inspiration, then surely African American artists, who had the blood of Africa running in their veins, could likewise.[18] But it would take the molding and forging of new ideas and a willingness to pursue a new direction in art to bring into existence so complex a movement.

The flowering of the creative arts in Harlem of the 1920s covered many media. Poets Langston Hughes, Claude McKay, and Countee Cullen, novelists James Weldon Johnson and Richard Wright, and cultural anthropologist Zora Neale Hurston, to mention only a few, joined the ranks of pacesetters W. E. B. Du Bois, Alain Locke, and Charles S. Johnson in promoting a creative spirit unrivaled in African American history to that time. Literature, history, visual art, and music all reached new levels of artistic refinement.

Of equal importance to artistic sophistication during the Harlem Renaissance was living the good life. Harlem came alive with the musical sounds of gospel, jazz, and the blues; entertainment and fun went hand in hand with the joyous expressions of song and dance.[19] Black music burst on the scene with the syncopation of Scott Joplin's ragtime, and black music commanded the patronage of white jazz lovers who swamped Harlem's dance halls. The Savoy, the Cotton Club, and the off-limit dens where gin was served unsparingly were visited by whites from downtown New York City looking for race music and black exotic entertainment. A frenzy of dance mania broke out in the nightspots of Harlem. New dance forms relying upon African motifs were created by Catherine Dunham and Pearl Primus, among others. These new forms helped change the face of dance in America.[20]

During the period, jazz proved to be the most readily accepted art form that emerged outside the music of the black church. Decades later, Romare Bearden's art of the 1960s would be greatly influenced by his memories of the jazz era in Harlem.[21] Jazz was born of the vital ingredients of black musical genius, the genius that combined elements of southern soul, particularly the sassy New Orleans flavor, with blues and gospel. These were the sounds that sent musical giants such as Duke Ellington, Fats Waller, and Louis Armstrong yelling and tooting the good news of the new black synthesis in musical expression. This music continues to inspire the many images that African American artists create even into the twenty-first century.[22]

Classical music, too, was a vital element of the Harlem Renaissance. The Negro spiritual had been well established as early as the 1870s by musical groups such as the famous Fisk (University) Jubilee Singers.[23]

For the visual artists of the Harlem Renaissance, the cultural awakening proceeded more slowly than for writers and musicians. Painters and sculptors are bound by material conventions in visual culture; they rely heavily on an established language of signs and symbols, fixed materials, and forms that date back to the Italian Renaissance. Musicians, and writers, on the other hand, have more freedom to mimic speech patterns of the vernacular. Thus musicians of the Harlem Renaissance were the first to exhibit this new spirit of racial difference.[24]

Visual artists of the Harlem Renaissance, by contrast, had to first free themselves from a Eurocentric art canon. They had to search the iconography of African art as well as other sources to create styles and forms of artistry. In the

1920s black painters and sculptors took their talents beyond the doors of neoclassicism and impressionism. They introduced into the Harlem Renaissance a new genre in art that, among other things, was respectful of the black features African Americans brought with them from Africa. African Americans were not alone in urging an aesthetic that emphasized the beauty of blackness and black heritage; Albert C. Barnes was an early white patron who promoted the notion that the purest of all indigenous American art in the twentieth century was the Negro song derived from Africa.[25] This growing spirit of "negritude" and racial awareness then characteristic of Harlem later flourished in other black metropolitan districts around the nation.

The explosion of creative artistry in Harlem attracted the attention of Manhattan's white artists. The white patrons encouraged a kind of support in the arts unknown to black people prior to this period. The prize to visual and literary artists was the patronage of publishing house heiress Charlotte Osgood Mason. This same form of patronage, although in smaller amounts, was given by the Harmon Foundation.[26] Photographer and critic Carl Van Vechten promoted the work of both literary and visual artists, the most outstanding form of publicity and media attention these artists received in the Renaissance.

Black Americans' newly directed search for cultural links with Africa invigorated their visual art. They reexamined art history as it was taught in mainstream institutions. Their search for identity and self-affirmation brought about a resurgence of interest in the story of the black artist's struggle to survive in this society, often described as both hostile and inattentive to black cultural aspirations. The artists of the Harlem Renaissance continue to be significant for contemporary black artists, who find in this history an important resource in the search to validate their own cultural worth. History benefits those privileged to recognize it, and contemporary African American artists have benefited immeasurably in recent years from a review of the cultural achievements of the Harlem Renaissance.

How strange, then, that even at the turn of the twenty-first century, African Americans still feel the need to unearth the contributions their ancestors made to American visual culture in order to place themselves within American art history. Yet, by the standards of the canon, art in America is either black or white. It can never be both. It is defined within the boundaries of race and seldom is given the chance to be considered simply human.

The vast majority of black artists who heeded Alain Locke's mandate to look to the ancestral arts of Africa for inspiration in their work had not yet been born when Locke and his followers spoke of the significance of the New Negro movement. However, these more recent artists are the immediate beneficiaries of the modernist move the artists of the 1930s and the 1940s made, the second generation of artists who followed the teachings of the Renaissance scholars. Romare Bearden, Jacob Lawrence, Elizabeth Catlett, and Charles White, black artists whose lineage connects us to the renaissance spirit by pursuing the black image as the primary theme in their work, are among those who kept alive the spark of genius from the Harlem Renaissance.

Significantly, of the fifteen recent artists chosen for our discussion who have been inspired by the Harlem Renaissance, only three, Martin Puryear, William T. Williams, and Keith Morrison, have moved away from traditional figuration. This is important, as traditional figuration was one of the tenets of the renaissance philosophy. The remaining twelve artists—Walter Williams, William Pajaud, Robert Colescott, Faith Ringgold, Emma Amos, Bob Thompson, Margo Humphrey, Mary Lovelace O'Neal, Stephanie Elaine Pogue, Varnette Honeywood, Erika Ranee Cosby, and I—work within modern figuration. The figural element in these artists' work is often influenced by an aesthetic rejection of European-based art, which often omits black subjects except as symbols of the exotic or the negative. Yet most of these artists have moved their work beyond the kind of self-introspection Locke advocated.[27]

Post-Renaissance artists whose work has been influenced by African art often use a modernist formula. They draw on cubism, expressionism, and forms of nonobjective abstraction, synthesizing old forms with newly invented ones. They are aware that the deconstruction of an object in modern art is itself African inspired; Picasso deconstructed the African mask, using the Baulé, the Bakota, and the Dan, among others, when creating a composition such as *Les Demoiselles d'Avignon.*[28]

African American artists at the turn of the twenty-first century frequently return to the work of Aaron Douglas and other pioneering Africanists who encouraged the use of African iconography in their work. Douglas used a hard-edged style of painting that African American artists of this generation still find adaptable to their artistry. Varnette Honeywood reintroduced in her work the silhouette form that Douglas used so successfully. Faith Ringgold has benefited enormously from her knowledge of how Douglas used geometric spatial inventions to juxtapose the sensibility of sound with the vibrant use of colors.

In the Harlem Renaissance, the rhythm of black life echoed profoundly in the visual depiction of a racially based art. Painters and sculptors of the period celebrated black life and portrayed black men and women as heroes and heroines of the race. In this context the Harlem Renaissance provided a new formula and impetus for black artists to be renewed in spirit as they unbridled their captive souls. The Harlem Renaissance was indeed a turning point in modern African American art.

Among the beneficiaries of the Harlem Renaissance, none showed more prowess in taste and stylistic invention than those who were born during the 1920s, a period in which the New Negro movement was still being defined. Primary among the artists of this generation whose work appears in the Cosby Collection of Fine Arts are the painters Walter Williams, William Pajaud, and Robert Colescott, all of whom were born during the nascent years of the Renaissance.

Walter Williams (1920–1998)

Walter Williams, a painter who grew up in the shadow of the Renaissance in Harlem, was born in Brooklyn. He spent most of his youthful years hanging out in Harlem, frequenting the jukebox joints, the local pool halls, and the few nightclubs that catered to black clientele. By the time Williams became an adult, Harlem had seen its heyday as the cultural capital of black America. After making the acquaintance of many painters, sculptors, musicians, and writers in Harlem who had figured prominently in the flowering of the Renaissance movement, Williams decided to become a painter.

He was acquainted with most of the painters we now consider second-generation Harlem Renaissance artists. He was a good friend and housemate of musician Charlie (Bird) Parker, whose new musical sound had helped revolutionize jazz. Williams chose to study painting at the Brooklyn Museum School of Art under the tutelage of Gregorio Prestipino, a figurative painter whose subjects often centered on the everyday life of city dwellers. Williams followed the figural pursuit of his teacher and visited the family owned neighborhood markets, seeking ideas for his paintings.

In the summer of 1953 Williams received a scholarship to study painting at the Skowhegan School of Painting and Sculpture in Maine. There he was exposed to the social commentary art of painter Jack Levine, whose satirically composed paintings had a lasting impression on the younger artist. Williams won first prize in painting at this prestigious summer art school. He later journeyed to Mexico, then to Italy and England, where painting became his daily occupation. Eventually he settled in Copenhagen, Denmark, where he remained until his death in 1998.

Following the restless move about Europe that many African American artists made ahead of him, Williams lived the life of the expatriate artist, gathering to himself friends who had also chosen to remain and work in Europe. In Copenhagen, Williams met Herbert Gentry, who had

lived in Stockholm. Sam Middleton welcomed Williams to Amsterdam, and Clifton Jackson, then living in Stockholm, shared with Williams his knowledge of the survival tactics an artist of color needed in a social welfare state.[29]

When I first visited Williams in Copenhagen in the summer of 1964, I was surprised to learn that his subject matter had not changed greatly since his days at Skowhegan, where the two of us were roommates. At an early age he had developed a style of painting that registered his own personal way of dealing with geometric figuration. It seemed clearly influenced by both Jacob Lawrence and Gregorio Presipino. Not until the late 1960s did Williams move toward a more romantically perceived style, the form his painting would take over the next decade.[30]

Roots, Southern Landscape (Plate 72), an oil painting with bits of paper collaged throughout its roughly painted surface, is one of many variations on the theme of *Southern Landscape*. It was a subject Williams began creating in the early 1960s. Repetitive symbols that appear often in Williams's work—blackbirds, butterflies, sunflowers, children collecting bouquets of flowers, and a bright red sun—tell us that a warm and colorful romance between the viewer and the southern landscape is about to take place. But central to all these symbols is an upturned tree trunk with its bare black roots exposed to the heat of the southern sun. The trunk of the tree is partly entwined by barbed wire.

As handsome as this romance of nature may seem, as shown in the curious gaze of black children playing innocently in the surrounding countryside, *Roots, Southern Landscape* is a tour de force in cultural subversion. It is an accomplished form of social commentary art under the guise of a well-planned painterly statement. The upturned tree trunk and its barbed wire represent African Americans in the flowering fields of wealth in America, uprooted from their native home in Africa and partly hemmed in by the inhumane rules of slavery, then segregation. The sunflower echoes the warmth of the sun and represents faith and hope for the future. The birds and butterflies symbolize the

flight to full freedom and first-class citizenship desired by all oppressed people. The shacks in the background reaffirm the poverty of the rural South, a visual reoccurrence often noted in Williams's paintings.[31]

Nurtured by the fervent spirit of the Harlem Renaissance ideal, that of building one's artistry on the principles of black life and a devotion to the African ancestral legacy, Williams anchored his art in the romance of the Old South and the idyllic American dream. He took the ideals of the Harlem Renaissance with him to Europe in the 1960s. There he painted stories from his childhood, memories of a bygone era in the teeming cities of the North and the romance of the South, a reinvented subject his art chronicled until he became too ill to paint in the 1980s.

William Pajaud (1925–)

William Pajaud, a native of New Orleans, studied painting at Xavier University of Louisiana with Numa Rousseve, a dedicated teacher. Pajaud admired the strong sense of social emancipation the great Mexican modernist painters, such as Diego Rivera and Rufino Tamayo, brought to their work. He traveled to Mexico and there painted the simple ways of the Mexican people in a series of works called *Mujeres*. The painting *Mujer con Maiz, Tortilla Maker 4* (Plate 73) captures the essence of a woman hard at work making the daily bread. The painting, however, is equally revealing in emphasizing the importance of the work ethic, part of the cultural tradition of a people whose ancestral lineage predates the European conquest of the Americas.

Pajaud's paintings are always carefully crafted to show an orderly process in a modernist style, akin to the style of the contemporary Mexican artist Rufino Tamayo. A white line separates heavily impastoed layers of colors in the earth tones befitting the Mexican genre. Pajaud has created his own visual world in which the ancient art of Mexico seems to come alive in his own painterly memory. *Hard Hat* (Plate 74), from the *Mujeres* series, shows a woman with a turtle on her head. It captures the gaze of

Plate 72. Walter Williams, *Roots, Southern Landscape,* **1978, oil, sand, enamel, collage, 47¾ x 58¾ in.**

Plate 73 (facing page). William Pajaud, *Mujer con Maiz, Tortilla Maker 4,* from the *Mujeres* series, 1973, oil on canvas, 58⅞ x 48 in.

Plate 74 (this page). William Pajaud, *Hard Hat,* from the *Mujeres* series, 1975, oil on canvas, 48 x 60 in.

142 **Plate 75. Robert Colescott,** *Death of a Mulatto Woman,* **1991, acrylic on canvas, 84 x 72 in.**

an ancient Mexican people—the Mayans—for whom time seems to have stood still.

Pajaud learned of the importance of the Harlem Renaissance through Hale Woodruff and Charles Alston, among others. Pajaud was in daily contact with their art when he served as curator for the fine collection of African American art owned by the Golden Gate Life Insurance Company in Los Angeles in the 1970s.[32]

Robert Colescott (1925–)

Robert Colescott is a painter who has moved in his art from an academic style to one characterized by satire and social commentary. He is particularly interested in depicting ideas of cultural reversal. Colescott often comments on stereotypes associated with black culture as well as forms of expression that tend to set people apart based on race alone. In the composition *Death of a Mulatto Woman* (Plate 75), Colescott redefines the poignancy of the negative image, that which centers on race mixing, race baiting, and the social conduct that was taboo in a segregated society. It also focuses on the piercing element so characteristic of art made by whites who poke fun at black physiognomies, particularly the facial features and anatomy of black women. Colescott has taken all such symbols and reversed them, using them to subvert definitions of culture based on race.

The rough surfaces that characterize Colescott's works throughout much of the past twenty years appear also in this painting. We see the action of the canvas as though we are looking at a television screen. In the background, curtains open to reveal the spectacle. A mulatto woman, in her dying moments, is borne on the shoulders of eight people, some black, some white. Symbolically, she is thrust across two continents. Africa is at her feet in the guise of a woman who wears a purple dress, a color associated with penitence and death. The mourning scene is one that is key to Christian ritual. The European continent is near the bottom of the stage, where Italy juts out into the Mediterranean Sea. In *Death of a Mulatto Woman*, we are reminded of the mixed ancestry of many African Americans, in particular those who were referred to as half-breeds in nineteenth-century America. Beneath the mulatto woman, who occupies the central part of the composition, a white male is intimately engaged with a black female, perhaps in some form of sexual activity. The irony Colescott presents is showing us the nonsense so often associated with race in the United States. All the action is focused on the death of the mulatto woman. A rainbow appears below the continent of Africa, and onlookers both black and white share the moments of her dying.

Colescott has produced a body of work with potent images. These images often take the high road to describing and deciphering the conflict of race in American society. Colescott's masterful play with symbols of cultural reversal appears in many compositions in which white people are transformed into black characters, as in his painting of Shirley Temple Black. Colescott is asking us to think about the awkward predicament in which we find ourselves when speaking of race. He also wants us to consider how absurd it is to spend our precious human time on things such as race that cannot be changed.

Faith Ringgold (1930–)

Faith Ringgold grew up as a child of the Great Depression. Having tried painting and soft sculpture, she has now turned to painting on fabrics. Her art has come full circle, since textiles and fabrics filled her childhood home.

While Ringgold's art experiences are limited almost exclusively to the northern urban scene, she broadened her visual vocabulary in the paintings of the 1960s and 1970s to include the Civil Rights movement in the South. Other parts of her vocabulary emphasize heterosexual love and an emphasis on black popular culture. More recently, she has returned to autobiographical subjects that reflect on her own life and the life of her immediate family.

Some of the most exciting painting of a narrative nature being done today comes from the hand of Ringgold.

She joyously combines fact with fiction and fantasy with history. She has created a number of paintings that show contemporary artists in the presence of modern art masters, such as Matisse and Picasso.

In recent years, Ringgold has turned to painting quilts. In the art of the quilt, Ringgold has brought diverging elements of artistry into an accomplished whole. She moves beyond tradition, emphasizing the individual strength of her own artistic ideas. In the biographical quilt titled *Camille's Husband's Birthday Quilt* (Plate 76), Ringgold uses well-known episodes from the comedian Bill Cosby's life and the early days of his marriage to Camille Olivia Hanks. Bill Cosby is first shown as a young comedian, then as a young actor. Portraits of Bill are interspersed with faces of Camille early in her career. A linear arrangement depicts the birth of the five children born to the Cosby union. Later in Camille's life, she is decked in academic regalia receiving a graduate degree in education from the University of Massachusetts. The colorful display of Ringgold's artistry is outstandingly clear as she portrays the various stages of the Cosby family's growth. Portraits of the father and mother dominate the composition.

This particular quilt shows Faith Ringgold expanding her painting into a larger form of expression that is more pictorial than painterly. She has captured the beauty of family life, that of the Cosby family. She portrays with great warmth the love shared in the family. The strength of Ringgold's artistry is reflected poignantly in the way she orchestrates form. Each episode centering on one of the Cosby children or the father or mother is a painterly poem all to itself. Yet all are united in one quilt to make a collaged message that states a very personal kind of artistry.

David C. Driskell (1931–)

Artists seldom like to comment on the art they have created, preferring to have others decipher their work. I am one such artist. However, some of my work can be characterized as attempts to present painterly expressions that echo the sentiments of my early childhood.

Specific themes in my oeuvre relate to childhood memories. Religious themes dominate many of these remembrances. I remember vividly the black churches in which my father served as minister in the 1940s and 1950s. Since I was born in a church parsonage in Eatonton, Georgia, in 1931, I remained close to church life throughout my youth. The church became a refuge for me in times of indecision, and it was there that I learned public speaking. I taught Sunday school classes and arranged musical tours for the junior choir, all of which provided a rich layer of cultural involvement that was religiously based. I refer to those poignant memories from time to time in my work, just as William H. Johnson, Romare Bearden, and other black artists recounted their childhood experiences.

In *Adam Showing Eve* (Plate 77), I used the serpent to present a variation on a biblical story. It is traditionally held that Adam was tempted by Eve to take of the apple and that Eve was tempted by the serpent. In *Adam Showing Eve*, the apple appears on the side of Adam, as does the serpent. It is my belief that men take the lead in most sexual encounters with women. My intention here is to question the concept that Eve was "at fault." One composition cannot reverse thousands of years of mythology, but my painting is an attempt to show another side of the story in the relationships between the sexes.

In a series of compositions completed in the 1970s, I drew attention to Americana, collectibles, and odd items relegated to our cultural past. In both *The Green Chair* (Plate 78) and *Antique Rocker* (Plate 79) I explored color as a symbolic statement. I perceived that we yearn for the "good old days" of our collective past. We go about the countryside collecting objects that have been discarded, bringing new life to them, and refurbishing them to place them in a more modern setting. I use all the colors in the rainbow to give these objects new life and resurrected beauty.

Plate 76. Faith Ringgold, *Camille's Husband's Birthday Quilt,* **1988, painted and pieced canvas and silk fabrics, 106 x 81¾ in.**

146 Plate 77. David C. Driskell, *Adam Showing Eve,* 1994, collage and encaustics on canvas, 30 x 30 in.

These painterly statements also refer to the notion of memory in another sense—how it informs the art of many black artists. I recall hearing Romare Bearden say that if indeed there is a clear distinction between what African American artists create and what artists of the majority culture make, it is that black artists often rely heavily on memory to inform their work. Reverting to memory, particularly to one's own personal experiences, gives a special validation to African American life, as Locke called for in the Harlem Renaissance movement. Validating the art of one's own personal experience allows elements of the narrative as well as certain allegorical principles to be revealed. For this reason my own art often centers on memories of growing up in the rural South.

Emma Amos (1938–)

Emma Amos created prints in the 1980s that revealed, among other things, her fine skills in drafting. The human figure, particularly that of a woman, is a recurring theme in Amos's work. More recently she moved away from the narrow confines of realism and incorporated textiles and collage materials as decorative elements and plein air borders in her work. The new, tightly planned compositions show a more abstract presentation of the figure.

In many of the mixed media compositions that Amos has created in recent years there appears a female figure who is autobiographical. *Sand Tan* (Plate 80), a sepia-tone etching executed in 1980, shows three female figures sitting on a blanket in beach attire. The blanket appears to be African in design. Similar patterns and free designs have appeared in Amos's recent paintings as borders and boundaries, closely associated with the decorative quilts created by Faith Ringgold.

Amos plans her compositions with utmost care, showing special concern for compositional accuracy, particularly the negative and positive spaces of a work. Amos is the only woman who was a member of Spiral, the group of black New York artists who frequently met in the 1960s to promote a unified vision. Amos was one of the few artists in the group to revisit the notion of collage, incorporating elements such as textiles in her work at a later time.

Amos is equally well known for the leadership she has provided the Skowhegan School of Painting and Sculpture over the years, serving as chair of the board of governors of the nation's most prestigious summer art school.

Bob Thompson (1937–1966)

Bob Thompson lived a short but productive life in both Europe and America. He was an artist whose vision extended familiar themes of the Italian Renaissance into lyrical fantasies of fauvistic landscapes. In his work, color and form were highly reminiscent of the expressionistic compositions of Franz Marc and artists of his genre. Thompson sought to create the visionary dream beyond the boundaries of the natural world.

Yet everything he painted seemed wedded to forms in the natural order. He embraced the human figure with an unconditional love through a simple style unencumbered by interior lines. An active palette of reds, oranges, greens, and yellows is juxtaposed with equally colorful linear patterns that define people, horses, and birds in flight. They are placed against a bucolic landscape that is often diverse in color.

Thompson painted *Horse and Blue Rider* (Plate 81) one year prior to his untimely death in 1966 from what is said to have been an overdose of drugs. This painting shows the nearly uncontrollable urge of the artist to transform subjects and place them in a world of dreams, fantasies, and myths. It was a world that seemed highly dependent upon an illusion, perhaps aided by chemical substances.

In *Horsemen of the Queen of Sheba* (Plate 82), two nude men clad in cap and hat attend three of the African queen's horses. One horse is red, one is orange, and the third purple. They blend harmoniously under the umbrella of a hilly landscape that is equally colorful. The artist uses wax-and-oil crayon, and the surface of the paper resists an overall coverage, producing atmospheric relief. Many of Thompson's compositions resonate with surreal tendencies. He also pays

Plate 78. David C. Driskell, *The Green Chair,* **from the** *Americana* **series, 1978, acrylic on canvas, 40 x 24 in.**

Plate 79. David C. Driskell, *Antique Rocker,* from the *Americana* series, 1978, acrylic on canvas, 36 x 24 in. 149

Plate 80 (facing page). Emma Amos, *Sand Tan,* **1980, aquatint etching, 33½ x 29⅝ in.** 151

Plate 81 (this page). Bob Thompson, *Horse and Blue Rider,* **1965, oil on canvas, 14 x 18 in.**

homage to the art of Gauguin, embellishing his style with content from artists of the Italian Renaissance. In addition, we see throughout the last two turbulent years of the artist's life a joyous affair with art, an art with a painterly appeal.

In the composition *Bird with Nudes* (Plate 83), created in 1964, we see a dark and brooding landscape with shadows of otherworldliness, even the occult. Two nude women, one yellow, the other red, hold large, dark, birdlike forms in a way that suggests they are about to release them to flight. Approaching the two bird handlers is a blue-gray, nude female. In a solid red foreground, a small dog stands motionless, witnessing the activity. The painting is certainly one of Thompson's most mysterious late works.

Thompson, without doubt, manifested the new creative spirit of modernism. He transformed both time and space in compositional studies that resonate with a highly personal style, one greatly influenced by past art movements.

Martin Puryear (1941–)

Martin Puryear began painting as a child at the Yudisky School of Art and the Corcoran School of Art in the 1950s. He studied painting in 1959 while attending the Catholic University of America in Washington, D.C. While his artistry is no longer based only on a personal reverence for nature, Puryear has brought an organic sensibility to sculpture that echoes his great love for nature. Materials such as wood, stone, metal, leather, and wire help direct his poetic journey. In his work, sentiment is blocked out and an etherealization of material and form takes place. Puryear's handsomely crafted works seem formed by a primordial human hand, untouched by technology, yet they are enhanced by the latest tools of the modern world. Puryear's creations omit nothing, yet they abbreviate content, showing his command of form.

Few artists in America have received the high accolades bestowed on Puryear in recent years. Without announcing allegiance to any particular school of thought in art,

Puryear single-handedly created his own niche in American sculpture, one that resists the pressures of labels, including those of race. Yet he humbly pays homage to traditional African sculpture and its powerful influence on Western art, a characteristic that is obvious in his work.

The ancestral images of African sculpture, with their simple sense of functional form and their power to stimulate the creative mind, have appealed to Puryear since his stay in Sierra Leone with the Peace Corps in the 1960s. African art continues to influence Puryear's work, particularly his use of wood. The artistry of the African sculptor and the craft of the carpenter in Sweden, where Puryear studied in the late 1960s, account for much of Puryear's mature sculptural style.

Puryear's art is as much about line defining form as it is about the beauty of wood. Each formal space in Puryear's work seems to be part of a larger puzzle—a design challenge that required an all-encompassing passion to execute. The passion draws us in, as each work evidences an extraordinary summoning power.

Puryear's work is based in material culture, in the ordinary things we see around us. *Nexus* (Plate 84), a circular composition created in 1979, shows Puryear's mastery of time, space, and form in one dynamic statement. He uses materials that captivate our imagination, extending the real into the unreal and rarefied.

Puryear works in the tradition of the ancient African sculptors who carved a delightful form with flawless precision. He moves the craft of carving beyond the bounds of its African roots to a universal essence. The circles he makes in wood are often like a Japanese bowl. They are not totally round but intentionally flawed so as not to be too perfect. The circle is completed at some point within the sphere, like the primordial symbol of the serpent consuming its own tail, but it is slightly altered so as to appear uneven rather than actually be perfectly round. This artistic maneuvering of form is part of the Renaissance spirit of invention and redefinition.

154 **Plate 83. Bob Thompson,** *Bird with Nudes,* **1964, oil on canvas, 36¼ x 48 in.**

Plate 84. Martin Puryear, *Nexus,* **1979, pine, maple, and gesso, 1½ in. thick, 45 in. diameter**

155

William T. Williams (1942–)

William T. Williams studied art at the Pratt Institute and Yale University. In the 1970s Williams's use of color field painting drew attention to his work. He explored color as a metaphor for form, as did Alma Thomas and Sam Gilliam. Since then, however, Williams has moved toward more personally chosen forms of expression, including an enhanced rustic, painterly surface and a lyrical and lively use of line. The evolution of Williams's work beyond color field painting has allowed him to be singled out as one of the most gifted artists of his generation.

In moving away from geometric abstraction, Williams revealed his place in the African American lineage. While many of Williams's compositions created in the 1980s show an affinity with a certain place and time, they also evoke memories of cultural experiences, ethnic myths, and futuristic dreams. He once noted, "It occurred to me that my memory had become a place rather than a past event. As such, it contains a rich deposit of materials that could be used, not to linger, but to illuminate the future."[33]

History has always played an important role in Williams's oeuvre. The Harlem Renaissance caught his attention at an early age. Its music, the art of Aaron Douglas, and the philosophy of renewal and rebirth—paramount as Renaissance ideas—help to locate Williams in the tradition of the Renaissance.

Perdido (Plate 85), a color lithograph created in 1991, brings to mind the handsomely crafted paintings Williams made in the 1970s, most of which were informed by geometric abstraction. While abstract forms still play an important role in *Perdido*, they now appear more lucid and almost baroque in their ability to entwine with color. Here color is like vines growing over a landscape of ancient classical columns. Conical, circular, and framed architectural shapes claim the same space as rapidly moving organic forms in a well-orchestrated composition. Color like that of a beautiful stained glass window is the dominant element.

And, in tribute to the power of Williams's ability to invent new forms with a classical setting, *Perdido* holds its own among the earlier works from the 1970s. It reveals the artist's continuing romance with color and the memory bank of rich cultural experiences from which Williams drew his inspiration.

Perdido is from a suite of five lithographs in which the central theme is jazz. An avid lover of jazz music, Williams set about renewing in his memory the central theme that Dizzy Gillespie created in a musical composition by the same title. The overall effect of drawing on the lithographic plate and painting a powerful image using identifiable geometric forms renewed Williams's interest in the abstract art he so successfully crafted two decades earlier.

Margo Humphrey (1942–)

Margo Humphrey began her art career in Oakland, California, during the early 1960s. She knew from childhood that art would be her chosen profession. She became actively involved in art events, exhibiting her work locally at every opportunity before entering Merritt Junior College in 1960. There she enjoyed a steady diet of courses in painting, drawing, and printmaking. By the time she reached graduate school at Stanford University in 1972, where she pursued the Master of Fine Arts degree in printmaking, Humphrey had already showed her work nationally in professional exhibitions.

From the beginning of her career, Humphrey evidenced an individual style, one particularly suited to the medium of lithography, in which satire and a whimsical look at cultural icons predominated. She celebrates these icons, such as Malcolm X, hallowed saints, and soul food, through a powerful narrative style that is both culturally enriching and characteristically humorous. Humphrey relies heavily on the power of color to evoke a mood, to go beyond racial stereotyping, and to endow the forms within her compositions with energy and emotion. Often she chooses a play on words to embellish her work. Humphrey, a colorist of the first order, uses color to activate memory and empower

Plate 85. William T. Williams, *Perdido,* 1991, lithograph 41 x 29 in.

157

visual ideas. Color in her work is also a metaphor that commands form, particularly when used for ceremonial emphasis in the African American experience.

The Last Bar-B-Que (Plate 86) is a tour de force in design and contextual ideas. It is a summit of ideas crossing the bounds of culture, religion, race, and gender. At first glance the work re-creates the composition of Leonardo da Vinci's *Last Supper*. Closer examination, however, shows that the only suggestion of a religious experience is the alignment of the people around the sacred table and the halo each person wears. The *Last Bar-B-Que* is, in the final analysis, no closer to da Vinci's *Last Supper* than Eubonics is to Elizabethan English. Each has its own symbolic origin.

The Last Bar-B-Que narrates the story of "the savior as self," or self-empowerment of the black race. People of both genders, of various colors, and with different kinds of body language are gathered before the common table conversing, lamenting their fates, and eating and drinking together. The artist has made some people blue, others yellow, and still others sienna. Humphrey says that these colors represent more accurately "the rainbow of the diaspora," the many colors found in the black race, and she uses blue as a symbol of divinity, much as Hindu artists paint the most sacred divinities in blue.

For Humphrey, color is associated with the celebration of life at its best. She feels that when we wear bright colors we make room for enthusiasm and a sense of the spiritual life. The artist remembers the vivid orchestrations of color her mother used: a yellow Easter dress, Congo red lipstick, and red nail polish, all of which Humphrey associates with personally rewarding experiences of African American life. Humphrey has re-created a language of form that reveals the meaning of *The Last Bar-B-Que* in her personal world. The Western tradition of representing Jesus as white is moved aside. Jesus is blue, transformed by African Americans to suit their own cultural identity.

Humphrey notes that the title of the work itself is an affirmation of cultural identity; it rings of the vernacular.

Familiar symbols appear throughout the composition. The dove in flight remains a symbol of peace, but it narrowly escapes the fate of the two other birds on the grill, sacrificed so others might live. A colorful array of animals, flowers, and fauna decorate the table and the garments of the people at the table. They also remind us that the earth in all its vast diversity is one world.

The color of one's skin, the issue of race, is present in *The Last Bar-B-Que*, but only in the sense that people are first and foremost human. Thus the colorful representation of people at the table is symbolic only. The various colors of people, in the final analysis, is immaterial, since we have in common the death that follows the last meal. The parade of ideas in *The Last Bar-B-Que* is visually stimulating but worlds away from da Vinci's *Last Supper*.

In many ways, Humphrey has brought to the medium of lithography a renewal that only she is capable of bringing. Her own formula of layering color over color is a stylistic principle uncommon to the medium of lithography. Using a rather personal formula for cultural and racial identity is a vital element of the new life Humphrey has invested in the medium. As did Francisco Goya and Honoré Daumier, Humphrey uses the particular traits of a printing medium that bridges the printed page and easel painting. She then enhances the medium, making lithograph an amazing form through which social commentary art can be realized. Humphrey sees her own art as an important extension of the mandate that many artists of the Harlem Renaissance followed, making art that was both culturally enlightening and aesthetically pleasing.

Keith Morrison (1942–)

Keith Morrison centers recent works on his childhood experiences, many of which come from his formative years in Jamaica. His art has evolved from realism to abstraction and back to realism over a period of thirty years. Never fearing the avant-garde, Morrison has moved full circle, in and out of fashion, bringing both individual and personal richness to his work.

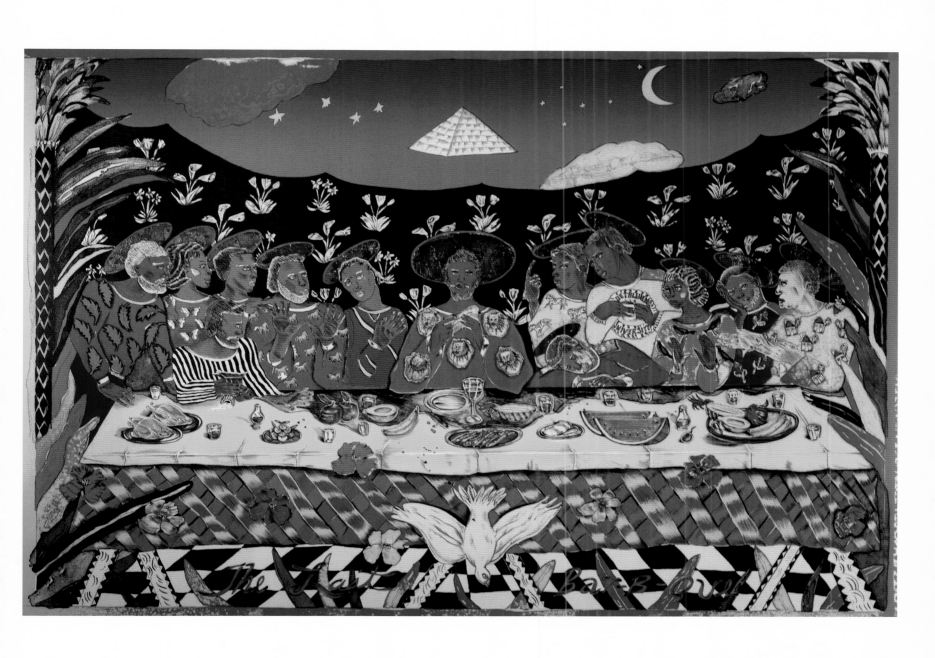

Plate 86. Margo Humphrey, *The Last Bar-B-Que*, 1988, lithograph, 26 x 38 in.

160 **Plate 87. Keith Morrison,** *Zanzibar,* **1981, watercolor, 23 x 30⅜ in.**

In the 1970s, Morrison dazzled our visual intellect by creating a series of intricately planned paintings in which the form was genuinely classical. In these early works the narrative was crafted like a film; one image followed another in sequence.

As Morrison's images moved through time, they became less classically based. In place of the brooding, almost earthlike, palette that dominated the canvases of the late 1960s through 1970s, Morrison substituted quiet and well-planned abstraction resulting in linearly driven geometric forms. *Zanzibar* (Plate 87) is one such composition in which a modernist formula is arrived at by reverting to a simple form of neoplasticism. But Morrison did not linger long with the geometric-based form of painting that *Zanzibar* represents. And while the diagonal movement of color in the composition symbolizes the political conflict the artist encountered in East Africa, after which he named the painting, he was never totally convinced that abstraction would sustain his new interest in the African diaspora. In a conversation I conducted with him in 1996, Morrison noted that he later realized he was more interested in the popular culture of the African diaspora, including things as simple as native fabrics, than in the political movements of a place.

The late 1980s saw Morrison move back to the realm of the figure. Powerful compositions emerged that speak a language of social disguise with mythic content heavily rooted in Caribbean lore. The artist in us all comes alive when we view Morrison's drama-filled paintings of the 1980s and 1990s. More recently, Afro–West Indian legends, from which ideas for so many of the paintings of the 1980s and the 1990s arose, are blended with the African American lore of the South, thus reflecting more fully the richness of African American life. Kenneth Baker, art critic for *The San Francisco Chronicle*,[34] described the ease with which Morrison moves between abstraction and memory, fantasy and history while incorporating African, Caribbean, and African American worlds into one composition.

In all the art Morrison has created over the past two decades, we see manifestations of both the spiritual and the natural. The paintings are poignant plays on life and death, with a formula for relief from the savagery we humans inflict on one another. Whether the composition is abstract or defined by objective symbolism, Morrison prevails as the master of the theme he carefully arranges for the viewer. He remains the consummate storyteller, timeless in his ability to inform us through art that is both old and new, primordial and classical.

Mary Lovelace O'Neal (1942–)

Mary Lovelace O'Neal is well known for her colorful work in abstract expressionism. Yet much of what she has created within the past five years is neither abstract nor expressionistic. Instead, many of O'Neal's new works, some of which celebrate her journey to North Africa in 1988, especially to Morocco, are thinly painted and poetically rendered. They are unlike the abstract expressionist series celebrating the life cycle of whales that she painted in the early 1980s.

O'Neal minimized her working tools when she arrived in Morocco in 1988. Easily accessible to her were metal and glass plates, so she chose to do a series of monoprints, all quickly drawn and painted onto a glass surface. The forms in the prints translate into sitting figures, architectural elements of buildings, and the desert landscape.

Painted Desert II (Plate 88) centers on a market where two Muslim women are sitting with their produce, silhouetted against a dimly lit building. The blazing midday sun looms heavily over the entire scene, and the shadows it makes are like the shadow of death waiting to claim its victims. The fully draped bodies of the two anonymous figures are lightly rendered. They are, however, strongly marked by the artist's usual linearly arranged calligraphic strokes, some of which reconnect with the painterly format of O'Neal's 1980s paintings.

A second monoprint in the series is also based on life in the Moroccan desert. In this composition from the *Desert Woman Series* (Plate 89), two traditionally garbed Muslim women walk together in the desert; they proceed slowly without relief from the tyranny of the midday sun.

Painted Desert II [signature] '91

Plate 88 (facing page). Mary Lovelace O'Neal, *Painted Desert II,* 1991, monoprint, 39 ⅝ x 27 ¾ in.

Plate 89 (this page). Mary Lovelace O'Neal, *Desert Women Series,* 1991, monoprint, 27 ⅝ x 39 ⅜ in.

Figural expressionism and a quiet sense of the romantic collide in an unusually workable format in O'Neal's *Desert Woman Series.* These dazzling images are more figural than abstract, a feat O'Neal seems to have reserved for this series alone. They are also metaphors of the veiled and secretly guarded social customs O'Neal found so intriguing in the Muslim women of Morocco.

The two female figures in *Desert Woman Series* seem more like a dancing couple than two figures heavily wrapped in costumes that physically impede movement. In spite of changes in the modern world, the women remain veiled in ancient garb. O'Neal observed, "Underneath the bundles of clothing worn by these Muslim women are the souls of modern women waiting to be relieved of the burden their garments of yesterday place upon them. In real life, they are as free as we as American women are. One day, they will reveal the depths of their covered souls."[35]

The portrayal of women in O'Neal's work harks back to the 1970s, when people were a central theme in her large compositions using the formal elements of action painting. Since that time, O'Neal has progressed through abstract expressionism and the minimalism of several black-on-black compositions. More recently, the figure has reemerged and is vitally connected to her visits to Egypt, Morocco, and other points of interest in Africa. Vibrant and more lyrical than the works that were so heavily based in abstraction, O'Neal's recent works are soundly constructed, and they leave no space untouched by the magic of her painterly hand.

Stephanie Elaine Pogue (1944–)

Stephanie Elaine Pogue was born in Shelby, North Carolina, but grew up in Elizabeth, New Jersey. She studied at Howard University and Cranbrook Academy. Until recently she pursued themes in art that were readily associated with the human figure. More often she used themes that adapted well technically to the color viscosity process in etching.

A highly personal portrayal of women is a major theme

throughout Pogue's career. In her earlier work we were introduced to a soft, subtle color sensibility that complemented Pogue's successful move to abstraction. In compositions that emphasized the beauty of the nude female figure, Pogue was often idealistic rather than romantic. These classically rendered women could have been fashion models who stopped off in the dressing room to disrobe in preparation for their next stroll across the stage. Although sometimes showing an affinity with the elongated figures of Modigliani, Pogue's nudes exude a sense of joy and love of life. At times they seem related more to the dreamlike females of Arthur B. Davis's mythically inspired works than to women in real life.

Seated Woman (Plate 90) suggests that in some ways Pogue's work is now closer in style and form to her compositions from the 1970s. In those works the artist relied heavily on decorative, arabesque-inspired backgrounds where female figures emerged as the dominant theme. Now, the work acknowledges visually that less complicated subject matter is really more.

The figure is not as detailed and is not made to conform to the figural expectations that were evident earlier. The simplified line in the figure, no longer interfering with, or trying to be integrated into, the baroque and arabesque linear patterns in the background, shows a masterful hand at work. It is a hand adept at abbreviating form in a way that reveals both the sensuous and erotic qualities of the female figure. Although only part of the figure is revealed in *Seated Woman*, the work invites speculation about what the woman's next move will be. She is handsomely augmented by the artist's use of a glowing yet privately perceived aura of colors. The warm and inviting colors—golden yellows, yellow-oranges, and burnt siennas—represent the woman's private moments and heighten the mood of the composition.

The women who comprise the series from which *Seated Woman* is taken are often passive. They exist. They are images of the moment, as fleeting as time. They seem calm but beautiful. The artist says these images provide a glimpse

Plate 90. Stephanie Elaine Pogue, *Seated Woman,* **1978, color viscosity etching, 19¾ x 15½ in.**

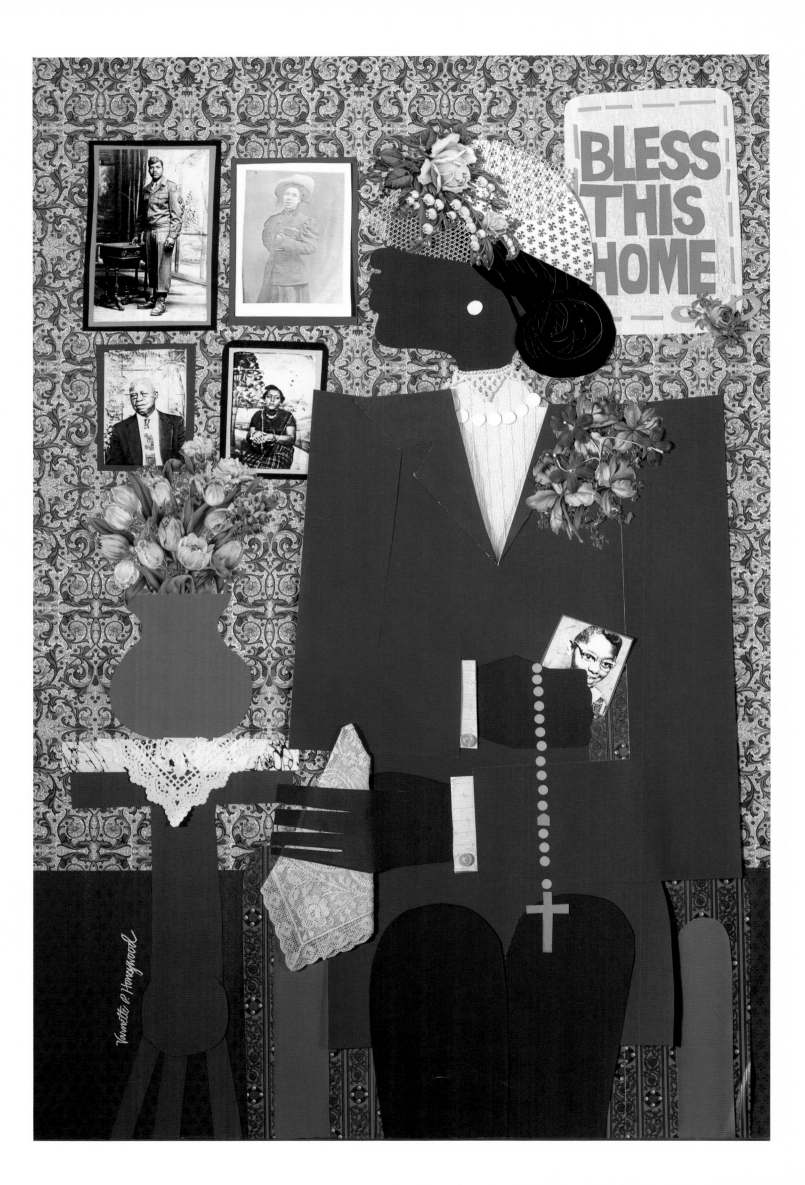

into the youthfulness of women. This woman seems as timeless as the Venus of Willendorf or the Cyladic female images of the ancient world; she ever so lightly exudes the life-giving qualities associated with women of the great world religions. Pogue's reverence for both classic and contemporary is made real through the magic of her craft.

Varnette Honeywood (1950–)

Varnette Honeywood began painting when she was a child. Early on, she knew she wanted to be an artist, and the encouragement she received from her family gave her confidence to pursue a career as a painter. She took art lessons first at the Chouinard Art Institute in Los Angeles and later at Spelman College, where the uncompromising voice of artist-teacher Hans Bhalla sounded the cadence of discipline in the classroom. In the nearby community of Atlanta, Georgia, she observed the lore and ritual of black culture and used these experiences to enrich her work. She later received a master's degree in education from the University of Southern California.

Her works are deeply felt personal statements in black genre in the tradition of Romare Bearden, the grandmaster of the collage. Her most widely known pieces are executed in collage, but her use of collage is very different from Bearden's. She is exacting in her selection of materials such as wallpaper patterns, flowers, lace, and photographs, most of which place the subject in history. Carefully cut images, repetitive patterns, and color field geometric shapes, reinforced by concise forms of painting, make up Honeywood's compositions.

In the work *Precious Memories* (Plate 91), painted in 1984, Honeywood portrays a well-dressed black woman sitting in front of an interior wall in a room with humble accommodations. A vase of flowers appears near portraits of family members at various stages of their lives. The composition may represent an autobiographical glimpse into Honeywood's own rich family traditions, passed down to the artist by her father and mother, who grew up in Pikes

County, Mississippi. Holding a portrait of her child in one hand and a fine lace handkerchief in the other, the woman in the picture presents herself as the reigning matriarch in her family. The rosary and cross in the right hand of the woman represent the Christian values she espouses.

Also message inspired, *Honor Thy Father and Mother* (Plate 92) portrays the same sense of devotion found in *Precious Memories*. In *Honor Thy Father and Mother*, a family of four children peer out at the viewer as though they are watching every move we make. It is this gift of portraying an empathetic scene that sets Honeywood's art apart from that of other artists who use black genre to comment on rituals and traditions in the African American community. *Honor Thy Father and Mother* successfully calls together four siblings, all of whom stand ready to serve their parents. The youngest, a male child, wears the stocking cap traditionally used by black boys to groom their hair properly in the evening for the following day. He holds in his hand a cup of tea, awaiting the arrival of his honored parents. Trust and honor go hand in hand as these four children preserve family ties and traditions.

Honeywood has successfully marketed her own art with the expert advice of her sister Stephanie. She makes her work accessible to the black community through posters, notecards, and limited editions. Her entrepreneurial skill is a model for struggling young African American artists.

Since the days of her first art lessons, Honeywood has remained steadfast in her commitment to portraying the black experience in a positive way through the painterly image.

Erika Ranee Cosby (1965–)

Erika Ranee Cosby has lived all her life in an environment where art, particularly that created by African American artists, has been a part of her everyday experience. When she pursued a dual major in art and political science at Wesleyan University in Connecticut, it was simply a matter

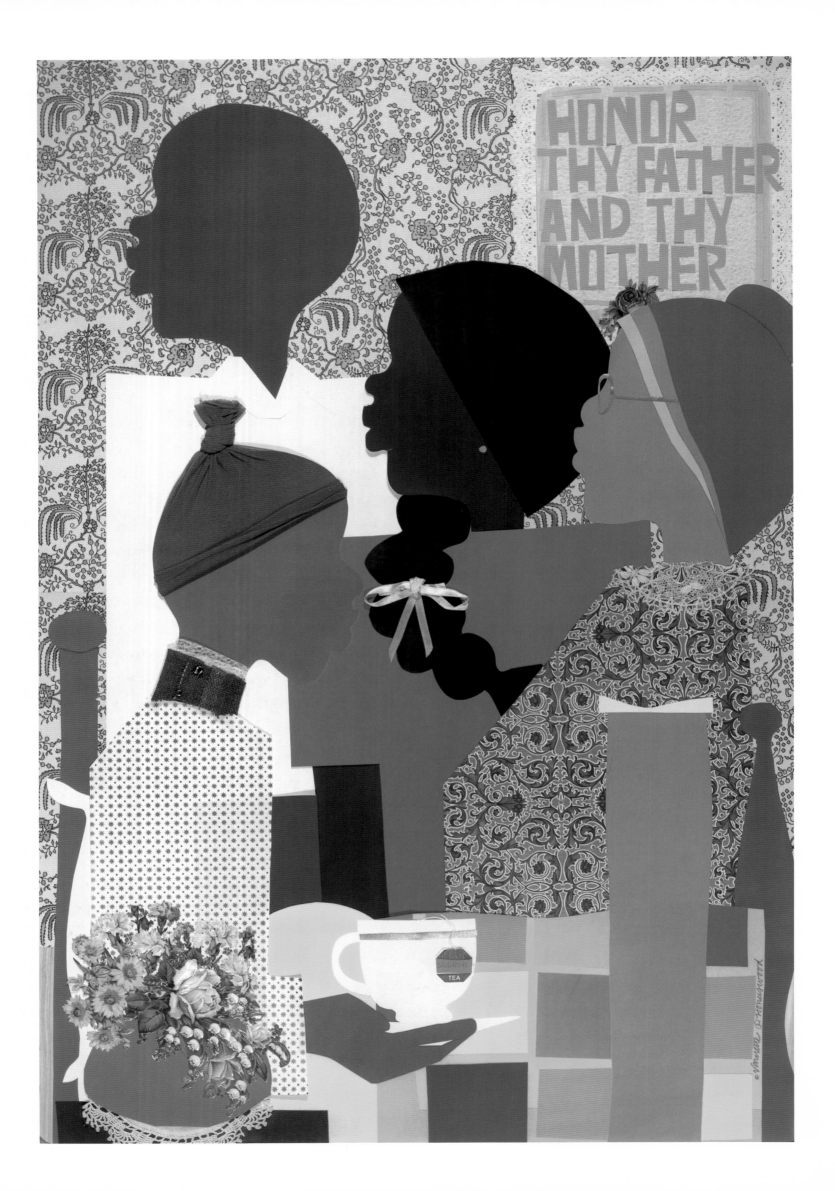

of time before she embraced art as a career. She then attended the University of California at Berkeley, where she received the Master of Fine Arts degree in painting.

From the time she began undergraduate study, Cosby showed a strong interest in creating art that made a statement about race, stereotypes, and black material culture. At first the theme of white dolls, at one time the only dolls that black girls were given, predominated in her work. Later she occasionally mixed a black doll with others that were white. This act echoes the dominance of the white population in the United States. More recently the artist has created compositions in which black dolls are mixed into the urban landscape along with portrait heads of black popular culture icons in the entertainment world.

The entertainment industry, a world that Cosby has observed since childhood, figures prominently in these new works, as does her interest in dolls. An element of satire reverberates throughout these mixed media compositions. An occasional piece of paper is seen with biting social commentary or photographic images of figures such as The Supremes. The black female domestic worker, who serves in unappreciative white households as maid, nanny, and animal- and house-sitter, also appears in Cosby's work, calling attention to the economic needs that keep the domestic worker away from her own children and family. These compositions appear as well-crafted, abstract expressionist paintings with a color sensibility that makes you want to touch the handsome quality of the paint. They are also strong social statements that play on the myriad contradictions that exist in race relations in the United States, particularly in those works in which Cosby uses black and white dolls as the subject.

In the painting *Hanging Out to Dry* (Plate 93), Cosby concisely interprets the negative elements associated with the black stereotype. She reverts to childhood experiences of growing up with white dolls, always conscious of the fact that none of the dolls readily available in the major stores she visited looked like she did. To Cosby, being aware of the

strides African Americans had made in civil rights and in the entertainment industry—her father, Bill Cosby, was a major success—being unable to find a black doll that did not fit the stereotype of the voodoo mammy was a chilling awakening. She detested the negative stereotype of finding a black doll with white features, including the long, straight locks of hair modeled after those of white children. It was in this context that Cosby decided to speak out about her concerns by painting the symbolic and historical absence of positive images of black children depicted as dolls.[36] The psychological torture black children prior to the 1970s grew up with of not seeing themselves represented in the doll world, other than in stereotypic form, became a major theme in Cosby's work in the late 1980s.

Hanging Out to Dry shows the upside-down posture Cosby assigns to the misrepresentation of standards of beauty in vogue in Western society. Although the artists of the Harlem Renaissance relished the notion of "black is beautiful," as did black artists of the 1960s, Cosby sees little change in the misguided assumptions that equate black skin with ominously unwelcomed events.

With the exception of Margo Humphrey, who creates themes that go against the grain of contemporary art, Cosby stands alone as she abhors creating the mild and palatable image that at times mirrors the consensus of happiness and joy in aesthetic taste. She loves muddying the aesthetic waters, and she has done it with grace and skill. Disturbing the racist skeleton hidden in many white closets, Cosby is at home poking fun at the black race while at the same time scolding whites for ignorance and for promoting inhumane racial stereotypes.

In many ways Cosby's work harks back to the idealistic formula in painting that both Alain Locke and Langston Hughes touted as a Harlem Renaissance ideal: that of revealing "the racial mountain," the monumental ignorance in mainstream white society of the color and richness of African American culture.

Plate 92. Varnette Honeywood, *Honor Thy Father and Mother*, 1983, collage, 40 x 30 in.

170 **Plate 93. Erika Ranee Cosby,** *Hanging Out to Dry,* **1991, shellac, oil, charcoal, pencil, 72⅛ x 83¾ in.**

Part 6 Notes

1. Robert Bone, *The Negro Novel in America* (New Haven: Yale University Press, 1965); Lucy R. Lippard, *Mixed Blessings: New Art in a Multicultural America* (New York: Pantheon Books, 1990), pp. 15–17.

2. Margaret Just Butcher, *The Negro in American Culture* (New York: Alfred A. Knopf, 1967), p. 214.

3. David C. Driskell, *Two Centuries of Black American Art* (New York: Alfred A. Knopf, 1976), p. 78.

4. Nathan Huggins, *The Harlem Renaissance* (New York: Oxford University Press, 1971), pp. 58–60, 89; Alain Locke, "The African Legacy and the Negro Artist, *Exhibition of the Work of Negro Artists* (New York: Harmon Foundation, 1931).

5. David C. Driskell, David Levering Lewis, and Debra Willis Ryan, *Harlem Renaissance: Art of Black America* (New York: The Studio Museum in Harlem and Harry N. Abrams, 1987), p. 106.

6. Tritobia Hayes Benjamin, *To Conserve a Legacy II* (brochure) (Washington, D.C.: Howard University Gallery of Art, 1999).

7. Driskell, Lewis, and Willis Ryan, *Harlem Renaissance*, p. 110.

8. Aaron Douglas papers, n.d., Fisk University Special Collections, Nashville, TN.

9. Huggins, *The Harlem Renaissance*, pp. 132, 295–296.

10. Aaron Douglas papers, n.d.

11. David Levering Lewis, *When Harlem Was in Vogue* (New York: Oxford University Press, 1979), pp. 127–217.

12. James A. Porter, *Modern Negro Art*, 3d ed. (Washington, D.C.: Howard University Press, 1992), pp. 4–7.

13. David C. Driskell, "The Flowering of the Harlem Renaissance: The Art of Aaron Douglas, Meta Warrick Fuller, Palmer Hayden, and William H. Johnson, pp. 105–106, in Driskell, Lewis, and Willis Ryan, *Harlem Renaissance*.

14. Ibid.

15. E. Franklin Frazier, "The Garvey Movement," *Opportunity*, vol. 4 (November 1926):346–348.

16. Huggins, *The Harlem Renaissance*, pp. 270–274.

17. Alain Locke, ed., *The New Negro: An Interpretation* (New York: Albert and Charles Boni, 1925), pp. 6–16.

18. Locke, "The Legacy of Ancestral Arts," pp. 254–267, in Locke, ed., *The New Negro*.

19. Richard J. Powell, *Rhapsodies in Black: Art of the Harlem Renaissance* (Berkeley: Hayward Gallery, Institute of Visual Arts, University of California Press, 1997), pp. 16–17.

20. Driskell, Lewis, and Willis Ryan, *Harlem Renaissance*, pp. 75–78.

21. Ibid., p. 77.

22. For a detailed account of the interaction among black artists, jazz musicians, and dancers, see David C. Driskell, "How African American Artists Saw Black Dance" (unpublished paper, in association with the exhibition *Black Art: Ancestral Legacy*, Dallas Museum of Art, March 1989).

23. Locke, "New Spirituals," pp. 200–205, in Locke, ed., *The New Negro*.

24. Huggins, *The Harlem Renaissance*, pp. 97–98, 197–198, 289–290.

25. Christa Clarke, "Defining Taste: Albert C. Barnes and the Promotion of African Art in the United States" (doctoral dissertation, University of Maryland, College Park, 1998), p. 51.

26. Driskell, Lewis, and Willis Ryan, *Harlem Renaissance*, pp. 111–112, 131.

27. Lewis, *When Harlem Was in Vogue*, p. 117.

28. Powell, *Rhapsodies in Black*, p. 29.

29. Walter Williams, conversation with author, Copenhagen, Denmark, November, 1972; also personal correspondence with author.

30. David C. Driskell, essay on Walter Williams in catalog *Oceans Apart* (New York: The Studio Museum in Harlem, 1978).

31. Walter Williams, conversation with author during an artist-in-residency at the Department of Art, Fisk University, Nashville, TN, 1968.

32. William Pajaud, correspondence with author, 1975–1976, about the subject of the exhibition *Two Centuries of Black American Art*.

33. William T. Williams, interview with author, New York, April 1995.

34. Kenneth Baker, *The San Francisco Chronicle*, April 13, 1996.

35. Mary Lovelace O'Neal, conversation with author, April 1988.

36. Erika R. Cosby, interview with author, June and July, 2000.

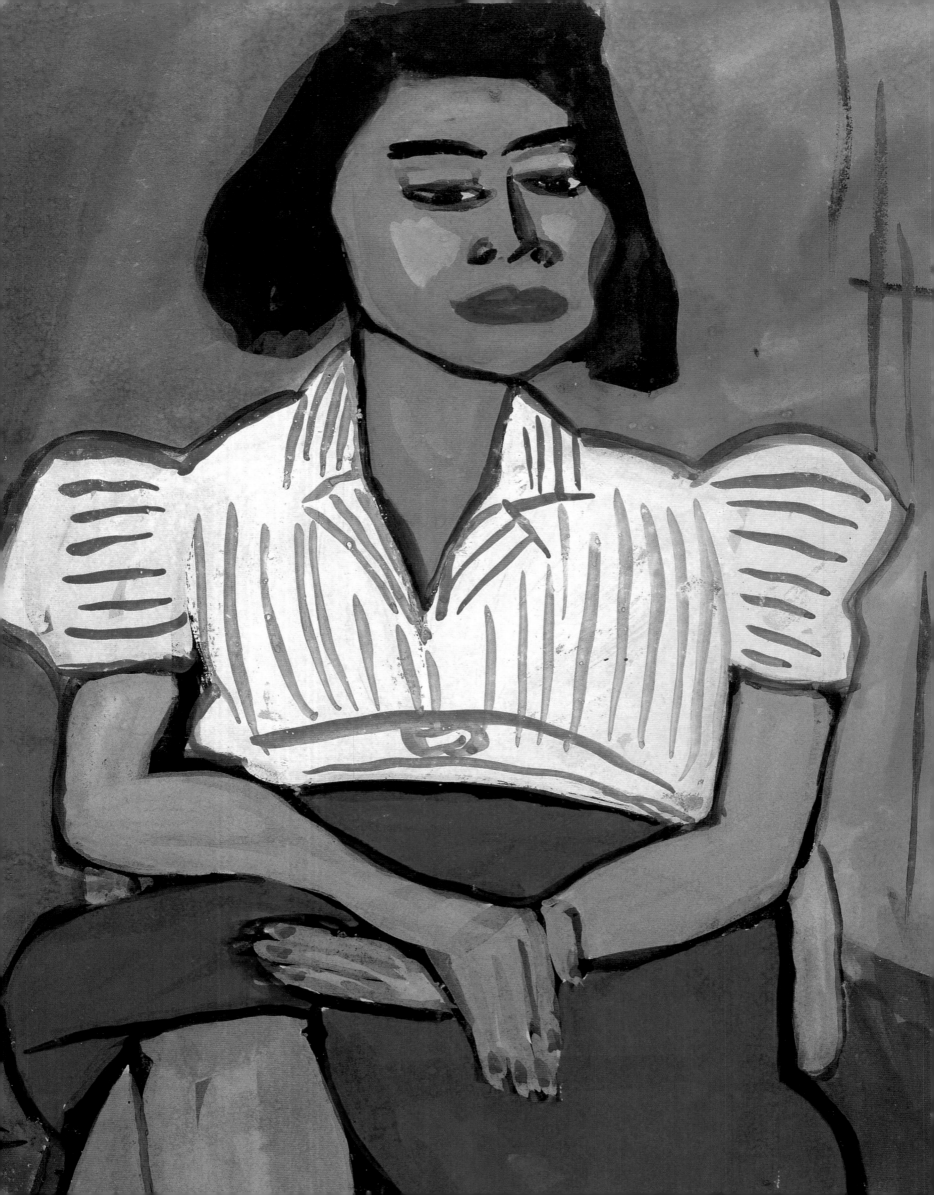

Afterword

African American artists in the nineteenth century worked to emancipate themselves culturally, hoping to enter the mainstream of American art by proving themselves able artists working in the styles of the day. None ventured into styles that would have set them apart from mainstream traditions. Daily they confronted bigotry and racial prejudice, which subtracted from the precious time they had to practice their art. The situation in America has not changed sufficiently; racial prejudice cannot be dismissed as a major obstacle to progress among African American artists today.

It would have been for naught if nineteenth-century African American artists Robert S. Duncanson, Edward Mitchell Bannister, and Mary Edmonia Lewis, all of whom were rediscovered and held up as role models in the Harlem Renaissance, had revolted against the prevailing styles of painting and sculpture. In place at that time was a widely held assumption that artists of color did not have the intellectual or creative capacity to compete competently with whites. It would have been inappropriate for them to pursue a lonely road of stylistic invention, refusing to take into account the tenets of romantic realism, naturalism, and neoclassicism.

In the same way, we do not expect African American artists at the beginning of a new millennium to stand aloof from contemporary trends. While contemporary black artists are less committed to realism than were their predecessors in the nineteenth century or during the Harlem Renaissance, we should not assume that realism will no longer figure into the African American artist's plan. After all, Picasso was free to appropriate forms of African art in his pioneering work in the first decade of the twentieth century; the reverse movement is also possible.

But in spite of the courage and dedication black artists, both men and women, showed throughout the last two centuries, the playing field of the art market and museum collection is not yet a level one. African American, Latino, Asian, First American, and women artists can expect to encounter prejudice during their review, a point that collector Bill Cosby ably makes in his introduction. Artists of color and women artists do enjoy a freedom to exhibit and make a living as artists beyond that accorded black artists of earlier generations, yet contemporary African American artists receive only marginal acceptance in mainstream museums today.

We spoke of the treatment Edward Mitchell Bannister received when he arrived at the galleries of the United States Centennial Exposition in Philadelphia in 1876 to receive the Bronze Medal he won in painting. He was turned away from the exhibition hall, barred from receiving his award in ceremony. Such cultural and racial bigotry is not limited to the bygone days of the nineteenth century. Aaron Douglas, whom Alain Locke referred to as "the father of black art," shared with me the story of his return to the Sherman House in Chicago in the 1950s to see a mural he had painted there two decades earlier. When he identified himself as the artist who created the work and asked to see it, he was told to follow an attendant who would accompany him. Assuming that the mural had been moved, Douglas quietly complied. They passed through a series of doors, the final of which exited into an alley in back of the hotel. No apologies were offered. This was the treatment accorded the artist whose pioneering vision for using African iconography ignited the spirit of the Harlem Renaissance.

Lois Mailou Jones spoke to me in 1997, vividly recalling how in the 1930s and 1940s she had to have a white friend send her art entries to the Corcoran Gallery of Art in Washington, D.C., since the work might never reach the jury if a black person were seen delivering it.

The prejudice mainstream that white society has shown artists of color has caused African Americans to create showcases of art for those of their own race. Not even the richness of the Harlem Renaissance provided such galleries and museums. The recent decades have seen the rise of the Studio Museum in Harlem, the California Museum of Afro-American Art in Los Angeles, and a National Center for Afro-American Art in Roxbury, Massachusetts, where black museum officials preside.

Detail from William Henry Johnson, *Untitled* (Plate 58).

While contemporary African American artists are under-represented in mainstream museum collections around the nation, and many could tell discouraging stories of their treatment as artists of color, some have achieved wide-spread recognition in spite of the obstacle of race. Among the artists cited here who moved beyond the Harlem Renaissance figuration into a more modern format, Jacob Lawrence, Romare Bearden, Robert Colescott, Martin Puryear, William T. Williams, and Bob Thompson have garnered accolades normally reserved for artists of the majority culture. Yet the art made by those of African ancestry is often lumped together under the heading of African American art without regard for the variety in style or expression among the works. Such disregard of stylistic schools would never be showed to artists of the majority culture; they never would be called simply "white artists." Here again we see the hand of racism.

Americans of European origin, in their search for a distinct language, have reinvented themselves since colonial times by naming and then relegating to the margin all people who seem different. These "others" in America have created jazz, blues, gospel, and forms of folk art that evidence a distinct flavor of blackness. It is this blackness that defines the originality of American music and identifies it with the black race in America.

Within the complex American cultural equation, fear of "otherness," or anything other than white, remains constant. African American art is forced to remain marginal to mainstream art, regardless of its cultural significance. Yet the badge of color on which such judgments are made is deceptive and fraught with contradictions. Martin Puryear is recognized around the world as one of America's leading sculptors and is considered by some as the nation's brightest star. While he proudly proclaims his African heritage, he is visibly a mixture of African, European, and First Nation ancestry. Yet in the main-stream he is labeled simply a "black" artist. Black America gladly recognizes all its sons and daughters who have provided a spark of creative genius that will mark the race. Yet because blackness is the other side of color in America, racism keeps the full rainbow of Puryear's ancestry from being acknowledged and celebrated.

African American artists have no choice but to see the color of their skin as the barrier to full inclusion in mainstream art. That many have chosen forms of expression both figural and racially based is a response to this exclusion, a strategy that dates back to the Harlem Renaissance.

As an artist and writer, I have always felt that African Americans spend too much time recognizing, and thus legitimizing, the so-called differences we have come to expect in the art of white and black races. And now we seem to believe that women as well deserve a separate place in the hierarchy of American art. Are they not, as women, legitimate artists? What these artists deserve is recognition as "artists," not as "women artists," a linguistic ploy as devious as the racist designation "black artist."

Perhaps the strategy of cultural emancipation, of proclaiming oneself capable of competing with the best artists in society—necessary for the black artists in nineteenth-century America and during the Harlem Renaissance—is still greatly needed. In many ways, cultural emancipation remains the cultural goal of African American artists at the beginning of the new millennium.

The handsome and culturally enlightening body of work by African American artists of the past two centuries that Camille and Bill Cosby have collected is a strong reminder of the genius of the black race. It reveals a story not yet fully told in the American art compendium. It is my hope that the readers of this book will no longer accept a limited, Eurocentric definition of American art without demanding to know this other story, the African American story of "the other side of color."

Charles Alston (1907–1977)
Woman and Child, c. 1955 (Plate 48)
Oil on canvas, 50 x 36 in.

Charles Alston was born in Charlotte, North Carolina, where his father was a prominent minister and educator. His early creations were animals made from the red clay he found around his home. After Alston's father's death, when Alston was still a child, Alston's mother remarried; in 1915 the family moved to New York City, where Alston attended high school and was an illustrator for his high school newspaper. Alston earned a Bachelor of Arts degree and a Master of Arts degree from Columbia University in New York City.

Upon graduation in the midst of the Depression, Alston became a supervisor of the Works Progress Administration (WPA) mural projects. Assigned to the Harlem Hospital, using his figurative cubist style he created two murals portraying the African American contribution to medicine. During this mural project, he met and married Myra Logan, an intern at the hospital. His work with the WPA expanded to teaching, as he cofounded the 306 group, a studio that became a prominent meeting place where writers, artists, dancers, and designers met to discuss art and its relationship to social and political issues. The Harlem-based group nurtured many African American artists, including Robert Blackburn, Georgette Seabrook Powell, and Jacob Lawrence.

Paintings Alston created during this period include portraits of blues singers and jazz musicians that were exhibited in the 1935 Harmon Foundation exhibition. After traveling to the South to study the lives of rural African Americans, Alston became a freelance commercial artist, designing book jackets and illustrating magazine articles. For the Office of War Information, he created cartoons and posters to inform the African American population of the war effort. After one year in the army, Alston's commercial career continued with work for book publishers, advertising agencies, and magazines such as *Collier's, Mademoiselle, Fortune,* and *Men's Wear.*

In 1948 Alston and Hale Woodruff were commissioned to paint two large murals portraying the role of African Americans in the history of California; the murals were installed in the Golden State Mutual Life Insurance Company's building in Los Angeles. In 1950 one of Alston's oil paintings was included in the Metropolitan Museum of Art's first exhibition of contemporary art and subsequently purchased by the museum. He also began teaching art at the Art Students League in New York, an assignment that lasted twenty years.

He was selected to coordinate the children's creative center at the 1958 Brussels World's Fair.

During the 1960s Alston was an active member of Spiral, a group of African Americans who met regularly to discuss their struggles in the world of art. In 1969 he was appointed to the New York City Art Commission, and in 1971 he became a full professor at the City College of New York. During the 1970s Alston continued to paint and created many sculptures, including a bust of Martin Luther King Jr. (1970). In 1973 he installed two large mosaic murals in the Bronx County court buildings. He continued to work on his artistic projects until he died of cancer in 1977.

Paintings, illustrations, murals, and sculptures by Charles Alston are in the collections of Golden State Mutual Life Insurance Company, Los Angeles, California; Clark Atlanta University, Atlanta, Georgia; Butler Institute of American Art, Youngstown, Ohio; The Detroit Institute of Arts, Michigan; Harlem Hospital, New York City; Metropolitan Museum of Art, New York City; and Whitney Museum of American Art, New York City.

Emma Amos (1938–)
Sand Tan, 1980 (Plate 80)
Aquatint etching, 33 ½ x 29 ⅝ in.

Emma Amos was born in Atlanta, Georgia. While a student at Antioch College in Yellow Springs, Ohio, she spent a year at London Central School of Art studying printmaking, painting, and weaving. Influenced by other American painters in Europe, her early work was done in an abstract expressionist style. In 1959 she received a bachelor's degree from Antioch, exhibited her work in Atlanta, and then settled in New York City, where she worked as a designer and weaver with textile designer Dorothy Liebes, creating fabrics for Bigelow Sanford. She also began to incorporate fiber and weaving into her artwork.

In New York Amos met her mentor, African American artist Hale Woodruff, who introduced her to Spiral, a group of artists that met regularly in Greenwich Village. She also studied lithography under Robert Blackburn, participating in his printmaking workshop from 1964 until 1982. In 1966 she received a master's degree from New York University. Inspired by the women's rights movement, Amos began to portray women in her paintings while her style became more figurative and she expanded her themes to include social, political, and gender issues.

Just as important to Amos's selection of subject matter is her integration of the expressive qualities of medium with movement. Although her preferred form of printmaking was

the aquatint, she also experimented with monoprints and collographs. These techniques gave her an opportunity to create in her etchings the flux of movement that had previously characterized her paintings.

During the 1970s Amos's art career flourished. She opened a studio in Soho and created the educational television show called *Show of Hands* that featured a variety of methods of working with wood, fabrics, clay, metal, and jewels. Amos wrote the scripts and cohosted the show, which aired for two years on WGBH in Boston. At the same time, she worked as a teacher at Newark School of Fine and Industrial Arts in New Jersey. In 1980 Amos became a professor at the Mason Gross School of the Arts at Rutgers University in New Brunswick, New Jersey, where she teaches drawing and painting. In her own work, she adopted the method of aquatinting, as shown in *The Gift*, a group of paintings that pays homage to her mentors and friends. Using the same technique, *Odyssey* depicts a hundred years of her family's history, beginning with her grandfather, Moses Amos, who became the first black pharmacist in Atlanta.

Amos has been the recipient of many awards, including a National Endowment for the Arts fellowship, a New York Foundation for the Arts fellowship, a Rockefeller Foundation fellowship, and an Art Matters fellowship. She has also been a generous volunteer, serving on the boards of numerous institutions, including the Skowhegan School of Painting and Sculpture in Maine, and on the editorial board of *Heresies*, a journal on art and politics. In 1995 she completed a mosaic mural, *The Sky's the Limit*, for a school on 167th Street and Jumel Place, in Manhattan.

Paintings and prints by Emma Amos are in the collections of Museum of Modern Art, New York City; The Newark Museum, New Jersey; Schomburg Center for Research in Black Culture, The New York Public Library, New York City; Studio Museum in Harlem, New York City; Library of Congress, Washington, D.C.; Miami Art Museum, Dade Cultural Center, Florida; and Minnesota Museum of American Art, Minneapolis.

William Ellisworth Artis (1914–1977)

African Youth, 1940 (Plate 53)
Bronze, height 9 ½ in.

William Ellisworth Artis was born in Washington, North Carolina, in 1914. While still young, he left his hometown for New York City, where his interest in ceramics was fostered at Augusta Savage's School of Arts and Crafts. His work was first on public display during the 1933 Harmon Foundation exhibition. During World War II Artis served five years in the army

and then studied art at several schools, including the Art Students League.

In 1947 Artis enrolled at Syracuse University, in New York City, studying sculpture under Ivan Mestrovick and earning a bachelor's and a master's degree. From 1954 until 1965, he was an associate professor of sculpture and ceramics at Chadron State College, in Chadron, Nebraska. From 1966 until 1974, he was at Mankato State College, in Mankato, Minnesota, where he taught ceramics and conducted extensive studies of clay samples from south central Minnesota. Throughout his teaching career, Artis was also a prolific sculptor and ceramist. His terra-cotta busts and heads mostly portray young faces, capturing the essence of their souls. Many of his ceramic vessels accentuate the viscous nature of glaze. In the early 1970s Artis shifted to porcelain, creating heads that were salt fired. In 1970 the College Art Association honored Artis as one of the nation's outstanding living sculptors and ceramists. The following year, Fisk University held a retrospective exhibition of Artis's work, and he was honored by membership into the National Sculpture Society. Illness forced Artis to stop working in 1974, and he died in 1977.

Sculpture and ceramics by William Ellisworth Artis are in the collections of National Portrait Gallery, Smithsonian Institution, Washington, D.C.; Slater Memorial Museum, Norwich, Connecticut; Joslyn Art Museum, Omaha, Nebraska; Clark Atlanta University, Atlanta, Georgia; Fisk University, Nashville, Tennessee; Howard University, Washington, D.C.; and Walker Art Center, Minneapolis, Minnesota.

Edward Mitchell Bannister (1828–1901)

Fishing, 1881 (Plate 9)
Oil on canvas, 30 x 50 in.

Homestead, 1883 (Plate 10)
Oil on canvas, 34 x 44 in.

Edward Mitchell Bannister was born in 1828 in St. Andrews, New Brunswick, Canada. Bannister moved to Boston and, while earning a living as a barber and a hand-tinter of photographs, studied drawing at Lowell Institute. In the early 1850s he began to exhibit and sell his work, mostly oil paintings with biblical and historical themes, through the Boston Art Club and Museum. On occasional trips to Providence, Bannister painted Rhode Island countryside scenes and Narragansett shore scenes in the style of the Barbizon school of French landscape painting. These, too, were well-received in Boston, especially his dramatic renderings of the relationship between sky and clouds.

In 1870 Bannister moved to Providence, where he contin-

ued to paint landscapes, which at this time dominated his work. Encouraged by his fellow artists and his patrons, Bannister submitted the highly acclaimed *Under the Oaks* (1875) for inclusion in the United States Centennial Exposition, held in 1876 in Philadelphia, and won the coveted bronze medal. After his success in Philadelphia, Bannister returned to a growing community of artists in Providence who were determined to exhibit and sell their work without paying large commissions to agents in Boston and New York. Bannister, with a group of artists—including George B. Whitacker, J. S. Lincoln, John Nelson Arnold, George L. Miner, Eimrich Rein, Charles Walter Stetson, George M. Porter, and Rosa Peckam—formed the Providence Art Club. Members exhibited their work, offered classes, and eventually formed the Rhode Island School of Design and Museum.

Bannister continued to win recognition at the annual exhibits of the Massachusetts Charitable Mechanics Association in 1878, 1881, and 1884. In his later paintings, his landscapes are less realistic and incorporate some of the more dramatic elements of nature, rather than just the pastoral or ideal. Bannister died of a heart attack at the age of seventy-four in 1901. That same year the Providence Art Club held a retrospective of Bannister's work.

Paintings by Edward Mitchell Bannister are in numerous Providence collections (Providence Art Club, Brown University Library, Rhode Island School of Design, Bannister Nursing Care Center) and National Museum of American Art, Smithsonian Institution, Washington, D.C.

Richmond Barthé (1901–1989)
Inner Music, 1985 (Plate 32)
Bronze, height 22 ¾ in.

Richmond Barthé was born in 1901 in Bay St. Louis, Mississippi. Sponsored by the Reverend Jack Kane, pastor of the Blessed Sacrament Catholic Church in New Orleans, Barthé left New Orleans in 1924 to attend the Art Institute of Chicago for four years.

Charles Schroeder became Barthé's mentor in Chicago, and he introduced him to three-dimensional work in clay. His first two busts won awards and brought him commissions as well. In 1929 Barthé went to New York City, furthering his development as a sculptor at the Art Students League. Two years later, an exhibition of his work at the Caz-Delbo Gallery in New York City brought him to the attention of the director of the Whitney Museum of American Art, who included his work in the museum's 1933, 1935, and 1939 exhibitions. *African Dancer*, *Blackberry Woman*, and *The Comedian* were purchased for the Whitney's permanent collection. In 1933 his

portrait of James Aggrey, an African educator, was exhibited at the Chicago World's Fair.

As one of the pioneers in depicting African Americans, Barthé's work was often lyrical, with emphasis on movement. He portrayed African American leaders (George Washington Carver and Booker T. Washington), local citizens (a boxer, a harmonica player, a shoeshine boy), and theatrical luminaries (Paul Robeson, Laurence Olivier, and Judith Anderson). In 1937 Barthé accepted a commission from the United States Treasury Department to create a series of bas-reliefs at the Harlem River Housing Project. Barthé's largest exhibit, eighteen bronzes, was held in 1939 at the Arden Galleries and lead to a Guggenheim fellowship in 1940 and 1941.

During World War II, Barthé created statues of black generals of the past (Jean Jacques Dessalines and Toussaint L'Ouverture), several renditions of Jesus for the Catholic church, and a sculpture for the Social Security Board Building in Washington, D.C. The National Institute of Arts and Letters awarded him a cash prize in 1946. He served as director of the Audubon Artists and belonged to the Sculptors Guild and National Sculpture Society. After the war Barthé left the stressful life of New York City for Jamaica and then Florence, Italy, finally settling in Pasadena, California, where he died in 1989.

Sculptures by Richmond Barthé are in the collections of the Metropolitan Museum of Art, New York City; Schomburg Center for Research in Black Culture, The New York Public Library, New York City; Clark Atlanta University, Atlanta, Georgia; Tuskegee University, Tuskegee, Alabama; Fisk University, Nashville, Tennessee; Whitney Museum of American Art, New York City; and Amistad Research Center, Tulane University, New Orleans, Lousiana.

Romare Bearden (1914–1988)
Sitting In at Baron's, 1980 (Plate 50)
Collage on masonite, 39 ⅝ x 29 ¾ in.

Magic Garden, 1980 (Plate 51)
Collage on masonite, 39 ¾ x 31 in.

Harlem Brownstone, 1980 (Plate 52)
Collage on masonite, 29 ⅞ x 40 in.

Romare Bearden was born in Charlotte, North Carolina, and raised in Harlem. His father worked for the Department of Health; his mother was an editor and founder of the Negro Women's Democratic Association. Their home was a gathering spot for artists and musicians during the Harlem Renaissance. Bearden studied mathematics at New York University, where he also drew cartoons for the school paper. After receiving a graduate degree in social work from Columbia University, he

became a case worker for the New York City Department of Social Services, where he worked until 1966.

Bearden continued to study art, including classes with German satirist George Grosz at the Art Students League, and to publish his cartoons (*Baltimore Afro-American, Life, Colliers, Judge,* and *College Humor*). Following the example his parents set, he was a civic leader, and his home became a gathering place for artists and musicians. He joined the Harlem Artists Guild, an organization instrumental in forcing the Works Progress Administration to offer commissions and jobs to African Americans. He also attended meetings of the 306 group, which met at 306 West 141st Street, the home studios of Charles Alston and Henry Bannarn.

Bearden's first solo exhibition, arranged in 1940 by the 306 group, consisted of works created with several techniques (gouache, watercolor, oil-based paint, and ink).

During World War II Bearden served in the army and continued to paint in his spare time. Upon his release in 1945, he exhibited his *The Passion of Christ* series (eleven watercolors and eleven oils) at the Kootz Gallery; the New York Museum of Modern Art purchased one of the series. His style now was defined as representational forms painted in pale and vibrant colors with the added definition of strong black lines. Taking advantage of his veteran's benefits, Bearden spent 1950 studying at the Sorbonne in Paris, where he met Henri Matisse and Joan Miró and studied literature, philosophy, and art history.

In the 1960s Bearden was an active member of Spiral, the group Norman Lewis and other black artists formed in an attempt to define their contribution to the civil rights movement. Bearden's contribution to the group was *Projections,* a collection of photodocumentary montages that captured the integrity of two cultures: African and African American. These "photomontages" (as he called them) marked a distinct departure from Bearden's earlier ink and watercolor abstractions and were exhibited at the Corcoran Gallery in Washington, D.C., in 1965. For the next several years Bearden continued to create collages of fragmented photographs, magazine and newspaper clippings, and synthetic polymer paint. His faces often showed the influence of African masks, while his subject continued to be African American culture.

Bearden's compositions became less fragmented in the 1970s as he relied more on the use of pure color. His work continued to be exhibited in galleries throughout the United States, Europe, and Japan. In 1972 he was elected a member of the National Institute of Arts and Letters, and his first book (*Six Black Masters in American Art,* coauthored with Harry Henderson) was published. Bearden also worked on murals for colleges and transit systems, including *Baltimore Uproar*

for a Baltimore subway station and *Pittsburgh Recollections,* 1984, for the Pittsburgh Allegheny Rapid Transit Authority. In a 1987 White House ceremony, Bearden was awarded the National Medal of Arts by President Ronald Reagan. Just before he died in 1988, Bearden coauthored (with Harry Henderson) *A History of African-American Artists from 1772 to the Present.*

Paintings and collages by Romare Bearden are in the collections of California African-American Museum, Los Angeles; New Britain Museum of American Art, New Britain, Connecticut; Virginia Museum of Fine Arts, Richmond, Virginia; Weisman Art Museum, University of Minnesota, Minneapolis; Sheldon Memorial Art Gallery and Sculpture Garden, University of Nebraska, Lincoln; Reynolda House Museum of American Art, Winston-Salem, North Carolina; Fred Jones Jr. Museum of Art, University of Oklahoma, Norman; Arizona State University Art Museum, Tempe, Arizona; National Museum of American Art, Smithsonian Institution, Washington, D.C.; and Metropolitan Museum of Art, New York City.

Elizabeth Catlett (1915–)

Maternity, 1980 (Plate 56)
Marble, height 26 in.

Woman Resting, 1981 (Plate 57)
Polychromed mahogany, height 19 ⅝ in.

The Family, 1983–1984 (Plate 58)
Marble, height 58 in.

Woman Sitting, 1985 (Plate 59)
Bronze, height 26 ½ in.

Reclining Woman, 1986 (Plate 60)
Mahogany, height 14 in.

Elizabeth Catlett was born in Washington, D.C., in 1915. In 1932 she enrolled at Howard University in Washington, D.C. Majoring in painting, she received a bachelor's degree with honors in 1937.

After briefly teaching art in a Durham, North Carolina, high school, Catlett decided to return to school. She entered the State University of Iowa master's program, studying under Grant Wood, who insisted all his students work in all major media. Sculpture became her medium of choice, and her thesis piece, a stone sculpture of a black mother and child, won first prize at the 1940 American Negro Exposition in Chicago. After moving to New Orleans, Catlett headed the art department at Dillard University, and and then taught at Hampton Institute in Hampton, Virginia.

In 1946, aided by a Julius Rosenwald Foundation fellowship,

Catlett traveled to Mexico, where she studied woodcarving and ancient ceramic sculpture techniques while continuing to work in three media: sculpture, painting, and printmaking. Although she became a Mexican citizen, her prints and sculptures continued to portray the African American experience and the need for social and economic freedom.

In the 1950s Catlett gained recognition, winning prizes in the 1956 Atlanta University annual exhibition of African American art and the 1959 International Graphics exhibition in Leipzig, Germany. In Mexico she won the 1962 Tlatilco prize and the 1964 Xipe Totec prize for her scepter. In 1959 she became the head of the sculpture department at the National School of Fine Arts, University of Mexico.

In the 1970s Catlett traveled throughout the United States, Europe, and Asia, giving speeches in support of the African American aesthetic and exhibiting her prints.

Sculptures and prints by Elizabeth Catlett are in collections at National Museum of American Art, Smithsonian Institution, Washington, D.C.; National Institute of Fine Arts, Mexico City; Amistad Research Center, Tulane University, New Orleans, Louisiana; Metropolitan Museum of Art, New York City; Museum of Modern Art, New York City; High Museum, Atlanta, Georgia; Clark Atlanta University, Georgia; Fisk University, Nashville, Tennessee; Howard University, Washington, D.C.; and National Museum of Czechoslovakia in Prague. Among her public installations are a bronze relief in the Chemical and Engineering Building at Howard University; a bronze portrait of Louis Armstrong for the city of New Orleans; a bronze bust of Phyllis Wheatley for Jackson State University in Mississippi; and life-size portraits of James Torres Bodet and José Vasconcelos for the Secretariat of Education building in Mexico City.

Claude Clark (1915–)

On Sunday Morning, 1940 (Plate 62)
Oil on canvas, 40 x 60 in.

Sponge Fisherman, 1944 (Plate 61)
Oil on board, 18 ¼ x 24 ½ in.

Claude Clark was born in Rockingham, Georgia, in 1915. At the age of twenty, he enrolled in the Pennsylvania Museum School of Industrial Art and studied for four years under Henry Pitz, Earl Horter, and Franklin Watkins. In 1939 he continued his studies at the Barnes Foundation in Merion, Pennsylvania, where he was introduced to the extensive art collection of renowned collector Dr. Albert C. Barnes. He also worked on various graphic arts projects for the Works Progress Administration.

Clark's teaching career began in the Philadelphia public school system. In 1948 he joined the faculty at Talladega College in Talladega, Alabama, where he spent seven years developing the school's art department and serving as associate professor. In 1955 he moved to California and completed a bachelor's degree at Sacramento State College and a master's degree at the University of California, Berkeley. While working on his degrees, he also taught art at an Alameda County juvenile justice facility. In 1968 Clark became a teacher at Merritt College in Oakland, California, and was requested by the Black Panther Party to author a curriculum guide: *A Black Perspective: A Black Teacher's Guide to a Black Visual Art Curriculum*.

Claude Clark's paintings range in expression but are singular in their reflection of African American themes. His early compositions depict iconography related to the African mask and ceremonial statuary. *Slave Lynching* (1946) is a powerful example of his ability to expose the injustice of slavery. Works completed in the 1950s and 1960s reveal a literal interpretation of the world that focuses on man and nature. Inspired by a Caribbean excursion sponsored by a Carnegie Corporation fellowship, Clark completed a series of floral paintings and landscapes. In 1976 and 1978, he traveled to Africa, where he was inspired to create a series of paintings depicting the African diaspora. In 1981 he retired from his teaching post at Merritt College.

Paintings by Claude Clark are in the collections of National Museum of American Art, Smithsonian Institution, Washington, D.C.; Library of Congress, Washington, D.C.; St. Louis Art Museum, Missouri; Fisk University, Nashville, Tennessee; Talladega College, Talladega, Alabama; Clark Atlanta University, Atlanta, Georgia; Philadelphia Museum of Art; and M. H. de Young Museum, San Francisco.

Robert Colescott (1925–)

Death of a Mulatto Woman, 1991 (Plate 75)
Acrylic on canvas, 84 x 72 in.

Robert Colescott was born in Oakland, California. He earned a Bachelor of Arts degree (1949) and Master of Arts degree (1951) from the University of California at Berkeley. A one-year break in his studies was spent in Paris, where he attended Fernand Léger's school. Influenced by Léger's philosophy of working in a figurative style to portray modern urban culture, Colescott ultimately abandoned abstraction for figurative painting.

Colescott began his teaching career at Queen Anne High School in Seattle and then transferred to Portland State

University in Oregon, where he also had his first showing at the Fountain Gallery. During the 1960s Colescott was an artist-in-residence at the American Research Center in Egypt and taught at The American University in Cairo. Influenced by the narrative form of Egyptian art, Colescott began to use satirical humor to alter the original works of such European artists as Edouard Manet, Jan van Eyck, and Vincent Van Gogh, thus conveying his ideas about European and African American culture, particularly the exclusion of African Americans from art history.

Before returning to the United States, Colescott taught art history at American College in Paris (1967–1969), and then in the 1970s he taught at California State College, Stanislaus; University of California, Berkeley; and the San Francisco Art Institute. During this period he began to receive widespread recognition for his paintings, especially those that reinsert African Americans into recognizable historical or artistic scenes. *George Washington Carver Crossing the Delaware: Page from an American History Textbook* (1975), for example, echoes Emanuel Leutze's famous nineteenth-century painting of George Washington leading his troops across the Delaware River; in Colescott's version George Washington Carver leads a similar group of African Americans, satirically rendered in blackface as mammies, minstrels, and cooks.

During the 1970s and 1980s, Colescott continued to receive fellowships that supported his painting (National Endowment for the Arts, 1976, 1980, 1983; John Simon Guggenheim Foundation, 1985) and to teach (University of California, Berkeley; San Francisco Art Institute; University of Arizona, Tucson). In 1987 the San Jose Museum of Art opened a retrospective exhibition of Colescott's work that subsequently traveled around the country. A year at the Roswell Foundation Artist's residency program in New Mexico helped him define this new direction.

In 1997 nineteen Colescott paintings were chosen to represent the United States at the forty-seventh Venice Biennale; the paintings were exhibited the following two years throughout the United States. His paintings are widely exhibited in the United States, Europe, and Japan, and he is a popular guest lecturer at universities and museums. He lives in Tucson; since retiring from teaching at the University of Arizona in 1995, he devotes himself to painting.

Paintings by Robert Colescott are in collections at Boston Museum of Fine Arts, Massachusetts; California African-American Museum, Los Angeles; Metropolitan Museum of Art, New York City; Museum of Modern Art, New York City; Hirshhorn Museum and Sculpture Garden, Smithsonian Institution, Washington, D.C.; High Museum of Art, Atlanta, Georgia; and Seattle Art Museum, Washington.

Eldzier Cortor (1916–)

Southern Theme/Magnolia II, 1947 (Plate 63)
Oil on canvas, 30 x 12 in.

Still Life: Souvenir No. IV, 1982 (Plate 65)
Oil on canvas, 57 x 33 in.

Homage to 466 Cherry Street, 1987 (Plate 64)
Oil on masonite, 36 ¾ x 46 ½ in.

Eldzier Cortor was born in Richmond, Virginia, and raised in Chicago. He attended the Art Institute of Chicago, earning a degree in 1936.

From 1936 to 1940, Cortor was employed by the Works Progress Administration, and taught drawing at the South Side Community Art Center. In 1940, aided by a Julius Rosenwald Foundation fellowship, Cortor enhanced his appreciation for African culture by spending a year among the Gullah-speaking inhabitants of the sea islands off the coast of Georgia and South Carolina.

Wanting to perfect the techniques of painting and woodblock printing, Cortor moved to New York and attended Columbia University. In his paintings he began to focus on African American women, with their elongated figures influenced by African sculpture. In 1946 *Life* magazine published a photograph of a nude study, which led to a Guggenheim Fellowship that enabled him to travel to Cuba, Jamaica, and Haiti. From 1949 to 1951 he taught at the Centre d'Art in Port-au-Prince, Haiti.

Cortor's production as an artist was interrupted by the McCarthy era, during which accusations of communist affiliations forced many artists into exile. Cortor moved to Mexico, where he pursued his interest in lithography. During the 1950s and 1960s, after he returned to New York, he worked in lithography, selling his prints through the Associated American Artists while submitting his work to juried shows. In the 1970s he created a series of head studies of African American women as well as still lifes that portray objects, pictures, and symbols of African American culture. His work has been included in exhibitions at the Metropolitan Museum of Art, the Carnegie Institute, Howard University, the Museum of Fine Arts, Boston, the National Center of Afro-American Artists, Roxbury, Massachusetts, and Kenkeleba House, New York City.

Paintings and prints by Eldzier Cortor are in the collections of Howard University, Washington, D.C.; Mary Brogan Museum of Art and Science, Tallahassee, Florida; National Museum of American Art, Smithsonian Institution, Washington, D.C.; and Studio Museum in Harlem, New York City.

Erika Ranee Cosby (1965–)

Hanging Out to Dry, 1991 (Plate 93)

Shellac, oil, charcoal, pencil, 72⅛ x 83¾ in.

Erika Ranee Cosby was born in 1965 in Los Angeles, California. She graduated from Wesleyan University in Middletown, Connecticut, receiving a Bachelor of Arts degree in 1987. Pursuing additional study in art at the School of Visual Arts in New York City, she enrolled in and earned a Bachelor of Fine Arts degree in 1989 and a Master of Fine Arts degree from the University of California, Berkeley, in 1991. During the summer of 1993 she completed postgraduate courses at the Skowhegan School of Painting and Sculpture in Maine.

In her artwork Cosby concentrates on image perception, especially the media's debasing stereotypes that alter the realistic qualities of people through negative representation. Studying product imagery of the past has enabled Cosby to perceive covert yet equally negative images in the contemporary media. Through the use of satire, metaphor, and allegory, her work examines the intent and the effect of these distorted images on African American culture. Among her mentors are artists David C. Driskell and Mary Lovelace O'Neal.

Paintings and collages by Erika Ranee Cosby have been exhibited at the Silverstein Gallery, New York City; Bomani Gallery, San Francisco, California; and the Weintraub Gallery, Sacramento, California. In 1996 one of Cosby's paintings was used on the cover of *Voices of Vision,* the first book published by the National Centers for African American Women of the National Council of Negro Women. In the same year she received a painting fellowship from the New York Foundation for the Arts.

She has participated in numerous group exhibitions, including *Artists in the Marketplace,* Bronx Museum of the Arts, New York City; *Norfolk '96,* Yale Summer School of Music and Art, New Haven, Connecticut; and *An Exploration of Color*, Bomani Gallery, San Francisco, California.

Beauford Delaney (1901–1979)

Beauford Delaney's Loft, 1948 (Plate 33)

Oil on canvas, 31 x 38 in.

Untitled (*Abstraction*), 1954 (Plate 34)

Oil on masonite, 18 x 15 in.

Born in 1901 in Knoxville, Tennessee, Beauford Delaney had nine brothers and sisters, and two of the boys—Beauford and Joseph—became well-known artists. Both boys began drawing at an early age, but Beauford also excelled at school. After graduation, he became a shoemaker's apprentice. Lloyd Branson, a local artist and patron of the shop where Beauford worked, saw his drawings and urged Delaney to go to Boston and study art.

At the age of twenty-three, Delaney went to Boston and enrolled at Massachusetts Normal School, taking additional evening classes at South Boston School of Art and at the Copley Society. In 1929 Beauford moved to Harlem (where his brother Joseph was also living), studied art at the Art Students League under Thomas Hart Benton and John Sloan, and began to specialize in portraits. His subjects were the interesting, creative people he met: dancers from Billy Pierce's dance studio, blues and jazz musicians Louis Armstrong and Duke Ellington, opera singer Marian Anderson, writer James Baldwin, and social leader W. E. B. Du Bois.

In 1930, three of Delaney's portraits were included in a group exhibition at the Whitney Studio Galleries. Three months later his portraits and charcoal drawings were exhibited at the New York Public Library, 135th Street branch. In 1934 Delaney's work was included in the Harmon Foundation traveling exhibition, and in 1936 he assisted Charles Alston with his Harlem Hospital mural project, with support from the Works Progress Administration. During this period his work grew more expressionistic, especially his cityscapes, as he explored the relationship of color and line. In the 1940s his work was exhibited at RoKo Gallery in New York City and at the Pyramid Club in Philadelphia. His expanding contacts in the art community helped him qualify for a fellowship to Yaddo, an art colony in Saratoga Springs, New York, where he was allowed to paint without worrying about rent or food.

In 1953, financed by a patron, Delaney went to Europe, where he continued to paint, creating portraits and works of an abstract nature that were widely exhibited in several Parisian galleries. In 1965 and 1968 he was awarded additional grants from the Fairfield Foundation and the National Council on the Arts, and he used some of the money to return to Knoxville and visit his family. Shortly after his return to France, his health deteriorated and he was unable to work. After suffering a long illness, in 1979 he died in Paris.

Paintings by Beauford Delaney are in the collections of Whitney Museum of American Art, New York; The Newark Museum, Newark, New Jersey; National Museum of American Art, Smithsonian Institution, Washington, D.C.; and Galerie Darthea Speyer, Paris.

Aaron Douglas (1899–1979)

Crucifixion, 1934 (Plate 28)

Oil on masonite, 48 x 36 in.

Aaron Douglas was born in Topeka, Kansas. At the University of Nebraska in Lincoln, he studied drawing, painting, and art history. With this academic background, he taught two years in a high school in Kansas City, Kansas, and then moved to New York, arriving in 1925, a time when African Americans were experiencing a social and cultural revival. Douglas became an active participant in the movement, called the Harlem Renaissance.

In New York Douglas began to study under Winold Reiss, a Bavarian artist-illustrator who encouraged him to create drawings of African Americans. Douglas soon developed a style of flat silhouetted figures, often using a veil of concentricate circles and linear shapes. During this period, Douglas sold illustrations to several magazines, including *Vanity Fair,* and contributed six pages of black-and-white illustrations to Alain Locke's book, *The New Negro: An Interpretation* (1925). James Weldon Johnson commissioned Douglas to illustrate *God's Trombones* (1927).

After painting a stylized mural of dancers inside Club Ebony in Harlem, Douglas received commissions for murals from Fisk University in Nashville, and the Sherman Hotel in Chicago. He also received a scholarship to study art at the Barnes Foundation run by Dr. Albert C. Barnes in Merion, Pennsylvania. In 1930, with the proceeds from his murals, he traveled to Paris, where he studied at the Académie de la Grande Chaumière and the Académie Scandinave. He also met Henry Tanner and Palmer Hayden in Paris.

When he returned to New York, Douglas continued to paint murals, including one at the Harlem YMCA and then four panels of African American history, *Aspects of Negro Life* (1934), for the Countee Cullen Branch of The New York Public Library. In 1937 Douglas joined the faculty of Fisk University; at the same time, he maintained a studio in Harlem and earned a master's degree at Columbia University's Teachers College. In 1944 he become chairman of Fisk University's art department and taught until his retirement in 1966. He continued to work in his studio on the Fisk campus until his death in 1979.

Paintings by Aaron Douglas are in the collections of Howard University Gallery of Art, Washington, D.C.; Aaron Douglas Gallery, Fisk University, Nashville, Tennessee; Amistad Research Center, Tulane University, New Orleans, Louisiana; Sheldon Memorial Art Gallery and Sculpture Garden, University of Nebraska, Lincoln; Schomburg Center for Research in Black Culture, The New York Public Library, New York City; Hampton University Museum, Hampton, Virginia; and Metropolitan Museum of Art, New York City.

David C. Driskell (1931–)

Antique Rocker, from the *Americana* series, 1978 (Plate 79)
Acrylic on canvas, 36 x 24 in.

The Green Chair, from the *Americana* series, 1978 (Plate 78)
Acrylic on canvas, 40 x 24 in.

Adam Showing Eve, 1994 (Plate 77)
Collage and encaustics on canvas, 30 x 30 in.

David C. Driskell was born in Eatonton, Georgia, and raised in North Carolina. In 1953 Driskell was awarded a scholarship to attend the Skowhegan School of Painting and Sculpture in Maine, where he developed an affinity for the New England countryside and depictions of nature in his paintings. In 1955 he received a Bachelor of Arts degree from Howard University, Washington, D.C. Initially a history major, Driskell switched to art after attending a drawing class taught by James Wells and a chance encounter with James Porter.

Driskell's first teaching job was at Talladega College in Alabama, and in 1956 his first one-man exhibition was held at the Savery Art Gallery in Talladega. He moved back to Washington, D.C., to enroll in the Catholic University of America, where he was awarded a Master of Fine Arts degree in 1962. From 1962 until 1966, he was an associate professor at Howard University. A 1964 Rockefeller Foundation fellowship enabled him to travel throughout Europe and Scandinavia, study art history at Rijksbureau voor Kunstistorisches Documentatae den Hague, and receive the Harmon Foundation Fellowship. In his own work, he began to favor still lifes rendered in an abstract manner and religious themes. He also began work on his *Americana* series, inspired by his collection of found chairs.

From 1966 until 1977, Driskell taught and chaired the art department at Fisk University in Nashville, Tennessee. A trip to Nigeria as a visiting professor brought him in contact with African artists, and the geometrics and colors of African art began to appear in his own paintings during this period. He also began to experiment with collage and gouache painting, employing forms derived from African art, as seen in his woodcuts with African iconography and *The Black Woman* series, which combines oil painting with collage. Driskell became a professor at the University of Maryland, in College Park, Maryland, in 1977. He chaired the Department of Art at the University of Maryland from 1978 to 1983 and subsequently became Distinguished University Professor of Art in 1995, a position that he held until his retirement in 1998. Additional travel grants enabled him to study in Japan, Brazil, Egypt, Saudia Arabia, and South Africa. In 1977 Driskell wrote and also narrated *Hidden Heritage*, which was an hour-

long award-winning CBS program on African American Art.

Regarded as one of the world's leading authorities on the subject of African American Art, Driskell has authored numerous catalogs, books, articles, and essays, and his lecture circuit includes universities, colleges, and museums in Europe, Africa, South America, and North America. Driskell is also a recognized curator of African American exhibitions, including *Two Centuries of Black American Art: 1750–1950* for the Los Angeles County Museum of Art, 1976, which was accompanied by a book published by Knopf. Among his other exhibitions and accompanying books are *Harlem Renaissance: Art of Black America* (Abrams, 1987); *Contemporary Visual Expressions*, Smithsonian Institution Press, 1987; and *African American Visual Aesthetics: A Post Modernist View* (Smithsonian Institution Press 1995).

Documenting Driskell's contributions to the interpretation of African-American art history, the Arts Council of Great Britain funded *Hidden Heritage: The Roots of Black American Painting,* a film that premiered at the British Academy of Film and Television Arts in 1990 in London. The same year Driskell completed two stained glass windows for the Peoples Congregational Church in Washington, D.C. Installed in the sanctuary and measuring fourteen feet in diameter, each window—devoted separately to the African American woman and the African American man—depicts Christianity and translations from slave narratives. A second stained glass window commission was completed in 1996 for the Deforest Chapel at Talladega College, in which sixty-five windows pay homage to leading African Americans.

Paintings, collages, prints, and sculpture by David C. Driskell are in the collections of Bowdoin College Museum of Art, Brunswick, Maine; Corcoran Gallery of Art, Washington, D.C.; Birmingham Museum of Art, Alabama; Arkansas Fine Arts Center, Little Rock; Howard University, Washington, D.C.; Fisk University, Nashville, Tennessee; and Portland (Maine) Museum of Art. Two companion exhibitions assembled by the University of Maryland [*Echoes: The Art of David C. Driskell* (of Driskell's work); and *Narratives of African American Art and Identity: The David C. Driskell Collection* (representations from his private collection)] traveled throughout the United States from 1998 until 2001.

Robert S. Duncanson (1821–1872)
Romantic Landscape, 1853 (Plate 8)
Oil on canvas, 16 ⅛ x 24 in.

Landscape with Brook, 1859 (Plate 5)
Oil on canvas, 10 x 16 in.

Falls of Minnehaha, 1862 (Plate 6)
Oil on canvas, 36 ¼ x 28 ¼ in.

Vale of Kashmir, 1864 (Plate 7)
Oil on canvas, 18 x 30 ⅛ in.

The first African American artist to receive national and international recognition, Robert S. Duncanson was born in 1821 in New York state. In 1840 he moved to Cincinnati, where he began to make a living as a painter. Often called the Queen City of the West, Cincinnati was becoming a cultural center, and it had a sizable community of free African Americans, most likely because the city was one of the underground railroad stops for slaves trying to escape from Kentucky across the Ohio River to freedom.

The Cincinnati art community recognized Duncanson's talent, showing his paintings in the Western Art Union's 1842 and 1843 annual art exhibitions. His association with Thomas Worthington Whittredge, William L. Sonntag, James Kellogg, William Kellogg, and J. P. Ball was artistically and socially beneficial as Duncanson perfected his landscape technique. At the time, large panoramas were very popular, especially scenes of the American wilderness; these paintings, usually eight feet tall and as long as a half mile, were unscrolled before an audience while a narrator read the story of the picture. Ball's daguerreotype studio, with Duncanson most likely working on the background scenery, created a large panorama to depict the history of slavery, from a small African village to the success of the underground railroad.

In 1845 Duncanson moved to Detroit, which was close to a large colony of free African Americans across the Canadian border in Windsor. He bought and sold property in Detroit in 1848, but he continued to work in Cincinnati, where the city's leading art patron, Nicholas Longworth, commissioned him to paint a series of large landscapes on the center hallway walls of his mansion. For more than a year, Duncanson worked on the project that would bring him recognition as an outstanding follower of the Hudson River school of painting. (Although covered with wallpaper for many years, the murals were rediscovered in 1932 when the mansion became a National Historic Monument and the Taft Museum of Art.)

Before traveling to Italy and England in 1853, Duncanson had finished his best-known work, *Blue Hole, Flood Waters, Little Miami River* (1851), which showed the confluence of the Ohio and Little Miami Rivers. His style had transformed from the naturalized imagery of the Longworth murals to a finely detailed romantic depiction of nature. When Duncanson

returned from Europe, he produced a series of paintings that romantically idealized the wilderness in central and eastern America.

Like many European artists, Duncanson was also inspired by great works of literature. *The Land of the Lotus-Eaters* (1860) was inspired by an Alfred Tennyson poem; *Vale of Kashmir* (1864) was inspired by a Thomas Moore poem; and *The Lady of the Lake* (1968) was inspired by a Sir Walter Scott poem. During the last few years of his life, the serenity of Duncanson's landscapes give way to stormy seascapes. Instead of expanses of vegetation and iridescent skies, Duncanson explored the tumultuous side of nature through the untamed forces of the ocean. He died December 2, 1872.

Works by Robert S. Duncanson can be seen at The Detroit Institute of Arts, Detroit, Michigan; Cincinnati Art Museum, Cincinnati, Ohio; Taft Museum of Art, Cincinnati, Ohio; University of Cincinnati; California African-American Museum, Los Angeles; National Gallery of Canada, Ottawa; Royal Palace, Stockholm, Sweden; and the National Museum of American Art, Smithsonian Institution, Washington, D.C.

Minnie Evans (1892–1987)

Design Made at Airlie Garden, 1969 (Plate 42)
Oil and mixed media on canvas board, 16 ¼ x 22 ¾ in.

Minnie Evans was born in Long Creek, North Carolina, in 1892, and raised in Wilmington, North Carolina, where she attended school until the sixth grade. Minnie's first ink sketches were done in 1935 after she had a vision that God wanted her to draw.

In the 1940s she began to work with color, first using crayons and then oils. In 1948 Evans took a job at Airlie Gardens, a fifty-acre botanical garden in Wilmington, where she worked as the gatekeeper until 1974. She often sat on a chair by the garden gate and worked on her drawings, sometimes selling them to visitors. Her art reflects the many colors of nature, mixed with religious and mythological images. Her work was exhibited at Church of the Epiphany, New York City (1966); Whitney Museum of American Art, New York City (1975); and North Carolina Museum of Art in Raleigh (1986). She continued to paint until her death in Wilmington in 1987.

Paintings by Minnie Evans, who is regarded as one of America's most unique visionaries, are in collections at Whitney Museum of American Art, New York City; St. John's Museum of Art, Wilmington, North Carolina; North Carolina Museum of Art, Raleigh; Kemper Museum of Contemporary Art, Kansas City, Missouri; and National Museum of American Art, Smithsonian Institution, Washington, D.C.

Meta (Emmeta) Vaux Warrick Fuller (1877–1968)

Peace Halting the Ruthlessness of War, 1917 (Plate 17)
Bronze, height 14 in.

Meta Vaux Warrick was born and raised in Philadelphia, Pennsylvania. Her interest in art began while she was a teenager, when she attended the Pennsylvania Museum School of Industrial Art (now Philadelphia College of Art). Upon graduation, she continued her art education in Paris, spending nearly three years studying drawing and sculpture at the Académie Colarossi and then anatomy at the École des Beaux Arts in Paris. When Auguste Rodin saw her *Secret Sorrow,* he urged her to devote all her time to sculpture.

In June 1902 Warrick's work was exhibited at L'Art Nouveau Gallery, owned by Samuel Bing. *Danseuse, Primitive Man,* and *Oriental Dancer* showed her ability to portray the gracefulness of the human form. The critical and financial success of this exhibit qualified her for a graduate school scholarship at the Pennsylvania Academy of the Fine Arts in Philadelphia. Before she left Paris, she finished *The Impenitent Thief*, which was included in the 1903 exhibition at the Salon du Société des Artistes Français.

Upon her return to the United States, themes of African American culture and the macabre began to dominate her work. In 1907 the Negro Development and Exposition Company contracted her to create a tableau for the 1907 Jamestown Exposition. She completed fourteen scenes that illustrate the history of African Americans, beginning with the indentured servants brought into Jamestown throughout the Civil War and Reconstruction. Her work won a gold medal.

A 1910 fire that destroyed much of her early work had left her too distraught to work, but W. E. B. Du Bois's request for a sculpture celebrating the fiftieth anniversary of the Emancipation Proclamation inspired her to return to sculpture. She completed a statuary of three figures titled *The Spirit of Emancipation.* In 1999 it was installed at the Harriet Tubman Park in Boston, Massachusetts.

Later, Fuller, commissioned by James Weldon Johnson for the America's Making Festival, created *Ethiopia Awakening* (c. 1921), symbolizing Americans of African descent and stimulating racial pride that would find expression in literature and the arts during the Harlem Renaissance. In 1915 her focus shifted to the relationship between mother and child. She also completed two works representing public figures: composer Samuel Coleridge Taylor and Emperor Menelik II of Abyssinia. World War I as well as mob lynchings and other acts of violence against African Americans within her own country compelled Fuller to create several works that portray the pain

and sorrow of hatred and death, including *Peace Halting the Ruthlessness of War* (1917) and *Mary Turner: A Silent Protest Against Mob Violence* (1919).

Fuller steadily produced prize-winning sculptures, including five works accepted for the 1931 Harmon Foundation exhibition in New York City and the 1940 American Negro Exposition in Chicago. *The Talking Skull* (1937), derived from an African folktale, was exhibited at the exposition. In 1961 Howard University, Washington, D.C., celebrated the opening of its Fine Arts building with an exhibition that included eight sculptures by Fuller. Until her death in 1968, Fuller was active in her community and in the civil rights movement.

Sculptures by Meta Vaux Warrick Fuller are in the collections of Danforth Museum of Art, Framingham, Massachusetts; Schomburg Center for Research in Black Culture, The New York Public Library, New York City; Howard University Gallery of Art, Washington, D.C.; Museum of Afro American History, Boston, Massachusetts; and Livingstone College, Salisbury, North Carolina.

Palmer Hayden (1893–1973)

Carousel, c. 1934 (Plate 26)
Oil on canvas, 20 ¼ x 26 in.

When Tricky Sam Shot Father Lamb, 1940 (Plate 27)
Oil on canvas, 30 x 39 ¾ in.

Woman in Garden, c. 1966 (Plate 25)
Oil on canvas, 24 x 31 in.

Palmer Hayden was born Peyton Cole Hedgeman in Widewater, Virginia. Peyton Hedgeman became Palmer Hayden because of a paperwork error during the recruitment process into the army. He first served in the segregated 24th Infantry Regiment, an all-black company, and then in the Tenth Cavalry stationed at West Point.

In 1920 Hayden left the Army and worked nights for the Post Office in New York City. During the day, he studied art at Columbia University, went to museums, and worked on his illustrations. He also began to work in oil on canvas. The Post Office job lasted five years, but he was finally dismissed because of excessive absences: He found it more and more difficult to leave his easel for his duties at the Post Office. Determined to receive additional instruction, he applied and was accepted at the Commonwealth Art Colony in Boothbay Harbor, Maine, where he did maintenance work on the grounds in exchange for tuition, room, and board. One of his Maine waterfront scenes was awarded first prize in the Harmon Foundation's 1926 *Exhibition of the Work of Negro Artists.*

The recipient of a scholarship from a private donor, Hayden went to Paris in 1927, where he met painter Henry Tanner and philosopher Alain Locke and was tutored by Clivette Le Fèvre, sculptor, painter, and instructor at the École des Beaux Arts. In 1928 his work was exhibited at Galerie Bernheim Jeune, then in group shows at the Salon des Tuileries (1930) and the American Legion Exhibition in Paris (1931). When he returned to New York, Hayden joined the staff at the Harmon Foundation and later qualified as an easel artist for the Works Progress Administration.

During this period, Hayden painted mostly New York waterfront scenes. In 1933 he won the Rockefeller Award at a Harmon Foundation exhibition for *Fétiche et Fleurs,* a still life using African iconography. His use of an African-patterned cloth and an African sculpture was in response to a call by Alain Locke for black artists to include an African aesthetic in their work. After leaving the Works Progress Administration in 1940, he began producing the *John Henry* series. It is his most widely known work.

For the next twenty years, he continued to focus on the daily life of black Americans, including their fashions, hairstyles, and surroundings. Among his late works is a series of historical sketches of African American soldiers, including one piece commissioned by the New York Creative Arts Public Service Program that depicts President and Mrs. Woodrow Wilson with African American cavalrymen at West Point. Hayden died in 1973 in New York City.

Paintings by Palmer Hayden are in the collections of National Museum of American Art, Smithsonian Institution, Washington, D.C.; California African-American Museum, Los Angeles; Whitney Museum of American Art, New York City; and Studio Museum in Harlem, New York City.

Varnette Honeywood (1950–)

Honor Thy Father and Mother, 1983 (Plate 92)
Collage, 40 x 30 in.

Precious Memories, 1984 (Plate 91)
Collage, 31 ¾ x 22 in.

Varnette Honeywood was born in Los Angeles, California. After a short time at Chouinard Art Institute in Los Angeles, she moved to Atlanta, Georgia, where she studied painting with Floyd Coleman at Spelman College, receiving a bachelor's degree in 1972. She returned to California to attend the teacher core program at the University of Southern California, Los Angeles, earning a master's degree in 1974. For five years after graduation, working through a joint educational project at the University of Southern California,

Honeywood developed art educational programs for various Los Angeles County schools. Her early works were of single figures in oils. Later she experimented with watercolors and acrylics, and collage, interpreting her environment and creating genre scenes of family experiences in the South. Influenced by her art history studies at Spelman, in the 1980s she embarked upon a sensitive depiction of African American culture.

Through a mail order business called Black Lifestyles, Honeywood, with her sister Stephanie, markets her paintings, prints, and note cards as well as the work of several other African American artists. Her illustrations have been used on numerous book covers, including those of every book in the *Little Bill Books for Beginning Reading* series written by Bill Cosby and published by Scholastic, *African American Literature: Voices in a Tradition* (Holt, Rinehart and Winston, 1992), *Through the Ivory Gate* (1993), and *The Hand I Fan With* (Doubleday, 1996). Her illustrations have appeared in several magazines (*Harper's, Essence*) and on posters sponsored by the Children's Defense Fund, the U.S. Department of Labor, Girls Incorporated, and Spelman College. Honeywood has lectured and participated in panel discussions throughout the United States and Canada.

Paintings, illustrations, and collages by Varnette Honeywood have been included in numerous group exhibitions, and she has held solo exhibitions at Spelman College, Atlanta, Georgia; Hampton University, Hampton, Virginia; Southern Bell Center, Atlanta, Georgia; and California Museum of African-American Art, Los Angeles.

Margo Humphrey (1942–)
The Last Bar-B-Que, 1988 (Plate 86)
Lithograph, 26 x 38 in.

Margo Humphrey was born in Oakland, California. At the California College of Arts and Crafts in Oakland she studied painting and printmaking, receiving the Bachelor of Arts degree in 1972. After studying for two years at Stanford University in Palo Alto, California, in 1974 she was awarded a Master of Arts degree in printmaking. In 1989 Humphrey joined the art faculty at the University of Maryland in College Park, where she is currently an associate professor.

Humphrey's colorful lithographic prints are rooted in African American culture, but they also draw upon her exposure to other cultures. As a visiting professor on a fellowship program (from Ford Foundation, National Endowment of the Arts, and Tiffany Foundation), she traveled to Nigeria, Uganda, Zimbabwe, South Africa, and Fiji. She has also taught at Tamarind Institute. Commissions Humphrey accepted include

The Tamarind Thirty-Year Portfolio, stage sets and costumes for the Oakland Ballet's production of *Peter and the Wolf,* and an installation for the *Blues Aesthetic: Black Culture and Modernism* exhibition at Herron School of Art, Indianapolis, Indiana. In 1992 she authored and illustrated *The River That Gave Gifts,* a children's book honored by First Lady Barbara Bush for National Literacy Week.

Prints and paintings by Margo Humphrey are in the collections of Los Angeles County Museum of Art, California; Museum of Modern Art, New York City; Philadelphia Museum of Art, Pennsylvania; National Gallery of Art, Lagos, Nigeria; and Museum of Modern Art, Rio de Janeiro, Brazil.

Clementine Hunter (1887–1988)
The Burial, c. 1964 (Plate 43)
Oil on panel, 16 x 20 in.

Clementine Hunter was born in 1887 on a cotton plantation near Cloutierville, Louisiana. After her family relocated near Natchitoches, Louisiana, Hunter lived at the Melrose Plantation on the Cane River. She worked in the fields with her parents and later as a domestic in the main house, focusing on her own family of five children and her work at the plantation.

In the 1940s, when she was more than fifty, Hunter began to paint religious scenes (*The Nativity, The Crucifixion, The Flight to Egypt, Angels*), giving African American traits to all the biblical characters; genre scenes (weddings, baptisms, funerals, dances, and revival meetings); and still lifes. In 1944 Hunter was awarded a Julius Rosenwald Foundation grant. Her first two solo exhibitions were in 1955, at The Delgado Museum in New Orleans, Louisiana (now the New Orleans Museum of Art), and Northwestern State College in Natchitoches.

In 1956 Hunter completed a series of murals depicting images of plantation life for three of the houses on the Melrose Plantation. The subjects were cotton picking, wash day, church scenes, and pecan gathering—all rendered in a two-dimensional style. During the later years of her life, Hunter worked on collages and experimented with abstract imagery. By the time of her death, she had lived more than a hundred years and had produced many paintings and an unknown number of quilts. Twenty of her quilts have been documented, with imagery similar to that used in her paintings: African influences in the use of pattern, perspective, color, and appliqué techniques.

Paintings by Clementine Hunter are in the collections of Dallas Museum of Art, Texas; High Museum of Art, Atlanta, Georgia; Louisiana State Museum, New Orleans; New York Historical Association, Cooperstown, New York; Amistad Research Center, Tulane University, New Orleans, Louisiana;

Birmingham Museum of Art, Alabama; Illinois State University, Normal, Illinois; Radcliffe College, Cambridge, Massachusetts; and Vassar College, Poughkeepsie, New York.

William Henry Johnson (1901–1970)
Ezekiel Saw the Wheel, c. 1939 (Plate 30)
Gouache, pen and ink on paper, 17 ½ x 11 ½ in.

Untitled (Seated Woman), c. 1939 (Plate 31)
Tempera on paper, 24 x 18 in.

William Henry Johnson was born in Florence, South Carolina, in 1901. In 1921 Johnson became a student at the National Academy of Design. Encouraged by his professor, Charles Hawthorne, Johnson's work flourished. For three summers, Hawthorne arranged for Johnson to study at the Cape Cod School of Arts. While at the Academy, he won numerous prizes for his work, including the Hallgarten Prize in 1923 and the Cannon Prize in 1925 and 1926. During his years at the Academy, Johnson showed he had an affinity for vibrant colors and a desire to capture humanity in its simplicity. His style was realistic; his paintings were still lifes, landscapes, and portraits.

In 1926, thanks to generous contributions from Hawthorne and artist George Luks, Johnson went to Paris to study art. In France, Johnson's style evolved into the manipulation of form and color, with an emphasis on imagery. He was greatly influenced by the impressionism of Paul Gaughin and the expressionism of Chaïm Soutine. He also met Henry Tanner; although not influenced by Tanner's artistic style, Tanner's success gave Johnson even greater resolve to be an artist. In 1929 Johnson traveled to Cagnes-sur-Mer, where a group of artists invited him to tour the museums and galleries throughout Europe.

To gain recognition in the United States, Johnson returned to New York, where he drew and submitted six paintings to the Harmon Foundation's 1929 exhibition, winning a gold medal and a $400 cash award. In 1930 Johnson moved to Denmark, then traveled to Norway and Tunisia. Scenes of fishermen, harbors, fjords, and Arabian bazaars flowed onto his canvases. In 1937, as a result of the escalation of fighting that led to World War II and an urge to reconnect with his African American roots, Johnson decided to move to New York City.

With the help of the Harmon Foundation, Johnson secured a job with the Works Progress Administration. His expressive application of color became confined within specified boundaries as seen in works such as *Chain Gang* (1939) and silkscreen prints like *Going to Church* (1941). Besides portraying African Americans' culture, he began to introduce religious themes. One portrait, *Jesus and the Three Marys* (1939), depicts a black crucified Christ with three black women watching him. By 1941 he was recognized as a significant artist, with his work included in two major New York exhibitions. He also depicted black soldiers for the Metropolitan Museum of Art's 1942 *Artists for Victory* exhibition.

In 1946 he was committed to a mental institution, where he died in 1970. Johnson's work, saved by the Harmon Foundation, was stored for many years, but more than a thousand survived and are currently in permanent collections throughout the United States.

Paintings by William Henry Johnson are in the collections of National Museum of American Art, Smithsonian Institution, Washington, D.C.; Howard University Gallery of Art, Washington, D.C.; Clark Atlanta University, Atlanta, Georgia; Fisk University, Nashville, Tennessee; Hampton University Museum, Hampton, Virginia; Tuskegee University, Tuskegee, Alabama; and Oakland Museum, Oakland, California.

Joshua Johnston (c. 1765–c. 1830)
Mrs. Thomas Donovan and Elinor Donovan, c. 1799 (Plate 2)
Oil on canvas, 30 ¼ x 25 ½ in.

Basil Brown, 1813 (Plate 4)
Oil on canvas, 25 x 20 in.

Lady on a Red Sofa, c. 1825 (Plate 3)
Oil on canvas, 30 ¼ x 25 ½ in.

Details of Joshua Johnston's early life are sketchy. He was born a slave, but records in Baltimore, Maryland, show he was manumitted on July 15, 1792, at the age of nineteen. He initially apprenticed to a blacksmith but is listed in city directories from 1796 to 1824 as a painter. Eighty portraits have been ascribed to Johnston, but he most likely augmented his income by painting signs, buildings, and carriages. His patrons were mostly white—local merchants, captains, seamen, and businessmen—and his surviving portraits include both individuals and families rendered in a palette of warm, dark tones of umber, ochre, and bright red. Whether seated or standing, Johnston's subjects are invariably shown with blank stares from eyes that are characteristically almond-shaped. The bodies are somewhat flat in dimension, but Johnston did pay particular attention to the lace bonnets, jewelry, and elegant dresses of the women in his portraits. In most of his full-length portraits, his subjects are holding objects—a piece of fruit, a book, a flower, or a letter.

Joshua Johnston's portraits are in the collections of Abby Aldrich Rockefeller Folk Art Center, Williamsburg, Virginia; National Gallery of Art, Washington, D.C.; National Museum of American Art, Smithsonian Institution, Washington, D.C.;

Maryland Historical Society, Baltimore; The Baltimore Museum of Art, Baltimore, Maryland; Whitney Museum of American Art, New York City; Chrysler Museum of Art, Norfolk, Virginia; and Bowdoin College Museum of Art, Brunswick, Maine.

Lois Mailou Jones (1905–1998)
Ville d'Houdain, Pas-de-Calais, 1951 (Plate 47)
Oil on canvas, 21 ¼ x 25 ⅝ in.

Nature Morte aux Geraniums, 1952 (Plate 46)
Oil on canvas, 28 ⅞ x 23 ½ in.

Lois Mailou Jones was born in Boston, Massachusetts, in 1905. She attended Boston High School of Practical Arts, and after school she studied at the Boston Museum School of Fine Arts. Her first paintings were watercolors done during her summers at Martha's Vineyard Island. She received a scholarship to continue her studies at Designers Art School of Boston, where she produced textile designs that were manufactured by Schumacher and F. A. Foster.

Interested in developing the artistic talents of African Americans, in 1927 Jones moved to Sedalia, North Carolina, where she established an art department at the all-black preparatory Palmer Memorial Institute. Because of the high quality of her students' work, in 1930 Jones was invited to join the art department at Howard University, Washington D.C., where she taught drawing, design, and watercolor painting for forty-seven years. While she taught, Jones continued to study and develop her own style of painting.

During a sabbatical year in Paris, Jones studied at Acadèmie Julien and exhibited at the Salon du Société des Artistes Français and the Société Artistes Indépendents. She was encouraged by several artists, including the French painter Celine Tabary, whose family invited her to live with them in northern France. Together in Washington, D.C., in 1940 Jones and Tabary formed the Little Paris group, providing encouragement for African American artists and arranging exhibitions with the District of Columbia Art Association. Sharing an affinity for France, the two artists maintained a studio in Cabris, where they spent numerous summers painting. Utilizing a postimpressionist style and a colorful palette, Jones painted Parisian street scenes, Cézanne-influenced landscapes, and, increasingly, scenes that spoke strongly about the social injustices suffered by African Americans. *Les Fétiches* (1938) shows the influence the African mask had on her work. *Meditation* (1944) shows the stoical attitude of a black man about to be lynched.

Jones moved to Haiti in 1953 and created paintings depicting Haitian culture. She portrayed the people and the land using bright colors, flat dimensions, and a more expressionistic application than in her Parisian paintings. She became a guest watercolor and painting instructor at the Foyer d'Art Plastique and Centre d'Art, and she was commissioned to paint a portrait of the Haitian president and his wife. She also received numerous awards for her sensitive portraits of the people of Haiti.

In the early 1970s, Jones traveled to fourteen African countries, collecting more than one thousand photographs of African art. Her paintings from this period are design-dominated abstract works that show the influence of cubism and African mythology. She retired from teaching in 1977 but continued to paint until she was in her nineties. In 1980 she was honored by President Jimmy Carter at a White House ceremony for her outstanding achievements in the arts. Many contemporary African American artists and teachers were students of Jones, including Elizabeth Catlett, David C. Driskell, and Mary Lovelace O'Neal.

Paintings by Lois Mailou Jones are in the collections of Boston Museum of Fine Arts, Massachusetts; Corcoran Gallery of Art, Washington, D.C.; Hirshhorn Museum and Sculpture Garden, Smithsonian Institution, Washington, D.C.; The Phillips Collection, Washington, D.C.; University Art Museum, Albany, New York; Brooklyn Museum of Art, New York City; Metropolitan Museum of Art, New York City; and National Palace, Haiti.

Jacob Lawrence (1917–2000)
Blind Musician, 1942 (Plate 67)
Gouache, 21 x 29 in.

Street Scene, Harlem, 1942 (Plate 66)
Gouache on board, 21 ¾ x 29 ¾ in.

Harlem Street Scene, 1959 (Plate 68)
Tempera on board, 16 x 11 ⅞ in.

Jacob Lawrence was born in Atlantic City, New Jersey; when he was two his family moved to Easton, Pennsylvania, and then to Philadelphia. When he was a young teenager, his mother enrolled him in an after-school art program, Harlem Art Workshop, in the basement of the 135th street branch of the public library. In this program Lawrence met two notable African American artists: James Lesesne Wells, the director of the program, and Charles Alston, to whom Lawrence was assigned. Under Alston, Lawrence's interest in art was nourished, and he followed Alston when he set up his own program at the Utopia Community Center.

As an adolescent, Lawrence dropped out of high school but remained committed to his art program. In 1936 he joined the

Civilian Conservation Corps and moved to Middletown, New York, where he worked on the construction of a dam. When he returned to New York City, he reconnected with Alston, who directed him to the Harlem Community Art Center, a program funded by the Works Progress Administration (WPA) and run by Augusta Savage. Under Savage's tutelage, he secured a position on the WPA's easel project. He also attended discussions of Alston's 306 group and Charles Seifert's lectures on African and African American history at the 135th Street public library and joined the Artists Union and the Harlem Artists Guild. These affiliations inspired Lawrence to choose the subject matter of his art: the history and social conditions of African Americans.

Much of Lawrence's early work portrays life in Harlem. He favored a unique narrative form, creating series of images that represent one aspect of history, whether a person (Toussaint L'Ouverture, Harriet Tubman, John Brown) or a historical movement (*The Migration of the Negro* and *And the Migrants Kept Coming*, depicting the great northern migration of southern black families). He also wrote informative captions for every painting in a series. When he was twenty, he had his first one-man show at the Harlem YMCA; the same year his entire series honoring L'Ouverture, the noted Haitian general, was exhibited at a show organized by the Harmon Foundation and The Baltimore Museum of Art.

Three Julius Rosenwald Foundation fellowships helped Lawrence continue painting. In 1941 he traveled to the South to depict life in a rural community and a southern urban community, sending paintings to New York's prestigious Downtown Gallery, run by Edith Halpert. During World War II, he entered the Coast Guard as a steward's mate and soon was promoted to public relations officer. This post enabled him to visually document life aboard a military ship. The paintings created during this period were exhibited at the Museum of Modern Art, New York City.

After the war, Lawrence focused on portraying individual African Americans (for example, a shoemaker, a watchmaker, a seamstress, a barber, a carpenter), and in 1946 he began his first teaching assignment at Black Mountain College in Asheville, North Carolina. He also completed a series for *Fortune* that portrayed the opportunities for blacks in the South and illustrations for Langston Hughes's *One-Way Ticket.* For many summers he taught painting at Skowhegan School of Painting and Sculpture in Maine.

During the 1950s and 1960s, Lawrence continued to paint, teach, and be recognized through awards and grants ($1,000 grant from National Institute of Arts and Letters, 1953; Chapelbrook Foundation fellowship, 1954; national secretary,

Artists Equity Association, 1954–1957). He also completed his thirty-painting series titled *Struggle: From the History of the American People,* which was dedicated to democracy and the ongoing struggle of all Americans for freedom. In 1956 he accepted a teaching position at Pratt Institute in Brooklyn, and in 1965 he served as artist-in-residence at Brandeis University; in subsequent years he taught at the Art Students League, New School for Social Research, and California State University at Hayward.

During the 1960s Lawrence traveled to Nigeria, which resulted in a series of paintings about that African country. A retrospective of his work opened at the Brooklyn Museum of Art in 1960 and toured several major cities. He also produced a series of illustrations for children, published in 1968 as a book, *Harriet and the Promised Land.* In 1970 the National Association for the Advancement of Colored People presented him with its highest honor, the Spingarn Medal. In 1971 he was appointed full professor at the University of Washington in Seattle, where he taught until 1983.

The National Institute of Arts and Letters elected Lawrence a member (1965), as did the National Academy of Design (1977) and the American Academy of Arts and Letters (1983). In 1974 the Whitney Museum of American Art in New York City organized a major retrospective of Lawrence's work. A 1986 exhibition at the Seattle Museum focused on work he created around the theme of the building trades. Until Lawrence's death on June 9, 2000, he was known as one of America's best contemporary artists, and an artist who was nurtured by and spokesman for the African American experience. He is now the first African American artist to have a catalogue raisonne.

Paintings by Jacob Lawrence are in collections at Metropolitan Museum of Art, New York City; National Gallery of Art, Washington, D.C.; Philadelphia Museum of Art, Pennsylvania; Phillips Collection, Washington, D. C.; Amistad Research Center, Tulane University, New Orleans, Louisiana; New Britain Museum of American Art, New Britain, Connecticut; Wadsworth Atheneum Museum of Art, Hartford, Connecticut; The Detroit Institute of Arts, Michigan; Reynolda House Museum of American Art, Winston-Salem, North Carolina; Weisman Art Museum, University of Minnesota, Minneapolis; Johnson Museum of Art, Cornell University, Ithaca, New York; Sheldon Memorial Art Gallery and Sculpture Garden, University of Nebraska, Lincoln; Hirshhorn Museum and Sculpture Garden, Smithsonian Institution, Washington, D.C.; Butler Institute of American Art, Youngstown, Ohio; New Orleans Museum of Art, Louisiana; Norton Museum of Art, West Palm Beach, Florida; California African-American Museum, Los Angeles; and North Carolina Museum of Art, Raleigh.

Hughie Lee-Smith (1915–1999)

Soliloquist, 1973 (Plate 54)
Oil on canvas, 33 ¾ x 36 ½ in.

Festival's End #2, 1987 (Plate 55)
Oil on canvas, 38 ½ x 38 ¾ in.

Hughie Lee-Smith was born in Eustis, Florida, and raised in Cleveland. In 1934 he won a one-year scholarship to the Detroit Society of Arts and Crafts School and then studied at the Cleveland Institute of Art. In 1938 he accepted a teaching position at Claflin College, in Orangeburg, South Carolina.

Lee-Smith's career as an artist began during the Depression, when he worked for the Federal Ohio Art Project; besides funding his education, the assignment came with instruction in lithography. Pursuing an interest in theater, he also designed and built theatrical sets. During World War II he served in the navy as an artist, drafting "morale" paintings for the Great Lakes Naval Base. In 1943 he won his first prize, at an exhibition of African American art sponsored by Atlanta University.

Using his veteran's benefits, Lee-Smith decided to return to school; studying art education, he earned a bachelor's degree from Wayne State University in 1953. His work, rendered in a socially realistic style, received numerous prizes, including recognition for *The Wall* (1952) from The Detroit Institute of Arts. A series of scenes of abandoned urban buildings was exhibited at a 1955 one-man show at Howard University in Washington, D.C. In 1957 Lee-Smith won the prestigious Emily Lowe award from the National Academy of Design and then decided to move to New York City.

Reflecting a period of personal isolation after the death of his wife and the absence of his daughter, who had moved to California, Lee-Smith's paintings during this period carry a lingering sense of isolation and alienation. At the same time, as he had during most of his career, he was painting numerous formal portraits, including a series of prominent African Americans born in Maryland for the state of Maryland. In 1967 he was elected a full member of the National Academy of Design. From 1969 to 1971, Lee-Smith served as artist-in-residence at Howard University and then returned to New York City where, from 1972 until 1992, he taught at the Art Students League. In 1981 he served as president of the Audubon Artists. Before his death in 1999, Lee-Smith saw several major retrospectives of his work and received praise from art historians that his realistic work powerfully depicts the social and personal problems of the twentieth century.

Prints and paintings by Hughie Lee-Smith are in the collections of Studio Museum in Harlem, New York; National Academy of Design, New York City; The Detroit Institute of Arts, Michigan; Museum of the National Academy of Design, New York City; Banneker-Douglass Museum, Annapolis, Maryland; Howard University, Washington, D.C.; Hunter Museum of American Art, Chattanooga, Tennessee; Clark Atlanta University, Georgia; and New Jersey State Museum, Trenton.

Mary Edmonia Lewis (c. 1845–c. 1911)

Marriage of Hiawatha, c. 1866 (Plate 11)
Marble, 27 in. height

Mary Edmonia Lewis was born in Greenbush, New York. At age fifteen she was accepted at Oberlin College in Oberlin Ohio, the first American college to admit women and blacks. There she took her first drawing class, learned that she had artistic talent, and began to take an interest in neoclassicism. Amid accusations of attempting to poison two friends, Lewis was not allowed to register for her fourth and final year at Oberlin. She had been exonerated of all charges, but the controversy was rekindled as she became a scapegoat for many other unsolved crimes. She even endured a severe beating, but there is no record of an attempt to find and prosecute her attacker.

From Oberlin, Lewis moved to Boston, began her training as a sculptor, and dropped "Mary" from her name, being known the remainder of her life as Edmonia Lewis. Her earliest works were cast plaster portraits and medallions of John Brown and other abolitionists, the sale of which supported her while she learned how to model clay and plaster. In 1865 Lewis traveled to Italy and ultimately settled in Rome. She became a devout Catholic and was able to make a living from the sale of idealized religious sculptures, including an altarpiece blessed by Pius IX. During occasional trips back to the United States, Lewis was viewed as an independent spirit who thrived in spite of the pitfalls of racism and sexism. Dr. Harriet K. Hunt, the first female physician in Boston, and Charlotte Cushman, an American actor living in Rome, became patrons of her work.

Primarily self-taught, although to some extent guided by Hiram Powers and Harriet Hosmer, Lewis became a master of the neoclassical style, as seen in her busts of Colonel Robert Gould Shaw (1866) and Henry Wadsworth Longfellow (1869). She turned to naturalism for her highly acclaimed Native American series, exemplified by *Marriage of Hiawatha* (1866) and *The Old Arrowmaker and His Daughter* (1872). *Forever Free* (1868), uniquely Lewis in its style, celebrates the Emancipation Proclamation, while *Hagar* (1869) becomes her personal symbol of the outcast. Her 1874 companion pieces, *Asleep* and *Awake,* depict two

infants in the neoclassical style. Even though it was not a prizewinner, *The Death of Cleopatra* (1875) was a favorite of those who attended the 1876 United States Centennial Exposition in Philadelphia. Lewis continued to live and work in Rome, but she spent the last few years of her life in northern California.

Sculptures by Edmonia Lewis can be seen at San Jose (California) Public Library; Forest Park (Illinois) Historical Society; Schlesinger Library of the History of Women, Radcliffe College, Cambridge, Massachusetts; Tuskegee University, Tuskegee, Alabama; Harvard University Library, Cambridge, Massachusetts; and National Museum of American Art, Smithsonian Institution, Washington, D.C.

Norman Lewis (1909–1979)

Untitled (Family Portrait), c. 1936 (Plate 49)
Oil on burlap, 26 ¼ x 36 in.

Mainly a self-taught artist, Norman Lewis was born in Harlem, New York. After spending two years as a seaman on South American freighters, Louis devoted his life to art. Encouraged by Augusta Savage, whose studio was in the neighborhood, Lewis was given lessons and shared Savage's studio space. He studied briefly at the John Reid Club Art School, producing *Johnny the Wanderer*, which won an honorable mention at a 1933 Metropolitan Museum of Art exhibition. Accepted to the Works Projects Administration, he was assigned to the Harlem Art Center, where he continued to receive technical training, and he also taught at a junior high school in Harlem.

Lewis was active in several organizations, including the Artists Union and the Harlem Artists Guild. The Studio 35 Club, organized by Willem de Kooning and Franz Kline, helped Lewis define more clearly his direction toward an art free of the old traditions. Until the 1940s Lewis's canvases primarily depicted the social strife African Americans suffered, including bread lines, evictions, substandard housing, and police brutality. *Yellow Hat* (1936), a figurative piece rendered in a cubist style, reflects his growing interest in modern art. By the 1950s the social realism in his early work shifted to abstract expressionism, and—inspired by the work of J. M. W. Turner and Claude Monet—he made a conscious effort to paint from his feelings rather than from his social obligations. To achieve the right state of mind, he quit his teaching job at Thomas Jefferson School of Social Science, where he was required to focus on social realism with his art students.

By 1949 Lewis's abstract work was being shown at Willard Gallery in New York City, where he had nine one-man shows within ten years. In 1955 his *Migrating Birds* won a prize at the Carnegie International Exhibition. To supplement his income, he returned to teaching, first in the Harlem Youth program and then at the Art Students League. In 1963 Spiral was formed and Lewis served as its chairman; members met regularly to discuss aesthetic values, philosophical problems, and social issues. In the 1970s Lewis received grants, fellowships, and awards from the Mark Rothko Foundation, National Endowment for the Arts, Guggenheim Foundation, American Academy, and National Institute of Arts and Letters, as well as commissions to paint murals in New York high schools. Before his death in 1979, Lewis gained international recognition through his exhibitions held in Argentina, France, Italy, and Ghana.

Paintings by Norman Lewis are in collections at Munson-Williams-Proctor Institute, Utica, New York; New Jersey State Museum, Trenton; Dayton Art Institute, Ohio; Studio Museum in Harlem, New York City; and National Museum of American Art, Smithsonian Institution, Washington, D.C.

Keith Morrison (1942–)

Zanzibar, 1981 (Plate 87)
Watercolor, 23 x 30 ⅜ in.

Born in Linstead, Jamaica, Keith Morrison was educated at the Art Institute of Chicago (Bachelor of Fine Arts, 1963; Master of Fine Arts, 1965). A painter, printmaker, curator, art critic, and teacher, Morrison has served on the faculties of Fisk University, Nashville, Tennessee; DePaul University, Chicago, Illinois; University of Maryland, College Park, Maryland; Maryland Institute, College of Art, Baltimore; and University of Michigan, Ann Arbor. He is currently dean of the College of Creative and Performing Arts at San Francisco State University, California.

For many years Morrison preferred abstract expressionism in his own work; however, in the mid-1970s he turned to narrative works employing metaphors and ironies stemming from Christianity, African mythology, and Caribbean folklore. Possessing a quality of surrealism, his paintings explore social issues and flaws of human nature, as well as the depth of his personal psyche. As a writer and art critic, Morrison has had his essays published in numerous books, exhibition catalogs, magazines, and newspapers. As a curator, he has organized exhibitions for many galleries, including (with Helmo Hernandez, director of the Ludwig Foundation in Havana) the 1999 exhibition *Metaphors/Commentaires: Artists from Cuba* at the Fine Arts Gallery, San Francisco State University.

Paintings and prints by Keith Morrison are in the collections of Pennsylvania Academy of the Fine Arts, Philadelphia;

Philadelphia Museum of Art, Pennsylvania; Corcoran Gallery of Art, Washington, D.C.; National Museum of American Art, Smithsonian Institution, Washington, D.C.; Art Institute of Chicago, Illinois; Hampton University Museum, Hampton, Virginia; Talladega College, Talladega, Alabama; Fisk University, Nashville, Tennessee; and San Francisco State University, California.

Archibald J. Motley Jr. (1891–1981)

Stomp, 1927 (Plate 18)
Oil on canvas, 30 x 36 in.

Senegalese Boy, 1929 (Plate 19)
Oil on canvas, 32 x 25 ¾ in.

Bronzeville at Night, 1949 (Plate 20)
Oil on canvas, 31 x 41 in.

Born in New Orleans and raised on Chicago's west side, Archibald J. Motley Jr. wanted to be an artist from a very early age. His father wanted him to be a doctor, but young Motley's talent garnered him a four-year scholarship to the Art Institute of Chicago. He studied under George Walcott and was also influenced by George Bellows's use of urban scenes.

Determined to depict veritable imagery of African Americans, Motley made his first subjects portraits of family members and friends. His portrait of his grandmother, *Mending Socks* (1924), and a dance hall scene, *Syncopation* (1925), won him critical acclaim and acceptance as an artist. He participated in the Art Institute's exhibitions in Chicago, and in 1927 his work was included in an exhibition of the Newark Museum in New Jersey.

In 1928, Motley's *Black Belt* won him a gold medal at the Harmon Foundation's exhibition in New York City and rave reviews in the newspapers. His ability to make a living as an artist occured a year later when he sold twenty-two of twenty-six paintings in his first one-man show at New Galleries in New York City.

In 1929 Motley received a Guggenheim fellowship, which he used for a year's study in France. *Senegalese Boy* was painted in Paris, as well as two of his most famous works, *Jockey Club, Paris* and *Blues.* After his return to Chicago, the Depression gave Motley an additional opportunity to work on murals and paintings that were placed in public buildings.

After the death of his wife in 1945, Motley worked for eight years in a factory, painting plastic shower curtains. In the 1950s, he went to Cuernavaca, Mexico, upon the urging of his nephew, Willard Motley, a successful novelist. There he returned to painting genre scenes, but this time they were set in Mexican nightclubs. His palette also changed, becoming brighter through the use of primarily pastel colors.

Motley lived in Chicago when the civil rights movement of the 1960s was gaining strength, but his paintings never showed the prevailing mood of anger that was prevalent at the time. He worked several years on a large painting originally designed to celebrate the hundred-year anniversary of the Emancipation Proclamation until his death in 1981.

Archibald J. Motley Jrs. paintings are in the collections of DuSable Museum of African-American History, Chicago, Illinois; Schomburg Center for Research in Black Culture, The New York Public Library, New York City; Hampton University Museum, Hampton, Virginia; Howard University Gallery of Art, Washington, D.C.; Ackland Art Museum, University of North Carolina, Chapel Hill; and North Carolina Museum of Art, Raleigh.

Mary Lovelace O'Neal (1942–)

Desert Women Series, 1991 (Plate 89)
Monoprint, 27 ⅝ x 39 ⅜ x in.

Painted Desert II, 1991 (Plate 88)
Monoprint, 39 ⅝ x 27 ¾ in.

Mary Lovelace O'Neal was born in Jackson, Mississippi. She earned a Bachelor of Fine Arts degree at Howard University, Washington, D.C., studying with Lois Mailou Jones, James Lesesne Wells, James A. Porter, and David C. Driskell. In 1969 Columbia University in New York City awarded her a Master of Fine Arts degree. The following year O'Neal moved to the San Francisco Bay Area to pursue a teaching career. She has taught at the San Francisco Art Institute; California College of Arts and Crafts, Oakland; Humboldt State University, Arcata, California; and University of California at Berkeley, where she is currently professor of painting. While at Berkeley, O'Neal held the position of Chair of the Art Department and University ombudsman during the 1990s.

O'Neal's abstract paintings evolved from large-scale color-laden imagery of palaces, whales, mermaids, doves, panthers, and her own mythology to more amorphic shapes of colorful kinetic brush strokes, sometimes in mixed media. Her extensive visits to Chile, Morocco, and Egypt and explorations of the Atacama and Sahara deserts have been a source of inspiration for her desert series and other works depicting Moroccan bath houses and palaces. Her paintings have been widely exhibited in California, New York, Chile, and Morocco.

Paintings by Mary Lovelace O'Neal are in collections at San Francisco Museum of Modern Art, California; Oakland Museum, California; Columbia University, New York City; Fisk University, Nashville, Tennessee; National Museum of Fine Arts, Santiago, Chile; Howard University, Washington, D.C.; and Tougaloo College, Mississippi.

William Pajaud (1925–)

Mujer con Maiz ,Tortilla Maker 4, from the *Mujeres* series, 1973
　(Plate 73)
Oil on canvas, 59 ⅞ x 48 in.

Hard Hat, from the *Mujeres* series, 1975 (Plate 74)
Oil on canvas, 48 x 60 in.

William Pajaud was born in New Orleans, Louisiana. Granted a full art scholarship, he earned a Bachelor of Arts degree from Xavier University in New Orleans, Louisiana, and a Master of Arts degree from Chouinard Art Institute in Los Angeles, which included certification in advertising design. In the early 1970s, Pajaud became interested in Mexican genre scenes and devoted a series of paintings to interpreting Mexican rural scenes.

Since 1957 Pajaud has been affiliated with Golden State Mutual Life Insurance Company in Los Angeles, serving as vice president, director of public relations and advertising, and curator of the Golden State Afro-American Art Collection. He also continues to re-create his memories of New Orleans and life in the South, as well his experiences in his newly adopted home in California, focusing on African American themes in an expressionistic style. Working mainly in watercolors and oils, but sometimes in acrylics and mixed media, he has portrayed genre scenes, biblical themes, and landscapes. He has also served as president of the National Watercolor Society and of the Art Education Foundation.

Watercolors by William Pajaud have been exhibited by the California Watercolor Society and the National Watercolor Society. His paintings and watercolors have been exhibited at the M. H. De Young Museum, San Francisco, California; Los Angeles County Museum of Art, California; California African-American Museum, Los Angeles; Butler Institute of American Art, Youngstown, Ohio; Illinois State Museum, Springfield; and Clark Atlanta University, Georgia.

Horace Pippin (1888–1946)

Roses with Red Chair, 1940 (Plate 40)
Oil on canvas, 13 ¾ x 10 ½ in.

Woman Taken in Adultery, 1941 (Plate 37)
Oil on canvas, 19 ⅝ x 24 in.

The Holy Mountain I, 1944 (Plate 41)
Oil on canvas, 30 x 36 in.

The Love Note, 1944 (Plate 39)
Oil on canvas, 10 ¼ x 8 ¼ in.

Victory Vase, 1944 (Plate 38)
Oil on canvas, 19 x 19 in.

Self-taught artist Horace Pippin was born in West Chester, Pennsylvania. Raised in Goshen, New York, he attended a one-room school through the eighth grade. In 1903 he began a series of jobs to support his ailing mother. After her death in 1911, he moved to Patterson, New Jersey, where he worked a variety of jobs until he enlisted in the army in 1917. Corporal Pippin was assigned to the French command of the all-black regiment of the 369th Infantry. Serving as a squad leader, Pippin suffered a disabling injury to his right shoulder and was discharged in 1919. His inability to use his right arm meant he was unable to either work or draw the war images that haunted him. Finally he devised a method of stabilizing his crippled arm with his knee, which allowed him to use a hot poker to create images on wood panels. He worked in this medium, known as pyrography, until his arm became strong enough to paint.

His first paintings were recollections of the war; he worked for three years on *End of War: Starting Home* (1931), including hard-carving the frame. A series of four paintings, *Cabin in the Cotton*, was Pippin's first attempt to portray the life of African Americans. Encouraged by others and hoping to make some money, Pippin displayed his paintings in the windows of various shops. When art historian Christian Brinton saw one of these nostalgic paintings, he sought out the artist to see additional examples of his work. In 1937 he chose ten of Pippin's paintings for an exhibition at the West Chester Community Center. By 1941 Pippin's work had been in group exhibitions in New York City (Museum of Modern Art, Bignou Gallery, Downtown Gallery), in Philadelphia (Carlen's Gallery), and in Chicago (Chicago Arts Club). To his early subjects of war and the South, Pippin soon added biblical scenes, landscapes, portraits, and colorful depictions of flowers. He also completed two narrative series comprised of seven paintings of two historical figures: John Brown and Harriet Tubman. His *Holy Mountain* series consists of four versions, inspired by the Bible and his desire to see peace end World War II. Horace Pippin died in 1946.

Paintings by Horace Pippin are in the collections of Metropolitan Museum of Art, New York City; Philadelphia Museum of Art, Pennsylvania; Pennsylvania Academy of the Fine Arts, Philadelphia; Schomburg Center for Research in Black Culture, The New York Public Library, New York City; Hirshhorn Museum and Sculpture Garden, Smithsonian Institution, Washington, D.C.; Howard University Gallery of Art, Washington, D.C.; The Phillips Collection, Washington, D.C.; and Butler Institute of American Art, Youngstown, Ohio.

Stephanie Elaine Pogue (1944–)

Seated Woman, 1978 (Plate 90)
Color viscosity etching, 15 ½ x 19 ¾ in.

Stephanie Elaine Pogue was born in Shelby, North Carolina, and raised in Elizabeth, New Jersey. She received a Bachelor of Fine Arts degree in painting from Howard University, Washington, D.C., in 1966, and a Master of Fine Arts degree in printmaking from Cranbrook Academy of Art in Bloomfield Hills, Michigan, in 1968.

Pogue's teaching career began at Fisk University in Nashville, Tennessee (1968–1981), where she served as professor of art, art department chair, and gallery director. In 1981 she accepted a position at the University of Maryland at College Park, where she currently teaches printmaking (including intaglio), handmade paper techniques, and drawing. She chaired the Art Department at the University of Maryland from 1992 to 1997. Actively involved in the academic environment, Pogue is often a guest lecturer, exhibition juror, curator, or visiting artist.

As a recipient of two Fulbright Hays Cross-Cultural Fellowships, granted in 1981 and 1986, Pogue traveled to India to study architecture and to Pakistan to study traditional arts and crafts. In 1982 she received the first of many CAPA awards from the University of Maryland, singled out for her advanced study in color etching techniques. With a strong color sense, a preference for simple geometric (sometimes architectural) shapes, and the technical ability to push the traditional boundaries of printmaking, Pogue has created a body of work that is exhibited in museums, galleries, and universities nationally and internationally.

Paintings and prints by Stephanie Elaine Pogue are in the collections of Whitney Museum of American Art, New York City; Studio Museum in Harlem, New York City; Cinque Gallery, New York City; Minneapolis Institute of Arts, Minnesota; Arkansas Art Center, Little Rock; Spelman College, Atlanta, Georgia; Xian College of Art, Xian, China; Xavier University, New Orleans, Louisiana; and Vanderbilt University, Nashville, Tennessee.

James Amos Porter (1905–1970)
Washerwoman, n.d. (Plate 45)
Oil on canvas, 18 x 13 in.

James Amos Porter was born in Baltimore, Maryland, in 1905. His father, an African Methodist Episcopal minister, headed a family of eight children. After James expressed a desire to be an artist, the elder Porter took him to Howard University and introduced him to James V. Herring, chairman of the art department. Although Porter was offered a scholarship to Harvard University, he decided to attend Howard, graduating in 1927. After postgraduate work in New York City—classes in anatomy and painting under Dimitri Romanowsky at the Art Students League and art education classes at Columbia University's Teachers College—he joined the faculty at Howard University, teaching drawing and painting.

As he worked on the academic side of art, Porter continued to be a creative artist, too. His work gradually gained recognition, including an honorable mention in the 1929 Harmon Foundation exhibition and the Schomburg portrait prize in the 1933 Harmon Foundation exhibition. Soon his paintings were being accepted in national juried exhibitions put on by museums and art galleries in New York City, Baltimore, Detroit, and Philadelphia. During his travels to these exhibitions, Porter became motivated to chronicle the accomplishments of African American artists. Assisted by research librarian Dorothy Burnett at the Harlem branch library, Porter was able to document the work of numerous African American artists. Burnett and Porter were married in 1929. Dorothy Porter became head of the Moorland Spingarn collection at the Howard University Library and continued to assist her husband with his research and writing.

In 1935 Porter studied art in Belgium, Germany, and Italy after he received a scholarship from the Institute of International Education and a Rockefeller Foundation grant. Before completing a master's degree in 1937 at New York University, he spent a sabbatical year studying medieval archaeology at the Sorbonne in Paris. His master's thesis, which carefully documented the arts and crafts of black potters, architects, weavers, ironworkers, engravers, and painters, became the first scholarly work to document the development of African American artists. Published in 1943, Porter's *Modern Negro Art* was based on several years of extensive research, and the positive impact it had on his students led Porter to establish the first college-level course in African American art history.

In 1953 Porter became head of Howard University's art department and director of its art gallery. In his own paintings, he concentrated on the portrayal of African Americans. He traveled to Cuba and Haiti, studying Caribbean artists and African influences in their art. In the 1960s he went to Africa, where he painted expressionist scenes, a departure from his former realistic style. These paintings were exhibited in Washington in 1965, and the next year the National Gallery of Art honored Porter as one of the nation's best art teachers. Porter's most important legacy is as the first historian of African American art. Porter continued to teach, write, and paint until his death in 1970.

Paintings by James Amos Porter are in the collections of Carl Van Vechten Gallery of Fine Arts, Fisk University, Nashville, Tennessee; National Museum of American Art, Smithsonian

Institution, Washington, D.C.; and Howard University Gallery of Art, Washington, D.C.

Martin Puryear (1941–)

Nexus, 1979 (Plate 84)
Pine, maple, and gesso, 1 ½ x 45 in.

Martin Puryear was born and raised in Washington, D.C. He began his college studies in the field of biology at The Catholic University of America, in Washington, D.C., but switched to art, including courses with painter Nell Sonneman, and earned a Bachelor of Arts degree in 1963. During a two-year Peace Corps assignment in Sierra Leone, West Africa, he taught art, biology, English, and French at a secondary school in Segbwena. He also developed an appreciation for the craftsmen he met, especially the woodworkers, and was able to learn their traditional techniques.

Before returning home, Puryear spent two years in Sweden, studying etching and sculpture while attending printmaking courses at the Royal Academy of Art in Stockholm. In Sweden he shifted his focus from painting and printmaking to sculpture. He also learned more about woodworking and furniture design while an assistant to cabinetmaker James Krenov. A grant awarded in 1969 allowed Puryear to continue his art education at Yale University, where he studied sculpture with Al Held, James Rosati, Robert Morris, Salvatore Scarpitta, and Richard Serra. He received a Master of Fine Arts degree in 1971 and then joined the art faculty at Fisk University in Nashville, Tennessee. During his two-year assignment at Fisk, he employed new materials in his abstract, minimalist sculptures, using concrete, rawhide, leather, and rope, and instead of milled wood, he used natural lengths of oak, pine, poplar, and osage orange.

From 1974 until 1978, Puryear was a professor of art at the University of Maryland in College Park, and then he accepted a position at the Chicago Circle Campus of the University of Illinois. He now lives and works in Accord, New York. Gaining widespread recognition, he was commissioned for a number of outdoor projects for public sites: *Box and Pole* for the Artpark in Lewiston, New York; *Bodark Arc,* for the Governor's State University, University Park, Illinois; *Sentinel,* a mortar and fieldstone sculpture installed on the campus of Gettysburg College, Pennsylvania; and *Ampersand,* a public gateway for the Minneapolis Sculpture Garden, Walker Art Center, Minnesota. Puryear created more than forty sculptures delineating lines, while his wall-mounted ring sculptures—crafted of bent saplings or strips of laminated wood—were widely exhibited at galleries in Chicago, Washington, and New York.

Puryear has participated in many exhibitions nationally and in Europe and is the recipient of many grants and awards. A 1983 John Simon Guggenheim Foundation grant funded his study of domestic architecture and gardens in Japan. In 1989 he was awarded the grand prize at the São Paulo Bienal, and in 1992 he was elected to the American Academy and Institute of Arts and Letters. In 1992, mounted by The Art Institute of Chicago, a retrospective was assembled and traveled around the country.

Prints, paintings, sculpture, and painted sculpture by Martin Puryear are in the collections of Corcoran Gallery of Art, Washington, D.C.; Metropolitan Museum of Art, New York City; Joslyn Art Museum, Omaha, Nebraska; Solomon R. Guggenheim Museum, New York City; Art Institute of Chicago; and Detroit Institute of Arts.

Faith Ringgold (1930–)

Camille's Husband's Birthday Quilt, 1988 (Plate 76)
Painted and pieced canvas and silk fabrics, 106 x 81 ¾ in.

Faith Ringgold was born in Harlem, New York, and earned a Bachelor of Arts degree and a Master of Arts degree at City College of New York. Upon graduation, she began a teaching career in the New York City public school system, where she was employed from 1955 until 1973.

During the fervent social and political climate of the 1960s, Ringgold became a leader in the equal rights movement, supporting equal representation of African American artists, and later of African American women artists, in the art world. She cofounded WSABL (Women Students and Artists for Black Liberation) and Where We At, a black women's group, and she participated in demonstrations organized by the Ad Hoc Committee of Women Artists. As a result of the Ad Hoc group's protests, the Whitney Museum of American Art in New York City included two African American female artists (Betye Saar and Barbara Chase-Riboud) in its 1971 *Contemporary Black Artists in America* exhibition. Ringgold's social and political views were themes for her early oil paintings on canvas, and they often are the subject of her story quilts.

Beginning in 1970 Ringgold taught college-level courses at Pratt Institute in Brooklyn, Wagner College on Staten Island, and the Bank Street College of Education in Greenwich Village. In 1973 she began to work in fabric, creating dolls, pictures framed with fabric, masks, and soft sculptures. She also began to hold performances associated with her artwork. Her first multimedia masked performance, *The Wake and Resurrection of the Bicentennial Negro,* was for the American bicentennial

celebration of 1976. By 1980 the story quilt became her favored medium; she combines hand painting, quilted fabric, appliqué, silkscreen, lithography, etching, and storytelling, often making series of quilts in which each quilt becomes one scene in a story.

In 1982, after her first solo exhibition at Studio Museum in Harlem and receipt of a fellowship from the MacDowell Colony in Peterborough, New Hampshire, Ringgold's compositions shifted to abstract imagery, as seen in the *Baby Faith and Willi* series and the *Emanon* series. In 1985 Ringgold accepted a position as full professor at the University of California, San Diego. Her first children's book was published in 1991; based on one of her story quilts, it became a Caldecott Honor Book and received a Coretta Scott King Award as best African American illustrated book for 1991. She has since written six more children's books and an autobiography, *We Flew Over the Bridge: The Memoirs of Faith Ringgold*. In 1990 a major exhibition, *Faith Ringgold: A Twenty Five-Year Survey*, toured thirteen museums. The Studio Museum in Harlem mounted a twenty-year retrospective of her work in 1984.

Paintings and quilts by Faith Ringgold are in collections of Bayly Art Museum, University of Virginia, Charlottesville; Metropolitan Museum of Art, New York City; American Craft Museum, New York City; Studio Museum in Harlem, New York City; Museum of Modern Art, New York City; Solomon R. Guggenheim Museum of Art, New York City; National Museum of American Art, Smithsonian Institution, Washington, D.C.; Phoenix Art Museum, Arizona; Spencer Museum of Art at the University of Kansas, Lawrence; High Museum of Art, Atlanta, Georgia; and Philadelphia Museum of Art, Pennsylvania.

Ellis Ruley (1882–1959)

Cherry Blossom Time, c. 1960s (Plate 44)
Oil-based house paint on board, 21 x 27 in.

Ellis Ruley was born in Norwich, Connecticut, in 1882. A self-taught artist, he worked as a laborer in coal yards and on construction sites. His interest in art began about 1939, but only after retiring in the early 1950s did he devote himself entirely to painting. He worked with house paint on masonite or poster board; occasionally he "signed" his work with a stamp bearing his name.

A naturalist, Ruley relied on his woodland property in Laurel Hill, Connecticut, for the settings of his paintings, and he used photographs from magazines as models for the people. Creating genre scenes against the backdrop of nature, he portrayed cowboys, Indians, exotic animals, and scantily clad women. He also drew scenes of outdoor places and activities (hunting and fishing, canoeing, the local park, a scenic waterfall, a farm), religious depictions, and a series of paintings devoted to English environmentalist and author Archibald Stansfeld Belaney (also known as Chief Grey Owl), who lived in the Canadian wilderness and published articles in *Country Life*.

The only exhibition of Ruley's work during his lifetime was in 1952 at the Norwich School of Art and Design. He died in 1959 under suspicious circumstances, and shortly after his death his house, with many paintings inside, was set on fire. In 1980 the Slater Museum in Norwich assembled some of Ruley's work for an exhibition. Glen Robert Smith wrote a book about Ruley in 1993 and organized a traveling exhibit called *Discovering Ellis Ruley*.

Paintings by Ellis Ruley are in the collections of Wadsworth Atheneum Museum of Art, Hartford, Connecticut, and Slater Memorial Museum, Norwich, Connecticut.

Augusta Savage (1892–1962)

Gamin, 1929 (Plate 23)
Plaster, height 9 ⅛ in.

Seated Boy (*Boy on a Stump*), 1940–1942 (Plate 24)
Bronze, height 31 ¼ in.

Augusta Savage was born in Green Cove Springs, Florida. Her studies of art began in New York, where she attended Cooper Union for two years. A Harlem librarian impressed with her work recommended she be commissioned to create a bust of W. E. B. Du Bois; the bust was so well-received that soon she was sculpting portraits of other African American leaders.

Wanting to study in Europe, in 1923 she applied for admission to the summer art school program in Fontainebleau, France, sponsored by the French government. When she was denied admission before she had completed the application process, Savage denounced the biased decision and, with the support of the Harlem community and Alfred W. Martin, leader of the Ethical Culture Society, fought the committee's decision. Her appeal was denied, but the media exposure brought her national attention and cast her into a lifelong leadership role in the struggle for equal rights.

Another role Savage took on was that of teacher, as she opened up her studio to anyone, adult or child, who was interested in learning. Her bust *Gamin* (1929) brought her recognition as an artist, too, including a scholarship that allowed her to study at the Académie de la Grande Chaumière in Paris. The next year, her work won acceptance and recognition at the Salon du Société des Artistes Français, and one of her African figures was honored at the French Colonial Exposition.

When she returned to Harlem, Savage exhibited in several galleries, received numerous commissions, and in 1932 opened the Savage School of Arts and Crafts with a $1500 grant from the Carnegie Foundation. In 1934 she became the first black woman elected to the National Association of Women Painters and Sculptors. During the 1930s, as president of the Harlem Artists Guild, she fought with the Works Project Administration for the inclusion of black history on public murals, for commissions for black artists, and for project administrative positions for black artists.

In 1937 Savage was commissioned to create a sculpture commemorating African Americans' contribution to song. *The Harp*, also known as *Lift Every Voice and Sing*, cast in plaster, was one of the most popular pieces at the 1939–1940 New York World's Fair. Unfortunately, Savage didn't have enough money to have the piece stored or cast in bronze, so it was destroyed when the fair was over. Toward the end of her career, Savage created and exhibited a body of work reflective of her European training. These works were not as enthusiastically accepted as her more expressive portraits. The American Negro Exposition held in Chicago at the Tanner Galleries in 1940 was the last exhibition in which Savage participated.

Sculptures by Augusta Savage are in the collections of Schomburg Center for Research in Black Culture, The New York Public Library, New York City; and The Howard University Gallery of Art, Washington, D.C.

Henry Ossawa Tanner (1859–1937)

The Thankful Poor, 1894 (Plate 12)
Oil on canvas, 35 ½ x 44 ¼ in.

Study for The Young Sabotmaker, c. 1894
44 ¼ x 35 ½ in. (Plate 13)

And He Vanished Out of Their Sight, 1898 (Plate 14)
Oil on canvas, 25 ¾ x 32 in.

Scene from the Life of Job, c. 1914 (Plate 15)
Oil on canvas, 41 x 49 ⅝ in.

The Good Shepherd, c. 1920s (Plate 16)
Oil on canvas, 25 ½ x 32 in.

Henry Ossawa Tanner was born six years before the end of the Civil War, in Allegheny, Pennsylvania. His parents' home is said to have been an official stopping place along the underground railroad. His father was a devout African Methodist Episcopal bishop and a champion of civil rights during Reconstruction.

Tanner attended the 1876 United States Centennial Exposition in Philadelphia, held within walking distance of his home, and viewed works by American and European artists, including two highly acclaimed pieces by Edward Mitchell Bannister and Edmonia Lewis. His father initially discouraged art as an occupation but ultimately supported his son while he studied art at the Pennsylvania Academy of the Fine Arts under Thomas Eakins. His early efforts to make a living as an artist included realistic seascapes, illustrations of animals in the zoo, photographic portraits, and paintings such as *And He Vanished Out of Their Sight* (1898) that reveal the depth of his spirituality.

At the age of thirty-one, Tanner sailed for Europe, choosing Paris because of his immediate affinity for the Académie Julien and its international community of artists. During his first few return visits to Philadelphia, he created a series of genre paintings that portray African Americans with dignity, including *The Banjo Lesson* (1893) and *The Thankful Poor* (1894). On the reverse side of this painting, discovered by David C. Driskell, is a preliminary sketch of *The Young Sabotmaker*, which was completed a year later.

Tanner's highest ambition was to be included in the Salon du Société des Artistes Français, an annual exhibition that drew thousands of people every day of its run. His first Salon submission in 1874, *The Banjo Lesson*, was accepted. His 1896 submission, *Daniel in the Lion's Den*, received an honorable mention. The next year, he traveled to Egypt and the Holy Land, observing the physical characteristics of the people and the locations of the biblical stories he had known since a child. While there, he learned that his *Raising of Lazarus* had received an award at the Salon and had been purchased by the French government for the Musée National d'Histoire et d'Art de Luxembourg.

Tanner spent most of his adult life in France, although he continued to travel to Philadelphia and to the Holy Land. He was often chided for not continuing with the genre paintings of African Americans, but he nevertheless focused on religious themes and developed a unique style.

During World War I, Tanner was a lieutenant in the Farm Service Bureau of the American Red Cross, helping the wounded convalesce by cultivating vegetable gardens. After the war, Tanner returned to his religious paintings and continued to garner large commissions and acclaim. He was elected a member of the National Academy of Design in 1909 and a full academician in 1927. His popularity inspired many young artists, and he became a mentor to William Edouard Scott, Hale Woodruff, Aaron Douglas, and Meta Vaux Warrick Fuller. Tanner continued to live in France and work on small paintings until his death in 1937.

Henry Ossawa Tanner's work is in the collections of Los Angeles County Museum of Art, California; National Museum of American Art, Smithsonian Institution, Washington, D.C.; High Museum of Art, Atlanta, Georgia; Greater Lafayette Museum of Art, Lafayette, Indiana; Fisk University, Nashville, Tennessee; Metropolitan Museum of Art, New York City; Art Institute of Chicago, Illinois; Philadelphia Museum of Art, Pennsylvania; and Telfair Museum of Art, Savannah, Georgia.

Alma Woodsey Thomas (1891–1978)
Azaleas Extravaganza, 1968 (Plate 22)
Acrylic on canvas, 72 x 52 in

A Fantastic Sunset, 1970 (Plate 21)
Acrylic on canvas, 47 ½ x 47 ¼ in.

Born in Columbus, Georgia, Thomas grew up in Washington, D.C. While attending Miner Teachers Normal School, she decided to become a kindergarten teacher. At her first job for the Thomas Garett Settlement House in Wilmington, Delaware, she taught arts and crafts, made children's costumes, and staged puppet shows.

Thomas pursued additional studies at Columbia University's Teachers College, earning a Master of Arts degree—her thesis was on the use of marionettes. At the age of thirty, Thomas enrolled in the costume design program at Howard University, but James V. Herring persuaded her to switch to the new fine arts program; in 1924 she was its first graduate. Most of her work at this time was in sculpture and the making of puppet heads. Upon graduation, she joined the faculty at Shaw Junior High School in Washington, D.C., where she taught art until her retirement in 1960.

During her teaching career, Thomas remained active as an artist, gradually shifting her focus to painting, especially watercolors. She spent her summer vacations in New York, visiting the museums and galleries. In 1939 she won her first prize, for a painting submitted to a Department of Commerce exhibition. As an active member of the art community, she became vice president of the Barnett-Aden Gallery, one of the first galleries to exhibit modern American art in Washington, D.C. Thomas participated in group shows at the gallery, and the gallery sponsored her first show of watercolors.

In 1946 Thomas joined the Little Paris group of African American women, including Lois Mailou Jones and Celine Tabary—mostly public school teachers and government employees—who dabbled in art. With a group of supportive friends encouraging her, at the age of sixty-five she began studying painting at American University. Under the guidance of Joe Summerford and Robert Gates, she experimented with abstract expressionism and cubism. Her first significant watercolor, *Joe Summerford's Still Life,* was produced during this period. In 1957 she studied under Jacob Kainen and became acquainted with the Washington color field school of painting, which used pure color in a controlled manner. Thomas's own work gradually evolved into pure abstract painting that displayed bright colors and themes derived from nature.

Although slowed by arthritis in the 1960s, Thomas continued to paint and formulate her own unique style. By the time Howard University assembled a retrospective of her work, she was creating what she called "Alma's stripes" or "earth paintings" that have realistic titles—*Azaleas Extravaganza,* for example—but are actually colored mosaic-like patterns. In April 1972 the Whitney Museum of American Art in New York City mounted her first museum exhibition, followed by an exhibition at the Corcoran Gallery of Art in Washington, D.C. She continued to paint until her death in 1978. In 1977, when she was eighty-six, President Jimmy Carter invited her to the White House, where, in an official ceremony, she was recognized for her achievements as a teacher and an artist.

Paintings by Alma Woodsey Thomas are in the collections of National Museum of American Art, Smithsonian Institution, Washington, D.C.; Metropolitan Museum of Art, New York City; and Hirshhorn Museum and Sculpture Garden, Smithsonian Institution, Washington, D.C.

Bob Thompson (1937–1966)
Bird with Nudes, 1964 (Plate 83)
Oil on canvas, 36 ¼ x 48 in.

Horse and Blue Rider, 1965 (Plate 81)
Oil on canvas, 14 x 18 in.

Horsemen of the Queen of Sheba, 1966 (Plate 82)
Oil pastel, 53 ½ x 33 ⅝ in.

Bob Thompson was born Robert Louis Thompson in Louisville, Kentucky. In 1955, through the Reserve Officers Training Corps, he was awarded a full scholarship to Boston University and enrolled in the premed program. In 1956 he withdrew and returned to Kentucky, where he began to study art under Ulfert Wilke at the University of Louisville. He also took courses at the Art Center Association from painters Mary Spencer Nay and Eugene Leake. He spent the summer of 1958 in Provincetown, Massachusetts, attending the Seong Moy School of Painting and Graphic Arts. During his second semester at the University of Louisville, Thompson received the Allen R. Hite Art Scholarship, an award renewed annually until he withdrew in January 1959 and moved to New York City.

Thompson's early paintings are abstract figurative pieces in earth tones of brown, gray, and black. Influenced by an American art form, jazz, Thompson was a regular at the Five Spot, a jazz club at Fifth Street and Cooper Square. Painted in vivid colors and flat abstract forms, *Homage to Ornette* (also known as *Garden of Music*) is a portrait of Ornette Coleman, John Coltrane, Sonny Rollins, Don Cherry, Charlie Haden, and Ed Blackwell. Other paintings from this period pay homage to LeRoi Jones and Nina Simone. His first solo show was in 1960 at the Delancey Street Museum in New York City.

In 1961 Thompson received a Walter Gutman grant, which allowed him to move to Paris, where he continued to paint and study classical artists whose works are housed at the Louvre, including Titian, Caravaggio, and Goya. Frescoes and paintings by Italian Renaissance artists Piero della Francesca and Massacio also inspired Thompson. In 1962, using a Whitney Opportunity Fellowship, he moved to the Mediterranean island of Ibiza. After his 1963 return to New York City, Thompson was widely exhibited in one-man shows and group exhibitions.

In 1965 Thompson moved to Rome. With a reputation for working at a vigorous pace, he produced a sizable body of work between 1959 and 1966, the year of his untimely death in Rome at the age of twenty-nine. In 1969 the New School Art Center in New York City held a retrospective of Thompson's work, and in his home town of Louisville, the J. B. Speed Museum mounted a memorial exhibition in 1971. In 1998 the Whitney Museum of American Art exhibited more than a hundred of Thompson's paintings and drawings.

Paintings by Bob Thompson are in the collections of Hirshhorn Museum and Sculpture Garden, Smithsonian Institution, Washington, D.C.; Metropolitan Museum of Art, New York City; Solomon R. Guggenheim Museum, New York City; National Museum of American Art, Smithsonian Institution, Washington, D.C.; Whitney Museum of American Art, New York City; Museum of Modern Art, New York City; Denver Art Museum, Colorado; and Art Institute of Chicago, Illinois.

James Lesesne Wells (1902–1993)

Georgetown Garden, 1958 (Plate 35)
Oil on canvas, 19 x 22 in.

Spanish Steps, 1972 (Plate 36)
Oil on canvas, 39¾ x 30 in.

James Lesesne Wells was born in Atlanta, Georgia. He attended Baptist Academy in Jacksonville, Florida, and won his first recognition at the age of thirteen as an artist at the Florida State Fair. Upon graduation, he moved to New York, supporting himself while taking art classes at the National Academy of Design. In 1925 he graduated from Teachers College at Columbia University, where he majored in art education.

A 1923 exhibit of African art at the Brooklyn Museum of Art influenced Wells to use African motifs in his own work. The woodcuts of the German expressionists and the vivid colors of the French fauvists (Henri Matisse and Georges Rouault) helped Wells formulate not only his style but his use of printmaking as an art form. Soon his prints were illustrating magazine articles, his work was included in a 1929 exhibition of international modernists at New Art Circle gallery, and he was asked to join the art faculty at Howard University.

While teaching, Wells continued to paint, often using the Bible as inspiration. *The Flight into Egypt* (1931), an expressionist painting, won him a $500 prize and a gold medal from the Harmon Foundation. Two years later, the white-line woodcut *Escape of the Spies from Canaan* (1932) won first prize in the Harmon Foundation's print division. Encouraged by Alain Locke, who was a neighbor in Washington, D.C., Wells was also creating woodblock prints with African themes. He especially liked the printmaking medium because it made art more affordable for African Americans.

During the Depression, the Federal Arts Project gave Wells a chance to refine his techniques in lithography, serigraphy, and etching through his own work and by teaching the techniques to others. In the 1940s he continued to devote himself to printmaking—studying, teaching, and winning prizes (Corcoran Gallery of Art's 1951 regional show, 1958 and 1959 from Washington Water Color Club, 1956 from the Society of American Graphics). In 1928 he was awarded a master's degree at Teachers College at Columbia University. In the 1960s Wells started adding color to his prints, and he continued to produce and win awards until he was in his eighties. In 1991 he was awarded the Living Legend Award at the National Black Arts Festival in Atlanta, Georgia. Wells died in Washington, D.C., in 1993.

Paintings by James Lesesne Wells are in the permanent collections of Howard University Gallery of Art, Washington, D.C.; Hampton University Museum, Hampton, Virginia; Graphics Division, Smithsonian Institution, Washington, D.C.; and Fisk University, Nashville, Tennessee.

Charles White (1918–1979)

Solid as a Rock, 1958 (Plate 1)
Linoleum cut, 39 x 17 in.

Seed of Heritage, 1968 (Plate 69)
Ink on illustration board, 60 x 45 in.

Homage to Langston Hughes, 1971 (Plate 71)
Oil on canvas, 48 x 48 in.

Wanted Poster #18, 1972 (Plate 70)
Oil on illustration board, 37 ¾ x 54 ⅞ in.

Charles White was born in Chicago, Illinois. By the time he was fifteen, he had dropped out of school and was earning money by painting theatrical sets and lettering signs.

Through his lettering work, White met other artists, including graphic artist George E. Neal, who as a teacher inspired his students to see the beauty of African American culture. In 1937 White won a scholarship to the Art Institute of Chicago. After completing the two-year course of study in one year, he worked on the mural projects funded by the Works Progress Administration (WPA). Under the direction of Mitchell Siporin and Edward Millman, White was introduced to the concept of socially conscious art and to the Mexican muralists.

Five Great American Negroes, one of White's WPA murals that featured five historical figures who overcame persecution, was completed in 1940 for the Chicago Public Library. The same year the Associated Negro Press commissioned White to create a mural in their honor for the 1940 American Negro Exposition in Chicago. The piece was titled *There Were No Crops This Year* and won first prize. In 1941 White moved to New Orleans, where he studied rural black culture in the South and continued to paint, with the support of a Julius Rosenwald Foundation fellowship.

In 1942 White moved to New York City. Instructed by Harry Sternberg at the Art Students League, White began to individualize the human form through elaborate drawings, moving away from his renderings of a stylized human image. He also began to work in black and white or sepia and white, partly inspired by German artist Käthe Kollwitz but also for its reproduction ability, which would allow his art to reach large numbers of people. Although he occasionally painted in color, White's mastery of the lithographic printing technique led him to increasingly prefer black-and-white or sepia-and-white illustrations.

In 1943 White accepted a teaching position at Hampton Institute, now Hampton University, in Virginia. Supported by a second Julius Rosenwald Foundation fellowship, White installed on Hampton's campus *Contribution of the Negro to American Democracy* (1943), a mural representing the historical contributions of numerous African Americans. During World War II White was drafted into the Army. Shortly into basic training, White was diagonosed with tuberculosis and sent to New York for recuperation. In 1946 he contributed to the first portfolio created by the New York Graphic Workshop,

and he created illustrations for his solo exhibition at the American Contemporary Artists Gallery in 1947. Wanting to learn about the Mexican muralists, White went to Mexico City to study at the Esmeralda National School of Painting and Sculpture. He took additional classes at the Taller de Gráfica Popular, where he met Diego Rivera and became aware of artists who were not just observers but also political participants in their society.

White's stay in Mexico ended with the deterioration of his health, but back in New York, after a year of convalescence, he regularly exhibited his work and continued to meet and be inspired by African American writers, artists, and musicians, including W. E. B. Du Bois, Thurgood Marshall, Langston Hughes, and Jacob Lawrence. During this period White focused on ordinary African Americans as heroic icons. In 1950, while traveling in Europe, White discovered that his lithographic prints were very popular there. A series of portraits of black women, exhibited in 1951 at American Contemporary Artists Gallery in New York City, received critical acclaim and led to additional awards and museum exhibitions (Metropolitan Museum of Art, 1952; American Academy of Arts and Letters, 1953).

In the late 1950s, exhibitions in California (University of California at Los Angeles, 1958, Long Beach Museum of Art, 1959) prompted White to move to Altadena, California, where he recuperated after another bout of tuberculosis. There were numerous exhibitions during the 1960s (Atlanta University, Georgia; Howard University, Washington, D.C.; Heritage Gallery, Los Angeles; and several California colleges) as the civil rights movement brought attention to the courageous portraits of ordinary black people. In 1965 White accepted a teaching post at Otis Institute of Art in Los Angeles and found teaching an additional source of inspiration for his own work.

J'Accuse (1966) is a series of portraits that focuses on oppression in American society. His *Wanted Poster* series (1969), modeled after old runaway slave posters and slave auction advertisements, was reproduced with funds received from the prestigious lithography workshop Tamarind and was widely distributed. A book of White's work, *Images of Dignity,* was published in 1967 by Johnson Publications of Chicago. The National Academy of Design awarded him prizes in 1971, 1972, and 1975 and elected him a full member in 1972. White continued to work until his death, in 1979. His last mural, *Mary McLeod Bethune* (1978), an oil on canvas, is installed inside the Exposition Park branch of the Los Angeles public library.

Murals, paintings, and illustrations by Charles White are in the collections of Hampton University Museum, Hampton,

Virginia; Howard University Gallery of Art, Washington, D.C.; and Whitney Museum of American Art, New York City.

Walter Williams (1920–1998)
Roots, Southern Landscape, 1978 (Plate 72)
Oil, sand, enamel, collage, 47¾ x 58¾ in.

Walter Williams was born in Brooklyn, New York; he did not take an interest in art until he was thirty years old. Using his veteran's educational benefits, in 1952 he enrolled in the school at the Brooklyn Museum of Art, where he studied for four years under the tutelage of Gregorio Prestopino, Ben Shahn, and Reuben Tam. After spending the summer of 1953 at the Skowhegan School of Painting and Sculpture in Maine, Williams had the first of a succession of one-man shows at Roko Gallery in New York City.

A John Hay Whitney fellowship, awarded in 1955, enabled Williams to travel and work in Mexico. From there, he toured Europe and finally, in the early 1960s, settled in Copenhagen, Denmark, which remained his home until his death in 1998. During this period he learned new techniques of woodblock printing and participated in exhibitions in the Scandinavian countries, Australia, Japan, Mexico, and the United States. In 1964 Williams organized a Copenhagen exhibition titled *10 American Negro Artists Living and Working in Europe.* Among his notable works are the *Black Madonna* series and, later in his stylistic development, his romantic images of African American life.

In 1968 Williams returned to the United States for one year to serve as artist-in-residence at Fisk University in Nashville, Tennessee, where he worked with artists Earl Hooks, Stephanie Pogue, and David C. Driskell. At Fisk, he began a series of paintings based on life in the South. In 1969 Williams created a series of colorful woodcuts of black children in fields of flowers with birds and butterflies in flight. These works were equally inspired by the social climate and by the civil rights movement of the 1960s. As his health deteriorated in the late 1970s, Williams became less productive, but in 1972 the Studio Museum in Harlem included his work in their *Four Black Artists Living and Working Abroad* exhibition. Walter Williams died in June 1998.

Paintings by Walter Williams are in the collections of Howard University Gallery of Art, Washington D.C.; Whitney Museum of American Art, New York City; Brooklyn Museum of Art, New York City; Metropolitan Museum of Art, New York City; and Philadelphia Museum of Art, Pennsylvania.

William T. Williams (1942–)
Perdido, 1991 (Plate 85)
Lithograph, 41 x 29 in.

Born in Cross Creek, North Carolina, color field artist William T. Williams began his college studies at City University of New York, New York Community College, then transferred to Pratt Institute, where he received a Bachelor of Fine Arts degree in 1966. After two years at Yale University in New Haven, Connecticut, he earned the Master of Fine Arts degree. He also studied painting at the Skowhegan School of Painting and Sculpture in Maine. Since 1970 Williams has been teaching painting and drawing at City University of New York, Brooklyn College. He has also spent many summers teaching at Skowhegan School of Painting and Sculpture.

Often working around the concept of a series, Williams uses color as a mechanism for creating form that is often abstract in nature. Paintings completed early in his career are hard-edged, precise geometric planes painted in vibrant colors. However, he soon discarded the conventional methods he had been using for a more informal technique of applying paint to a canvas, sometimes creating an encrusted surface reminiscent of the physical characteristics of African masks. Staying constant is his experimentation with new ways to create spatial volume with color.

In 1985 the Southeastern Center for Contemporary Art in Winston-Salem, North Carolina, organized an exhibition of work by Williams, and he has participated in numerous traveling exhibitions and group shows.

Paintings by William T. Williams are in the collections of Studio Museum in Harlem, New York City; Whitney Museum of American Art, New York City; Museum of Modern Art, New York City; Fisk University, Nashville, Tennessee; and Detroit Institute of Arts.

Hale Aspacio Woodruff (1900–1980)
Indian Summer, c. 1939 (Plate 29)
Oil on canvas, 7½ x 10½ in.

Hale Aspacio Woodruff was born in Cairo, Illinois, and raised in Nashville, Tennessee. In 1918, Woodruff went to Indianapolis to work in a hotel and attend John Herron Art Institute. He eventually arranged for a free room at the "colored" YMCA, in exchange for work as a desk clerk. He earned extra money drawing cartoons for a local newspaper and lettering sales posters for stores. While at the Y's front desk, he met many African American leaders as they sought a room during their stay in Indianapolis.

To raise money for a trip to Europe, Woodruff entered one of his paintings in the 1926 Harmon Foundation competition and won second prize. The resulting media coverage brought additional donations, and he left for Europe in 1927. Although

he initially pursued a course of study at Académie Moderne and Académie Scandinave, he ultimately left the classroom for the museums, studying Henry Tanner, Claude Monet, and Paul Cézanne.

After four years abroad and the sale of some of his landscapes, in 1931 Woodruff returned to the United States to teach at Atlanta University (now Clark Atlanta University) in Atlanta, Georgia. Besides teaching drawing, color theory, and painting techniques, Woodruff arranged trips to the local museum, High Museum of Art. On Woodruff's first trip to the museum, to attend a lecture by Grant Wood (whose *American Gothic* had gained widespread recognition), he was turned away because of his color. When Wood learned what had happened, he scolded the museum administration and sought out Woodruff to apologize. From that time on, thirty years before integration in the South, Woodruff and his black students were allowed into the museum.

Woodruff encouraged his students to paint what they knew, the hills and neighborhoods of Atlanta, and he arranged exhibits of his students' work. In 1934, after the Harmon Foundation decided to eliminate its annual exhibition of works by Negro artists, Woodruff convinced the Atlanta University administration to have its own annual exhibition, a tradition that lasted thirty-five years.

While actively committed to education, Woodruff continued to work on his own compositions. During the Depression he became fascinated with Diego Rivera, a Mexican muralist who used art to teach history and forge a sense of identity among his impoverished countrymen. In 1934 Woodruff joined Rivera's crew as he worked on his Hotel Reforma mural in Mexico City. Woodruff returned to Atlanta just in time to secure two commissions from the Works Progress Administration. He also completed a series of murals at Talladega College in Talladega, Alabama, portraying the mutiny of fifty-four slaves aboard the *Amistad* in 1839, their Connecticut trial, and their trip back to Africa.

A fellowship in 1943 enabled Woodruff to move to New York. Woodruff accepted a position at New York University and continued with a full schedule of teaching while he created murals. In 1948 he and Charles Alston were commissioned to paint two large murals portraying the role of African Americans in the history of California; the murals were installed in the Golden State Mutal Life Insurance Company's building in Los Angeles. Next came the six-paneled *Art of the Negro*, created in New York and installed at Atlanta University. In what Woodruff considered his best work, he depicts the aesthetics of African culture and its relation to modern art and to the emerging African American artists.

During the 1950s Woodruff's African iconography gradually evolved into abstract expressionism, as seen in his *Celestial Gates* series. Still socially active, he and several New York artists formed Spiral, where artists met to discuss the cultural and political issues relevant to African American artists. In 1968 Woodruff retired from academia, ending a long relationship with New York University. He continued to paint until his death in 1980.

Paintings and murals by Hale Aspacio Woodruff are in the collections of Hampton University Museum, Hampton, Virginia; The Newark Museum, Newark, New Jersey; Talladega College, Talladega, Alabama; Golden State Mutual Life Insurance Company, Los Angeles, California; Metropolitan Museum of Art, New York City; Howard University Gallery of Art, Washington, D.C.; and Clark Atlanta University, Atlanta, Georgia.

Acknowledgments

Selecting the works of art that appear in this book and engaging in the research that led to the writing of the text have been a labor of love for many wonderful people. I shall begin by mentioning Camille and Bill Cosby, whose genuine friendship I have enjoyed for more than two decades. They have entrusted to me the responsibility of curating a major collection of American art across racial lines, of which only a small selection appears here in print. The African American component of the Cosby Collection of Fine Arts is all but definitive in its overview of American art history.

Certainly, without the generous support and creative thinking about this publication that both Camille and Bill provided, a book of this nature could not have been realized. But I am also greatly indebted to a cadre of dedicated individuals whose physical efforts and constant advice enabled me to pursue with diligence the sometimes-onerous task of looking more carefully at archival and primary sources that informed the writing of the accompanying text. Among those I cite are Daphne Driskell-Coles, my assistant, who labored over a period of years to interpret my scribbles in longhand and type and edit the manuscript; René Hanks, associate curator of the Cosby Collection of Fine Arts, who wrote the well-researched biographies of the artists whose works are represented here; Joanna Shaw-Eagle, whose editing skills at reading and reviewing the written text were invaluable; and Ophelia Speight, Rodney Moore, Jeremy Austin, Daviryne Driskell-McNeill, and Darius Driskell, all of whom played a significant role in helping to assemble much-needed materials for the initial stages of my research, which began in 1993. Frank Stewart meticulously treated each work of art he photographed like a precious object, always seeking to present it in the best possible way, as did photographer David Stansbury, who in Frank's absence was called upon to photograph a number of works.

My colleagues, among whom are Keith Morrison, Juanita Marie Holland, Steven Jones, and Julie McGee, to mention only a few, queried me from time to time about the progress of this book and offered valued advice about artists, events, and ideas relevant to the interpretation of the works I selected. Certainly my advanced graduate students pursuing doctoral degrees in African American art history at the University of Maryland—Renée Ater, Adrienne L. Childs, and Tuliza Fleming—whom I have been honored to mentor over the past four or five years, deserve special credit for the help they provided from time to time.

Last, I am greatly indebted to several generations of scholars and mentors who helped plant the seed of interest and inquiry in my mind during my undergraduate studies at Howard University in the 1950s and whose scholarship in the history of African American art, long before it became a popular subject, continues to inspire me to learn more about our African and African American past. This burning desire to revisit an inclusive history of American art and help define the field was awakened in me by the teachings of Professors James V. Herring, Alain L. Locke, and my mentor, James A. Porter, in the nascent years of the academic pursuit of African American art history. They are the worthy progenitors of an enduring legacy.

I wish to acknowledge with sincere appreciation the help received from Peg Alston of Peg Alston Fine Arts, New York, New York; Eric Hanks of the M. Hanks Gallery, Santa Monica, California; June Kelly of June Kelly Gallery, New York, New York; and Sherry Washington of the Sherry Washington Gallery, Detroit, Michigan; all specialize in the sale of works by African American artists. Their professional services greatly helped our efforts to obtain permissions to reproduce a number of important works in this book.

DAVID C. DRISKELL

Selected Bibliography

Adams, Brooks. "Tanner's Odyssey." *Art in America* (June 1991):108–113.

Allen, Ana M. *The Beginner's Guide to Collecting Fine Art, African American Style*. Washington, D.C.: Positiv! Productions, 1998.

Alma Thomas. Nashville: Carl Van Vecten Gallery, Fisk University, 1971.

Anderson-Spivy, Alexandra. *Romare Bearden: The Human Condition*. New York: ACA Galleries, 1991.

African-American Art: The Paul R. Jones Collection. Newark, DE: University Gallery and the Department of Art History, University of Delaware, 1993.

Ater, Renée D. "Race, Gender, and Nation: Rethinking the Sculpture of Meta Warrick Fuller." Unpublished dissertation. College Park: University of Maryland, 2000.

Bearden, Romare. "The Negro Artist and Modern Art." *Journal of Negro Life* (December, 1934).

——— and Harry Henderson. *Six Black Masters of American Art*. New York: Zenith Books, 1972.

———. *A History of African-American Artists from 1792 to the Present*. New York: Pantheon books, 1993.

Bearing Witness. Jontyl Robinson et al., eds. New York: Spelman College and Rizzoli International Publications,1996.

Beauford Delaney: A Retrospective. New York: The Studio Museum in Harlem, 1978.

Beauford Delaney: A Retrospective, 50 Years of Light. New York: Phillippe Briet, Inc., 1991.

Benjamin, Tritobia Hayes. *Lois Mailou Jones: The Passion for Art*. Washington, D.C.: Howard University Libraries, 1988.

———. *The World of Lois Mailou Jones*. Washington, D.C.: Meridian House International, 1990.

———. *The Life and Work of Lois Mailou Jones*. San Francisco: Pomegranate, 1994.

Black Artists in the WPA, 1933–1943. Brooklyn, NY: The New Muse Community Museum of Brooklyn, 1976.

Boime, Albert. "Henry Ossawa Tanner's Subversion of Genre." *The Art Bulletin*, vol. 75, no. 1 (1993):415–442.

Bond, Fred F. *A One-Man Exhibition: Prints and Paintings by James L. Wells*. Nashville: Carl Van Vechten Gallery, Fisk University, 1973.

Bontemps, Arna Alexander, ed. *Forever Free: Art by African-American Women 1862–1980*. Alexandria, VA: Stephenson, 1980.

———. *Choosing: An Exhibit of Changing Perspectives in Modern Art and Criticism by Black Americans, 1925–1985*. Washington, D.C.: Museum Press, 1985.

Brawley, Benjamin. *The Negro Genius*. New York: Dodd, Mead & Company, 1937.

Breeskin, Adelyn D. *William H. Johnson: 1901–1970*. Washington, D.C.: Smithsonian Institution Press for the National Collection of Fine Arts, 1971.

Brenson, Michael and Lowery Stokes Sims. *Elizabeth Catlett Sculpture: A Fifty-Year Retrospective*. New York: Neuberger Museum of Art, 1998.

Britton, Crystal, ed. *Selected Essays: Art and Artists from the Harlem Renaissance to the 1980s*. Atlanta: National Black Arts Festival, 1988.

Butcher, Margaret Just. *The Negro in American Culture*. New York: Alfred A. Knopf, 1967.

Campbell, Mary Schmidt. *Tradition and Conflict: Images of a Turbulent Decade 1963–1973*. New York: The Studio Museum in Harlem, 1985.

——— and Sharon F. Patton. *Memory and Metaphor: The Art of Romare Bearden, 1940–1987*. New York: The Studio Museum in Harlem and Oxford University Press, 1991.

Clarke, Christa. "Defining Taste: Albert C. Barnes and the Promotion of African Art in the United States." Doctoral dissertation. College Park: University of Maryland, 1998.

Coar, Valencia Hollins. *A Century of Black Photographers: 1840–1960*. Providence: Museum of Rhode Island School of Design.

Coker, Gilbert and Corrine Jennings. *The Harmon and Harriet Kelley Collection of African American Art*. San Antonio: San Antonio Museum of Art, 1994.

Conwill, Kinshasha Holman. "In Search of an 'Authentic' Vision: Decoding the Appeal of the Self-Taught African American Artist." *American Art*, vol. 5, no. 4 (1991):2–8.

A Cross Currents Synthesis in African American Abstract Painting. New York: Kenkeleba House, 1992.

Davis, Donald F. "Aaron Douglas of Fisk: Molder of Black Artists." *The Journal of Negro History*, vol. 49, no. 2 (Spring 1984):95–99.

Dover, Cedric. *American Negro Art*. Greenwich, CT: New York Graphic Society, 1960.

Driskell, David C. *Amistad II: Afro-American Art*. New York: United Church Board for Homeland Ministries, 1975.

———. *Two Centuries of Black American Art*. New York: Alfred A. Knopf, 1976.

———. *Hidden Heritage: Afro-American Art, 1800–1950*. San Francisco: The Art Museum Association of American, 1985.

———, ed. *The African American Aesthetic in the Visual Arts and Postmodernism*. Washington, D.C.: Smithsonian Institution Press, 1995.

——— and Gladys E. Rodgers. *Claude Clark: On My Journey Now*. Atlanta: The Apex Museum, 1996.

Du Bois, W. E. B. *The Souls of Black Folk*. New York: New American Library, 1969.

Fax, Elton C. *Seventeen Black Artists*. New York: Dodd, Mead & Company, 1971.

Ferris, William, ed. *Afro-American Folk Art and Crafts*. Jackson: University Press of Mississippi, 1983.

Fields, Barbara J. "Slavery, Race, and Ideology in the United States of America." *New Left Review* (May–June):1990.

Fifty Years of Paintings by Georgia Artist Claude Clark. Atlanta: Hammonds House Galleries and Resource Center for African American Art, 1990.

Fine, Elsa Honing. *The Afro-American Artist: A Search for Identity*. New York: Hacker Art Books, 1982.

Fleming, Tuliza. *Breaking Racial Barriers: African Americans in the Harmon Foundation Collection*. Washington, D.C.: National Portrait Gallery, Smithsonian Insitution, in association with Pomegranate, San Francisco, 1997.

Fogliatti, Cynthia Jo, ed. *Romare Bearden: Origins and Progressions*. Detroit: The Detroit Institute of Arts, 1986.

Foresta, Merry A. *A Life in Art: Alma Thomas, 1891–1978*. Washington, D.C. Smithsonian Institution Press for the National Museum of American Art, 1981.

Frazier, E. Franklin. "The Garvey Movement." *Opportunity,* vol. 4 (November 1926):346–348.

Gayle, Addison, ed. *The Black Aesthetic.* Garden City, NY: Doubleday, 1971.

Gelburd, Gail. *A Blossoming of New Promises: Art in the Spirit of the Harlem Renaissance.* Hempstead, NY: The Emily Lowe Gallery, Hofstra University, 1984.

Gibson, Ann. *The Search for Freedom: African American Abstract Painting 1945–1974.* New York: Kenkeleba House, 1991.

Greene, Carroll. *The Evolution of Afro-American Artists: 1800–1950.* New York: City University of New York, 1967.

———. *Romare Bearden: The Prevalence of Ritual.* New York: Museum of Modern Art, 1971.

Gordon, Allan M. *Echoes of Our Past: The Narrative Artistry of Palmer C. Hayden.* Los Angeles: Museum of African American Art, 1988.

Hall, Robert L. *Gathered Visions: Selected Works by African American Women Artists.* Washington, D.C. and London: Smithsonian Institution Press, 1992.

Hammond, Leslie King. *Ritual and Myth: A Survey of African American Art.* New York:The Studio Museum in Harlem, 1982.

———. *Black Printmakers and the W.P.A.* New York: Lehman College Art Gallery, 1989.

———, ed. *Gumbo Ya Ya: Anthology of Contemporary African American Women Artists.* New York: Midmarch Arts Press, 1995.

Hanks, Eric. "Journey from the Crossroads—Palmer Hayden's Right Turn." *International Review of American Art,* vol. 16, no. 1 (1999):31–35.

Harlem Renaissance: Art of Black America. Inroduction by Mary Schmidt Campbell; essays by David C. Driskell, David Levering Lewis, and Deborah Willis Ryan. New York: The Studio Museum in Harlem and Harry N. Abrams, 1987.

Hartigan, Lynda Roscoe. *Sharing Traditions: Five Black Artists in Nineteenth-Century America.* Washington, D.C.: Smithsonian Institution Press, 1985.

———. "Landscapes, Portraits, and Still Lifes," *I Tell My Heart: The Art of Horace Pippin.* Judith Stein, ed. Philadelphia: Pennsylvania Academy of the Fine Arts, in association with Universe Publishing, 1993.

Henkes, Robert. *The Art of Black American Women: Works of Twenty-Four Artists of the Twentieth Century.* Jefferson, NC: McFarland, 1993.

Herzog, Melanie. "Elizabeth Catlett in Mexico: Identity and Cross-Cultural Intersections in the Production of Artistic Meaning." *The International Review of African American Art,* vol. 11, no. 3 (1994):19–25.

Holland, Juanita. *The Life and Work of Edward Mitchell Bannister (1828–1901): Research Chronology and Exhibition Record.* New York: Kenkeleba House, 1992.

———. (Co-Workers in the Kingdom of Culture: Edward Mitchell Bannister and the Boston Community of African American Artists, 1848–1901.) Doctoral dissertation. New York: Columbia University, Department of Art History and Archeology, 1996.

———, ed. *Narratives of African American Art and Identity: The David C. Driskell Collection.* San Francisco: Pomegranate, 1998.

Horace Pippin. Washington, D.C.: The Phillips Collection, 1976.

Huggins, Nathan. *The Harlem Renaissance.* New York: Oxford University Press, 1971.

An Independent Woman: The Life and Art of Meta Warrick Fuller. Framingham, MA: The Danforth Museum of Art, 1984.

Jacob Lawrence: The Migrations Series. Washington, D.C.: The Rappahannock Press in Association with the Phillips Collection, 1993.

Jacob Lawrence: An Overview: Paintings from 1936–1994. New York: Midtown Payson Galleries, 1995.

Jacobs, Joseph. *Since the Harlem Renaissance: 50 Years of Afro-American Art.* Lewisburg, PA: The Center Gallery of Bucknell University, 1985.

James A. Porter: Artist and Art Historian, The Memory of the Legacy. Washington, D.C.: Howard University Gallery of Art and College of Fine Arts, 1993.

James Porter: Recent Paintings and Drawings. Washington, D.C.: Barnett-Aden Gallery, 1948.

Johns, Elizabeth. *300 Years of Art in Maryland.* College Park: University of Maryland Art Gallery, 1984.

Kenter, Joseph D. "Robert S. Duncanson (1821–1872): The Late Literary Landscape Paintings." *The American Art Journal,* vol. 15, no. 1 (1983):35–47.

———. *The Emergence of the African-American Artist: Robert S. Duncanson 1821–1972.* Columbia and London: University of Missouri Press, 1993.

Kingsley, April. *Afro-American Abstraction.* San Francisco: The Art Museum Association, 1982.

Kirschke, Amy Helene. *Aaron Douglas: Art, Race, and the Harlem Renaissance.* Jackson: University Press of Mississippi, 1995.

LeFalle-Collins, Lizetta, ed. *Novae. William H. Johnson and Bob Thompso*n. Los Angeles: California Afro-American Museum, 1990.

LeFalle-Collins, Lizetta and Shifra M. Goldman. *In the Spirit of Resistance: African American Modernists and the Mexican Muralist School.* New York: The American Federation of Arts, 1996.

Leeming, David. *Amazing Grace: A Life of Beauford Delaney.* New York: Oxford University Press, 1988.

Lewis, David Levering. *When Harlem Was in Vogue.* New York: Oxford University Press, 1979.

Lewis, Samella. *The Art of Elizabeth Catlett.* Claremont, CA: Hancroft Studios, 1984.

———. *African American Art and Artists.* Berkeley: University of California Press, 1990.

———.*Art: African American,* 2d ed. Los Angeles: Hancroft Studios, 1990.

——— and Ruth G. Waddy. *Black Artists on Art,* vols. 1 and 2. Los Angeles: Contemporary Crafts, Inc., 1976.

Lippard, Lucy. *Mixed Blessings: New Art in a Multicultural America.* New York: Pantheon Books, 1990.

Livingston, Jane and John Beardsley. *Black Folk Art in America 1930–1980.* Jackson: University of Mississippi, 1982.

Locke, Alain, ed. *The New Negro: An Interpretation.* New York: Albert and Charles Boni, 1925.

Locke, Alain. "The African Legacy and the Negro Artist," *Exhibition of the Work of Negro Artists.* New York: Harmon Foundation, February 1931.

———. *Negro Art: Past and Present.* Washington, D.C.: Association in Negro Fold Education, 1936.

———. *The Negro in Art: A Pictorial Record of the Negro Artist and the*

Negro Theme in Art. Washington, D.C.: Associates in Negro Folk Education, 1940.

———. *The Negro and His Music and Negro Art: Past and Present*. New York: Anchor Books, Anchor Press/ Doubleday, 1936, rep. 1974.

Lois Mailou Jones and Her Former Students: An American Legacy. Washington, D.C.: Department of Art, Howard University, 1995.

Long, Richard A. *William H. Johnson, Afro-American Painter*. Atlanta: Spelman College, 1970.

McElroy, Guy. *Robert S. Duncanson: A Centennial Exhibition*. Cincinnati Art Museum, 1972.

———, Richard J. Powell, and Sharon F. Patton. *African-American Artists 1880–1987: Selections from the Evan-Tibbs Collection*. Washington, D.C.: Smithsonian Institution Traveling Exhibition Services, 1989.

McElroy, Guy. *Facing History*. San Francisco: Bedford Arts, 1990.

The Many Facets of Palmer Hayden (1890–1973). New York: Just Above Midtown, 1977.

Matthews, Marcia. *Henry Ossawa Tanner: American Artist*. Chicago: University of Chicago Press, 1969.

Metcalf, Eugene W. "Black Art, Folk Art, and Social Control." *Winterthur Portfolio*, vol. 18, no. 1 (1987):1–3.

Morrison, Keith. *Art in Washington and Its Afro-American Presence: 1940–1970*. Washington, D.C.: Washington Project for the Arts, 1985.

Mosby, Dewey F. *Across Continents and Cultures: The Art and Life of Henry Ossawa Tanner*. Kansas City, MO: Nelson-Atkins Museum of Art, 1995.

———, Darrel Sewell, and Rae Alexander-Minter. *Henry Ossawa Tanner*. Philadelphia Museum of Art, 1991.

New York/Chicago: WPA and the Black Artist. New York: The Studio Museum in Harlem, 1978.

Oceans Apart. New York: The Studio Museum in Harlem, 1978.

O'Connor, Francis V. *Art for the Millions: Essays from the 1930s by Artists and Administrators of the WPA Federal Arts Project*. Greenwich, CT: New York Graphic Society, 1973.

Palmer Hayden: Southern Scenes and City States. New York: The Studio Museum in Harlem, 1974.

Parks, James Dallas. *Robert S. Duncanson: 19th Century Black Romantic Painter*. Washington, D.C.: Associated Publishers, 1980.

Patton, Sharon F. *African American Art*. New York: Oxford University Press, 1998.

Perry, Regina. *Selections of Nineteenth-Century Afro-American Art*. New York: Metropolitan Museum of Art, 1976.

———. *Free Within Ourselves: African American Artists in the Collection of the National Museum of American Art*. Washington, D.C.: National Museum of American Art, Smithsonian Institution, 1992.

Porter, James A. *Modern Negro Art,* 3 ed. Washington, D.C.: Howard University Press, 1992.

———. *Ten Afro-American Artists of the Nineteenth Century*. Washington, D.C.: Howard University, 1967.

Powell, Richard J. *The Blues Aesthetic: Black Culture and Modernism*. Washington, D.C.: The Washington Project for the Arts, 1989.

———. *Homecoming: The Art and Life of William H. Johnson*. Washington, D.C.: The National Museum of American Art, Smithsonian Institution Press, 1991.

———. *African-American Art: 20th Century Masterworks, II*. New York: Michael Rosenfeld Gallery, 1995.

———. *Black Art and Culture in the 20th Century*. New York: Thames and Hudson, 1997.

———. *Rhapsodies in Black: Art of the Harlem Renaissance*. Berkeley: Hayward Gallery, Institute of International Visual Arts, University of California Press, 1997.

——— and Jock Reynolds. *To Conserve a Legacy*. Andover, MA and New York: Addison Gallery of American Art and The Studio Museum in Harlem, 1999.

Reynolds, Gary A. and Beryl J. Wright, eds. *Against the Odds: African-American Artists and the Harmon Foundation*. Essays by David C. Driskell, Clement Alexander Price, Richard J. Powell, and Deborah Willis. Newark, NJ: The Newark Museum, 1989.

Richardson, Marilyn. "Edomia Lewis, *The Death of Cleopatra*: Myth and Identity," *International Review of African American Art,* vol. 12, no. 2 (1995).

Robinson, Jontyle T. *The Art of Archibald J. Motley, Jr.* Chicago: Chicago Historical Society, 1991.

Schwartzman, Myron. *Romare Bearden: His Life and Art*. New York: Harry N. Abrams,1990.

Stein, Judith E., ed. *I Tell My Heart: The Art of Horace Pippin*. Philadelphia: Pennsylvania Academy of the Fine Arts, in association with Universe Publishing, 1993.

Taha, Halima. *Collecting African American Art*. New York: Crown, 1998.

Three Masters: Eldzier Cortor, Hughie Lee-Smith, Archibald John Motley, Jr. New York: Kenkeleba House, 1988.

Tibbs, Thurlow. *Surrealism and the Afro-American Artist*. Washington, D.C.: Evans-Tibbs Collection, 1983.

Washington, M. Bunch. *The Art of Romare Bearden: The Prevalence of Ritual*. New York: Harry N. Abrams, 1973.

Weekley, Carolyn and Stiles Tuttle Colewill. *Joshua Johnson: Freeman and Early American Portrait Painter*. Williamsburg, VA: Abby Aldrich Rockefeller Folk Art Center, Colonial Williamsburg Foundation, and Maryland Historical Society,1987.

Wheat, Ellen Harkins. *Jacob Lawrence: American Painter*. Seattle: University of Washington Press, 1986.

———. *Jacob Lawrence: The Frederick Douglas and Harriet Tubman Series of 1938–1940*. Hampton, VA: Hampton University Museum, 1991.

Williams, Reba and Dave Williams, eds. *Alone in a Crowd: Prints of the 1930s–40s by African American Artists*. Reba and Dave Williams, 1993.

Willis-Thomas, Deborah. *Black Photographers, 1840–1940: An Illustrated Bio-Bibliography*. New York: Garland Publishing, Inc., 1985.

———. *An Illustrated Bio-Bibliography of Black Photographers: 1940–1988*. New York: Garland Publishing, Inc., 1985.

Wilson, Sarah. *Horace Pippin: A Chester County Artist*. West Chester, PA: Chester County Historical Society, 1988.

Wolfe, Rinna Evelyn. *Edmonia Lewis*. Parisippany, NJ: Dillon Press, 1998.

Woodson, Shirley. *Walter O. Evans Collection of African American Art*. Detroit: Typocraft, 1991.

Index of Artworks

Alston, Charles
 Plate 48. *Woman and Child*, 84 (detail), 94
Amos, Emma
 Plate 80. *Sand Tan*, 150
Artis, William Ellisworth
 Plate 53. *African Youth*, 103
Avery, Milton
 Figure 11. *Connecticut Landscape*, 6

Bannister, Edward Mitchell
 Plate 9. *Fishing*, 21
 Plate 10. *Homestead*, 22
Barthé, Richmond
 Plate 32. *Inner Music*, 60
Bearden, Romare
 Plate 50. *Sitting in at Baron's*, 98
 Plate 51. *Magic Garden*, 100
 Plate 52. *Harlem Brownstone*, 101
Benton, Thomas Hart
 Figure 5. *The Bible Lesson*, 4
 Figure 14. *Going West*, 8

Catlett, Elizabeth
 Plate 56. *Maternity*, 108
 Plate 57. *Woman Resting*, 109
 Plate 58. *The Family*, 110
 Plate 59. *Woman Sitting*, 110
 Plate 60. *Reclining Woman*, 111
Clark, Claude
 Plate 61. *Sponge Fisherman*, 114
 Plate 62. *On Sunday Morning*, 115
Colescott, Robert
 Plate 75. *Death of a Mulatto Woman*, 142
Cortor, Eldzier
 Plate 63. *Southern Theme/Magnolia II*, 117
 Plate 64. *Homage to 466 Cherry Street*, 118
 Plate 65. *Still Life: Souvenir No. IV*, 120
Cosby, Erika Ranee
 Plate 93. *Hanging Out to Dry*, 170

Delaney, Beauford
 Plate 33. *Beauford Delaney's Loft*, 61
 Plate 34. *Untitled (Abstraction)*, 62
Douglas, Aaron
 Plate 28. *Crucifixion*, 53
Driskell, David C.
 Plate 77. *Adam Showing Eve*, 146
 Plate 78. *The Green Chair*, 148
 Plate 79. *Antique Rocker*, 149
Duncanson, Robert S.
 Plate 5. *Landscape with Brook*, 16
 Plate 6. *Falls of Minnehaha*, 17
 Plate 7. *Vale of Kashmir*, 18
 Plate 8. *Romantic Landscape*, 18

Evans, Minnie
 Plate 42. *Design Made at Airlie Garden*, 68 (detail), 78

Fuller, Meta Vaux Warrick
 Plate 17. *Peace Halting the Ruthlessness of War*, 34

Hayden, Palmer
 Plate 25. *Woman in Garden*, 48

Plate 26. *Carousel*, 49
 Plate 27. *When Tricky Sam Shot Father Lamb*, 50
Honeywood, Varnette
 Plate 91. *Precious Memories*, 166
 Plate 92. *Honor Thy Father and Thy Mother*, 168
Humphrey, Margo
 Plate 86. *The Last Bar-B-Que*, 159
Hunter, Clementine
 Plate 43. *The Burial*, 80

Inness, George
 Figure 8. *In the Hackensack Valley (Landscape with Stream)*, 5

Johnson, William Henry
 Plate 30. *Ezekiel Saw the Wheel*, 57
 Plate 31. *Untitled (Seated Woman)*, 58, 172 (detail)
Johnston, Joshua
 Plate 2. *Mrs. Thomas Donovan and Elinor Donovan*, 10
 Plate 3. *Lady on a Red Sofa*, 14
 Plate 4. *Basil Brown*, 15
Jones, Lois Mailou
 Plate 46. *Nature Morte aux Geraniums*, 90
 Plate 47. *Ville d'Houdain, Pas-de-Calais*, 93

Knox, Simmie
 Figure 4. *Portrait of Bill and Camille Cosby*, xvi

Lawrence, Jacob
 Plate 66. *Street Scene, Harlem*, 122
 Plate 67. *Blind Musician*, 123
 Plate 68. *Harlem Street Scene*, xxii, 125
Lee-Smith, Hughie
 Plate 54. *Soliloquist*, 104
 Plate 55. *Festival's End #2*, 106
Lewis, Mary Edmonia
 Plate 11. *Marriage of Hiawatha*, 24
Lewis, Norman
 Plate 49. *Untitled (Family Portrait)*, 97

Marsh, Reginald
 Figure 7. *Frozen Custard*, 4
 Figure 9. *High Yeller*, 5
Matisse, Henri
 Figure 6. *Tête au Volutes*, 4
Morrison, Keith
 Plate 87. *Zanzibar*, 160
Motley, Archibald J. Jr.
 Plate 18. *Stomp*, 38
 Plate 19. *Senegalese Boy*, 39
 Plate 20. *Bronzeville at Night*, 40

O'Keeffe, Georgia
 Figure 13. *Red Pear with Fig*, 7
O'Neal, Mary Lovelace
 Plate 88. *Painted Desert II*, 162
 Plate 89. *Desert Women Series*, 163

Pajaud, William
 Plate 73. *Mujer con Maiz, Tortilla Maker 4*, 140
 Plate 74. *Hard Hat*, 141
Pippin, Horace
 Plate 37. *Woman Taken in Adultery*, 71

Plate 38. *Victory Vase*, 72
 Plate 39. *The Love Note*, 74
 Plate 40. *Roses with Red Chair*, 75
 Plate 41. *The Holy Mountain I*, 76
Pogue, Stephanie Elaine
 Plate 90. *Seated Woman*, 165
Porter, James Amos
 Plate 45. *Washerwoman*, 89
Prendergast, Maurice
 Figure 10. *Summer Day*, 6
Puryear, Martin
 Plate 84. *Nexus*, 155

Ringgold, Faith
 Plate 76. *Camille's Husband's Birthday Quilt*, 145
Roesen, Severin
 Figure 15. *Still Life with Fruit*, 8
Ruley, Ellis
 Plate 44. *Cherry Blossom Time*, 81

Savage, Augusta
 Plate 23. *Gamin*, 45
 Plate 24. *Seated Boy (Boy on a Stump)*, 46
Shahn, Ben
 Figure 12. *Anger*, 6

Tanner, Henry Ossawa
 Plate 12. *The Thankful Poor*, xiv, 26
 Plate 13. *Study for The Young Sabot Maker*, xix (detail), 27
 Plate 14. *And He Vanished Out of Their Sight*, 29
 Plate 15. *Scene from the Life of Job*, 31
 Plate 16. *The Good Shepherd*, 32
Thomas, Alma Woodsey
 Plate 21. *A Fantastic Sunset*, 42
 Plate 22. *Azaleas Extravaganza*, 43
Thompson, Bob
 Plate 81. *Horse and Blue Rider*, 151
 Plate 82. *Horsemen of the Queen of Sheba*, 152
 Plate 83. *Bird with Nudes*, 154

Wells, James Lesesne
 Plate 35. *Georgetown Garden*, 65
 Plate 36. *Spanish Steps*, 66
White, Charles
 Figure 1. *The Wall*, xi
 Figure 2. *Bill*, xii
 Figure 3. *Cathedral of Life*, xv
 Plate 1. *Solid as a Rock* (detail), xxiv
 Plate 69. *Seed of Heritage*, 126
 Plate 70. *Wanted Poster #18*, 127
 Plate 71. *Homage to Langston Hughes*, 129
Williams, Walter
 Plate 72. *Roots, Southern Landscape*, viii (detail), 139
Williams, William T.
 Plate 85. *Perdido*, 132 (detail), 156
Woodruff, Hale Aspacio
 Plate 29. *Indian Summer*, 54

Index

Bold numbers refer to biographical information; *italic numbers* refer to illustrations.

Adam Showing Eve (Driskell), 144, *146*
Aden, Alonzo J., 41
African American art:
 and art education, x, xiv, 35, 86, 87
 collecting, x–xi, xvii–xx, 1–9, 134
 Harlem Renaissance era, 47, 51, 52, 64, 67, 86, 92, 133–137, 147, 169, 170
 "naïve" or "primitive," xiii, xviii–xix, 116
 New Black image era, 85–130
 "outsider," 69–83, 116
 pioneers, 7–8, 11–31, 85, 133–134, 173
 and racial issues, 11, 19, 30, 85, 133, 173–174
 and religious subjects, 28, 30, 52, 56, 70, 73
 and slavery, xviii, 12, 13, 20, 23, 69
 twentieth-century torchbearers, 35–67
 unschooled ("outsider"), 69–83, 116
African art, 12, 20, 23, 51, 52, 64, 86, 87, 91, 112–113, 136–137, 153
 See also New Negro movement.
African Youth (Artis), 102, *103*
Alston, Charles, 52, *84*, 86, **92**, *94*, 95, 121, 143, **175**
The Amistad Murals, 52, 86
Amos, Emma, 95, **147**, *150*, **175–176**
And He Vanished Out of Their Sight (Tanner), 28, *29*
Anger (Shahn), 5, *6*
The Annunciation, 28
Antique Rocker (Driskell), 144, *149*
Armstrong, Louis, 135
Art education, and African American art, x, xiv, 35, 86, 87
Art history journals, role in highlighting artists, 3, 12
Artis, William Ellisworth, *102*, *103*, **176**
Ashcan painters, 85
Aspects of Negro Life, 52, 96
Avery, Milton, 5, *6*
Azaleas Extravaganza (Thomas), 41, *43*, 44

Baker, Kenneth, 161
Baldwin, James, 60, 63
The Banjo Lesson, xix, 25, 28
Bannister, Edward Mitchell, 3, 11–12, **20**, *21*, *22*, **23**, 30, 44, 85, 134, 173, **176–177**
Barbizon school of painting, 20, 35
Barnes, Albert C., 51, 112, 136
Barnes Foundation, 112–113
Barthé, Richmond, **56**, **59**, *60*, 64, 102, **177**
Basil Brown (Johnston), 13, *15*
Bearden, Romare, 41, 87, 92, 95, **96**, *98*, **99**, **102**, *100*, *101*, 121, 136, 147, **177–178**
Beauford Delaney's Loft (Delaney), 59–60, *61*
Benton, Thomas Hart, *4*, 5, *8*
Bhalla, Hans, 167
The Bible Lesson (Benton), *4*, 5
Bill (White), x, *xii*, xiii
Bird with Nudes (Thompson), 153, *154*
Blind Musician (Lawrence), 121, *123*

Bone, Robert, 133
Bowser, David Bustill, 11–12
Brackett, Edmund, 23
Brady, Mary Beattie, 87, 116
Brancusi, Constantin, 85, 135
Bronzeville at Night (Motley), 37, *40*
Builders series, 124
The Burial (Hunter), 79, *80*

Cabin in the Cotton II, 70, 73
California Museum of Afro-American Art, 173
Camille's Husband's Birthday Quilt (Ringgold), 144, *145*
Carousel (Hayden), 47, *49*
Cathedral of Life (White), xiii, *xv*
Catlett, Elizabeth, **105**, **107**, *108*, *109*, *110*, *111*, **112**, 136, **178–179**
Cherry Blossom Time (Ruley), *81*, 82
Chicago, 64
Chicago Defender, 119
Chicken Shack (Motley), 37
Chrichlow, Ernest, 95
Cinque Gallery, 95
Clark, Claude, **112–113**, *114*, 115, **179**
Cole, Thomas, 13, 85
Colescott, Robert, *142*, **143**, **179–180**
Collage, 96, 99, 102, 147, 167
Collecting African American art, x–xi, xvii–xx, 1–9, 134
Color, and African Americans, xiii, 60, 158
Connecticut Landscape (Avery), 5, *6*
Contribution of the Negro to American Democracy (White), 86
Cortor, Eldzier, **113**, **116**, *117*, *118*, *119*, *120*, **180**
Cosby, Bill (William O.), xvii–xix, xx
Cosby, Camille, xiii–xiv, xviii
Cosby, Erika Ranee, ix–xi, **167**, **169**, *170*, **181**
Cosby family, x–xi, *xii*, xiii–xiv, *xvi*, xvii–xix, xx, 1, 3, 5, 7, 110, 112, 144, *145*, 174
Crucifixion (Douglas), 52, *53*
Cullen, Countee, 135

Daniel in the Lion's Den (Tanner), 28
Davis, Steuart, 5
De Kooning, Willem, 96
Death of a Mulatto Woman (Colescott), *142*, 143
The Death of Cleopatra (Lewis), 25
Delaney, Beauford, **59–60**, *61*, *62*, **63**, **181**
Desert Women Series (O'Neal), 161, *163*, 164
Design Made at Airlie Garden (Evans), *68* (detail), *77*, *78*
Dolls, 88, 169
Douglas, Aaron, 47, **51–52**, *53*, 64, 86, 96, 134, 137, 157, 173, **181–182**
Douglas, Robert Jr., 11–12
Dream Deferred (White), ix
Driskell, David C., xiii, xviii, **xx–xxi**, **144**, *146*, **147**, *148*, *149*, **182–183**
Du Bois, W. E. B., 47, 86, 135
Duncanson, Robert S., 8, 11–**13**, *16*, *17*, *18*, **19**, 30, 85, 134, 175, **183–184**
Dunham, Catherine, 135

Eakins, Thomas, 25
Egyptian art, 51, 86.
Ellen's Isle (Duncanson), 19
Ellington, Duke, 135
Ethiopia Awakening (Fuller), 86
European art scene, 35, 36, 55, 59, 60, 63, 85, 91, 137–138
Evans, Minnie, *68*, **77**, *78*, 82, **184**
Exhibition catalogs, 2, **3**
Exhibition of the Work by Negro Artists, 87, 88
Ezekiel Saw the Wheel (Johnson), 56, *57*

Falls of Minnehaha (Duncanson), 13, *17*, 19
The Family (Catlett), *110*, 112
A Fantastic Sunset (Thomas), 41, *42*
Festival's End #2 (Lee-Smith), 105, *106*
Fishing (Bannister), 20, *21*
Fisk University, 2, 52, 86
Fisk (University) Jubilee Singers, 135
Forever Free (Lewis), 23
Frozen Custard (Marsh), *4*, 5
Fuller, Meta Vaux Warrick, *34*, **35–36**, 86, **184–185**

Gamin (Savage), *44*, *45*, 46
Garvey, Marcus, 86
"Gatekeeper" practices, xiii–xiv
Gates, Robert, 41
Gentry, Herbert, 60, 137–138
Georgetown Garden (Wells), 64, *65*
Gilliam, Sam, 157
Going West (Benton), 5, *8*
The Good Shepherd (Tanner), 30, *32*
The Green Chair (Driskell), 144, *148*

Halpert, Edith, 116, 121
Hampton University, 2
Hanging Out to Dry (Cosby), 169, *170*
Hard Hat (Pajaud), 138, *141*
Harlem, 52, 63, 64, 121, 134–136, 137
Harlem Brownstone (Bearden), 99, *101*
Harlem Renaissance era, 52, 64, 67, 92, 133–137
 and Alain Locke, 47, 51, 59, 85–86, 147, 169
 and twentieth-century torchbearers, 35–67
 See also New Negro Movement.
Harlem Street Scene (Lawrence), *xxii*, 124, *125*
Harleston, Edwin, 52
Harmon Foundation, 51, 59, 87, 88, 91, 136
The Harp (*Lift Every Voice and Sing*) (Savage), 44
Harper, William A., 35
Hawthorne, Charles W., 55
Hayden, Palmer, 36, **47**, *48*, *49*, *50*, 64, **185**
Herring, James V., 41, 63, 88, 133–134
High Yeller (Marsh), *5*, 5
The Holy Mountain series (Pippin), 73
The Holy Mountain I (Pippin), 73, *76*, 82
Homage to 466 Cherry Street (Cortor), *118*, 119
Homage to Langston Hughes (White), *129*, 130
Homer, Winslow, 25
Homestead (Bannister), 20, *22*
Honeywood, Varnette, 137, *166*, **167**, *168*, **185–186**

Honor Thy Father and Thy Mother (Honeywood), 167, *168*
Hope, John, 3
Horse and Blue Rider (Thompson), 147, *151*
Horsemen of the Queen of Sheba (Thompson), 147, *152*
Hosmer, Harriet, 23
Howard University, 2, 63–64, 86, 91
Hudson River school of painting, 8, 13, 20, 85
Huggins, Nathan, 134
Hughes, Langston, 30, 86, 135, 169
Humphrey, Margo, **157–158**, *159*, 169, **186**
Hunter, Clementine, *79*, *80*, 82, **186–187**
Hurston, Zora Neale, 135

In the Hackensack Valley (Landscape with Stream) (Inness), *5*
Indian Summer (Woodruff), 52, *54*, 55
Inner Music (Barthé), 59, *60*
Inness, George, *5*

Jackson, Clifton, 138
Jazz, as artistic influence, 96, 135, 157
Job and His Three Friends (Tanner), 28
John Henry series (Hayden), 47
Johnson, Charles Spurgeon, 52, 135
Johnson, James Weldon, 135
Johnson, Sargent Claude, 86, 102
Johnson, William Henry, **55–56**, *57*, *58*, 64, *172*, **187**
Johnston, Joshua, 7–8, *10*, 11–13, *14*, *15*, 30, 85, 134, **187–188**
Jones, Lois Mailou, 41, 64, 86–87, **88**, *90*, **91–92**, *93*, 173, **188**
Joplin, Scott, 135

Kainen, Jacob, 41
Kline, Franz, 96
Knox, Simmie, *xvi*
Krake, Holcha, 55
Kraushaur, Antoinette, 116

Lady on a Red Sofa (Johnston), 13, *14*
Lam, Wilfredo, 95
Land of the Lotus Eaters (Duncanson), *xvii*, 19
Landscape painting, 8, 13, 19, 20
Landscape with Brook (Duncanson), 13, *16*
The Last Bar-B-Que (Humphrey), 158, *159*
Lawrence, Jacob, x, *xxii*, 41, 92, 116, **119**, **121**, *122*, *123*, **124**, *125*, 136, 138, **188–189**
Learning to Read the Scriptures (Tanner), 28
Lee-Smith, Hughie, **102**, **104**, **105**, *106*, **190**
Leininger-Miller, Theresa, 102
Les Fetisches (Jones), 91
Levine, Jack, 137
Lewis, David Levering, xx
Lewis, Mary Edmonia, *23*, *24*, **25**, 30, 85, 107, 134, 173, **190–191**
Lewis, Norman, **95–96**, *97*, 113, **191**
Lewis, Samella, 105, 107
Lewis, Sinclair, 113
Lift Every Voice and Sing (The Harp) (Savage), 44
Lithography, 168
Lochs of Scotland (Duncanson), 19

Locke, Alain Leroy, 36, 135, 173
and African art, 19, 85–86, 87, 91
as artistic influence, 51, 88, 133–134
New Negro/Harlem Renaissance movement, 47, 51, 59, 85–86, 136, 147, 169
Longfellow, Henry Wadsworth, 23
The Love Note (Pippin), 73, *74*

Magic Garden (Bearden), 99, *100*
Marc, Franz, 147
Marriage of Hiawatha (Lewis), 23, *24*
Marsh, Reginald, *4*, *5*
Mary (Tanner), 28
Mason, Charlotte Osgood, 136
Maternity (Catlett), 107, *108*
Matisse, Henri, *4*, 5
Maurer, Leonard, 85
McKay, Claude, 135
Memory, as artistic influence, 147, 157
Mending Socks (Motley), 37
Metoyer, Louis, 79
Mexican muralists, 52, 106, 124, 138
Middleton, Sam, 138
Midsummer Night in Harlem (Hayden), 47
Miller, Henry, 60, 63
Minion, Francois, 79
Modigliani, Amedeo, 35, 135
Mora, Francisco, 107
Morgan, Sister Gertrude, 79
Morrison, Keith, **158**, *160*, **161**, **191–192**
Motherwell, Robert, 96
Motley, Archibald J. Jr., *10*, 13, **36–37**, *38–40*, **41**, 47, 64, **192**
Mujer con Maiz, Tortilla Maker 4 (Pajaud), *138*, *140*
Mujeres series (Pajaud), 138
Murals, 52, 86–87, 92
Museums, xvii–xix, 35, 173–174
Music, as artistic influence, 96, 135, 157
Musical Interlude (Barthé), 59

"Naïve" or "primitive" art, xiii, xviii–xix, 116
National Center for Afro-American Art, 173
Nature Morte aux Geraniums (Jones), *90*, 91
Nexus (Puryear), 153, *155*
The New Negro, 51, 135
New Negro movement, 47, 51, 64, 86, 87, 102, 134, 136
See also Harlem Renaissance.
New York City, 64, 95
Newspapers, role in highlighting artists, 3, 119
Nude (White), xiii

O'Keeffe, Georgia, 5, *7*
The Old Arrowmaker and His Daughter (Lewis), 23
On a Cuban Bus (Porter), 88
On Sunday Morning (Clark), 113, *115*
O'Neal, Mary Lovelace, **161**, *161–163*, **164**, **192**
Orozco, Jose Clemente, 107
"Outsider art," 69–83, 116

Painted Desert II (O'Neal), *161*, *162*
Pajaud, William, **138**, *140*, *141*, **143**, **193**
Parker, Charlie (Bird), 137

Peace Halting the Ruthlessness of War (Fuller), *34*, 36
Peale, Charles Wilson, 13
Perdido (Williams), *132*, **156**, 157
Perieria, I. Rice, 41
Photomontages, 96, 99
Picasso, Pablo, 11, 35, 135, 137, 173
Pierre-Noël, Vergniaud, 91
Pioneers, in African American art, 7–8, 11–31, 85, 133–134, 173
Pippin, Horace, xviii, *70*, *71*, *72*, **73**, *74*, *76*, **77**, 82, **193**
Pippin, Jennie Ora, 73
Pittsburgh Courier, 119
Pogue, Stephanie Elaine, **164**, *165*, **167**, **193–194**
Polk, Charles Peale, 13
Pollock, Jackson, 11, 96
Porter, Charles Ethan, 11–12
Porter, James Amos, 19, 64, **87–88**, *89*, 113, **194–195**
Portrait of Bill and Camille Cosby (Knox), *xvi*
Portrait of Burwell Banks (Simpson), 2
Portrait of Charity Banks (Simpson), 2
Powell, Richard, 63
Precious Memories (Honeywood), *166*, 167
Prendergast, Maurice, 5, *6*
Prestipino, Gregorio, 137, 138
"Primitive" or "naïve" art, xiii, xviii–xix, 116
Primus, Pearl, 135
Puryear, Martin, **153**, *155*, 174, **195**

Quan Quan, Marie Therese, 79
Quilts, 144

Racial issues, and African American art, 11, 19, 30, 85, 133, 173–175
Reclining Woman (Catlett), *111*, 112
Red Pear with Fig (O'Keeffe), 5, *7*
Reiss, Winold, 51
Religious subjects, in African American art, 28, 30, 52, 56, 70, 73
The Resurrection of Lazarus (Tanner), xvii
Richardson, Marilyn, 25
Ringgold, Faith, 137, **143–144**, *145*, **195–196**
Rivera, Diego, 52, 107, 138
Rodgers, J. A., 51, 86
Rodin, Auguste, 36
Roesen, Severin, 5, *8*
Romantic Landscape (Duncanson), *18*, 19
Roots, Southern Landscape (Williams), *viii*, ix, 138, *139*
Roses with Red Chair (Pippin), 73, *75*
Rousseve, Numa, 138
Ruley, Ellis, **79**, *81*, *82*, **196**
Ryan, Debra Willis, xx

Sand Tan (Amos), 147, *150*
Savage, Augusta, **44**, *45*, **46**, 102, 121, **196–197**
Scene from the Life of Job (Tanner), 28, *31*
Schmidt-Rotluff, Karl, 35
Scott, William Edouard, 35
Sculpture, 23–25, 35–36, 44, 46, 56, 59, 102, 107, 112
and African art, 12, 20, 51, 52, 153
Seated Boy (Boy on a Stump) (Savage), *46*

Seated Woman (Pogue), 164, *165,* 167
Seed of Heritage (White), xiii, *126,* 128, 130
Senegalese Boy (Motley), 37, *39*
Shahn, Ben, 5, *6*
Siqueiros, David, 107
Simpson, William, 2
The Singing Slave (Barthé), 59
Sitting in at Baron's (Bearden), *98,* 99
Skowhegan School of Painting and
 Sculpture, 147
Slavery, and African American art, xviii, 12, 13,
 20, 23, 69
Sleet, Maude, 99
Smith, Albert H., 35, 36
Solid as a Rock (White), *xxiv*
Soliloquist (Lee-Smith), 102, *104,* 105
Sonntag, William, 13
Southern Theme/Magnolia II (Cortor), 116,
 117, 118
Spanish Steps (Wells), 64, *66*
Spiral, 95, 96, 147
Sponge Fisherman (Clark), 113, *114*
Stamos, Theodore, 41
Still Life: Souvenir No. IV (Cortor), 119, *120*
Still Life with Fruit (Roesen), 5, *8*
Senegalese Boy (Motley), 37, *39*
Stomp (Motley), 37, *38*
Street Scene, Harlem (Lawrence), 121, *122*
*Struggle: From the History of the American
 People* (Lawrence), 124
Studio Museum, 173
Studio 35 Club discussions, 96
Study for The Young Sabot Maker (Tanner),
 xix, 27, 28

Summer Day (Prendergast), 5, *6*
Swanson, Howard, 60

Tamayo, Rufino, 138
Tanner, Henry Ossawa, xiii, *xiv,* xvii, xix, 11–12,
 25, 28, *26, 27, 29,* **30,** *31, 32,* 35, 36, 73, 85,
 134, **197–198**
Tête au Volutes (Matisse), *4,* 5
The Thankful Poor (Tanner), xiii, *xiv,* xix, 25,
 26, 28
Thomas, Alma Woodsey, **41,** *42, 43,* **44,** 157,
 198
Thompson, Bob, **147,** *151, 152,* **153,** *154,*
 198–199
The Three Marys (Tanner), 28
Toussaint l'Ouverture series (Lawrence), 119,
 121
Twentieth-century torchbearers, of African
 American art, 35–67
Two Disciples at the Tomb (Tanner), 28

Uncle Tom and Little Eva (Duncanson), 19
Under the Oaks (Bannister), 20
Unschooled art ("outsider" art), 69–83, 116
Untitled (Abstraction) (Delaney), 60, *62*
Untitled (Family Portrait) (Lewis), 95, *97*
Untitled (Seated Woman) (Johnson), 56, *58,*
 172

Vale of Kashmir (Duncanson), *18,* 19
Van Vechten, Carl, 136
Victory Vase (Pippin), *72,* 73
Ville d'Houdain, Pas-de-Calais (Jones), 91, *93*

Walker, William Aiken, 73
The Wall (White), ix, *xi*
Waller, Fats, 135
Wanted Poster #18 (White), *127,* 128, 130
Wanted Poster series (White), 128, 130
Washerwoman (Porter), 88, *89*
Washington color field school of painting, 41
Weber, Max, 52, 85
Wells, James Lesesne, **63–64,** *65, 66,* 88, 121,
 199
When Tricky Sam Shot Father Lamb (Hayden),
 47, 50
White, Charles, ix–x, *xi, xii,* xiii, *xxiv, xv,* 1,
 86–87, **124,** *126, 127,* **128,** *129,* **130,** 136,
 199–201
"White marbalan" group, 23
Williams, Walter, viii, **137–138,** *139,* **201**
Williams, William T., *132, 156,* **157, 201**
Woman and Child (Alston), *84,* 92, *94*
Woman in Garden (Hayden), *47, 48*
Woman Resting (Catlett), 107, *109,* 112
Woman Sitting (Catlett), *110,* 112
Woman Taken in Adultery (Pippin), 70, *71,* 73
Women artists, 23, 35–36, 174
Woodruff, Hale Aspacio, **52,** *54,* **55,** 86, 87, 95,
 113, 143, **201**
Wright, Richard, 135
Works Progress Administration (WPA) era, 52,
 92, 112

Zanzibar (Morrison), *160,* 161